D0846295

THE
UNIVERSITY OF WINNIPEG
WINNIPEG 2. MAN.
CANADA
DISCARDED

DISCARDED

THE
CHROMOLITHOGRAPHS
OF LOUIS PRANG

NE
2312
.P7 M32
1973

THE
CHROMOLITHOGRAPHS
OF LOUIS PRANG

BY *Katharine Morrison McClinton*

Clarkson N. Potter, Inc./Publisher NEW YORK

DISTRIBUTED BY CROWN PUBLISHERS, INC.

Copyright © 1973 by Katharine Morrison McClinton

All rights reserved. No part of this publication may be reproduced, stored in a retrieval system, or transmitted, in any form or by any means, electronic, mechanical, photocopying, recording, or otherwise, without the prior written permission of the publisher.

Published simultaneously in Canada by General Publishing Company Limited.

Inquiries should be addressed to Clarkson N. Potter, Inc.
419 Park Avenue South, New York, N.Y. 10016.

Printed in the United States of America

Library of Congress Catalog Card Number: 72-87339

ISBN: 0-517-504111

First Edition

Designed by Ruth Smerechniak

Acknowledgments

My study of L. Prang & Company began ten years ago when I discovered the Prang Proof Books at the New York Public Library. Notes on Prang are included in my book *Collecting American Victorian Antiques,* but, since then, the New York Public Library has withdrawn the Proof Books from circulation. The source material for this present book was found in the valuable large collection of Prang material at Hallmark, Inc. I spent some time in Kansas City and, through the courtesy of Mr. Norman Rowland of Hallmark, Inc., I was not only given carte blanche use of the material in the collection but I was also supplied with the majority of photographs including the color plates used as illustrations in the book. In my study of the collection I was given valuable aid by Mrs. La Vaughn Wangler, cataloger and consultant of the Hallmark Historical Collection.

I also wish to thank Mr. Sinclair Hitchings, Keeper of Prints in the Print

Department, Boston Public Library; Mr. R. Eugene Zepp, Assistant Librarian, Print Department; and especially Mr. Paul Sorenson, Assistant Curator of Prints, Boston Public Library. I also wish to thank Mr. Carey Bliss, Head of Rare Books, Huntington Library and Art Gallery; Mrs. Penelope P. Behrens, Reference Department, Library of the Boston Athenaeum; Mr. Richard C. Nylander, Curator of Collections, The Society for the Preservation of New England Antiquities; Mr. Wilson Duprey, Director of Maps and Prints, The New-York Historical Society; Warren R. Howell of John Howell Books; D. Roger Howlett of Child's Gallery, Inc; Robert C. Vose, Jr., of Vose Galleries; Justin Schiller, Ltd.; Howell J. Heaney, Rare Book Librarian, and Frank M. Halpern, Reference Librarian, of The Free Library of Philadelphia; Mrs. Peggy Gilbert and Miss Carol Crossan of Norcross, Inc.; John Mackay Shaw, author of *Childhood in Poetry;* Milton Kaplan of the Library of Congress; Cornell University Library; University of Michigan Museum of Art; Albany Institute of History and Art; Robert G. Wheeler, Vice President, Research and Interpretation, The Henry Ford Museum; Linda S. Ferber, Assistant Curator, The Brooklyn Museum; Jeffrey R. Brown, Curator of Collections, Indianapolis Museum of Art; Henry F. Marsh, A. F. Tait Project, Adirondack Museum; The Bancroft Library, University of California; Dorothy Mozley, Genealogy and Local History Librarian, The Springfield Public Library, Springfield, Massachusetts; Colonel George F. Johnston of the New York Seventh Regiment.

Also I wish to express my appreciation to Jane West, my editor, and to the many readers of *Spinning Wheel* and *Antiques* Magazine who answered my requests for information about the chromos and paintings owned by Louis Prang, and to the magazines for printing my queries.

Contents

One L. Prang & Co. and the Chromolithograph 1

Two Album Cards, Mottoes, and Other Miscellaneous Publications 27

Three Juveniles, Toy Books, Pastimes, and Games 45

Four Trade Cards and Other Advertisements 59

Five Greeting Cards and Other Illuminated Cards 73

Six Prang and Flowers 91

Seven Shaped Booklets, Fancy Silk Novelties, Fine Art Books, and Booklets 103

Eight Books and Educational Publications 119

Nine Civil War Maps and Pictures, Landscape and Sport Series 139

Ten Artists Whose Pictures Were Produced By L. Prang & Company 167

Appendixes 203

Index 241

THE
CHROMOLITHOGRAPHS
OF LOUIS PRANG

CHAPTER *One*

L. Prang & Co. and the Chromolithograph

THE CHROMOS OF L. PRANG & COMPANY, LONG NEGLECTED FOR THE MORE popular Currier & Ives prints, have now become of interest and thus open up a new field for antiques collectors. There are many different categories, from album cards to advertising items, and a wide range of subject matter from small floral cards, Christmas cards, and other greeting cards to Civil War scenes and art studies. L. Prang & Company lithographs were made from 1860 through 1897. Vast quantities were published, especially in the 1880s and 1890s when the business grew so large that literally millions of items were put out. For this reason, in spite of the years of neglect and destruction, there should still be quantities of prints of different types available to the collector.

Whatever the collector's interest, he will want to know what chromo-lithographs are, where and when they were first made, and how they were

made. A lithograph differs from a steel engraving and a woodcut because it is printed from a stone and from a perfectly smooth surface with neither raised nor sunken areas. When it was invented, by Alois Senefelder of Bavaria about 1796, lithography brought a new reproductive process to the graphic arts. It permitted the artist to put his drawing directly on the lithographic stone without the intervention of an engraver. The result was a direct facsimile which retained the artist's individual touch.

In Senefelder's book, *The Invention of Lithography,* of which a translation was published in 1911, he describes the discovery of the process: "I had just ground a stone plate smooth in order to treat it with etching fluid and to pursue on it my practice in reverse writing when my mother asked me to write a laundry list for her. The laundress was waiting but we could find no paper. I wrote the list hastily on the clear stone and with my prepared stone, ink of wax, soap, and lampblack intending to copy it as soon as paper arrived." He discovered that by wetting the stone and inking it with the soapy, oily ink he could make neat copies of his list. From this chance beginning Senefelder brought the art of plain lithography to its highest perfection, but it was some years before anything was done in color lithography.

As early as 1835 patents were issued both in Germany and France for the first distinct process of printing three colors over each other from three separate stones. A few years later in 1839 color lithography was introduced into the United States by William Sharp of Boston. Sharp produced fruit and flower pieces and music cards. Other early producers of color lithography in America included Major, Knapp & Co. of New York, T. Sinclair and P. S. Duval & Son of Philadelphia, and J. H. Bufford of Boston. However it was left to Louis Prang to experiment and, step by step, finally to perfect the process. Prang used the term Chromolithography, meaning printing in color from drawings on stone, for the production of his art studies, calling them Prang's American Chromos. The first requisite in chromolithography was an original painting in oil or watercolor. In making a lithographic reproduction the artist begins by tracing an outline of the painting in all its details on a transparent sheet of gelatin. This outline is transferred to a stone in red or blue chalk and from this outline impressions may be taken. The next step for the artist is to analyze the picture by its various values and intensities and then determine exactly the colors he will have to use for a perfect facsimile. Having done this, the lithographer will know the number of plates (stones) needed for his work, as each color requires a separate one. He now transfers the picture outline in red or blue chalk to each plate to guide in drawing each color of the picture. Colors are sometimes superimposed on the various plates enabling the artist to produce fine gradations of tints and shades with comparatively few color plates. The stone used is called lithographic stone; it was quarried to perfection only at Solenhofen, Bavaria. These stone slabs were three or four inches in thickness, and before being used were polished. A crayon was used called lithographic crayon, the composition of

which was mainly a fatty soap colored with lampblack. Lithographic ink was similar in composition to the crayon and was rendered fluid by dissolving in water.

After the lithographer finished one plate in all its gradations, the plate underwent a process of fixing with an acidulated solution of gum arabic. This solution caused a chemical reaction between the soap in the crayon and the stone plate, making the outlines insoluble in water but at the same time covering all the blank spaces of the plate with a skin of gum arabic impermeable to oil. In printing, the flat printing plate is kept damp with a wet sponge. Then, ink is spread over the plate with a roller; the water is retained by the blank spaces while the ink is attracted to the outlines drawn by the greasy crayon. The first color plate then goes into the proof press and the artist's proofs are taken in the color desired. This serves as a guide in drawing the succeeding plate which, when finished, is again proved, first on a sheet of white paper, next on the sheet already covered with the preceding color. This process continues from plate to plate until the work is complete. After the picture is finished it is embossed to give it the appearance of being painted on canvas. The picture is then pasted to cardboard, cut, trimmed, and varnished. If there are any defects they are touched up by hand with a brush. The deeper, stronger, and richer the original painting to be reproduced the more color plates required to obtain a perfect facsimile.

A half chromo is also a colored lithograph first printed on a plain proof but fewer plates are used for the color. Hence, such colored lithographs have no depth or feeling of oil but they are often pretty pictures.

Louis Prang made the reproduction of color his lifelong study. As a boy in Breslau, Prussia, in his father's calico-printing establishment, he learned the fundamental principles of dyeing, color mixing, designing, engraving, and printing. He also had a year's work as a chemist in a paper mill. For five years he traveled throughout Europe studying calico printing. Prang was forced out of Germany by his activity in the revolutionary movement in 1848 and arrived in New York April 5, 1850. After several attempts at business Prang took his first regular job on *Gleason's Pictorial* under the direction of Frank Leslie. There was a brief connection with Rosenthal, Duval & Prang in Philadelphia, and in 1856 Prang formed a partnership with Julius Mayer, a lithographic printer in Boston. Prang polished the stones and made the drawings and his partner did the printing on a handpress. Their specialty was color work and their first job was a bouquet of roses in four colors, which was sold to a ladies magazine for two hundred fifty dollars. Prang & Mayer printed a *Bird's View Map of Harvard* which included at its bottom a series of small views of Old Cambridge including Longfellow's House, The Observatory, Law School, Divinity Hall, and Residence of Professor Agassiz. In 1858 the company put out a lithograph of sperm whaling, *The Conflict,* by the artist J. Foxcroft Cole. This is considered one of the finest and most interesting lithographs of American whaling. The color lithograph is 17½ inches by 28½ inches and is dated 1858. There were a few

other Prang & Mayer prints, mostly scenes around Boston. One of the earliest of the Prang & Mayer hand-tinted lithographs is of the Chauncy Hall School and First Congregational Church, Boston, dated 1857. There was also a scene of New Bedford, Massachusetts, 1858, by J. Foxcroft Cole, one of a series of eight pastoral scenes by Cole that were published in the American Artists Series in 1870.

In 1860 Prang bought out his partner. Times were critical due to the outbreak of the Civil War and Prang's business did not prosper at first. However, shortly after the events of Charleston Harbor a friend showed Prang an engineer's plan of the harbor with forts and channels marked. "This would be a good thing for you to publish," said his friend. A few days later Prang had four presses running. On the day the maps were done—and before they were in the shops or newsstands—Prang himself sold so many copies at twenty-five cents each that he had a hat full of silver coins at the end of the day. In all, the map sold forty thousand copies. Prang was soon ready with another map and during the four years that followed he printed a series of maps showing where the armies were fighting and the deployment of troops and equipment during the major battles. Red and blue pencils were included with the maps for marking the movement of the troops. Prang also published card-size portraits of popular generals, and millions of these were sold at ten cents each. Later Prang published a large broadside with fifty of the heads on one sheet. In 1863 Prang published portraits of George and Martha Washington after paintings by Stuart. Also in 1863 a series of campaign sketches by Winslow Homer were published in black and white, as well as a series of album-size Civil War sketches called "Life in Camp" in color. "Democracy," a small Civil War cartoon, was printed in the 1860s. There was also a small tinted print of Abraham Lincoln and his son Tad published in 1862, and a print of Lincoln's home in Springfield, Illinois, was printed in 1865.

Another early print was the Old Dock-Square Warehouse, a Gothic landmark in Boston, that was torn down in 1860. This picture by Prang was advertised in *Prang's Chromo,* January 1868 but it was probably made in 1860–61. This was a half chromo and was 10¾ x 15 inches. *The View of the Stone Fleet,* which sailed from New Bedford November 16, 1861, was another color lithograph made by L. Prang & Company in 1862. A broadside of portraits of fifty-two species of fowls was another early black-and-white print.

The other business of L. Prang & Company at this time included album cards; card publications for day schools and Sunday schools, Christmas and New Year's cards, mourning cards, illuminated crosses, designs for monuments and headstones, games, juveniles, and toy books.

The publication of album cards was an especially happy idea. In the late nineteenth century an album holding colorful cards was found on the center table of every parlor. The cards were put up in envelopes containing twelve cards each, and their subjects included flowers, leaves, birds, butterflies, animals, marine and landscape views.

However, although he was now a successful publisher, Louis Prang was not

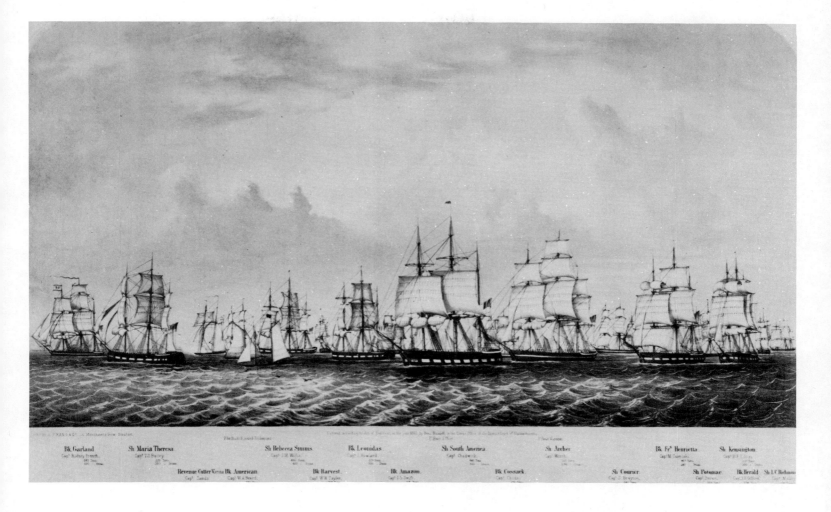

View of the Stone Fleet which Sailed from New Bedford, November 16th, 1861. Early Prang chromo. The Harry T. Peters "America on Stone" Lithography Collection, Smithsonian Institution.

satisfied, for he had a goal and ideal toward which he had worked from the first. He had once seen a color lithograph by the Berlin firm Storch & Cramer and he determined to equal or surpass it. With this goal in mind Prang took his family to Europe in 1864 and there he studied the latest lithographic processes. He also brought back a staff of skilled artists to work in his plant in Boston.

Prang's first full chromolithographs were produced in 1866 according to *Prang's Chromo*, April 1869. The first chromos were a set of six Cuban scenes which were sold together in a paper portfolio. The public did not take favorably to them: "there was nothing to hang up in the parlor." Mr. Prang next tried a pair of landscapes, *Early Autumn on Esopus Creek, N.Y.* and *Late Autumn in the White Mountains*, by Bricher, which also failed to sell. Prang's third attempt was A. F. Tait's *Group of Chickens*. This was followed by his *Group of Duck-*

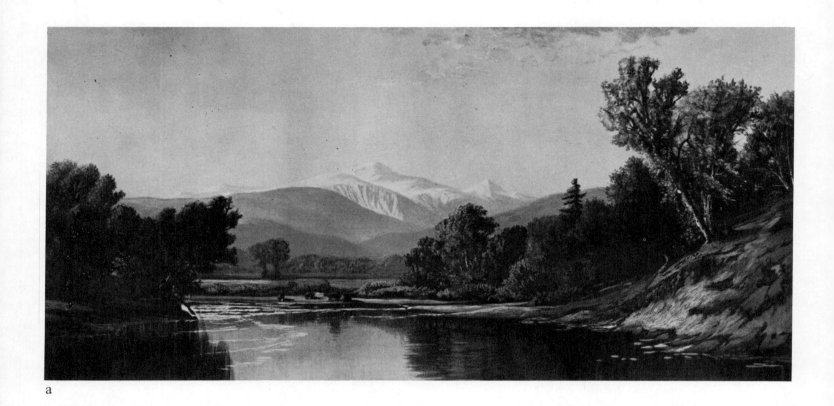

a

(a) *Late Autumn in the White Mountains.* Chromo by L. Prang & Co., after painting by A. T. Bricher. (b) Label from back of chromo. *Collection, Print Department, Boston Public Library.*

b

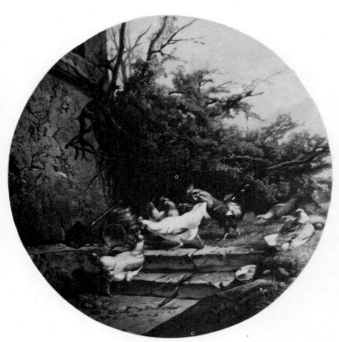

The Poultry Yard, 1871. Plaque. Chromo, after painting by E. Lemmens. *Hallmark Historical Collection.*

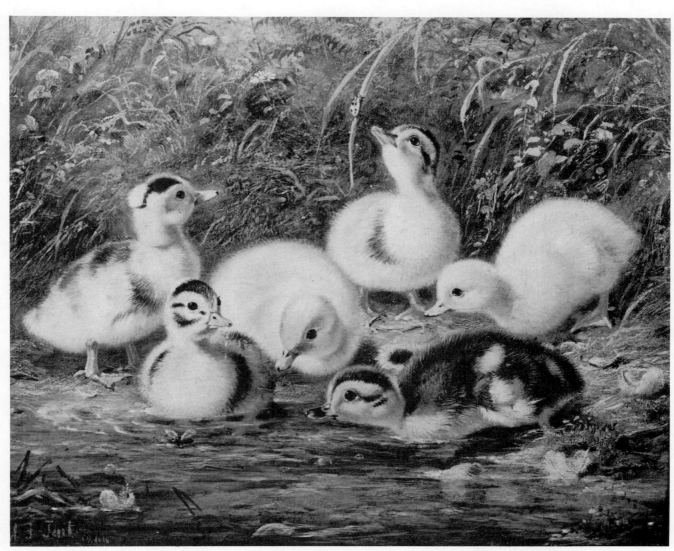

Group of Ducklings. A. F. Tait, 1866. Original painting from which one of Prang's first chromos was made. *The Old Print Shop.*

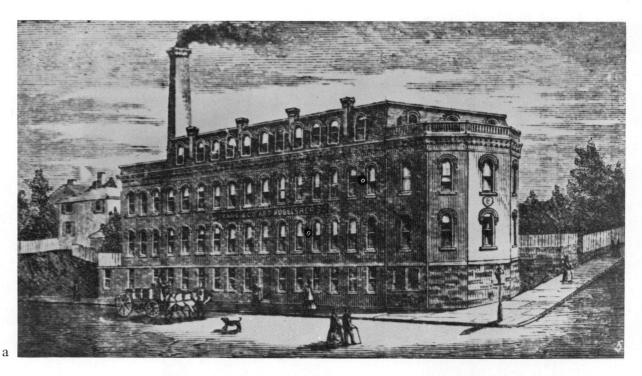

a

Exterior (a) and interior (b) views of L. Prang & Co. plant, including (c) a portrait of Mr. Prang in his office. *Hallmark Historical Collection.*

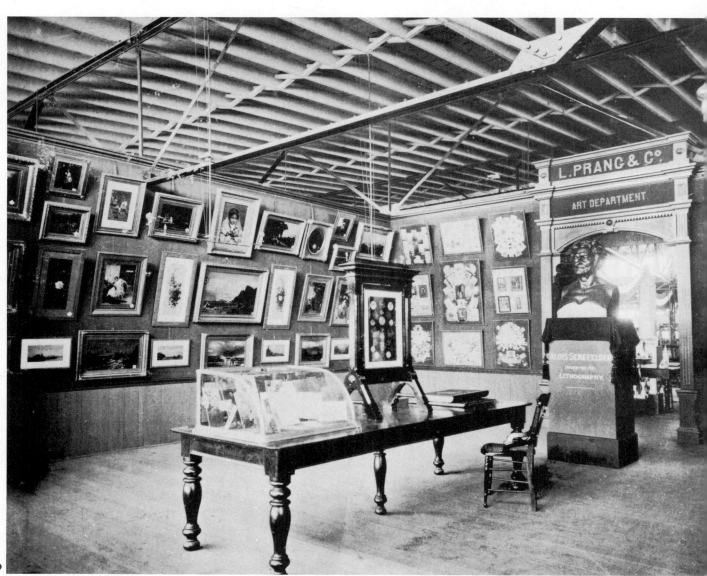

b

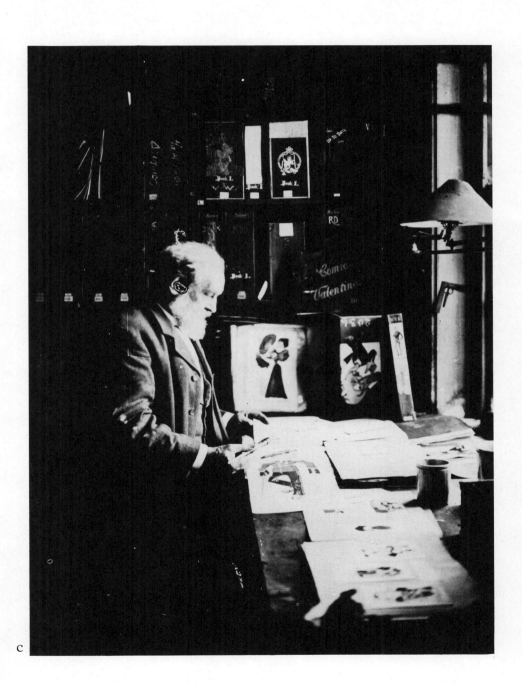

c

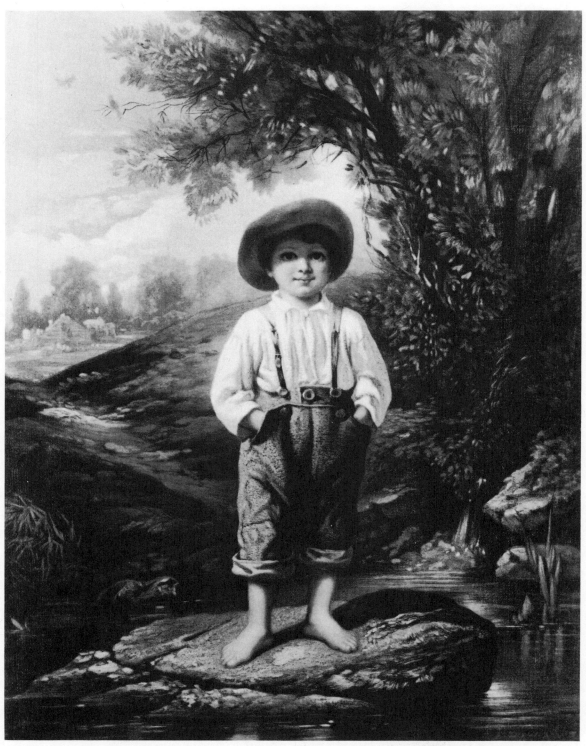

The Barefoot Boy. Chromo by L. Prang and Co., after painting by Eastman Johnson, 1866–1867. *The Library of Congress.*

lings. This was an immediate, great, and permanent success. Other poultry groups were done by E. Lemmens. This was soon followed by Eastman Johnson's *Barefoot Boy,* which illustrated Whittier's poem of that name.

By 1867 the business had grown to such dimensions that Prang erected a new building at 286 Roxbury Street in the Roxbury district of Boston. This housed forty presses and seventy workmen. Besides his chromos, Prang made half chromos and also carried on a regular printing business. He also made further exploration in new fields of art printing. From this time on each year saw a new group of pictures for the parlor. These were facsimiles of the work of the well-known artists of the past and present both in Europe and America. They reflected the best creative art as well as the popular taste. In Prang's establishment the artistic work was executed by artists who had themselves produced paintings of the kind they were employed to imitate. For example, William Harring was the artist who worked on the lithographic stones for Thomas Hill's painting of Yosemite Valley and anyone watching him transfer the painting to the long series of lithographic stones "will perceive that he is laboring in the spirit of an artist and by the methods of an artist."

Beginning in January 1868, Prang published a quarterly journal called *Prang's Chromo, A Journal of Popular Art,* which was actually a house organ put out by the firm to publicize their chromos. The journal included a complete catalog of the chromos up to date and announcements of the newest chromos with illustrations, articles relating to chromos as well as comments from newspapers both in America and abroad and letters from well known people praising the chromos. Early in his business career Prang made contacts not only with artists but with poets, writers, and statesmen by sending them complimentary chromos. In return they wrote thanking him and making favorable comments about the chromos and these letters Prang printed in *Prang's Chromo.*

The contents of the first four issues of the *Chromo* are as follows:

No. 1 (for January, 1868) contains, in addition to a complete catalogue of our chromos and illuminated publications up to that date, an article from "The Boston Daily Advertiser," describing how chromos are made by James Redpath; letters from James Parton, Harriet Beecher Stowe, Longfellow, Church the painter, Whittier, and Bayard Taylor; "Hints on Framing," by Louis Prang; and two essays on chromolithography in America, by Charles Godfrey Leland.

No. 2 (for April, 1868) contains an article entitled "Illustrations of Progress," by Lydia Maria Child; "Controversy with an Art-Critic" (between Clarence Cook and Louis Prang); short papers,—"Decorate your Schools," "A Hint to Teachers," "Moral Influence of Art," and "A Word on Chromos,"—by various writers; Editorial Notes; "Boston Art-Notes," from "The Daily Advertiser"; and letters on Prang's chromos, by Whittier, Wendell Phillips, George L. Brown [the artist], Mary L. Booth, Lydia Maria Child, Edward Everett Hale, T. W. Higginson, J. T. Trowbridge, George Wm. Curtis, E. Stuart Phelps, Louisa M. Alcott, Lucy Larcom, Harriet E. Spofford, Grace Greenwood, Alice Carey, "Ber-

Prang's Chromo.

A Journal of Popular Art.

VOL. I. BOSTON, JANUARY, 1868. No. 1.

HOW CHROMOS ARE MADE.

FROM THE BOSTON DAILY ADVERTISER.

CHROMO-LITHOGRAPHY is the art of printing pictures from stone, in colors. The most difficult branch of it — which is now generally implied when chromos are spoken of — is the art of reproducing oil paintings. When a chromo is made by a competent hand, it presents an exact counterpart of the original painting, with the delicate gradations of tints and shades, and with much of the spirit and tone of a production of the brush and pallet.

To understand how chromos are made, the art of lithography must first be briefly explained. The stone used in lithographing is a species of limestone found in Bavaria, and is wrought into thick slabs with finely polished surface. The drawing is made upon the slab with a sort of colored soap, which adheres to the stone, and enters into a chemical combination with it after the application of certain acids and gums. When the drawing is complete, the slab is put on the press, and carefully dampened with a sponge. The oil color (or ink) is then applied with a common printer's roller. Of course, the parts of the slab which contain no drawing, being wet, resist the ink; while the drawing itself, being oily, repels the water, but retains the color applied. It is thus that, without a raised surface or incision — as in common printing, wood-cuts, and steel engravings — lithography produces printed drawings from a perfectly smooth stone.

In a chromo, the first proof is a light ground-tint, covering nearly all the surface. It has only a faint, shadowy resemblance to the completed picture. It is in fact rather a shadow than an outline. The next proof, from the second stone, contains all the shades of another color. This process is repeated again and again and again; occasionally, as often as thirty times. We saw one proof, in a visit to Mr. Prang's establishment, — a group of cattle, — that had passed through the press twelve times; and it still bore a greater resemblance to a spoiled colored photograph than to the charming picture which it subsequently became. The number of impressions, however, does not necessarily indicate the number of colors in a painting, because the colors and tints are greatly multiplied by combinations created in the process of printing one over another. In twenty-five impressions, it is sometimes necessary and possible to produce a hundred distinct shades.

The last impression is made by an engraved stone, which produces that resemblance to canvas noticeable in all of Mr. Prang's finer specimens. English and German chromos, as a rule, do not attempt to give this delicate final touch, although it would seem to be essential in order to make a perfect imitation of a painting.

The paper used is white, heavy "plate paper," of the best quality, which has to pass through a heavy press, sheet by sheet, before its surface is fit to receive an impression.

The process thus briefly explained, we need hardly add, requires equally great skill and judgment at every stage. A single error is instantly detected by the practised eye in the finished specimen. The production of a chromo, if it is at all complicated, requires several months — sometimes several years — of careful preparation. The mere drawing of the different and entirely-detached parts on so many different stones is of itself a work that requires an amount of labor and a degree of skill, which, to a person unfamiliar with the process, would appear incredible. Still more difficult, and needing still greater skill, is the process of coloring. This demands a knowledge which artists have hitherto almost exclusively monopolized, and, in addition to it, the practical familiarity of a printer with mechanical details. "Dry-

ing" and "registering" are as important branches of the art of making chromos as drawing and coloring. On proper registering, for example, the entire possibility of producing a picture at every stage of its progress depends. "Registering" is that part of a pressman's work which consists in so arranging the paper in the press, that it shall receive the impression on exactly the same spot of every sheet. In book work, each page must be exactly opposite the page printed on the other side of the sheet, in order that the impression, if on thin paper, may not "show through." In newspaper work this is of less importance, and often is not attended to with any special care. But in chromo-lithography the difference of a hair's-breadth would spoil a picture; for it would hopelessly mix up the colors.

After the chromo has passed through the press, it is embossed and varnished, and then put up for the market. These final processes are for the purpose of breaking the glossy light, and of softening the hard outlines which the picture receives from the stone, which imparts to it the resemblance of a painting on canvas.

Mr. Prang began his business in the humblest way, but has rapidly increased his establishment, until he now employs fifty workmen, — nearly all of them artists and artisans of the most skilful class, — and is preparing to move into a larger building at Roxbury. He uses eighteen presses; and his sales are enormous. His catalogue now embraces a large number of Album Cards, about seventy sets of twelve in each set; a beautiful series of illuminated "Beatitudes" and "Scriptural Mottoes;" an endless list of our great men, and of men not so great after all; of juveniles, notably, a profusely illustrated edition of "Old Mother Hubbard;" and of half chromos and chromos proper. Tait's "Chickens," "Ducklings," and "Quails" were the first chromos that met an instant and wide recognition. Nineteen thousand copies of the "Chickens" alone were sold. Bricher's "Early Autumn on Esopus Creek" is one of the best chromos ever made on a small scale. The "Bulfinch" and the "Linnet" (after Cruikshank) are admirable. There are other chromos which are less successful, and one or two that are not successful at all; but they are nearly all excellent copies of the originals, with which the defects must be charged.

The chromos of Bricher's paintings are really wonderfully accurate.

Mr. Prang's masterpiece, however, is not yet published, although it is nearly ready for the market. It entirely surpasses all his previous efforts. It is Correggio's "MAGDALENA," and can hardly fail, we think, to command a quick sale and hearty recognition.

Like every modern discovery, chromo-lithography has its partisans and detractors, — those who claim for it perhaps impossible capabilities, and those who regard it as a mere handicraft, which no skill can ever elevate into the dignity of an art. We do not care to enter into these disputes. Whether an art or a handicraft, chromo-lithography certainly re-produces charming little pictures vastly superior to any colored plates that we have had before; and it is, at least, clearly entitled to be regarded as a means of educating the popular taste, and thereby raising the national ideal of art.

A correspondent, looking at chromos from this point of view, thus indicates (it may be somewhat enthusiastically) their possible influence on the culture of the people: —

"What the discovery of the art of printing did for the mental growth of the people, the art of chromo-lithography seems destined to accomplish for their æsthetic culture. Before types were first made, scholars and the wealthier classes had ample opportunities for study; for even when Bibles were chained in

churches, and copies of the Scriptures (then aptly so-styled) were worth a herd of cattle, there were large libraries accessible to the aristocracy of rank and mind. But they were guarded against the masses by the double doors of privilege and ignorance. A book possessed no attractions for the man who could not read the alphabet; and, *because* they were rare and hard to get at, he had no incitement to master their mysteries. Made cheap and common, the meanest peasant, in the course of a few generations, found solace for his griefs in the pages of the greatest authors of his times and of all time. Mental culture became possible for whole nations; and democracy, with its illimitable blessings, gradually grew up under the little shadow of the first 'printer's proof.'

"Until within a quite recent period, art has been feudal in its associations. Galleries of priceless paintings, indeed, have always been in certain favored cities and countries; but to the people, as a whole, they have been equally inaccessible and unappreciated, because no previous training had taught the community *how* to prize them. It was like Harvard College without the district school, — a planet without satellites, and too far removed from the world of the people for its light to shine in the cottage and in the homes of the masses.

"Now, chromo-lithography, although still in its infancy, promises to diffuse not a love of art merely among the people at large, but to disseminate the choicest masterpieces of art itself. It is art republicanized and naturalized in America. Its attempts hitherto have been comparatively unambitious; but it was not Homer and Plato that were first honored by the printing-press. It was dreary catechisms of dreary creeds. So will it be with this new art. As the popular taste improves, the subjects will be worthier of an art which seeks to give back to mankind what has hitherto been confined to the few."

MR. PARTON ON PRANG'S CHROMOS.

NEW YORK, Dec. 29, 1866.

GENTLEMEN, —

I have just received the exquisite specimens of your art which you have been so generous as to send me. The letter respecting them arrived last night.

It has been a favorite dream with me for years, that the time would arrive when copies of paintings would be multiplied so cheaply, and reduced so correctly, as to enable the working-man to decorate his rooms with works equal in effect to the finest efforts of the brush. I could not see that there was any natural obstacle in the way of this, which science could not overcome. The works which are issued by your house, which have often and long detained me at the picture-shop windows in Broadway, show me that my dream is coming true.

I do not wonder at the enthusiasm with which you pursue your beautiful vocation. The business of this age is to make every honest person an equal sharer in the substantial blessings of civilization; and one of the many means by which this is to be effected is to make the products of civilization cheap.

In prosecuting your business, therefore, you are aiding to bring about the essential equality of merit, opportunities and circumstances. Besides, what a future is there for art where a great picture can adorn a hundred thousand homes, instead of nourishing the pride of one, and when an artist can draw a steady revenue from the copyright of his works, instead of eating up one picture while he anxiously and hurriedly completes another!

For the public sake and your own, gentlemen, I wish you success.

JAMES PARTON.

Messrs. L. PRANG & Co.

wick" [James Redpath], W. D. Howells, T. B. Aldrich, and Charles Dawson Stanley.

No. 3 (for September, 1868), contains letters eulogizing Mr. Prang's publications from Mr. Godey [editor of "The Lady's Book"], the author of "Emily Chester" [Anna M. Crane], Caroline Chesebro, W. S. Robinson ["Warrington"], Louise Chandler Moulton, Gen. Sidell, Charles C. Hazewell (editor, "Boston Traveller"), J. H. A. Bone (editor, "Cleveland Herald"), Edmund Clarence Steadman, etc. It has also two letters by Louis Prang, addressed to "The Philadelphia Bulletin" and "The Buffalo Courier," in which the theories of certain art-critics are examined and refuted.

No. 4 (for Christmas, 1868) contains cuts and descriptions of twenty-nine of our chromos; an engraving and account of "Our New Publishing House"; "Pictures for the Home," by Mrs. Harriet Beecher Stowe; letters from Rev. Henry Ward Beecher, Ralph Waldo Emerson, F. E. Church, Eastman Johnson, John G. Whittier, William D. O'Connor, and Miss Anna E. Dickinson.

A step-by-step description of the process of reproducing Eastman Johnson's *Barefoot Boy* is given in *Prang's Chromo,* April 1869:

It is a small picture—about thirteen inches by ten—but to reproduce it in chromolithograph requires twenty-six slabs of stone weighing not far from two tons and worth fourteen hundred dollars. The time occupied in preparing these stones for the press is about three months, and when once the stones are ready an edition of a thousand copies is printed in five months more. It may be possible in a few words to convey some idea of the manner in which this particular boy standing barefoot upon a rock in a brook with trees, a grassy bank and blue sky behind him is transferred from a thousand dollar canvas to whole stacks of five dollar pasteboard.

As far as possible, the chromo-lithographer produces his copy by the method which the artist employed in painting the original. He first draws upon a stone, with his pencil of soap and lampblack, a faint shadow of the picture,—the out line of the boy, the trees, and the grassy bank. In taking impressions from this first stone an ink is used which differs from printer's ink only in its color. Printer's ink is composed chiefly of boiled linseed-oil and lampblack; but our chromo-lithographer, employing the same basis of linseed-oil, mixes with it whatever coloring matter he requires. In taking impressions from the first stone, in laying, as it were, the foundation of the boy, he prefers a browned vermillion. The proof from this stone shows us a dim beginning of the boy in a cloud of brownish red and white, in which can be discerned a faint outline of the trees that are by and by to wave over his head. The face has no features. The only circumstances clearly revealed to the spectator are, that the boy has his jacket off, and that his future trousers will be dark. Color is placed, first of all, where most color will be finally wanted.

The boy is begun. He wants more vermillion, and some portions of the trees and background will bear more. On the second stone, only those portions

Prang's American Chromos.

Early Autumn on Esopus Creek, N.Y. (After A. T. BRICHER)	Size 9¼ by 18⅜ inches		$6.00
Late Autumn in the White Mountains. (After A. T. BRICHER)	" 9¼ by 18¼ "		6.00
Six American Landscapes. (After A. T. BRICHER)	" 4½ by 9 "	(Per set)	9.00
Strawberries and Baskets. (After Miss V. GRANBERY)	" 13 by 18 "		7.50
Cherries and Basket. (After Miss V. GRANBERY)	" 13 by 18 "		7.50
Flower Bouquet	" 13⅛ by 16⅜ "		6.00
Blackberries in Vase. (After LILLY M SPENCER)	" 13⅛ by 16⅜ "		6.00
Fringed Gentian. (After H. R. NEWMAN)	" 6⅜ by 10¼ "		6.00
Easter Morning. (After Mrs. JAMES M. HART)	" 14 by 21 "		10.00
Group of Chickens. (After TAIT)	" 10 by 12½ "		5.00
Group of Quails. (After TAIT)	" 10½ by 14 "		5.00
Group of Ducklings. (After TAIT)	" 10 by 12½ "		5.00
The Poultry Yard. (After LEMMENS)	" 10½ by 14 "		5.00
Poultry Life. { A } (After LEMMENS) { B } (Companions)	" 5½ by 7⅜ "		4.50
The Kid's Play-Ground. (After BRUITH)	" 10½ by 17¼ "		6.00
Corregio's Magdalena	" 12⅜ by 16⅜ "		10.00
Under the Apple-Tree. (After G. E. NILES)			
Rest by the Roadside. (Companion pictures)	" 7 by 8⅞ "		5.00
Autumn Leaves — Maple	" 11 by 14 "		1.00
Autumn Leaves — Oak	" 11 by 14 "		1.00
Wood-Mosses and Ferns. (After ELLEN ROBBINS)	" 10½ by 14½ "		1.50
Bird's Nest and Lichens. (After ELLEN ROBBINS)	" 10½ by 14½ "		1.50
The Bulfinch. (After WM. CRUICKSHANK)	" 7¾ by 9⅞ "		3.00
The Linnet. (After WM. CRUICKSHANK)	" 7¾ by 9⅞ "		3.00
The Baby: or, Going to the Bath. (After BOUGUEREAU)	" 7 by 9¾ "		3.00
The Sisters. (Companion to the Baby)	" 7 by 9¾ "		3.00
Dead Game. (After G. BOSSETT)	" 8¼ by 11½ "		3.00
A Friend in Need. (After F. SCHLESINGER)	" 13 by 16½ "		6.00
The Barefoot Boy. (After EASTMAN JOHNSON)	" 9¼ by 12½ "		5.00
Sunlight in Winter. (After J. MORVILLER)	" 24 by 16¼ "		12.00
Sunset: California Scenery. (After A. BIERSTADT)	" 18¼ by 12 "		10.00
Horses in a Storm. (After R. ADAMS)	" 22¼ by 15¼ "		7.50
Our Kitchen-Bouquet. (After WM. HARRING)	" 18½ by 13½ "		5.00
The Unconscious Sleeper. (After L. PERRAUTL)	" 13 by 16½ "		6.00
The Two Friends. (After GIRAUD)	" 13 by 16½ "		6.00
The Boyhood of Lincoln. (After EASTMAN JOHNSON)	" 16¾ by 20½ "		12.00
Fruit Piece, No. 1. (After C. BIELE)	" 16½ by 12 "		6.00
The Doctor. (After HENRY BACON)	" 8½ by 11½ "		5.00
Harvest. (After B. B. G. STONE)	" 8½ by 14¼ "		5.00
The Crown of New England. (After GEO. L. BROWN)	" 23¾ by 15⅜ "		15.00

Prang's Half Chromos.

The Winter Wren			
The Ruby-Crowned Wren			
The Savannah Sparrow	Each 6¼ by 8¼ inches		$1.00
The Black-Throated Blue Warbler			
Piper and Nut-Crackers. (After LANDSEER)	Size 10 by 12⅜ "		2.00
Piper and Nut-Crackers. (After LANDSEER)	" 6⅜ by 7¾ "		1.00
May Flowers	" 7¾ by 9½ "		1.00
Apple-Blossoms	" 7¾ by 9½ "		1.00
Mother's Care	" 8¼ by 11¾ "		1.25
Victory: or, The Remedy worse than the Disease	" 10 by 12½ "		2.00
Victory. (The same subject reduced)	" 6¼ by 7¾ "		1.00
Awakening. (A Litter of Puppies)	" 8⅜ by 11⅜ "		2.00
The Twins. No. 1. (Lambs and Sheep)			
The Twins. No. 2. (A companion picture)	Each 10 by 11½ "		2.00
Scotch Terrier and Puppies	Size 8¼ by 10¼ "		2.00
Not Caught Yet. (After E. LANDSEER)	" 8 by 12 "		2.00
Just Caught. (After HERRING)	" 8 by 12½ "		2.00
The Frightened Ducklings	" 10 by 11⅜ "		2.00
Old Dock-Square Warehouse	" 10¼ by 14¾ "		1.00
Cocker and Woodcock. (After ANSDELL)	" 8¼ by 11⅜ "		2.00
Have Patience. (Girl and Dog)	" 13¾ by 16¾ "		4.00
Rabbits and Kittens	" 14¾ by 17¾ "		6.00
Morning. (After ROSA BONHEUR)	" 12 by 17½ "		5.00
Evening. (After ROSA BONHEUR)	" 12 by 17½ "		5.00
*Twelve Views on the Hudson	(Per set)		1.50
*Twelve Views of American Coast-Scenes	"		1.50
Summer Fruit — Currants, Oranges, &c. (Companion pieces)			
Autumn Fruit — Grapes, Peaches, Pears, &c. (After S. FULLER)	" 15½ by 10½ "	(Per pair)	10.00

** These two series of miniature pictures are put up in sets of twelve assorted copies, and mounted on white board. Size, 2¾ by 4½.*

Prang's Chromo, vol. I, no. 4 (Christmas 1868), p. 8. Libraries, Cornell University.

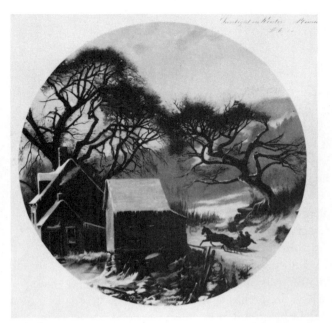

Plaque, *Sunlight in Winter*, 1871. Chromo, after painting by J. Morviller. *Hallmark Historical Collection.*

Plaque, *The Kid's Playground*, 1871. Chromo by L. Prang & Co., after painting by A. Bruith. *Hallmark Historical Collection.*

Horses in Storm. Chromo, after painting by R. Adams. *Hallmark Historical Collection.*

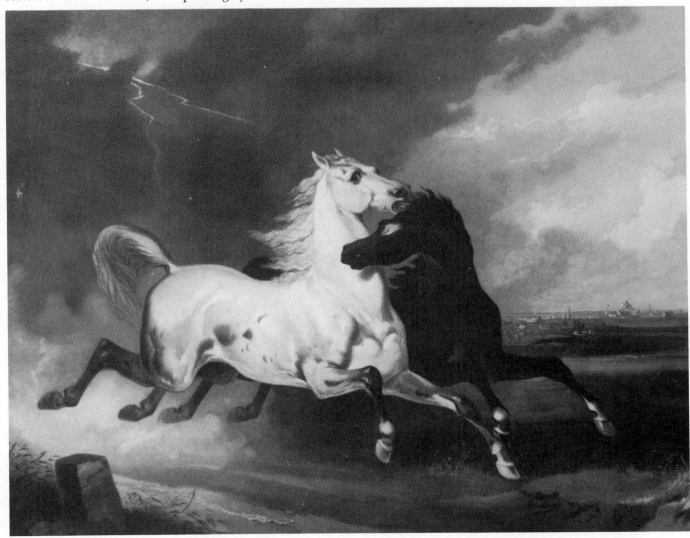

of the picture are drawn, which, at this stage of the picture, require more of that color. Upon this second stone, after the color is applied, the first impression is laid, and the second impression is taken. In this proof, the boy is manifestly advanced. As the deeper color upon his face was not put upon the spots where his eyes are to be, we begin to discern the outline of those organs. The boy is more distinct, and the general scheme of the picture is slightly more apparent.

As yet, however, but two colors appear,—brown-vermillion and white. On the third stone, the drawing is made of all the parts of the picture which require a blue coloring,—both those that will finally appear blue, and those which are next to receive a color that will combine with blue. Nearly the whole of the third stone is covered with drawing; for every part of the picture requires some blue, except those small portions which are finally to remain white. The boy is now printed for the third time; a bright blue color being spread upon the stone. The change is surprising, and we begin now to see what a pretty picture we are going to have at last. The sky is blue behind the boy, and the water around the rock upon which he stands is blue; there is blue in his eyes, and in the folds of his shirt; but in the darker parts of the picture the brown-vermillion holds its own, and gains in depth and distinctness from the intermixture with the lighter hue.

Stone number four explains why so much blue was used upon number three. A bright yellow is used in printing from number four; and this color, blending with the blue of the previous impression, plasters a yellowy, disagreeable green on the trees and grass. The fifth stone, which applies a great quantity of brown-vermillion, corrects in some degree this dauby, bad effect of the yellow, deepens the shadows, and restores the spectator's confidence in the future of the boy. In some mysterious way, this liberal addition of vermillion brings out many details of the picture that before were scarcely visible. The water begins to look like water, the grass like grass, the sky like sky, and the flesh like flesh. The sixth stone adds nothing to the picture but pure black; but it corrects and advances nearly every part of it, especially the trunks of the trees, the dark shade upon the rocks, and portions of the boy's trousers. Stone number seven gives the whole picture, except the figure of the boy, a coat of blue; which, however, only makes that bluer which was blue before, and leaves the other objects of their previous color, although brighter and clearer. The eighth stone merely puts "madder lake" upon the boy's face, hands and feet, which darkens them a little, and gives them a reddish tinge. He is, however, far from being a pleasing object; for his eyes, unformed as yet, are nothing but dirty blue spots, extremely unbecoming. The ninth stone, which applies a color nearly black, adds a deeper shade to several parts of the picture, but scarcely does anything for the boy. The tenth stone makes amends by putting upon his cheeks, hands and feet a bright tinge of blended lake and vermillion, and giving to his eyes a somewhat clearer outline.

To an inexperienced person, the picture now appears to be in a very advanced stage; and many of us would say, "Put a little osculation into that boy's eyes and let him go." Trees, rocks, grass, water, and sky look pretty well,—look a thousand times better than the same objects in paintings which auctioneers

praise, and that highly. But we are only at the tenth stone. That child has to go through the press sixteen times more before Mr. Prang will consider him fit to appear before a fastidious public.

Stones number eleven, twelve, thirteen, fourteen, fifteen, and sixteen all apply what seems to the uninstructed eye mere black. The colors are, indeed, extremely dark, although not pure black; and the chief object of these six impressions is to put into the picture those lines and shadows which the eye just mentioned cannot understand, but also enjoys. It is by such minute applications of a color that a picture is raised from the scale of merit which escapes censure to that which affords delight. The last of these shading stones gives the boy his eyes, and from this time he looks like himself.

The seventeenth stone lays upon the trees and grass a peculiar shade of green, that corrects them perceptibly. Number eighteen just touches the plump cheeks, the mouth and toes of the boy, with mingled lake and vermillion, at which he smiles. The last seven stones continue the shading, deepening, and enriching of the picture by applying to different parts of it the various mitigations of black. It is then passed through the press upon a stone, which is grained in such a way as to impart to the picture the roughness of canvas; after which it is mounted upon thick pasteboard, and varnished. The resemblance to the original is then such that it is doubtful if Mr. Eastman Johnson would pick out his own boy if he were surrounded with a number of copies.

It is not every picture that admits of such successful treatment as this, nor does every chromo-lithographer bestow upon his productions so much pains and expense. A salable picture could be made of this boy in ten impressions; but, as we have seen, he receives twenty-six; and the process might be prolonged until a small quarry of stones had been expended upon him. Some landscapes have been executed which required thirty-two stones.

Mr. Prang is rapidly increasing his business, and improving his beautiful art. He has begun his contemplated "Gallery of American Painters," in which he proposes to produce at least one characteristic picture by each of our eminent artists. He has already published several landscapes by Bricher; several groups of chickens and the like, by Tait; several fruit pieces by Lily M. Spencer and Miss V. Granberry of New York; a couple of genre pictures by Niles of Boston; a series of Ruggles's "gems" in oil colors; besides a great variety of illuminated texts and cards by Miss Jennie Lee of Jersey; and cartoons and lithographs by Mr. Homer and others. [*Prang's Chromo,* April 1868]

Our latest Chromos. . . . "The Crown of New England," "Harvest," "The Doctor" and Bricher's "Spring" and "Autumn" . . . have been published since the last issue of "The Chromo" [*Prang's Chromo,* April 1869].

Other important chromos issued by Prang at this time included *Family Scene in Pompeii* (14¾ x 19 inches), by the Belgian artist Coomans which required forty-five different stones. Although a steam press made five thousand impressions a day the labor was all by hand and forty-five days were required to

The Doctor, 1869. Chromo by L. Prang & Co., after painting by Henry Bacon. *Hallmark Historical Collection.*

Little Bo-Peep, 1870. Chromo by L. Prang & Co., after painting by J. G. Brown. *Hallmark Historical Collection.*

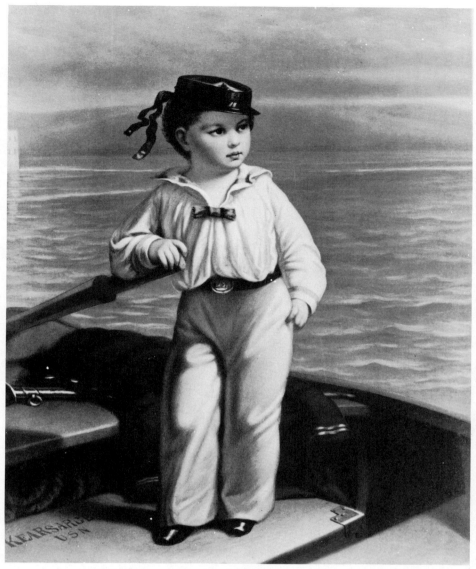

Young Commodore. Chromo by L. Prang & Co., after painting by B. F. Reinhart, 1869. *The Library of Congress.*

produce one hundred fifty copies. *Sunset on the Coast* (24 x 13¾ inches) by De Haas and *Launching the Life Boat* (24 x 13¾ inches) by Edward Moran were also published at this time. Prang received letters from both De Haas and Moran testifying to the fidelity of the reproductions of their pictures.

Pictures of childhood by John G. Brown issued in 1869 included *Three Tom Boys* (17 x 21 inches), *Queen of the Woods,* and *Little Bo-Beep,* both (14⅛ x 18⅛ inches), *Maiden's Prayer,* and *Playing Mother.* Other early children's pictures were *The Boyhood of Lincoln* (16¾ x 21 inches) by Eastman Johnson; *Wild Fruit* (9¾ x 13 inches) by George C. Lambdin; *Young Commodore* (9¾ x 13 inches) by B. F. Reinhart; *Little Prudy* and *Little Prudy's Brother* (9 x 11 inches) by Mrs. E. Murray; and *Prattling Primrose* and *Dreaming Daisy* (10 x 12 inches) by Mrs. Sophia Anderson. These pictures continued to be favorites for many years.

Each year Prang added new chromos to his list. In September 1870, the *Prang's Chromo* listed facsimiles of the following pictures: four landscapes by James M. Hart—*Spring, a scene near Cayuga Lake, N.Y.; Summer, a scene near Stockbridge, Massachusetts; Autumn, a scene near Farmington, Connecticut;* and *Winter, a scene near New Russia, Essex County, New York,* each 16 x 9 inches. *The Joy of Autumn,* a scene of red and yellow Indian summer by William M. Hart, *Lake George* and *View on the Hudson near West Point* by Herman Fuechsel and *The Close of Day,* a sunset haymaking scene in Columbia County, New York, by Arthur Parton, were other new chromo landscapes. Two still-life pictures, *Flowers of Memory* by Miss E. Remington and *Flowers of Hope* by Martin J. Heade; and also *Prairie Flowers* after Jerome Thompson, and *Wildflowers* by Miss Ellen Robbins were added to the list of flower chromos.

A description of a visit to the Prang establishment given in the Lowell, Massachusetts, *Daily Courier* of May 5, 1885, is as follows:

> Entering the office one steps at once into an atmosphere of art. Some of the more striking and recent productions of the house are displayed on the counters; a frame of medals won in scores of exhibitions attract the eye: on the long table are albums devoted to the cards and pictures which form so extensive a feature of the firm's catalogue. Sometimes chromos and the oil paintings from which they were taken are hung side by side in identical frames. So close are the reproductions that often even the artist could not tell which was brush and which was printing-press. Through an open door one catches a glimpse of Mr. Prang's private office literally covered with choice pictures, many of them the originals of the chief works of the establishment. The second floor was devoted to press work. There were 8 power presses and 18 hand presses.

The panels and card pictures were printed in large sheets by power but the large chromos were printed by hand. The third floor was the artists' quarters. In 1885 there were thirty-two artists employed in drawing on stone or zinc. Prang had used zinc plates as a substitute for lithographic stones for nearly all his color work since 1873. One hundred and fifty girls were employed in the final work of examining, sorting, and mounting the prints.

Prang exhibited his chromos in many exhibitions and received numerous medals. The first, a Bronze Medal, was won at the Massachusetts Charitable Mechanic Association in 1865. By fall of 1868 Prang had won twenty medals—bronze, silver, and gold. These included medals won at the Vienna World's Fair in 1873, the Centennial Exposition in Philadelphia, and the International Exposition in Paris in 1878 and expositions in Sydney and Melbourne, Australia. From this time to 1900 Prang's chromos received worldwide attention and there was a ready market in all parts of the world. Representatives made trips to Central and South America and shipments were also made to India. To meet the heavy demands branch offices were opened. The New York branch occupied an entire four-story building at 38 Bond Street and the Philadelphia branch was quartered

in a three-story building at 1110 Walnut Street which also maintained a free Normal Drawing School for the public school teachers of Philadelphia. The Prang agency on the Pacific Coast was in San Francisco and foreign agencies were maintained in London, Berlin, and Melbourne.

The first Prang Christmas cards were put on sale in 1874 and by 1880 they had become the major part of the business. However, because of foreign competition Prang gave up the Christmas card business in 1890 and centered his interests in book printing, especially art educational books. The firm was also busy with advertising, calendars, and posters.

Mr. Prang's connection with the magazine *Modern Art* in 1893 shows that he was moving with the times in the field of art. Louis Rhead, the well-known modern poster artist, was employed to design the frontispiece of the autumn issue in 1895 and in the same year a modern calendar was put out by L. Prang & Company with the cover of the calendar by Louis Rhead. A poster to advertise Prang's Easter Publications, April 1896, was also by Louis Rhead.

The last five years of Mr. Prang's personal involvement in the company were devoted to the publishing of the ten volumes of W. T. Walter's *Oriental Ceramic Art*.

In August 1897 Louis Prang & Company and the Taber Art Company of New Bedford, Massachusetts, were consolidated under the title of Taber-Prang Art Company and the company moved to Springfield, Massachusetts. The Taber Art Company had been founded in 1862 and the company's business consisted of making photographic reproductions on gelatin plates; from these plates the pictures were printed on a handpress and hand colored by a staff of girls. The prints were called Artotypes. Others were sent to New York to be colored in oil. The prints were framed in shadow box frames. The stock of prints included such subjects as *Young Handel at the Piano* and *The Meeting of the Three Wise Men in the Desert.*

The following is a quote from a letter of Henry M. Downey, assistant superintendent of the Taber-Prang Art Company: "The Prang Co. was nothing but a strictly lithographic plant. They did a large commercial business in making lithographs." Although Mr. Downey was prejudiced in behalf of Taber, the catalogues of the combined companies continued to list a large group of Prang chromos, including the long narrow New England landscapes by Louis K. Harlow; Eastman Johnson's *Barefoot Boy; The Prize Piggies; Hector,* a dog, and *Two at a Cast,* fish, by T. S. Steele. These, together with *The Plowman* by Georgi; *Ripened Wheat Field* by von Volkman; *The Stage Coach* by Georgi; *Red Riding Hood* by Herman; and *Old King Cole* by Rehm-Victor were listed as Prang Color Prints and an illustrated color catalogue was available in 1912. The majority of the prints now were reproductions of famous old masters. The Taber-Prang Art Company was last listed in the 1937 Springfield, Massachusetts, directory.

Taber-Prang was involved in some interesting Art Nouveau productions.

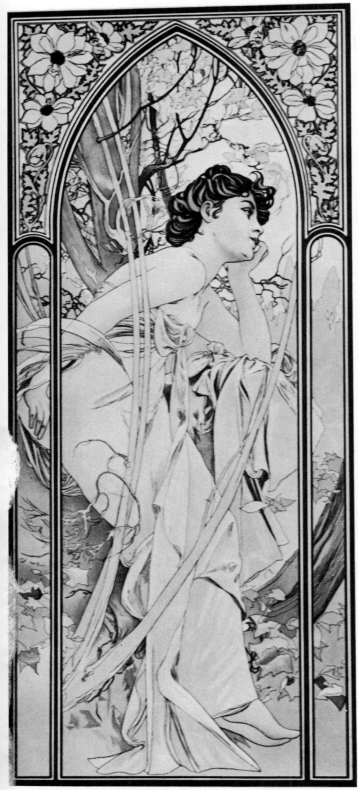

Reverie du Soir. Chromo panel by Taber-Prang Art Company, after Mucha. *Hallmark Historical Collection.*

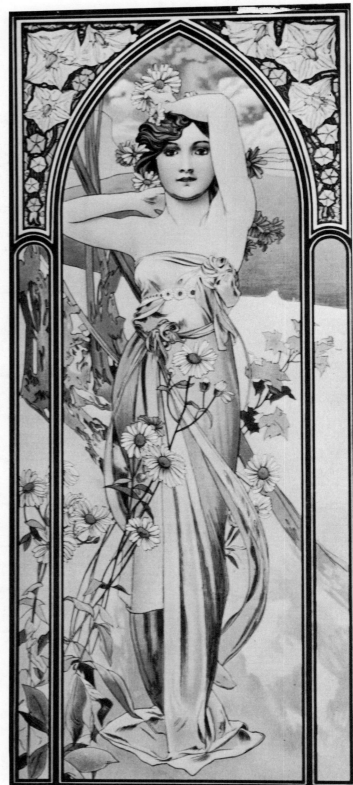

Eclat du Jour. Chromo panel by Taber-Prang Art Company, after Mucha. *Hallmark Historical Collection.*

Four scenes of Negro minstrels. Chromos by Taber-Prang Art Company. *Hallmark Historical Collection.*

In 1899 Mucha designed four panels called *The Four Times of Day*. These panels along with a group of Art Nouveau paintings of women were reproduced by Taber-Prang Art Company in 1901. The pictures included *Ivy Leaves* and *Laurel Leaves,* 15 x 15-inch squares, with heads of women with flowing hair and a framework of flowers and leaves in Art Nouveau style. There was also a group of smaller designs, 7 x 9 inches, of similar style women under the titles of *Alethe, Ianthe, Calliope, Haidee, Lirope, Ligia,* and *Thalia.* Some of these Art Nouveau pictures are shown in the Prang section of the 1917 Taber-Prang Art Company catalogue. Since there are no artists' signatures it is not known who did the pictures except for the panels, which are definitely by Mucha.

In the early 1900s Taber-Prang Art Company also put out a series of theatrical prints including a group of dancing girls and a series of Negro minstrels. One of the minstrel series is of musicians illustrating the song "My Ann Liza" and was illustrated in the Taber-Prang Art Company Catalogue of 1917.

After his first wife died, Mr. Prang married Mary Dana Hicks, his long-time associate in the educational book department. After their marriage the Prangs traveled extensively until Mr. Prang's death in 1909 at the age of eighty-five. Lithographer, book publisher, art educator, and colorist, his was a long and successful life. The love of art and of nature, especially flowers, was the motivating factor in his life and in his business.

Girl dancers. Chromos by Taber-Prang Art Company. *Hallmark Historical Collection.*

In their time Prang Chromos were never really accepted as art but they were very popular. The parlor walls of an average Victorian house were hung with these chromos while the original painting graced the walls of the wealthy. Although Prang Chromos like other nineteenth-century decorative art have been scorned for years, one should not forget that Prang brought paintings of great beauty, which would otherwise never have been seen, into the average nineteenth century home. Prang also made a great contribution to art education, and his support of living American artists by making facsimiles of their paintings as well as holding Christmas card competitions meant opportunity to young artists. Prang called Walter's *Oriental Ceramic Art* his "Monument" and anyone who has turned the pages of its ten volumes, perfect in technique and tonality of color, would never again question the worth of Louis Prang's contributions.

Album Cards, Mottoes, and Other Miscellaneous Publications

THE VICTORIAN CRAZE FOR ALBUMS AND ALBUM CARDS PRODUCED SUCH A demand that they formed the backlog of many printing companies in the late nineteenth century. L. Prang & Company published album cards almost from the beginning, and although other lithographers were also producing them, Prang's offered the widest selection. In addition to mosses, butterflies, autumn leaves, and flowers, there were cards of specialized subjects. In 1863 the cards of American birds were sold in four parts. There were also cards with various kinds of roses and also two sets of cards illustrating American childhood. In 1864 there were winter and summer landscapes and views of the Hudson River and the White Mountains.

These series of small scenes were put up in envelopes or in patented albums in extension form with hard covers. There were twelve colored scenes to a series

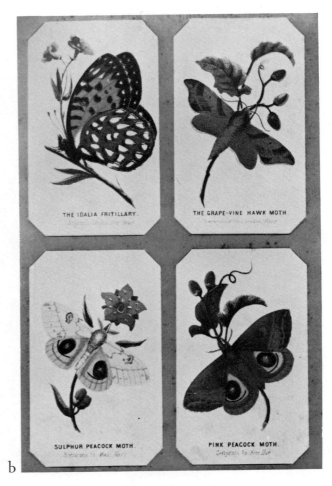

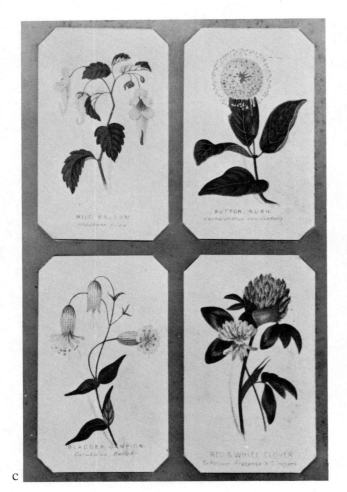

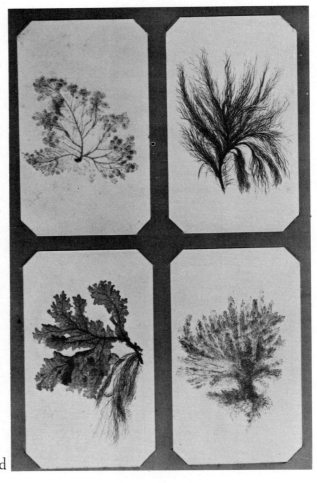

Album cards: (a) birds, (b) butterflies, (c) flowers, (d) seaweed. *Hallmark Historical Collection.*

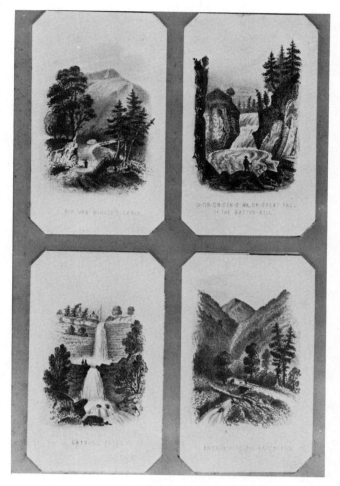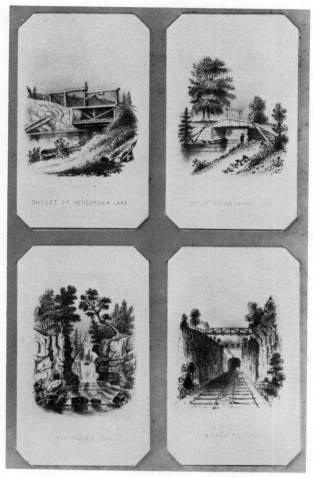

Album cards. Hudson River Series, 1864. *Hallmark Historical Collection.*

with no marks except "Pat. April 15, 1864." This series was also listed in *Prang's Chromo* under half chromos and mounted on white board, as were the twelve views of American Coast Scenes. The 1864 Hudson River Views, listed in *Prang's Chromo* January 1868, included:

Rip Van Winkle's Cabin
Entrance to The Katzbergs
Outlet of Henderson Lake
Outlet of Paradox Lake
New Hamburg Tunnel
Scene of the Catskill near Palensville
Confluence of the
 Hudson and Sacondago

Catskill Falls
Di-On-On-Deh-O-Wa, or Great Fall
 of the Batten-kill
The Fawn's Leap
In the Glen at Idlewild
View at Cohoes Falls

On page 7 of the same issue of the *Chromo*, the scenes of the following series were listed. These are different pictures from those of the 1864 series although they are the same size. The listing in *Prang's Chromo* is as follows:

Twelve Views on the Hudson. These little pictures are put up in sets of 12 assorted copies and mounted on white board. Size, 2¾ x 4½ inches. They represent scenes,—Near New Hamburg; Stony Point; Above Newburg, looking South; Northern Entrance to Highlands; The Storm King; Breakneck Mt. from foot of Clo' Nest; The Palisades; Mouth of the Hudson; Port Washington Station; The Highlands from the North; Peekskill Bay; New York from West Hoboken. Price per set,—$1.50.

The 1864 White Mt. Album included the following views: Profile Lake; Gate of Notch (Crawford House); Summit of Mt. Lafayette (Summit House); The Pool; Emerald Pool (Glen House); On Meadows, N. Conway; Artist's Brook, Bridge & Mill; Diana Baths; Artist's Brook; Mt. Kearsarge (from Sago River); Willy House (Mt. Willard); Profile Lake.

The Niagara Falls Album, 1865, included the following views: Hermit's Cascade; American Falls from Goat Island; American Fall; Cave of Winds; American Horseshoe; From Suspension Bridge; Whirlpool from Suspension Bridge; Whirlpool; Horseshoe below Tower; Horseshoe from Table Rock; American Rapids from Bridge; Tower and Horseshoe.

In 1864 new sets of flowers and fruit cards were issued as well as the popular Humming Bird cards, Pilgrim's Progress, Maxims of Poor Richard, and Children of the Bible. Also issued in 1864 was *Life in Camp,* a series of Civil War sketches by Winslow Homer.

In *Prang's Chromo,* January 1868, album cards were listed as follows:

Pocket Albums filled with Prang's
Album Pictures in Oil Colors.

1. Central Park Album.
2. Sea Moss Album.
3. Flower Album.
4. Wood Moss Album.
5. Hudson River Album.
6. Butterfly Album.
7. Rose Album.
8. Fruit and Blossom Album.
9. Wild Flower Album.
10. Niagara Falls Album.
11. Landscape Album.
12. White Mountain Album.
13. American Bird Album.
14. Variety Album.
15. Autumn Leaf Album.

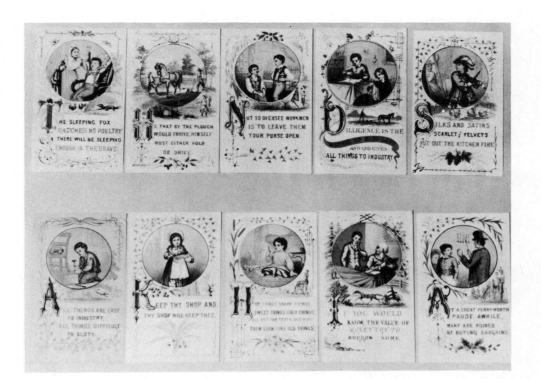

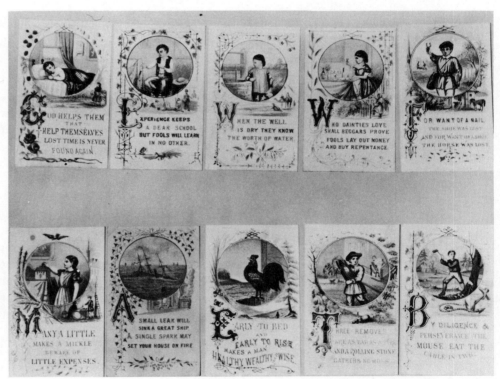

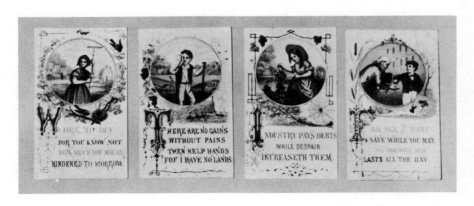

Poor Richard's Maxims. L. Prang & Co., 1868. *Hallmark Historical Collection.*

A comment from the Philadelphia press concerning album pictures and cards was also printed in the January 1868 *Prang's Chromo*.

> The Album Pictures, of which an almost infinite variety are made, "form an event" in the history of popular pictures. During the past four years, many hundred thousand packs of them, twelve in a pack, have been sold; and the demand is still so great, that from four to six presses are still kept constantly running on them. The greatest favorites are the Autumn Leaves and the Roses. Great numbers of these cards are sold all over Great Britain—which is probably the first instance in which publications of this kind have gone abroad from America as a regular article of trade.
>
> Prang's cards may be seen in all the show-windows of print and fancy shops in England, Ireland and Scotland. . . . Very few households are now without a specimen of these or of the Sunday-school cards, which are filling a great demand and have had an incredible sale.

In *Prang's Chromo,* Christmas 1868, album cards put up in envelopes containing twelve cards included the following subjects:

Wild Flowers of America,	9 different sets.
American Sea-Mosses,	3 different sets.
Views in Central Park, N.Y.	3 different sets.
Butterflies of America,	5 different sets.
American Wood-Mosses,	2 different sets.
American Autumn-Leaves,	5 different sets.
Summer Landscapes,	
Winter Landscapes,	
American Cultivated Flowers,	2 different sets.
American Fruits and Blossoms,	2 different sets.
Humming Birds of America,	2 different sets.
American Singing Birds,	4 different sets.
Roses,	2 different sets.
Life of Childhood,	2 different sets.
Life in Camp,	2 different sets.
Funny Characters,	
Animals (Home-Pets),	2 different sets.
Views on the Hudson,	
White Mountain Scenery,	
Views of Niagara Falls,	
Street Scenes in New York,	
Assorted Lot (containing one card each of 12 different kinds)	
Vessels and Marine Views,	3 different sets.
Views in Newport, R.I.,	5 different sets.
Language of Flowers,	
Views in Boston Harbor,	
Paradise of Childhood,	

Floral cards on black ground. *Hallmark Historical Collection.*

Floral card. L. Prang & Co., 1878. *Hallmark Historical Collection.*

In addition there were album friendship cards with verses and space for a name or photograph, and album congratulation cards for birthdays, weddings, Christmas, and New Year's. The majority of these cards continued to be produced throughout the 1870s.

In 1870 scenes on the Pennsylvania Central Railroad, scenes on the Erie Railroad, and a series of nursery rhymes were added to the list of album cards. The popularity of albums and album cards had grown enormously by this time and many pages of the 1871 catalogue were devoted to album pictures.

These later album cards were printed in oil colors and a set of twelve sold for fifty cents. They were the size of common card photographs, approximately 2¾ x 4½ inches. Prang also sold card albums for square and octavo center tables.

The prices of the albums ranged from $3.00 for one holding 100 cards to $18.00 holding 1,000 cards. Photographic albums were also available in pocket size and some could be purchased completely filled with cards. "There is no more interesting and pleasing Centre-Table Book than one of our Albums filled with a selection from our rich variety of Cards in all colors. We attend to the filling, if ordered, charging simply for Albums and Cards." Album insertion cards, more elaborate than the album cards, were available to decorate the first and last page of a photograph album. These were designs with an invitation in verse to add the reader's portrait to the collection and thanking him for having granted the request. There were twelve different designs for the first page of the album and twelve for the last page, at 10 cents each.

Although many pages in the 1871 catalogue were devoted to album cards and album cards were listed in the catalogue of 1876 along with the larger size Imperials, none are listed in the 1878 catalogue. Instead, similar subjects—flowers and landscape series—are listed as Prang's Imperials. These were larger than album cards and were matted. Many were from original flower paintings by Mrs. O. E. Whitney.

For the collector with a small purse album cards are an interesting and satisfying hobby. All old scrapbooks contain album cards including many by L. Prang & Company. Of course, a real find would be one of the rare albums filled by the company.

Photographic likenesses of men in public life were also put out in album card size. These included generals of the army from both the North and South, navy heroes, members of the cabinet, senators, and presidents, as well as the wives of important men. Card portraits included in the catalogue of 1871 were of the following:

Gen. Anderson, hero of Fort Sumter	Col. Kit Carson, Mexican Forces
Col. Baker, fell at Ball's Bluff	Gen. Casey
Gen. Banks	Gen. Cochrane
Gen. Barry	Gen. Cooper
Gen. Beauregard, C. Army	Gen. Corcoran
Col. Berdan	Gen. Couch
Hon. F. P. Blair	Gen. Curtis
Gen. Bragg, C. Army	Gen. Dana
Col. Briggs. 10th Mass.	Jefferson Davis, Pres. Confederacy
John Bright of England	Gen. J. A. Dix
Gen. Brooks	Gen. Doubleday
John Brown	Hon. Stephen A. Douglas
Parson Brownlow	Mrs. Douglas
Miss Brownlow	Com. Dupont
Gen. Buell	Gen. Duryea
Gen. Burnside	Col. E. E. Elsworth
Gen. Butler	Erickson, builder of the Monitor
Gen. Butterfield	Com. Farragut

Gen. Floyd, C. Army
Com. Foote
Gen. Franklin
Gen. Fremont
Garibaldi, Italian patriot
Com. Goldsborough
Gen. Grant
Mrs. Grant
Gen. Halleck
Gen. Hancock
Gen. Hardee, C. Army
Gen. Heinzelman
Gen. E. W. Hinks
Gen. Hitchcock
Com. Hollins, C. Navy
Hon. Joseph Holt
Gen. Hooker
Gen. Hughes, C. Army
Gen. Hunter
Col. E. F. Jackson, 9th Pa.
Stonewall Jackson, C. Army
Gen. Jameson
Andrew Johnson
Gen. A. S. Johnston, C. Army
Gen. Johnson, C. Army
Gen. B. F. Kelly
Gen. Keys
Gen. R. King
Gen. Kearney
Gen. Lander
Gen. James Lane
Gen. Lee, C. Army
Abraham Lincoln
Mrs. Lincoln
Gen. Logan
Gen. Lyon
Gen. Magruder, C. Army
Gen. Mansfield
Gen. Martindale
Mason, ex-Senator, C. Senate
Gen. McCall
Gen. McClellan

Mrs. McClellan
Gen. B. McCullock, C. Senate
Gen. McDowell
Gen. McDuffie, C. Army
Gen. Meade
Gen. Meagher
Gen. Milroy
Gen. Mitchell
Gen. Morell
Gen. Mulligan
Gen. Ord
Gen. Osterhaus
Gen. Pope
Gen. A. Porter
Gen. Fitz J. Porter
Com. Porter
Gen. Price, C. Army
Gen. Richardson
Gen. Rosecrans
Gen. Winfield Scott
Gen. Sedgwick
Gen. Sheridan
Gen. Sherman
Gen. Shields
Gen. Sickles
Gen. Sigel
Slidell, ex-Senator, C. Senate
Gen. Slocum
Gen. C. S. Smith
Sprague, Gov. of R.I.
E. M. Stanton, Sec. of War
Alex. Stephens, C. Senate
Gen. Thomas
Gen. Wadsworth
George Washington
Mrs. Martha Washington
Gideon Welles, Sec. of Navy
Capt. Wilkes, Navy
Hon. Henry Wilson
Gen. H. A. Wise, C. Army
Gen. Wood
Gen. Wyman

In addition to album pictures L. Prang & Company published many larger portraits. Some were steel engravings like the series of Our Women Warriors after Eastman Johnson. One portrait was of a nurse writing a letter at the dictation of a wounded soldier whose cot is standing under a tree. These engravings are 26 x 32 inches and are on India paper, and sold for $15 dollars — $5 dollars if printed on plain paper. Also listed in the early catalogue were crayon portraits

of seven women identified with the women's movement. These were taken from original photographs and each plate was 20 x 24 inches. There were also bust portraits, 21 x 27 inches and 19 x 24 inches, of George and Martha Washington after copies of Stuart's paintings in the Boston Athenaeum. They were lithographed in outline with one tint from copies made by Fabronius in 1868. The original copies by Fabronius were sold in the Prang sale of December 1875. A lithograph of Abraham Lincoln after a painting by Matthew Wilson was lithographed by L. Prang & Company in several sizes—22 x 28 inches and 14 x 19 inches. This was available in January 1868. Prang published another lithograph of Lincoln in the 1860s. In 1894 Taber Art Company, before it was combined with L. Prang & Company, put out a portrait of Lincoln after a painting by Cobb and in 1901, the newly formed company of Taber-Prang Art Company published a lithograph of Lincoln from a charcoal drawing by J. R. De Camp.

L. Prang & Company also published lithograph portraits of Charles Sumner and General Grant by Thure de Thulstrup in the early 1860s. The Grant portrait could be had in both colors or plain crayon, 14 x 19 inches. Portraits of Henry Ward Beecher and Beethoven were also published by Prang. The Beethoven portrait was published on December 17, 1870, to celebrate the hundredth anniversary of his birth. The lithograph was made after a copy of the painting in the Royal Library in Berlin by Ferdinand Schimon. It was issued in two sizes—18 x 23¾ inches at $20 dollars and cabinet size, 11 x 14 inches, at $5 dollars. The chromos were sold by subscription only; therefore, since they were not produced in great quantities, the lithographs are rare today.

A portrait of particular topical interest both at the time it was issued in 1870 and also in view of recent events was that of Senator H. R. Revels of

Senator Revels. Chromo by L. Prang & Co., after painting by Theodore Kaufmann, 1870. *Collection, Print Department, Boston Public Library.*

Mississippi, the first black United States Senator. The lithograph was a full chromo after an oil painting executed from life by Theodore Kaufman. The following letters from *Prang's Chromo,* September 1870, give added information about the lithograph:

Nemesis has perhaps never before been so conspicuously apparent in history as in the case of Senator Revels. Here is the first colored man ever elected to the United States senate, occupying the very seat which was held immediately before him by Jefferson Davis, the head and front of the great slaveholders' rebellion. This fact, aside from all other considerations, makes Senator Revels an object of great interest; and we think that we shall not say too much, if we claim to have filled a great national want, grown partly out of admiration, partly out of curiosity, by the publication of an excellent full chromo after an oil-painting from the life, executed by Mr. Theod. Kaufmann, of Washington. Mr. Fred Douglass, to whom a copy of our chromo was sent by one of his friends, with a request for his opinion of the same, has written the following letter, which has been handed to us with permission to publish it:—

Rochester, June 14, 1870

My Dear Sir:—

I shall find it no hardship to say a good word for the portrait of Senator Revels, which has just been published by Messrs. Prang & Co., in Boston, for it is a remarkably good one. Since my letter to you in April, have several times seen Mr. Revels, and I can therefore speak of his picture from personal knowledge. It strikes me as a faithful representation of the man. Upon public grounds, I thank the publishing house of Prang & Co., for giving the country this admirable picture of our first colored American Senator. Whatever may be the prejudices of those who may look upon it, they will be compelled to admit that the Mississippi Senator is a man, and one who will easily pass for a man among men. We colored men so often see ourselves described and painted as monkeys, that we think it a great piece of good fortune to find an exception to this general rule.

Heretofore, colored Americans have thought little of adorning their parlors with pictures. They have had to do with the stern, and I may say, the ugly realities of life. Pictures come not with slavery and oppression and destitution, but with liberty, fair play, leisure, and refinement. These conditions are now possible to colored American citizens, and I think the walls of their houses will soon begin to bear evidences of their altered relations to the people about them. This portrait, representing truly, as it does, the face and form of our first colored U. S. Senator, is a historical picture. It marks, with almost startling emphasis, the point dividing our new from our old condition. Every colored householder in the land should have one of these portraits in his parlor, and should explain it to his children, as the dividing line between the darkness and despair that over-hung our past, and the light and hope that now beam upon our future as a people.

Yours respectfully,
Frederick Douglass

We subjoin a letter from Hon. H. R. Revels himself, certifying to the faithfulness of the likeness.

Washington, March 30, 1870

Gentlemen,—
It affords me great pleasure to say that the portrait of myself, painted for you by Mr. Th. Kaufmann, is exceedingly life-like. The color and expression is perfect.

Respectfully,
H. R. Revels

L. Prang & Company also published an 11 x 13 inch photograph of Booker T. Washington in 1870.

Rewards of Merit cards for both day and Sunday schools were also popular at this time. These were small cards with gold or floral borders and were printed in gold and color. A space was left for the name of the teacher and pupil. Some cards contained mottoes or Poor Richard's maxims and others had an oval for a photograph of the teacher. There were Sunday school attendance certificates and also illuminated Scripture texts in medieval and "elegant modern church" style. These were all album size, although they were also made in larger size, and sold in sets.

Motto cards usually had scripture texts such as "The Lord is Risen" or "The Lord Is My Shepherd." Others related to a child's behavior such as "Be a Good Boy"; "Do right and Fear Not" or "Where there is a Will there is a Way." There were also wreath mottoes with quotations from poets, illuminated bookmarks, and marriage certificates printed in gold and colors, or red roses and openings for photographs of the bride and groom.

Illuminated cards were a specialty with L. Prang & Company. There were early illuminated Christmas cards for the decoration of halls on Christmas Eve, and large religious motto cards, Scripture texts—including the Beatitudes and The Lord's Prayer—and illuminated crosses to hang on the wall. Illuminated crosses were 11 x 14 inches and included flower composition crosses "Old Church Style," crosses with the motto "Glory to God," and "Modern Church Style" crosses with the motto "God is Love." The majority of these crosses were after designs by Mrs. O. E. Whitney. There were bookmarks with Bible texts, with mottoes and with poems by Shakespeare, Tennyson, Browning, Longfellow, and Bryant. The Illuminated Lord's Prayer, which was decorated by Audsley, was also packaged in a series of twelve cards and in extension book form in gold, purple, and green. The Beatitudes, after original designs by Miss Jennie Lee, was "one of the richest Illuminated Publications ever issued in print." It consisted of twelve plates 11 x 14 inches and was "put up in one elegant portfolio." The folio complete sold for twelve dollars. Considerable space in *Prang's Chromo,* January 1868, is given to their description and to the quotes from the Philadelphia press and from Mrs. Harriet Beecher Stowe. In the letter thanking

THE
UNIVERSITY OF WINNIPEG
PORTAGE & BALMORAL
WINNIPEG 2. MAN CANADA

Mr. Prang for the chromos which he sent her, Mrs. Stowe also included a list of chromos that she wanted for her colored school.

There were also books of beautifully illuminated alphabets in red, blue, and gold. Illuminated bookmarks and illuminated Rebus Cards were packed twelve in an envelope.

Other miscellaneous publications included "Flags of All Nations," "Arms of All Nations," and "Arms of All the States in the United States." These were printed on 11 x 14-inch sheets. Also listed in the 1871 catalogue was "The Language of Flowers," a box of fifty cards for three dollars. This represented a favorite pastime of the sentimental Victorians. A vocal quality was ascribed to flowers and there was a sign manual of the language of flowers. Bouquets of mixed flowers such as pansies and broom carried the message "My heart would be at ease, if my solitude were blest with your society." Mignonette-Heliotrope-Pink declared, "I love you with a pure and devoted love."

One item that should be of special interest to collectors is *The Rose of Boston,* a booklet in the cut-out shape of a rose containing twenty-eight views of public buildings of Boston. "Roses and Life," an allegorical poem, was also cut in the shape of a rose with branches and leaves that folded out to reveal the poem.

The Prang Proof Books of the 1880s list such items as writing paper. Longfellow stationery with views of the house was packaged in a folder, which was a replica of Longfellow's residence. The chimneys were to be used as containers for stamps. The inside cover shows a likeness of Longfellow and his children and is an illustration of "The Children's Hour."

Illuminated mottoes. L. Prang & Co., 1868. *Hallmark Historical Collection.*

"A Dickens Memorial," 10 × 12 inches, was put out to commemorate the anniversary of his death. It was decorated with holly leaves and winterberries and bore the motto "Lord Keep My Memory Green," which surrounded an autograph of Charles Dickens. All these items are marked with Prang's copyright. They are unusual and rare items, as is a decorated satin tape measure and the hat tips or labels which L. Prang & Company made for Ferry & Napies.

In the 1870s women had a great interest in watercolor painting, painting on panels, and in the decoration of screens, pottery, and such. To meet the demand for designs, L. Prang & Company put out a series of designs for copying. These included flowers and ferns, garden flowers, roses, autumn leaves, moss rosebuds, snowdrop and ivy, birds and flowers, birds and nests, bouquets, crosses and autumn leaves, moss crosses and gold crosses with flowers, apple blossoms, fuchsia and pinks, water lilies, ferns, camelia and morning glories, goldenrod, aster, autumn woodbine, bloodroot, winterberries and geranium. These compositions could be had on white, yellow, blue, black, or birchbark grounds.

A popular recreation of the middle and late nineteenth century was Psaligraphy, or the art of cutting pictures in black paper. *Prang's Chromo*, January 1868, includes a description of the set that Prang published and sold. It came in "an elegant box containing full instructions and specimens for the study of this most attractive and fashionable art. A pair of scissors accompanies each box. Price per box $5.00."

Another favorite pastime of the late nineteenth century lady was china painting. There were numerous classes in china painting throughout the country and exhibitions were held both in America and abroad. Magazines such as the *Art Journal* and *Art Amateur* devoted space to articles on china painting and often published designs for decorating plates and other articles of china. In 1890 L. Prang & Company published three series of designs for decorating plates. Each series included six plate designs. There were six designs for begonia

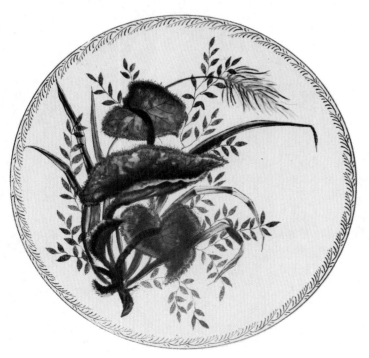 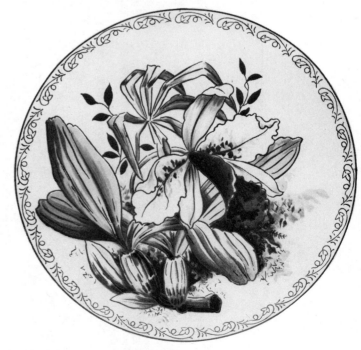

Designs for china painting: (a) begonia, (b) orchid. *Hallmark Historical Collection.*

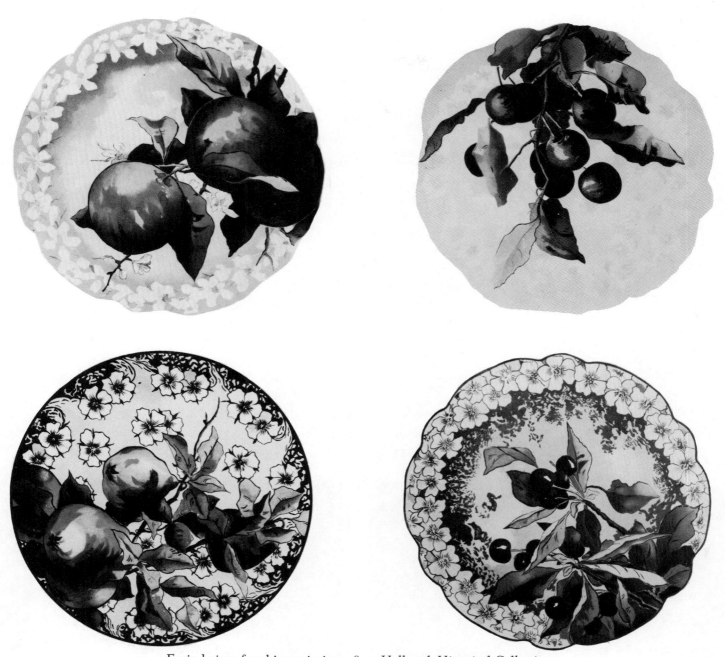

Fruit designs for china painting, 1890. *Hallmark Historical Collection.*

leaves; six for orchids; six fruit designs including oranges, apples, peaches, plums, pears, and cherries; and six flower designs including azalea, geranium, clematis, Scotch rose, nasturtium, and chrysanthemum. These designs were by Lucy Comins, who was a well-known teacher of china painting, and the artist Ellen A. Richardson. A set of fish designs were by F. Schuyler Matthews. The original watercolor sketches of these designs were sold at the sale of oil and watercolor paintings owned by Mr. Prang in November and December 1899, at Copley Hall, Boston, Massachusetts.

Dance programs, listed in the Prang catalogue as "Orders of Dances," were printed with appropriate designs in various colors on tinted Bristol board. Menu

cards with designs on a black ground designed by "Pilule" were made in "hamper" and floral designs and some had quotations from Shakespeare or Whittier.

A unique and rare publication of L. Prang & Company was the series of Melanopolychromes by "Pilule." These color lithographs were 14 x 17 inches and included the following humorous subjects:

1. April Showers bring forth May Flowers.
2. R.S.V.P. (reply if you please.)
3. Our Mutual Friend.
4. There's Never Smoke Without Fire.
5. One Touch of Nature makes the whole World Kin.
6. The Missing Link.
7. The Chain Complete.

These prints are signed by the artist "Pilule, del" and were listed in the catalogue of 1878. It is not known how many of these were printed but certainly not as many as other Prang publications, and they were only listed in the one catalogue. Samples of these were included in the book of valentine samples of the London dealer Arthur Ackerman and were labeled Society Prints.

Menu cards. After "Pilule," 1880–1881. *Hallmark Historical Collection.*

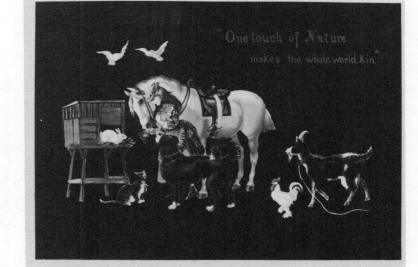

Melanopolychromes. Signed "Pilule, del." L. Prang & Co., 1875. *Collection, Print Dept., Boston Public Library.*

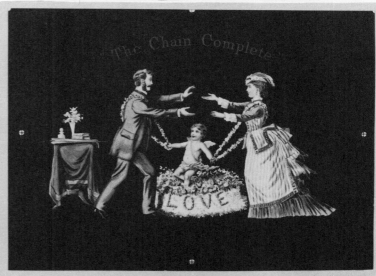

L. Prang & Company also published many humorous valentines. In their 1892–1893 catalogue, humorous cards and booklets were listed. The cards included Humorous Bears, Owls, Cats, Turtle and Rabbit by William H. Beard, and the following Christmas cards: Humorous Figures; Christmas Guests; Christmas "Menu"-et; Christmas Duet (cats); Minstrels (cats); Comrades (Japanese Dolls); Prize Piggies; Age 4 Weeks (puppy). Booklets included: *You May not See the Cream of This; This Little Line I Hope You'll See; A Christmas Tune;* and *A Christmas Matinee.*

In the later years of the firm L. Prang & Company issued postcards. One group of postcards showed views of New England. These were printed on large sheets and the individual cards were cut apart. Views were often the same as those of earlier album cards. There are several postcards that deserve the collector's attention, including that printed for the Philadelphia Centennial in 1876. There is also a poet's postcard and a rare Abraham Lincoln card printed in 1909 on the hundredth anniversary of his birth. This card was put out by the Taber-Prang Art Company.

CHAPTER *Three*

Juveniles, Toy Books, Pastimes, and Games

A SMALL GROUP OF JUVENILES, TOY BOOKS, PASTIMES, AND GAMES WERE AMONG the first publications of L. Prang & Company in 1863. There were two series of toy books, the Doll Series and the Christmas Stocking Library. The tiny Doll books are some of the most interesting and fascinating items Prang published. The story was printed on a cutout in the shape of one of the characters of the story. The wolf wearing grandmother's nightcap was the cutout shape for *Little Red Riding Hood*. The catalogue of 1871 proclaims, "the style of these books originated with us." Titles of these books are: *Little Red Riding Hood, Robinson Crusoe, Goody Two-shoes, Cinderella,* and *King Winter*. The books sold for 25 cents each and three Doll Books put up in "an elegant fancy box" sold for $1.00 as a Christmas package. Today these books are valuable items for the collector of children's books.

46

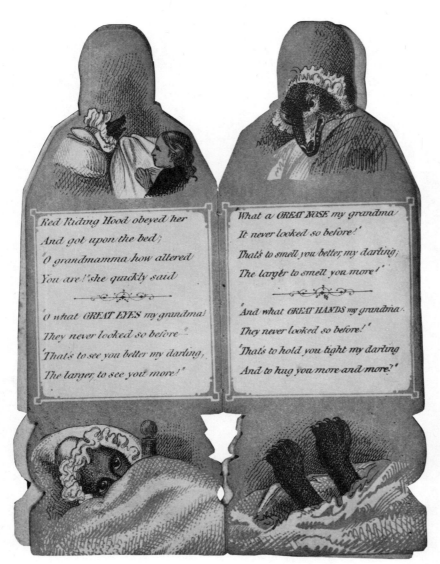

Toy book, *Little Miss Riding Hood.* Cut-out, Doll Series, published by L. Prang & Co., 1863. *Rare Book Department, The Free Library of Philadelphia.*

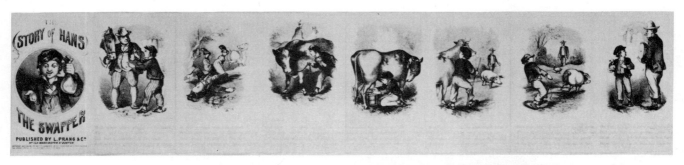

Toy Book, *The Story of Hans the Swapper.* Panorama, published by L. Prang & Co., 1864. *The Henry E. Huntington Library and Art Gallery.*

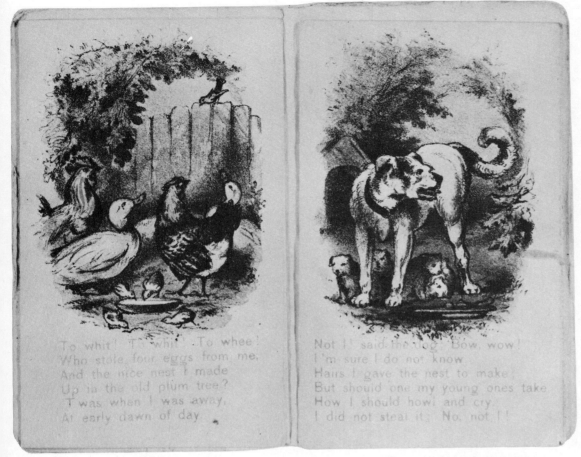

Pages from Toy Book, *Who Stole the Bird's Nest?* Panorama, published by L. Prang & Co., 1865. *Rare Book Department, The Free Library of Philadelphia.*

The Christmas Stocking Library was published in 1864–1865. It comprised a series of tiny extension or panorama books. There were six volumes including *A Visit from St. Nicholas; Dame Duck's Lecture; Story of Hans, the Swapper; In the Forest; Who Stole the Bird's Nest?* and *A Farm Yard Story.* The stories were written in verse and each story contained a moral. The illustrations were original, although the artist is not known, and were printed in bright oil colors. These little books are listed in *Prang's Chromo,* April 1869; *Prang's Chromo Advertiser,* September 1870; and in the 1871 catalogue of L. Prang & Company. *A Visit from St. Nicholas* is, of course, Clement Moore's poem, and the thirteen colored lithographs are thought to be by Thomas Nast. *In the Forest* consists of a series of animal scenes—the fox and the raven, a squirrel and tanager, Robin Red, a bullfrog on a drum, a group of dancing animals, and a scene of two children asleep in their beds—with a verse reminiscent of *The Butterfly's Ball* ("Dragonfly waltzed with the Beatle, Dandy Frog led out Miss Mole, And, escorted by a Badger, Mistress Coon forsook her hole"). Published in 1865, it is

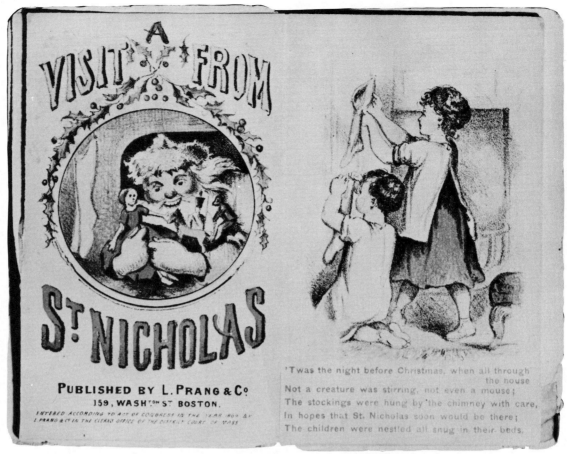

Toy Book, *A Visit from St. Nicholas.* Cover and first page. Panorama, published by L. Prang & Co., 1864. *Collection of John Mackay Shaw.*

Toy Book, *In the Forest.* Panorama, published by L. Prang & Co., 1865. *The Metropolitan Museum of Art, Harris Brisbane Dick Fund, 1948.*

Toy Book, *Dame Duck's Lecture*. Panorama, published by L. Prang & Co., 1864. *The Henry E. Huntington Library and Art Gallery.*

Toy Book, *A Farm Yard Story*. Panorama, published by L. Prang & Co., 1864. *The Henry E. Huntington Library and Art Gallery.*

a panorama book of twelve pages containing lithographs colored with oil paints. It bears the inscription, "Entered according to Act of Congress in the year 1865. L. Prang & Co. in the clerk's office in the District Court of Mass." *Dame Duck's Lecture* and *Farm Yard Story* were both in verse with twelve scenes. The first two verses of *Farm Yard Story* are:

> *"Beneath a shady maple tree*
> *Within a whitewashed pen*
> *Surrounded by her family*
> *Dwelt good old mother Hen.*
>
> *No gad-about was she, I ween,*
> *Though neighbors there were plenty*
> *For Mrs. Duck twelve children had*
> *And Mrs. Goose had twenty."*

These little books were packaged in a cardboard box with a holly branch design decorating the cover. The box is marked L. Prang & Co. and the date 1864, and the six titles are listed on the inside of the box cover.

Kinderlieden, a book of "German Religious Songs for Children," was also put out by Prang at this time, and in 1866 he published *A New Version of Old Mother Hubbard* by Ruth Chesterfield. The latter is about 10 x 12 inches in size and has illuminated border decorations in gold and various colors. Charles G. Leland, who was well known in Philadelphia art education circles at this time, describes the book as follows: "A very quaint and beautiful work is the 'Mother Hubbard and her Dog' published by Prang & Co. in which the ancient rhyme is given a new form, somewhat enlarged, and in another and more edifying spirit, copiously, nay, exuberantly and most richly adorned with massive illustrations set in gold and arabesquerie, grotesquerie and fantasquerie (we need eccentric words for such designs) such as were never seen in the children's books of the last generation" (*Prang's Chromo*, January 1868). The book sold for $3. This book is rare and is an important collector's item. A copy sold in London recently for forty dollars and one in New York was priced at sixty dollars.

In 1863 L. Prang & Company printed a series of small books of slate pictures. These were divided into four parts with sixteen black-and-white plates in each part. The plates were of everyday household articles, farm implements, and fruit and flowers, in simple outline form. *Paradise of Childhood, Nursery Rhymes,* and *Children's Activities* were other children's books listed in early catalogues and in the *Chromo Advertiser*, 1869–1870. Prang also printed cards for children with legends in French. The Sunday school cards including Children of the Bible, Life of Joseph, Ten Commandments, Pilgrim's Progress, and Poor Richard's Maxims were also for children.

A group of books published by Estes & Lauriat of New York in 1884 were illustrated by L. Prang & Company. These included *The Boys of '61* by Charles Coffin Carlton, *Three Vassar Girls in Italy, Our Little Ones,* and *Four Feet, Two Feet and No Feet.* The latter two were for small children.

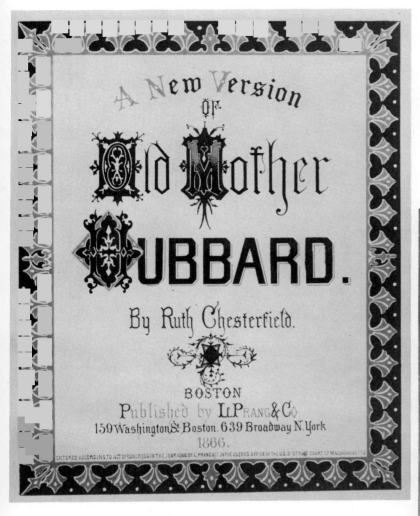

Title page of children's book, *A New Version of Old Mother Hubbard*. By Ruth Chesterfield, published by L. Prang & Co., 1866. *Miami University Library, Oxford, Ohio.*

Page of text from *A New Version of Old Mother Hubbard*. By Ruth Chesterfield, published by L. Prang & Co., 1866. *Miami University Library, Oxford, Ohio.*

Slate pictures, published by L. Prang & Co., 1863. *Hallmark Historical Collection.*

In the sale of original paintings owned by Prang that was held at Copley Hall, Boston, in 1899, there were Mother Goose figures by Rose Mueller Sprague. These were illustrations for a book called *Old Stories in New Attire,* which contained costume pictures in color of eight familiar characters from Mother Goose rhymes and fairy tales. *A Gay Day for 7,* also by Mrs. Rose Mueller Sprague, was a juvenile story published by L. Prang & Company late in the nineteenth century. *A True Story of My Dolls,* by Elizabeth S. Tucker, was a small book, 5¼ x 4⅜ inches, that was listed with Prang's art books in the catalogue of 1892. Another art book listed was *Three Little Pussy Cats* by Ellen Beauchamp, size 4 x 6⅜ inches. This book was undoubtedly for children. Prang also published folders of doll pictures.

Idealized children's heads and pictures of children were favorite subjects of Prang lithographs from the 1870s on. The great sellers were *Little Prudy* and *Little Prudy's Brother* by Mrs. E. Murray. Rebecca S. Clarke was the author of the Little Prudy and Dotty Dimple series of books for children that were popular at this time. The Little Prudy series was initiated in 1864 and many editions were published between that date and the early 1900s. Prang followed these lithographs of *Little Prudy* and *Dotty Dimple* with many other sentimental pictures of children such as Flora, Daisy, Rosa. The popular *Prize Babies* by Ida Waugh was published in the early 1890s. Other child subjects by Ida Waugh

Flora and *Rosa.* Idealized portraits of children and flowers. Chromos by L. Prang & Co., after paintings by Maud Humphrey. *Hallmark Historical Collection.*

Children's Party. Chromo by L. Prang & Co., after painting by Ida Waugh. *Hallmark Historical Collection.*

Travelling Comedians. De Vos. Original painting after which chromo was made by L. Prang & Co., ca. 1878. *Paul W. Cooley*.

included *Prize Babies Walking Match, The Progressive Laugh, Playing School, The Children's Party, The Interrupted Picnic, The Little Rogue, Wide Awake and Fast Asleep, I'm a Daisy, Little Sunbeam, What is It?* (baby and turtle), and *Our Young Commodore*. All these sentimental pictures of children so popular in late Victorian days are collector's items today.

Prints of cats, dogs, and monkeys dressed in costumes were favorite subjects for Prang cards. Although these would be amusing to children they were not designed specially for the juvenile market. Such subjects were popular with Victorian audiences. Two pictures of dressed-up monkeys entitled *Travelling Comedians* were after paintings by De Vos and were listed in the 1878 Prang catalogue under animal pictures. There were also humorous pictures of dogs and bears by J. H. and Harry Beard.

Pictures entitled *Arms of All the States of the United States, The Flags of All Nations,* and *Arms of All Nations* were for framing but were also "especially

adapted for an album collection by children as every Flag or Arm is separately printed and may be cut out by itself" (*Prang's Chromo,* January 1868).

The Taber-Prang Art Company catalogue of 1912 illustrates a set of Mother Goose pictures in color by Lucy Fitch Perkins. There were ten pictures, each 17 x 20 inches. *The King was in His Counting House, The Maid was in the Garden, The King of Hearts, The Queen of Hearts, The Queen was in the Parlor, My Mary she minds her Diary, There was a Girl in Our Town, Blow Wind Blow, One Misty Morning,* and *Dance to your Daddy.* These were designed as a frieze for the nursery or schoolroom. A set of Hiawatha pictures by Nancy Smith was also designed for use in the nursery or schoolroom and a series of Hiawatha silhouettes by Mary Hamilton Frye interpreted four incidents in the childhood of Hiawatha. There was also a set of ten of Dieffenbach's shadow pictures of children.

An early publication of L. Prang & Company was a group of lithographed games. The games, which included Fortune-Telling, Courtship, Goblins, Snap, Dissected Figures, The Revolutionary War, and Red Riding Hood, were probably not original with Prang. The games of Snap and Red Riding Hood were old games also put out by such companies as Parker Brothers. McLoughlin Brothers' 1867 catalogue included the game of Little Red Riding Hood. "Dissected" picture games were put out under various titles such as "cut-up objects" and "chopped" or "sliced objects." Although the game of Goblins and the Revolutionary War are not listed by Parker Brothers or McLoughlin, they too were undoubtedly old games and not original with Prang. The Hunting Frolic, 1868, was a puzzle for sportsmen. In 1892 Prang published the Animal Game Series that included such card games as High Low-Jack, Whist, Tiddlywinks, and Euchre. All the games were packed in boxes and lithographed in color. Any of the seven games put out before 1870 are rare and would be a valuable addition to a collection.

The *Prang Chromo Advertiser* for 1870 lists the following items under Pastimes: "Twirl Me Around, No. 1 and 2 . . . a series of cards exhibiting on each side a picture complete in itself, which by an ingenious arrangement are so placed that the two combine to produce a third picture when the card is rapidly twirled around."

"Fortune Telling Flowers No. 1" was also an ingenious contraption and if found today would be an interesting and rare collector's item. The catalogue of 1868 describes it as follows: "A new device to create merriment in all seasons. It will tell the future; it will entertain a whole company; beneficial especially in times of malaria; it will catch and keep flies, and prove itself useful as a fan or a mantelpiece ornament. All gypsies will have to retire from business before so eminent and cheap a rival." The device proved so popular that a similar article, "Fortune Telling Cards, No. 2," was put out for men. "The Language of Flowers" was a set of fifty cards put up in an elegant box. These cards could be grouped and arranged to send a sentimental message.

Sets of Magic Cards I, II, and III and Rebus Cards for the entertainment of both adults and children were put out in 1865 and also listed in *Prang's Chromo Advertiser*, September 1870. The titles of the Magic Cards in Part I were:

1. The Squirrel and the Woodman.
2. The Russian Flower Pot.
3. The Chivalrous Rebel.
4. The Haunted Murderer.
5. The Janus Willow Tree.
6. The Eagle of the Republic.
7. The Living Forest.
8. The War Bouquet.
9. Play and Earnest.
10. The Mystic Stags.
11. The Forest of Dark Deeds.
12. The Old Gipsey.

Since these were loose cards they are often found singly in old albums or miscellaneous collections of cards. Illuminated rebus cards with new and original subjects were packaged with twelve cards in one envelope for 25 cents. These, too, are often found singly today.

L. Prang & Company also printed several small humorous books. In 1864 the company issued a small extension or panorama book called *Husband Wanted*. It consisted of twelve lithographed panels with a lacquered pictorial cover. Other humorous books were the *Leedle Yawcab Strauss* series, 1894. These were in verse and were published for their comic value. It is not known how many were printed but these books were not big sellers like the Christmas cards or the large chromolithographs.

Magic Cards, published by L. Prang & Co., 1865. *Justin G. Schiller, The Antiques Center of America, Photograph Courtesy Roy Blakey.*

THE SQUIRREL AND THE WOODMAN

THE CHIVALROUS REBEL.

THE EAGLE OF THE REPUBLIC.

THE HAUNTED MURDERER

1. RESULT OF IMPROVIDENCE.

2. A GOOD RULE WORTH REMEMBERING.

3. A RHYME FOR THE CHILDREN.

9. A GOOD RULE.

Rebus cards, published by L. Prang & Co., 1865. *The Henry E. Huntington Library and Art Gallery.*

Husband Wanted. Panorama of twelve lithographed panels with lacquered pictorial cover, published by L. Prang & Co., 1864. *Justin G. Schiller, The Antiques Center of America, Photograph Courtesy Roy Blakey.*

This long-neglected group of Prang toy books, pastimes, and games gives a fascinating picture of the home recreations of the late Victorian era in America. They have been overlooked even by collectors of children's books and few of them are found in the well-known collections. However, the John Mackay Shaw collection at Florida State University contains several, and libraries such as the Philadelphia Free Library and Huntington Library contain a few items. The books are also now found occasionally in lists of dealers of old books. They are not cheap but are within the range of a beginning collector.

Trade Cards and Other Advertisements

ADVERTISING ITEMS INCLUDING TRADE CARDS, CALENDARS, BROADSIDES, POSTERS, and merchandise catalogues are important to the collector who specializes in the field of advertising antiques.

American trade cards were made as early as the eighteenth century by many well-known engravers including Paul Revere, Nathaniel Hurd, Henry Dawkins, and James Smither. The cards were used by early craftsmen and represented the hand trades such as the silversmith, the coppersmith, and the cabinetmaker. They were usually ornamented with conventional borders. As the century progressed trade cards became more pictorial and instead of decorative designs the cards often depicted the tradesman working at his trade. From about the middle of the nineteenth century trade cards were lithographed rather than

engraved and the designs became more realistic, often including a picture of the shop or of the product advertised such as a stove or a bottle of ink. There were many American lithographers who produced these cards including Sarony, Major & Knapp, Kimmel & Foster, William Sharp & Sons, Endicott, and J. H. Bufford. After the Civil War cheaper processes were used and floral cards became the most popular. The typical trade card was aimed at the middle class and the cards thus give a unique view of how the average American lived then.

In the 1870s American manufacturers needed advertising for their goods and with the perfecting of color lithography the trade card became an effective business device. Trade cards were inserted in packages, passed out with purchases, and mailed to customers. Thousands of trade cards were passed out daily by dealers such as stationers and bookstores where Prang's chromos and other publications were sold. Trade cards were also handed out at the various local and world's fairs where Prang exhibited his publications. The International Centennial Exposition at Philadelphia in 1876 gave a great impetus to the trade card. L. Prang & Company had a booth and distributed thousands of trade cards as did other merchants.

The trade card usually had an attractive colored picture with a sales pitch stamped on the back. Prang's own cards were ornamented with flowers (moss roses) and autumn leaves, although he used many different designs including the card with fans and roses that was often sold as a valentine, and one of Cupid with a flower cart. Trade cards were saved and kept in albums. The fad for saving trade cards flourished until after the turn of the century.

Trade card. Cupid on birchbark cart with daisy wheels. Used by L. Prang & Co.

Valentine cards used as trade cards by L. Prang & Co. *Hallmark Historical Collection.*

Not only were Prang trade cards, posters, and catalogues put out by the firm to advertise their own cards and booklets, but trade cards, calendars, and posters were printed and sold by Prang to other companies for advertisements. These included advertisements for such merchandise as thread, textile fabrics, drugs and cosmetics, baking soda, tobacco, beer, ale, and wine. The largest category of advertising publications was that of trade cards and these were the

Floral and birchbark trade card designed by Mrs. O. E. Whitney, 1878. *Hallmark Historical Collection.*

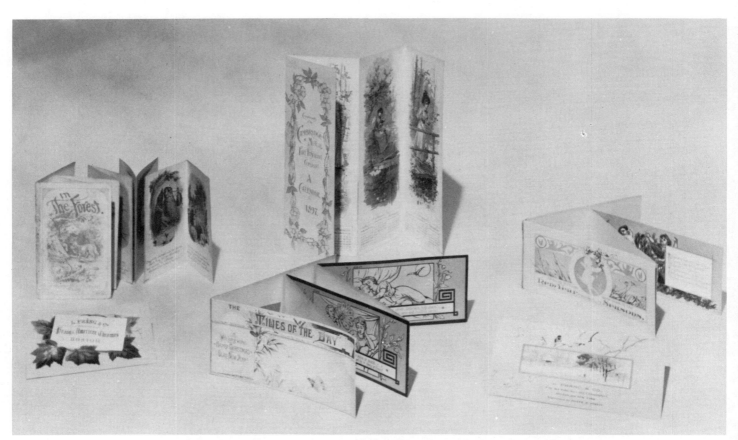

Prang trade cards and extension calendars. *Hallmark Historical Collection.*

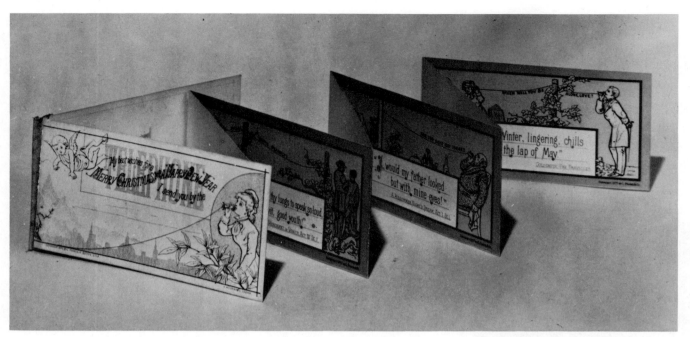

Extension telephone card, often used as a trade card. *Hallmark Historical Collection.*

first items to be mass produced. They are thus the most available and also one of the least expensive groups of items for Prang collectors. Many of the cards were made as "stockcards"—the name and address of the merchant to be added later. There were thousands of these cards printed in hundreds of different designs, including floral designs, bird designs, bell cards, sportsmen's cards, bookmark cards, bouquet, wreath, ribbon, fan, egg, shells, sea mosses, vases, amorettos, flowers, hearts in flowers, and calendar cards. Backgrounds were blue, gold, or birchbark. Special designs included extension cards, The Four Ages, The Times of Day, The Arts, and Telephone Cards. The cards were sold in lots from one hundred to five thousand and the prices were from $1.50 to $50 a lot. The name or advertising copy was printed at a small additional cost. Several of the designs including ribbon, gold-ground florals, and The Arts Series could be embossed if the order was over one thousand cards. This data gives an idea of the vast quantities of cards that were printed and also of the availability of thousands that are awaiting today's collectors. From this time on to the end of the century much of Prang's business centered on advertising.

L. Prang & Company made many trade cards for Lautz Bros. & Company to advertise their Acme Soap; for Clark's Mile-End Spool Cotton; for Hood's Sarsaparilla; for Rough on Rats, a rodent and bug killer; Well's Health Renewer; Mrs. Winslow's Soothing Syrup; Standard Screw-Fastened Boots and Shoes; Adjustable Corsets, and Swan's Highly Perfumed Bear's Oil; Smith Bros. & Co.; Magee Mistic Range; Estes & Lauriat, publishers; J. Larrabee & Co., Albany and New York; and J. Leach, Stationer and Printer.

There was a set of twelve *H. M. S. Pinafore* cards with scenes, verses, and music from the operetta, printed by Prang in 1879. These cards were used as trade cards by E. N. Denison & Co., Jewelers and Silversmiths, of Westerly, R.I. They were also popular with many other firms. These cards were marked

L. Prang & Company with the copyright date 1879. The trade cards of Gaff, Fleischmann & Co. Compressed Yeast were of oak leaves or eggs and flowers. These were marked Copyright, L. Prang & Co. 1877. Prang's small floral cards were also used as trade cards by Gaff, Fleischmann & Co., but these did not have the Prang mark. The trade card for Edward Kakas Furs, Boston, pictured a fox and a squirrel and was also marked Copyright 1877 L. Prang & Co. However, the most important trade cards were the series of birds that were put in the packages of Arm & Hammer baking soda. These cards are stamped with the Arm & Hammer trademark. The same series of birds was also used on album cards. There were also Prang trade cards put in packages of cigarettes.

Many Prang trade cards do not have the Prang stamp and for this reason they are difficult to identify. Those in the albums at the Boston Public Library and those in the Proof Books at the New York Public Library came from Mr. Prang's and the company's own files and are thus authentic records. Although the imprint of another company is often found on a similar card it may be a Prang card since Prang printed jobs for other companies. Trade cards were usually printed in the primary colors—red, blue, and yellow. According to R. Burdick, whose large collection of trade cards is now in the collection of the Print Department of The Metropolitan Museum of Art, "Prang cards can be recognized by the attractive shades of ink and the general harmony of layout." Besides the many Prang trade cards with bird and flower designs, children were also a popular subject.

In addition to trade cards L. Prang & Company printed many labels for such products as ink, spice, cooking extracts, patent medicines, and cosmetics as well as labels for beer bottles. So great was the output of labels in the 1890s that Prang's finer cards and chromos were often overlooked. Henry M. Downey was assistant superintendent of the Taber Art Company plant at the time when it combined with L. Prang & Company, August 1897. According to Mr. Downey:

> The L. Prang Co. of Roxbury, Mass., was nothing but a strictly lithographic plant. They did a large commercial business in making lithographs and their best customer was G. & C. Merriam of this City. Merriam had the L. Prang Co. make all their colored pictures for Webster's Dictionary such as birds, animals, flags of all nations, etc. . . . After the two companies combined to form the Taber-Prang Art Co. the Prang department made for years all the labels in colors for the brewery bottles for beer and ale manufactured and brewed by the various breweries around Boston. I can now see labels for Bunker Hill beer, Charlestown ale, Harvard beer, Burkhardt beer, Suffolk ale. (from a letter in the files of The Springfield Library, Springfield, Massachusetts.)

Other Prang beer advertisements in the 1890s included those for Bismark Beer, William Smith & Co. Lager Beer, Norfolk Brewery, Pfaff's Lager Beer, Roessle Brewing Co., and George Wiedemann Brewing Co. One of Wiede-

mann's advertisements was of a beautiful woman dressed in lavender holding a bunch of violets. This was lithographed after a painting by Leon Moran. There were also several beer advertisements with portraits of old men reading newspapers in a setting that included beer jugs and mugs. The one for George Wiedemann depicted an old man in a miner's hat. The American Brewing Company's advertisement was called The Philosopher. It was a scene of a man writing. A bottle of beer and a glass were nearby. In an advertisement for Franklin Brewing Company two men are shown reading *Brewer's Journal.* The advertisement for Allen's Ale and Porter shows an old man sitting in a Windsor chair reading a newspaper. The Continental Bottling Company at about the same time had an advertisement that depicted a girl with cape, cap, and red shoes holding a jug and standing on a barrel. Although the artist for these beer advertisements has not been identified they are all excellent compositions and the lithographic work is precisely registered. These prints are rare and interesting items for the collector.

Advertisement for Franklin Brewing Company. Chromo by L. Prang & Co. *Hallmark Historical Collection.*

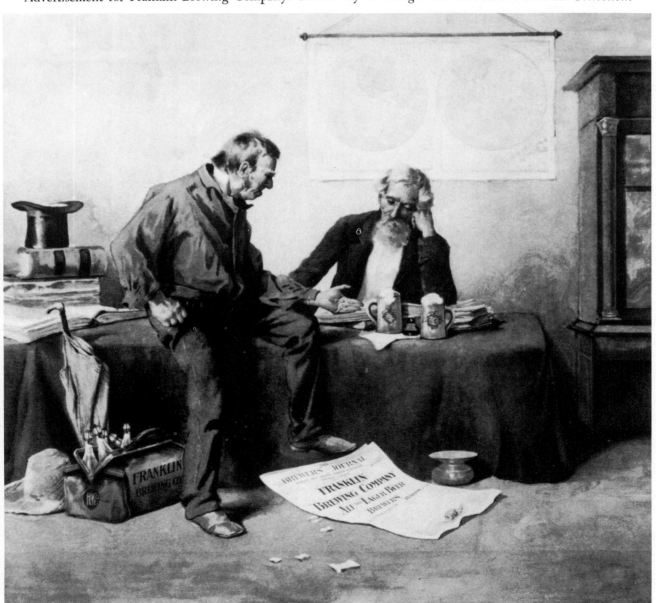

Advertisement for George Wie-
demann Brewing Company.
Chromo by L. Prang & Co.,
after watercolor by Leon Mor-
an. *Hallmark Historical Collec-
tion.*

Advertisement for Roessle Brewing Company. Chromo by L. Prang & Co., after painting by Claude Raquet
Hirst. *Hallmark Historical Collection.*

From 1880 through 1900 Prang printed hundreds of calendars. Calendars were often printed on trade cards but in the 1880s Prang began the production of large calendars. Many of these large calendars were used for advertising as they are today. In fact the majority of the thousands of calendars were for advertising and they are some of the most interesting. In 1886 a calendar was issued for Philip Brewing Company. A Temperance calendar for anybody's use was also issued in the same year. In 1887 Prang put out a series of folding calendars. These included children illustrating the Procession of Months; landscapes and figures; children's heads; Ye Merrie Months; The Zodiac, and a folding Telephone calendar. There were also calendars with scenes of Boston, New York, Washington, Baltimore, and Philadelphia for 1890. Other calendars of 1890 included the Zodiac Calendar which was first issued in 1889. The Season Calendar portrayed children and toys, and there was also a fishing calendar. In the 1890s there were also many decorative calendars including an Audubon calendar; an Easter Lily calendar; Dream Roses and Girls; British Authors; Seals of States; Louisa M. Alcott; Happy Childhood; Remembrance (with pansies), and a Christian Endeavor Calendar. A calendar of California scenes was illustrated by Victor A. Searles in 1900. A bicycle calendar was put out in 1896. In 1897 a calendar with wild roses and scenes of girls in the woods was printed for Cambridge Mutual Fire Insurance and in 1898 Prang published a calendar for the same company with decorations of double and single violets. These are

Children's calendar, 1887. Chromo by L. Prang & Co., after painting by Maud Humphrey. *Hallmark Historical Collection.*

(a) Sketches for Seashore Calendar, 1897. (b) Sketches for California Calendar, 1900. *Hallmark Historical Collection.*

only a few of the many calendars that were issued by L. Prang & Company. Some were decorative art calendars but all could be printed with the name of a company added and thus be used for advertising. The companies using Prang calendars and posters were not only in the Boston area but throughout the United States and even Europe.

Other advertising clients of L. Prang & Company included Dennison Crepe Paper Company; C. D. Boss & Son, Milk Biscuits; Non's Extract of Malt; George Lanendoer & Co., Chemists of Boston; Hall's Tobacco and Cigarettes; Grand Sachem Cigars; Pompadour Perfumes; David S. Brown of New York; John Hancock; National Milling Company; Continental Bottling Company. Maplewood Hotel in the New Hampshire White Mountains; Melville Garden, Boston Harbor, and Mason's Columbian Lodge were also advertising clients of L. Prang & Company. Prang printed Capitol Almanacs from 1890 through 1894.

L. Prang & Company put out many posters to advertise their own publications. These were in the form of window cards which could be used by dealers of Prang lithographs. There were poster announcements of Christmas and New Year cards, valentines, Easter cards, art publications, and educational books. The poster advertising Prang's valentines in 1883 was of a girl holding a group of cherubs placed as balloons on sticks. A poster calendar in 1896, with a cover by the well-known Art Nouveau artist, Louis Rhead, was by F. Schuyler Mathews, the artist who did much work for Prang including the back designs of Christmas cards and many landscape scenes in New England. There was also a poster by Arthur W. Dow. The most valuable Prang poster today is the one for Easter Publications designed by Louis Rhead. Prang also publicized his business through

Poster for Prang's Fine Art Publications, ca. 1885.
Hallmark Historical Collection.

Poster advertising Prang's Christmas Cards. *The Norcross Historical Collection.*

"ROSES, ROSES ALL THE YEAR." A Calendar for 1896. By Bessie Gray. Four beautiful studies of roses, in full colors, with a calendar of the days of the year for three months on each card. The whole fastened with silk ribbon and bow to a handsome cover. Size 8x10 inches. In a box. Price, $1.00.

"ROSES, ROSES ALL THE WAY." Illustrated by Bessie Gray. Nine full-page illustrations in colors of roses, and many pages of poetic quotations. Fastened with silk ribbon and bow to a conventionalized cover design of roses in colors. Size, 10x9 inches. Price $1.50.

"WHEELING THROUGH THE YEAR." A Bicycle Calendar for 1896. By Henry Sandham. Seven artistic plates with characteristic views of the use of the bicycle. Each plate has a calendar of the days of the year for two months, and the whole is prettily fastened to a cover design with silk ribbon and bow, arranged to turn. Size, 8x10 3-4 inches. Price, $1.00.

A POSTER CALENDAR

FOR

1896

By F. Schuyler Mathews

GOTTEN UP IN TRUE POSTER STYLE

Price, $1.00

"A notable work just issued by L. Prang & Co. for the holiday trade is the novelty of a 'Poster Calendar' for 1896—a series of sheets about the size of the usual magazine poster, one for each month, joined loosely by a cord, and prefaced by a cover design. The latter is a charming piece of work by Louis J. Rhead; a picturesque girl in yellow dress and with red hair, a palette by her side, about to begin the calendar, whose blank sheets hang before her. The designs for the twelve months are by F. Schuyler Mathews—attractive pictorial figure subjects of modern daily life in flat tints, gracefully drawn, expressive in character, and bright and harmonious in color. There are two figures for each month, all male and female, except those for March and October, in which both are masculine. The subject for January is a New Year's dance; for February, a valentine; for March, a young man in a gale of wind, and a boy flying a kite; next an April fool scene; May, an engagement; June, a wedding; July, boating; August, driving; September, lawn tennis; October, football; November, Thanksgiving dinner; and December, under the Christmas mistletoe."—BOSTON HERALD, September 1, 1895.

Cover design by Louis Rhead, for poster calendar, 1896. Advertisement in *Modern Art, 1895. Rare Book Division, New York Public Library.*

Poster. Prang's Easter Publications, after design by Louis Rhead. *Collection Robert Koch.*

Original drawing for trademark adopted by Prang in the 1880s. *Hallmark Historical Collection.*

Title page of Prang Catalogue, Spring, 1879. *Hallmark Historical Collection.*

Cover of L. Prang & Co. Easter card catalogue, 1885. *Hallmark Historical Collection.*

the distribution of chromos. Complimentary chromos were presented to important public figures—writers, artists, statesmen, and politicians. *Prang's Chromo,* was of course, his most important piece of advertising.

Through the years Prang used several different trademarks. The first one consists of overlapping letters (P, A, and C) within a circle (see p. 6). In the 1880 s, Prang first used his henceforth characteristic rose trademark (see p. 70). For his educational books, Prang used the Greek *akroter* (see p. 190). Later various conventionalized monograms were used.

However, the most important means of advertising were the many catalogues issued by L. Prang & Company. The earliest catalogue available today is the rare small catalogue issued in 1871. From this year on there were seasonal catalogues, at least two a year. There were also specialized catalogues advertising Christmas and other greeting cards, art publications such as booklets and fancy articles, and educational publications. These catalogues are valuable for the collector of Prang chromos since they usually give detailed descriptions of the subject matter of the pictures. For this reason the catalogues are also valuable to the art dealer for identification purposes.

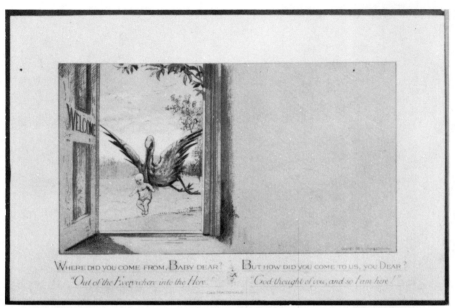

Rare birth announcement, published by L. Prang & Co., 1881. Verse by George Macdonald. *Hallmark Historical Collection.*

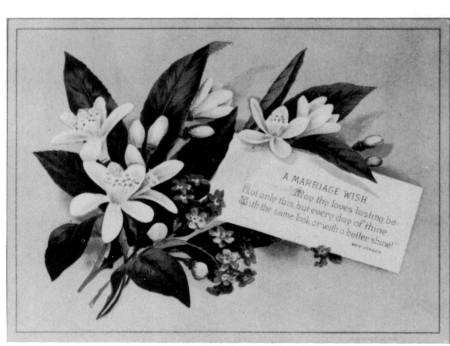

Wedding announcement, published by L. Prang & Co. in the 1880s. Verse by Ben Jonson. Very rare. *Hallmark Historical Collection.*

CHAPTER *Five*

Greeting Cards and Other Illuminated Cards

PRANG'S CHRISTMAS CARDS DID NOT APPEAR IN AMERICA UNTIL 1874 BUT THE theme of Christmas was included in the first products of the company. There were small album cards with Christmas, New Year's, birthday, and wedding congratulations listed in *Prang's Chromo*, September 1868. There were also large illuminated Christmas and New Year's cards for hanging on the wall. These were 11 × 27 inches and included the following inscriptions: "For unto you is born this day, in the City of David, a Saviour"; "Merry Christmas"; "Glory to God in the Highest, on Earth Peace, Good Will towards Men"; "Happy New Year." There was also a larger 12 × 16 inch "Merry Christmas." In the catalogue of 1871 large illuminated Christmas and New Year's cards of the same size and same themes were listed. There were also larger cards, 8 × 22 inches and 11 × 27 inches, bearing the inscriptions, "Holiday Gifts" and "Holiday Presents."

At the Vienna Exposition in 1873, Mr. Prang distributed small business cards that had designs of flowers on a tinted or black background with a ribbon scroll for the name. These cards attracted much attention and Prang received many orders for similar business cards. It was the suggestion of an English woman that the ribbon or scroll on the cards be filled in with a Christmas greeting and that the card be sold as a Christmas card. These first Prang Christmas cards appeared in England in 1873 but were not sold in America until a year later. Such was the story of the development of the Prang Christmas card.

The first cards that Prang produced specifically for Christmas were flower cards—a single blossom or a small bouquet on a ground of contrasting color. Designs included an autumn leaf, purple pansies, lilies, fuchsias, columbine, a rose or carnation, with a ribbon that said Merry Christmas or A Happy New Year. The same designs were later used for birthday, Easter, and valentine cards. The designer of these early cards was Mrs. O. E. Whitney. Her cards not only included garden flowers but also the wild flowers of Massachusetts, pussy willows, ferns, barberries, clover, dogtooth violets, and Michaelmas daisies. Often a butterfly, a robin's egg, or feathers appeared among the flowers. Cupids were seen riding in a flower cup drawn by a butterfly, ringing Christmas bells or bearing wreaths of flowers. There were cards with seashells and mosses, Alpine flowers, and American birds.

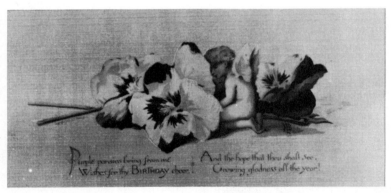

Floral birthday cards designed by Lizbeth B. Humphrey. L. Prang & Co., 1886. *Hallmark Historical Collection.*

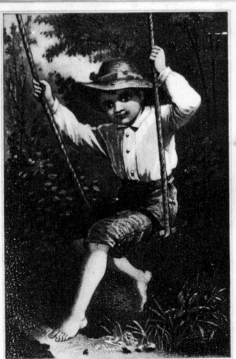

Birthday card. Peacock feather lithographed on satin. L. Prang & Co., 1880s. *Hallmark Historical Collection.*

Birthday card of boy in swing. Original watercolor design. *Hallmark Historical Collection.*

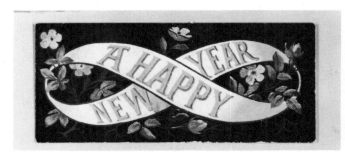

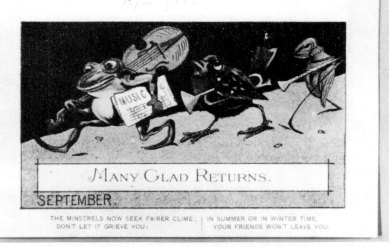

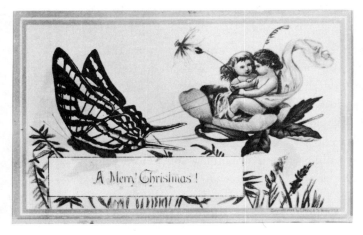

Humorous birthday card. L. Prang & Co., 1881. *Hallmark Historical Collection.*

Small early Christmas and New Year's cards, published by L. Prang & Co. in the 1870s. *Hallmark Historical Collection.*

An Easter Greeting, published by L. Prang & Co., 1886. *Hallmark Historical Collection.*

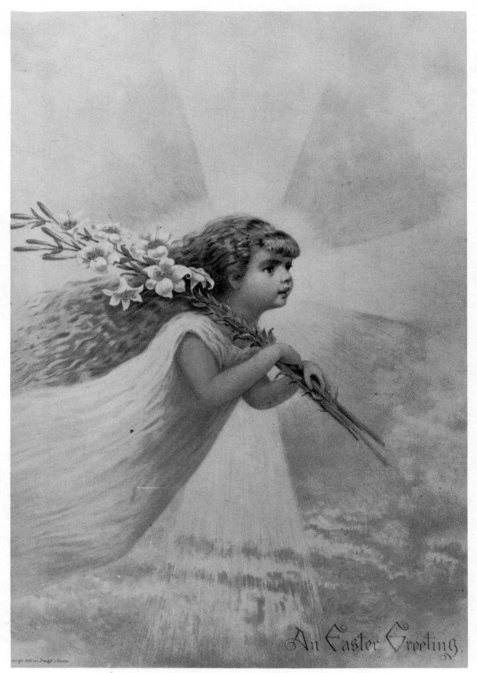

At the beginning the cards were small usually 3½ × 2 inches or 4 × 2½ inches and were printed on one side only. By the end of the 1870s the cards became more elongated, 5½ × 2¾ inches and 6¾ × 2¼ inches, according to the styles of the times. From the 1880s the cards were larger—6 × 8 and 7 × 10 inches—and the verses were longer. The cards began to assume a more distinctive Christmas theme. There were children in snow scenes with their sleds, girls with dolls, penguins in the snow, and the Song of the Stork, an Old World motif. Humorous cards were also popular and these portrayed mishaps of skaters and hunters, a cat in a ruff or a pug dog in a lace collar, a bear hugging an Eskimo or the F. S. Church designs of owls with exaggerated eyes, monkeys, grotesque pelicans, or a Christmas goblin in red holding a shell from which issues a small chick. The chick pictures of A. F. Tait were used at a later date on greeting cards.

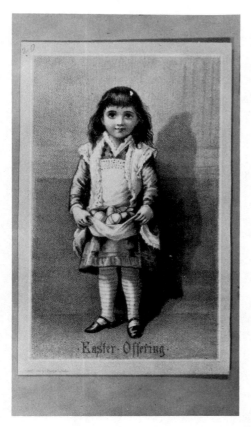

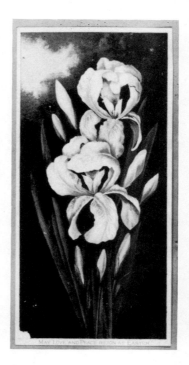

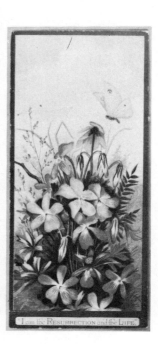

Group of small Easter cards, published by L. Prang & Co. Chick in eggshell possibly from painting by A. F. Tait. *Hallmark Historical Collection.*

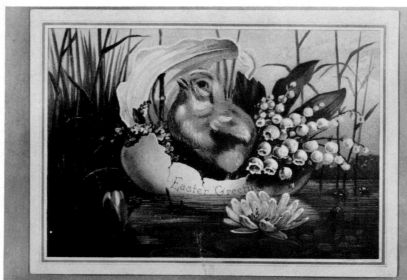

By 1878 Prang's Christmas and New Year's cards had become standard items in the general holiday trade both in England and the United States. A variety of new cards were listed in the Prang catalogue of 1878. The list included floral designs, birchbark, figure designs, designs on red or gold grounds, elf designs, still life designs, and the extension cards—The Times of Day, The Telephone, The Arts, and The Months. There were also embossed floral and figure designs although embossed cards were never a popular item with Prang. These small cards were put up in sets of six or twelve to an envelope and many had red, gold, or green backgrounds. From 1875 to 1880 black backgrounds were in vogue and these plain contrasting backgrounds brought out the colors and contours of the designs. Cards with brilliant red backgrounds had the effect of old Roman or Pompeiian wall decorations and were most festive. Some large upright cards were also made with borders of green mistletoe or red berries in gold foliage. The greeting was usually brief—a small couplet or prose—and the letters were worked into the design. As with all Prang's publications the register was usually faultless and this gave a finish and character to the cards.

By 1880 Mr. Prang realized that his Christmas cards were popular art education. He now aspired to give his work real artistic value and not only raise the level of popular taste but stimulate interest in original decorative work among American art students. To this end, in the spring of 1880, Prang arranged a competition and offered prizes of $1,000, $500, $300, and $200 respectively. An exhibition of the designs sent in was held in June 1880, at the American Art Gallery in New York. The judges were Samuel Colman, artist; Richard M. Hunt, architect; and E. C. Moore, head of the silver department of Tiffany & Company. The awards were given to Rosina Emmet, first prize; Alexander Sandier, second prize; Alfred Fredericks, third prize; and Alice S. Morse, fourth prize. While the main interest in the competition centered on the prizes, there was a further impetus given to artistic effort by the fact that L. Prang & Company reserved the right to purchase at their customary prices any card in the contest that met their approval.

On the backs of the winning cards were pasted labels stating the prize won, the artist's name, and the amount of prize money. The name of the designer and the details of the competition were also included on the back of the card. By this time the cards had increased in size, the dimensions averaging between 6 × 8 and 7 × 10 inches, and each card was richly fringed. Many cards were made with decorative backs on which verses were printed. Some verses were by well-known poets such as Tennyson, Longfellow, Whittier, and Bryant but the majority of the verses were written to order by Celia Thaxter and Emily Shaw Forman. The verses usually harmonized in theme with the design. One of the loveliest verses was on the back of a card showing two angels with downcast eyes holding candles, which was submitted to the 1882 contest by Dora Wheeler. The design on the back of the card was of two angel wings, a crescent moon, and stars, and the verse by Celia Thaxter was in special decorative lettering.

Christmas card by Dora Wheeler, published by L. Prang & Co., 1882. *The Norcross Historical Collection.*

Shining ones with drooping eyes,
 At the gates of Paradise,
Waiting for the word of joy
 That shall sin and death destroy

Quench your tapers burning dim
 For the tender Christmas hymn
Rises faintly through the hush,
 Heralding the morning's blush.

See the delicate white light
 Silvering the edge of night!
Spread your pinions half unfurled!
 Shafts of splendor smite the world!

Angels twain that watch and pray
 For the dawn of Christmas Day,
Lift your lids and look abroad,
 Lo! the glory of the Lord!

Second prize, 1880, by Alexander Sandier. *The Norcross Historical Collection.*

In February 1881, a second contest and exhibition were held, with the artists John La Farge and Samuel Colman as judges, together with Stanford White, the famous architect. The prizes were awarded in order of excellence to Elihu Vedder, Dora Wheeler, C. C. Coleman, and Rosina Emmet. In remarking on the prize cards, the New York *Evening Post* said: "It is easy to see that art is advancing in this country, when Elihu Vedder makes our Christmas cards." "The prize winner," according to *The Nation* of March 3, was "a young woman with ribbons flying from her head, relieved against a light blue sky, with a white scroll containing the figures 1882. The whole framed in a border of conventionalized leaves and flowers in light greens, blues and gold." It was inscribed "To my wife" and had the following poem by Celia Thaxter:

> *Thy own wish I wish thee in every place*
> *The Christmas joy, the song, the feast, the cheer*
> *Thine be the light of love in every face*
> *That looks on thee, to bless the coming year.*

First prize, second contest, 1881, by Elihu Vedder. *Hallmark Historical Collection.*

Vedder submitted a second design for which Prang paid $150 and Vedder asked that 10 percent of the fee be sent to a lady (Celia Thaxter, who also wrote the verse for this card). This second card showed a half-nude goddess of fortune sitting at her wheel with arms extended, showering pearls.

Another card in the 1881 contest was "Resurgam" by the artist W. Hamilton Gibson, a well-known watercolorist and member of the American Water-Color Society. Mr. Gibson was a painter of nature and painted many pictures for Prang, including a series of scenes with birds and animal life symbolizing the seasons. "Resurgam," the card that he entered in the 1881 contest, showed a design of butterflies rising from the tomb, symbolizing resurrection and eternity. Although the card received no award from the judges, it received considerable publicity due to an attempt to stuff the ballot box so that it would win the popular prize, as evidenced by this notice in a New York newspaper, November 20, 1881: "We regret to announce that a determined and organized effort was made to secure the first popular prize for a design possessing a minimum of artistic value. This which had until a day or two ago the number 691 bears the letter "E" and the motto "Resurgam." Although the card did not receive any prize, Prang purchased it, published it in different styles and sizes, and it remained popular for several years. In the 1884 catalogue of Easter Cards, it was listed under Art Prints in Satin. It was supplied with fringe, cord, and tassels and could be ordered in banner form to hang on the wall or in standard size to stand on a mantel or center table. It was 11¼ × 13½ inches, and cost $30. On plush, it was $33; on satin, $42; and on silk plush with satin mount, $48.

A third competition was held in 1882 based on a slightly different plan. The sum of $4,000 was offered instead of $2,000 and there were two sets of prizes—Artist's Prizes and Popular Prizes. The first Popular Prize as well as Artist's Prize went to Dora Wheeler. The card depicted a desolate mother and child huddled against a barren tree and a figure of the Virgin and Child shining through a cloud of glory with the inscription, "Good Tidings of Great Joy." The second Artist's Prize went to Miss L. B. Humphrey; the second Popular Prize to Walter Satterlee; the third Artist's Prize to Miss L. B. Humphrey; the third Popular Prize to Frederick Dielman; the fourth Artist's Prize to Alfred Fredericks, and the fourth Popular Prize to Miss Florence Taber.

By 1881 Prang was printing almost five million Christmas cards a year. However, after the first years many of the better artists lost interest in the competitions and the appearance of distinguished names and artistic designs grew less frequent. Instead many amateurs were attracted to the competitions. In order to bring back the better-known artists L. Prang & Company employed a group of well-known American painters to design cards and also to enter the competition. The artists included E. H. Blashfield, Robert F. Bloodgood, I. H. Caliga, Thomas Dewing, Frederick Dielman, Rosina Emmet, Alfred Fredericks, Fred W. Freer, I. M. Gaugengigl, W. St. John Harper, Lizbeth B. Humphrey, Will

Design for back of American second popular prize Christmas card, 1882, by Walter Satterlee. *Hallmark Historical Collection.*

Second Artist's Prize, 1882. Designed by Lizbeth B. Humphrey. *The Norcross Historical Collection.*

Angel with wreath of candles and toys. L. Prang & Co. *Hallmark Historical Collection*.

H. Low, Leon Moran, Percy Moran, Thomas Moran, H. Winthrop Pierce, A. M. Turner, Douglas Volk, J. Alden Weir, C. D. Weldon, and Dora Wheeler. New York and Brooklyn greeting card dealers were invited to be the judges and the exhibition of designs was held at Reichards Gallery, New York, November 1884.

In this fourth and last prize competition the combination of decorative beauty and the expression of the Christmas sentiment seemed well combined. The first prize in this contest went to C. D. Weldon for his card showing a little girl before the fire dreaming of the wonders of Christmas, which take shape in the smoke rings above her; the second prize, for a composition of angels heralding the Nativity, went to Will H. Low. The third prize was awarded to the well-known artist Thomas Moran for a night scene of an angel above a medieval city, and the fourth prize, for a design that placed a group of children within a background of holly, went to Frederick Dielman. A fifth prize was given by popular vote to Miss L. B. Humphrey for her "Boston" card.

The effect of the competitions was widespread and the influence on popular taste and the appreciation of decorative beauty apart from interest in the subject matter was certainly improved. Besides the prize cards, many other beautiful cards were reproduced as well and found a ready market. The Longfellow card was issued early in the 1880s and this proved so successful that a Whittier card with the poem "Snowbound" was issued in 1884. This was followed by a Bryant card for Christmas 1885. These "Literature Cards" were from designs by Miss Humphrey.

In the catalogue of 1885–1886 were included many favorite flower cards from designs by Mrs. O. E. Whitney. These included floral panels and pansies, violets, and lilies of the valley in baskets. There was also a series of birds and landscapes by Miss Fidelia Bridges and flowers by Mrs. Ellen T. Fisher. Some of these cards were in the shape of diamonds and stars and all could be ordered with or without silk fringe. Another novelty was the cards with rosebuds, forget-me-nots and other flowers in folded sheets of paper set on a veneer background. Also included in the 1885–1886 list of Christmas cards were several cards with conventional Christmas subjects such as the Guardian Angel and Cherubs by Miss Jennie Brownscombe. New Year's cards of children in landscapes by E. B. Bensell included a scene of a little boy beating a drum as well as humorous cards of children with turkeys and a child under an umbrella at a duck pond. There were also humorous cards by W. H. Beard including dancing bears, three owls with a book, and a turtle and hare. "Court Cards" showing the four honors of Hearts were from designs by Joseph G. Parmenter. Some of these cards had blown-glass frosting to simulate snow and some had silk cords for hanging. Later cards were printed on silk grounds and some double cards contained a sweet-smelling sachet.

In the catalogue of 1890 Prang offered a limited stock of Christmas cards "left over from last year." They were as follows:

Young Maids with Blossoms.
River and Inlet Scenes.
Female Figure and Winter Scene (by the late Miss L. B. Humphrey).
Children's Heads.
Boys from Mother Goose.
Girls from Mother Goose.
Babies' Heads.
Wild Roses, Apple Blossoms and Landscapes.
Children with Garlands of Evergreen.
Holly, Orchids, Geraniums, etc.
Duchesse de Vallambrosa Roses and Chrysanthemums.
Five o'clock Tea.
Red Letter Days (by the late Miss L. B. Humphrey).
Baskets of Crocuses and Apple Blossoms (by Mrs. E. T. Fisher).
Olive Bough of Peace. (Folder with olive branch and fruit outside.
 Verses inside by Mrs. Celia Thaxter, in handwriting of author.)
Child Peeping Through Door.
Baby with Umbrella in Snow-storm.
Little Women.
Winter Landscapes.
Landscapes.
The Four Seasons (landscapes).
The Prize Babies.
Christmas Harmony.

No prize cards or religious Christmas scenes were included. In the catalogue of 1892–1893 the list of cards included similar subject matter and old cards were offered at reduced prices rather than new designs since Prang was now in the process of closing out his greeting card business. Now the favorite subjects included children, flowers, winter landscapes, animals, Shakespeare heroines, and humorous scenes such as turkeys in costume, dressed-up cats, bear and owl, the Prize Piggies, chickens and pup, and familiar objects such as a watch, a banjo, a horseshoe, and a candlestick.

Supposedly, L. Prang & Company never did print a great number of valentine cards. However, in the first issue of *Prang's Chromo*, January 1868, valentine cards are listed:

Valentines in cards, Humorous.

Not to forget Valentine Day we offer in season a line of twenty-five different Card Valentines, which will prove very acceptable for a nice small gift when the day arrives. Size, 2½ × 4. Price (in five colors) each 10¢, (in two colors) each 5¢.

Later valentines were mostly from designs by Maud Humphrey, Laura C. Hills,

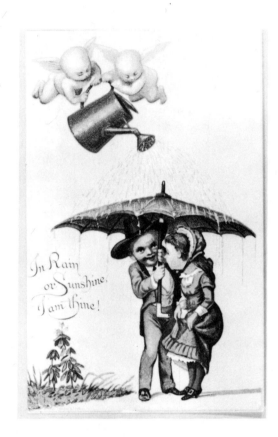

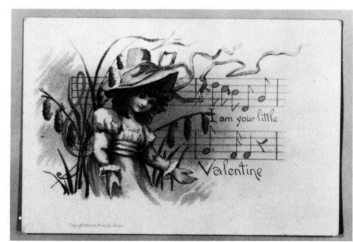

Valentines, published by L. Prang & Co., in the 1880s.
Hallmark Historical Collection.

Poster advertising Prang's valentines. "Hearts are Trumps." *The Norcross Historical Collection.*

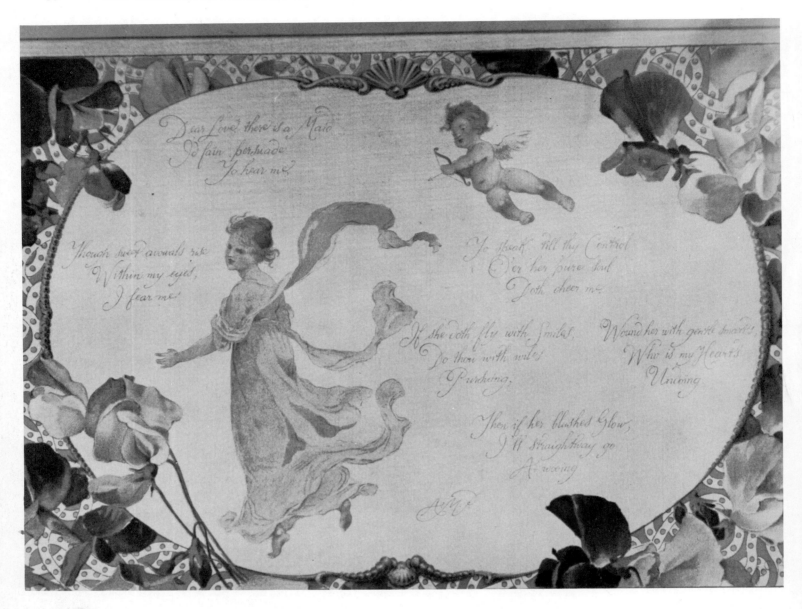

Rare valentines, lithographed on satin, by L. Prang & Co., 1888. *Hallmark Historical Collection.*

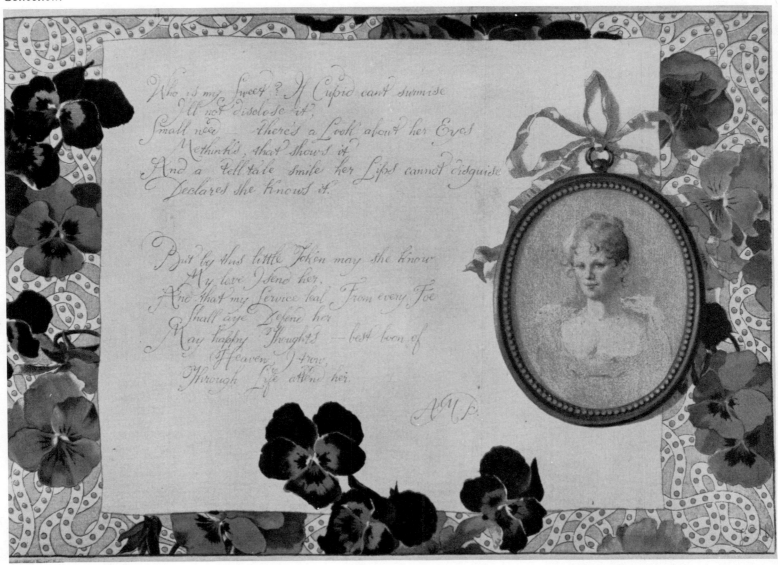

and F. Schuyler Mathews. Although Prang valentines are rare today they were put out in quantities large enough to call for a special valentine poster and dealers had many books of sample cards for the customer's selection.

The high quality of Prang greeting cards was not always maintained but generally speaking even the comic cards had some artistic value. Although Prang made no lace-paper cards he did succumb to the style of the times and produced cards with borders of silk fringe and also printed cards on satin. However, the technical excellence and the perfect finish of the lithograph seldom varies and for this reason alone Prang cards deserve the collector's attention. Here was an example of commercial art at its best, as a part of daily life. Apart from L. Prang & Company the American market was supplied by imported cards during the nineteenth century and it was this foreign competition that led Prang to give up the publication of Christmas cards in the 1890s.

Greeting cards are perhaps the most rewarding category of L. Prang & Company publications. The cards were printed in such large quantities that they are today the most readily available items for the collector. The cards are found in thrift shops, in old scrapbooks, in attic trunks, and soon they will be appearing in the high-class antique shops. There are sixty-seven books containing Prang greeting cards at the American Antiquarian Society in Worcester, Massachusetts, and the Museum for Preservation of New England Antiquities has a fine collection of greeting cards from the shop of Arthur Ackermann, the London dealer. Both Hallmark and Norcross also have important collections of Prang holiday cards.

EASTER OFFERING

Prang and Flowers

THE LARGEST AND MOST IMPORTANT CATEGORY OF PRANG CHROMOS WAS flowers. Except for the large chromo reproductions of paintings almost every other publication from trade cards to large panels included floral decoration of some sort. Although flowers of all varieties are seen in the designs, the rose was Mr. Prang's favorite flower. The first Prang print was of roses, Prang's trade card was decorated with roses, and after 1880 the Prang trademark became a conventional spray of roses together with the large letter "P." Several publications in the cut-out shape of a rose were printed in 1868, and even bookmarks were made in the shape of a rose. Two groups of album cards of roses were on the list of Prang publications in *Prang's Chromo,* Christmas 1868, and these were the favorites among the album cards.

The earliest large chromos of flowers were *Flower Bouquet, Fringed Gen-*

tian, by H. R. Newman and *Easter Morning,* a flower-wreathed cross by Mrs. James M. Hart. Mr. Newman's painting had won distinction at an exhibition of the National Academy. The description given in *Prang's Chromo,* Christmas 1868, is as follows: "In front of a mass of half-decayed limbs, which form a background, the most pretty wood-color shades graduating into one another, springs up the fresh gentian stalk, bearing its pale-green leaves, and radiant with the bright blue of its crowning blossoms. Artistically, nothing could be more perfect than the contrast of colors—the living blue and green set off against the sober shades of the dead, decaying wood and leaves."

New flower chromos listed in September 1870 included *Flowers of Memory* after a painting by Miss E. Remington. This was a composition of pansies and sprigs of rosemary lying on two volumes of Shakespeare. *Flowers of Hope* by Martin J. Heade was a companion piece. It depicts Mayflowers set in a shell upon a table with a bit of lace drapery. Prang's catalogue of 1878 lists Flower Pieces, including the following Chromos:

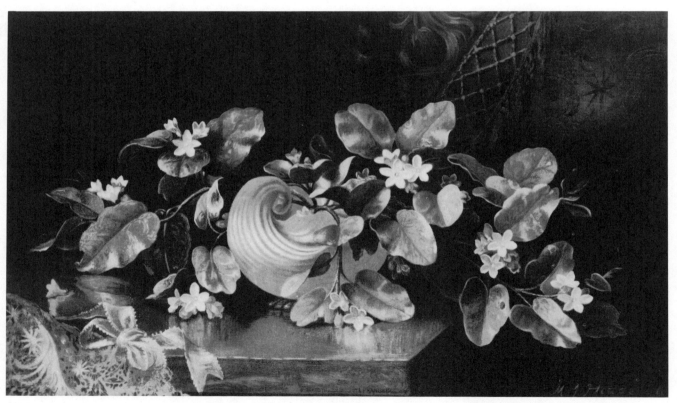

Flowers of Hope, 1870. Chromo (14¾ × 8½ inches). M. J. Heade. *Collections of The Library of Congress.*

FLOWER PIECES, ETC. CATALOGUE, 1878

Easter Morning. After Mrs. James M. Hart. 14 x 21.

Easter Morning, No. 2.
Easter Morning, No. 3.
Easter Morning, No. 4. } Companions, after Mrs. O. E. Whitney. 6¾ x 10⅜.
Easter Morning, No. 5.

After the Rains.
Before the Frosts. } Companions, after Florence Peel. 9⅜ x 6⅝.

Flowers of Hope. After M. J. Heade.

Flowers of Memory. After Miss E. Remington. 14⅜ x 8½.

Wild Flowers, No. 1.
Wild Flowers, No. 2. } Companions, after Miss Ellen Robbins. 10 x 7.

Flower Bouquet. 13¼ x 16⅜.

Fringed Gentian. After H. R. Newman. 14 x 17.

Wild Roses. After Mrs. Nina Moore. 12⅛ x 9.

Gatherings by the Wayside. Mementos of Old England.

 THE PRIMROSES AT HOME. SPRING'S DELIGHT.

 THE HEDGE SPARROW'S MANSION. BRAMBLE AND WILD PLUMS.

 Companions, after C. Ryan. Size mounted on gray board, 14 x 11.

White Lily.
Calla Lily. } Companions, after George C. Lambdin. Size in mat 21 x 28.

The Lily Pond. After Mrs. O. E. Whitney. 11 x 14.

Moss Roses and Blush Roses.
Fuchsias and Roses. } Companions, after George C. Lambdin. 15 x 27½.

Poppy, Bachelor's-buttons, and Daisies.
Morning Glories. } Panels, after Miss A. E. Hardy. 14 x 27.

Bouquet of Asters. After Miss Ellen Robbins.

Bouquet of Hyacinths. After Miss Ellen Robbins. 14 x 27.

Camellia.
Dark Red Rose. } Companions, after Aloïs Lunzer. 14 x 17.

June Morning. (Roses.) George C. Lambdin. 22 x 28.

Azaleas and Roses.
Roses and Buds. } Companions, after George C. Lambdin. 22 x 28.

FLOWER BOUQUETS IN THE 1878 CATALOGUE

 2. Tea Rose, Aster, etc. Size, in oval mat, 11 by 14.

 6. Daisies and Violets. } Companions, after Mrs. O. E. Whitney.
 7. Violets and Lilies of the Valley. } Size of each, in arch-top mat, 11 by 14.

 8. Water Lily and Violet.
 9. Water Lily and Iris. } Companions, after Mrs. O. E. Whitney.
10. Water Lily and Winterberries. } Size of each, in oval mat, 11 by 14.
11. Water Lily and Rosebuds.

15. Roses, Geraniums, Pansies, etc. } After Mrs. O. E. Whitney. Size
16. Ferns and Wild Flowers. } of each, in arch-top mat, 14 by 17.

17. Ferns and Wild Flowers. After Mrs. O. E. Whitney. Size, in square mat, with rounded corners, 14 by 17.

25. Calla Lilly, Geraniums, etc.) Companions, after Mrs. O. E. Whitney.
26. Water Lily, Sweet-Brier, etc.) Size of each, in square mat, 11 by 17.

 N.B. Nos. 25 and 26 can also be had on gold or black ground.

27. Nasturtiums, on gold ground) Companions, after Miss C. Chaplin.
28. Petunias.) Size of each, in arch-top mat, 14 by 22.

30. Autumn Leaves—Maple.) Companions, size of each, in oval mat, 14 by 17.
31. Autumn Leaves—Oak and Elm.)
32. Lilacs. After M. D. Longpré. Size, 22 by 28.

 N.B.—No. 32 can be had either on white or on black ground.

33. Mayflowers, on gray ground.) Companions. Size of each, in
34. Apple-Blossoms, on gray ground.) oval mat, 11 by 14.

35. Mayflowers, on white ground.) Companions, after Mrs. O. E. Whitney.
36. Apple-Blossoms, on white ground.) Size of each, in oval mat, 11 by 14.

39. Pansies, etc.,—black ground.) Companions, after Mrs. O. E. Whitney.
40. Pansies, Azalea, etc.,—black ground.) Size of each, in mat, 11 by 14.

41. Black Panel, Wild Roses, Violets, etc.
42. Black Panel, Pansies, etc.
43. Black Panel, Anemones and Violets. } Companions, after Mrs. O. E.
44. Black Panel, Mayflowers. Whitney. Size of each,
45. Black Panel, Roses and Pinks. in mat, 11 by 17.
46. Black Panel, Autumn Leaves.

 N.B.—Nos. 41 to 46 may also be had on gold ground.

47. White Roses,— black ground. \ Companions, after Mrs. O. E.
48. Moss Roses,— black ground. | Whitney. Size of each, in
49. Yellow and Red Roses,—black ground. | double mat, 9 by 11.
50. Pink, Mignonette, etc.,—black ground. (Companions, after Mrs. O. E.
51. Red and Yellow Roses,—black ground. | Whitney. Size of each, in
52. White and Red Roses,— black ground. / oval mat, 6½ by 8.

53. Small Panel, Autumn Leaves and Acorns.
54. Small Panel Moss Rose Bud.
55. Small Panel, Ivy and Winterberries. } Companions, after Mrs.
56. Small Panel, Pink and Moss Rose Bud. O. E. Whitney. Size of each,
57. Small Panel, Strawberry. in mat, 6 by 11.
58. Small Panel, Mayflowers.

Snowdrop, Auricula, etc.) Companions, after Miss Helen Noack.
Crocus and Snowdrop.) Size of each, in mat, 8⅞ by 13⅞.

Golden Rod, Aster, etc.) Companions, after Miss C. Chaplin.
Blood Root, Winterberries, etc.) Size of each, in mat, 11 by 17.

Buttercup, Clover and Daisies) Companions, after Mrs. O. E. Whitney.
Woodbine.) Size of each, in mat, 11 by 19

Water Lily, Sweet-Brier, etc.,—on birch bark. After Mrs. O. E. Whitney.

Size, in mat, 11 by 17.

Holly.
Fuchsia.
Carnations. } Companions, after Mrs. O. E. Whitney.
Moss Roses and Ferns. Size, in mat, 7 by 11.
Apple-Blossoms.

Daisies, Ferns, etc.
Mayflowers, etc.
Water Lily, etc. } Companions, after Mrs. O. E. Whitney.
Moss Rose Buds. Size, in mat, 7 by 11.
Salvia, etc.
Japan Quince, etc.

Violets, Lily of the Valley, etc.
Carnation, Violets, etc.
Convolvulus. } Companions, after Mrs. O. E. Whitney.
Autumn Leaves. Size, in mat, 7 by 11.
Cyclamen and Fern.
Asters and Creeper.

There were many floral mottoes and floral crosses, the majority of these by Mrs. O. E. Whitney. There were also numerous flower studies by Mrs. Ellen T. Fisher, who was a sister of Abbott Thayer and who worked exclusively for Mr. Prang for four years. Chromos of flowers by Mrs. Fisher—the original paintings being sold in the sale of 1892—included: Wisteria; Fleur-de-lis (19½ × 13½); Asters; Hollyhocks; Cardinal Flowers; Japan Lilies; Beech Leaves and Autumn Ferns; Daffodils; Marigolds; Poppies; Balm and Spirea, all 13½ × 9½. One of the best-known flower painters at this time was Theresa Hegg. Prang reproduced several of her paintings. Prang also published chromos of roses by Jean-Baptiste Robie whose paintings of flowers and fruit were well known throughout Europe and America. There were also chromos of roses by Paul de Longpré. A card of "Prices Paid Artists" lists the following paintings by de Longpré: Lilacs, $60; Roses, $60; Clematis, $40; La France Roses, $40; Iris and Lilacs, $60. Additional paintings by de Longpré that were owned by Prang and sold in 1899 included Morning Glory, Rêve d'Or Roses, and La France Rose. Cherry Blossoms, Roses and Flax (18 × 23), and Peonies (30 × 21) by de Longpré show flowers arranged in jars.

Flower wreaths with mottoes and quotations from poets included rose wreaths—white rose and heliotrope; water lily, violets and mayflowers; apple blossoms, strawberries and blackberries; and a memorial wreath with tuberoses on a gold and purple ground with space for a portrait of the deceased. These wreaths were designed by Fidelia Bridges, who was an associate member of the National Academy.

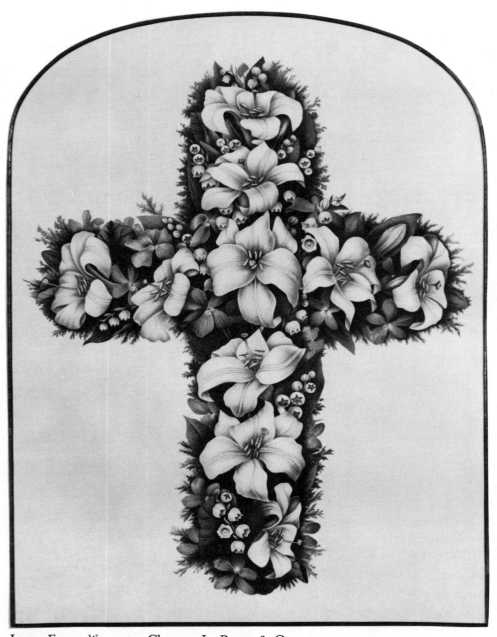

Large Easter lily cross. Chromo, L. Prang & Co.,
after painting by Mrs. O. E. Whitney. *Hallmark
Historical Collection.*

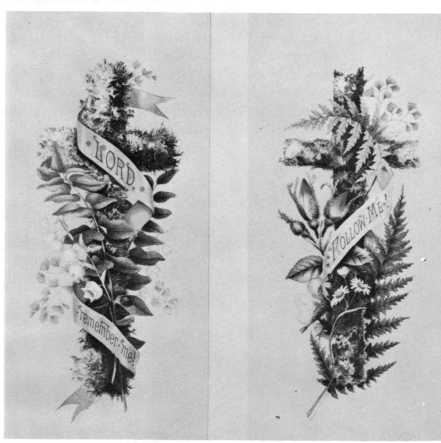

Three flower wreaths with mottoes. L. Prang & Co., after paintings by Fidelia Bridges. *Hallmark Historical Collection.*

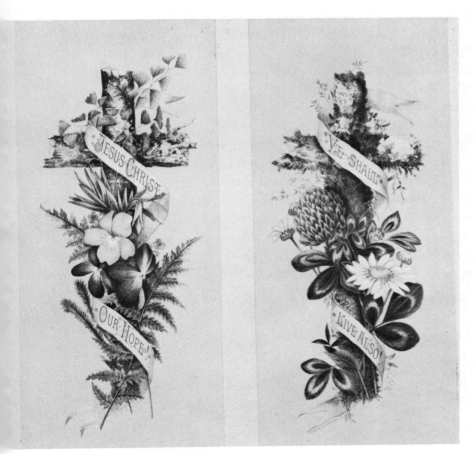

Motto crosses with ferns and flowers. Chromos, L. Prang & Co., after paintings by Mrs. O. E. Whitney. *Hallmark Historical Collection.*

In the 1888–1889 catalogue of Prang's Art Studies the following flower compositions were listed: Jacqueminot Roses, No. 1; Marechal Niel Roses; and Pink Moss Roses and Niphetos Roses by Mrs. E. T. Fisher (7 × 10 inches). Flower studies by Mrs. O. E. Whitney included Pansies, Clematis, Tulips and Carnations, Verbenas and Chrysanthemums, Violets, Asters and Snowberries, Snow-balls and Pinks, Pansies and Ivy Leaves (10 × 7), Apple-blossoms and Bees, Cherry Blossoms (9¾ × 5), Azaleas and Pelargoniums (6¼ × 8½). Flower studies by Thaddeus Welch included Jacqueminot Roses, No. 2; Nasturtiums, No. 2; and Duchesse de Vallambrosa Roses (22 × 28).

Most interesting flower chromos for collectors today are those after paintings by George C. Lambdin. These were made between 1870 and 1875 when the pictures themselves were sold in the Peremptory Sale of Prang's paintings. The list of paintings in the sale included: *White Lilies; Calla Lilies; Azaleas and Roses; Roses and Buds; June Morning* (roses); *Tea Roses and Blush Roses* (Black panel); *Water Lilies* (Black panel); *Fuchsias and Roses;* and *Moss Roses.* Flowers in Oil in the catalogue of 1888–1889 included the following by George C. Lambdin: *June Morning* (Roses in rich profusion on sky-blue background) size 18 × 24; *Roses,* dark ground, size 13 × 20; *White Azaleas and Tea Roses,* dark ground; *Red and White Roses and Buds,* dark ground, size 9½ × 21½. In the same catalogue other flower studies included *Oleander Blossoms; Yellow Rose and Bud* by E. Kratzer; *Asters; Hyacinths; Bullrushes, Poppies and Daisies;* and *Fleur-de-Lis,* on gold ground. There were also *Roses* and *Blackberries* and the ever-popular *Flowers of Hope* and *Flowers of Memory.*

Other well-known flower painters who worked for Prang included Aloïs Lunzer, who illustrated the books, *Native Wild Flowers and Ferns,* James Callowhill, who painted plates for the book of the W. T. Walters Oriental Art Collection, and Miss Annie C. Nowell, whose paintings were among those lithographed on satin. As listed in the catalogue of 1892–1893, they were *White Roses, No. 2; Yellow Scotch Roses; Blush Roses;* and *Pink Scotch Roses.* These were on mats and were 17¾ × 2½ inches in size. Annie C. Nowell also painted a water-color panel of red and yellow chrysanthemums; *Chrysanthemums in Wicker Basket; Chrysanthemums in Blue Vase; Jonquils and Wild Roses;* and *Morning Glories.* She also did a watercolor of *Grapes and Apples* and *Indian Corn,* both of which paintings Prang made into chromos. There were also roses by Mrs. Virginia Janus. Female figures holding garlands of roses or aprons of flowers were lithographed on silk, 16 × 20 inches in size, and were from paintings by Jennie Brownscombe, who frequently exhibited her paintings at the National Academy. There were also many lithographs of flowers in baskets and flowers in vases. Booklets of flowers included *Flower Fancies; The Violet; The Chrysanthemum; The Song of the Rose;* and *Buttercups, Daisies and Field Flowers.* Bessie Gray painted a series of Bermuda flowers which were made into lithographs by Prang.

The compositions of landscape, flowers, and birds by Miss Fidelia Bridges

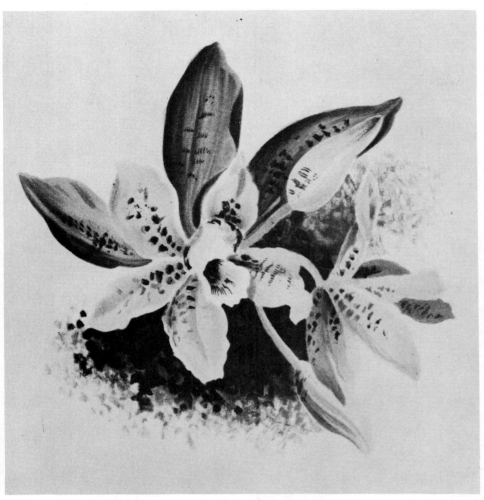

Orchids. Chromo, L. Prang & Co., after painting by Alois Lunzer.

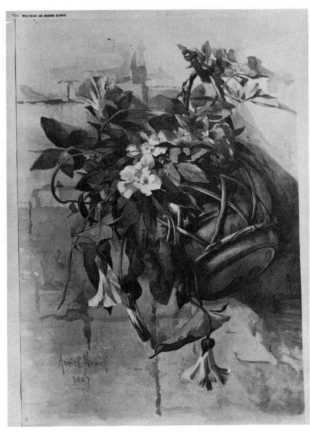

Wild roses and morning glories in hanging vase, 1887. Chromo, L. Prang & Co., after painting by Annie C. Nowell. *Hallmark Historical Collection.*

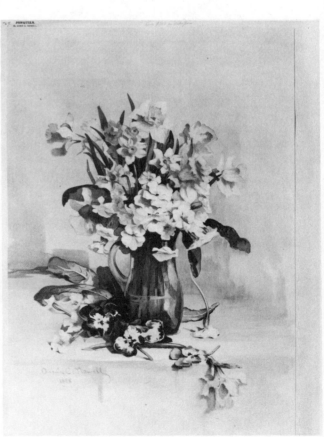

Jonquils, 1888. Chromo, L. Prang & Co., after painting by Annie C. Nowell. *Hallmark Historical Collection.*

Female figures with garlands. A proof sheet—individual cards were separated and cut. *Hallmark Historical Collection.*

as shown in her series The Months deserve special mention and are among the most beautiful of the Prang chromos. These lithographs are 18 × 12 inches on margin and the original watercolors were 12 × 9¼ inches. These were first published in 1876. They are described in the Prang catalogue of Art Studies, 1888–1889.

THE TWELVE MONTHS

January (Snowstorm, Birds, etc.)	July (Wheat Field against blue sky)
February (Birds and Snow)	August (Water Lilies, Swallow, Reeds)
March (Swallows, Pussy Willow)	September (Birds, grasses, etc.)
April (Landscape)	October (Goldenrod, Birds, etc.)
May (Birds, blossoms against blue sky)	November (Landscape)
June (Yellow birds and nest, blossoms)	December (Snow scene)

Size, on margin, 18 × 22. Price, each, $1.50.

These would be valuable additions to any collection of flower prints. A related series of chromos by W. Hamilton Gibson showed birds and squirrels in characterizations of winter. Gibson also painted flowers and insects in such compositions as the *Clover-field and Butterfly*. Hector Giacomelli, a French illustrator of birds and flowers, painted a series of small watercolor scenes of birds and flowers for Prang in the 1880s. These were listed on the "Prices paid Artists" card and the amounts for each picture ranged from $90 to $200. Watercolors of pupils of Ross Turner, the well-known Boston teacher of watercolor painting and author of books on watercolor painting, included *Waterlilies, Hollyhocks, Sunflowers, Wild Roses in Vase; Iris; White Peonies; Carnations; Pink Water-Lily Pond; Red and Pink Roses in Glass Bowl; Red Roses in Glass Mug*.

These are only a few of the thousands of Prang flower lithographs, which include all varieties of garden flowers and wild flowers in all manner of delightful and fanciful arrangements. There are also series of flowers and children with flower wreaths and garlands. Many of these flower lithographs were later printed on satin.

The flower chromos of L. Prang & Company are some of the most interesting flower prints available and it seems strange that they have never received the attention of collectors of flower illustrations. Their color compares favorably with that of the old prints of France and other European countries. In composition they usually represented the natural growth of the flowers although often such Victorian touches as a jewelbox, a fan, or a bit of lace are included in the picture. In fact it is their Victorian qualities that make the pictures especially interesting. Not only are the flowers themselves—violets, fuchsias, and moss roses—the nineteenth century favorites, but the compositions of the flower bouquets are typically Victorian—pansies and azaleas; calla lily and geraniums; pinks and moss roses. Anyone who turns the pages of a Prang record book of flower chromos will get a fascinating picture of the romance and sentimentality of flowers in Victorian

days. Millions of these flower lithographs were sold throughout the country in the last quarter of the nineteenth century so that there should be many prints available for collectors today. Aside from print collectors' interest the chromos are valuable aids in identifying the original paintings from which the chromos were made. These paintings are now coming on the market and are sought by collectors of nineteenth century American painting.

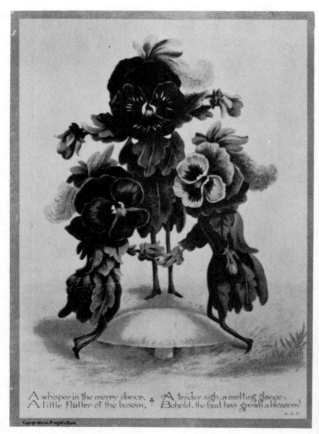

Dancing Pansies. Chromo, L. Prang & Co., 1884.
Hallmark Historical Collection.

Sub-Rosa. Chromo, L. Prang & Co.,
Hallmark Historical Collection.

Shaped Booklets, Fancy Silk Novelties, Fine Art Books, and Booklets

As MENTIONED IN CHAPTER 3, ONE OF THE EARLY PUBLICATIONS OF L. PRANG & Company was the Doll Series of books in the shape of regular paper dolls, and this series was advertised in the catalogue of 1871. Two other cut-out items were listed in the same catalogue under "Miscellaneous Publications." *The Rose of Boston* contained twenty-eight views of public buildings and a bird's-eye view of the city of Boston—"the whole in form of a beautiful rose in full bloom." *Roses and Life* was an allegorical poem published in the form of an extension book that folded up and was cut out to represent a rose in full bloom with branches and leaves.

Prang also produced booklets in the shape of pansies and tiny leaf cards— lily leaves, rose leaves, cabbage leaves, and an oyster shell. These small leaf cards were embossed and ornamented with a small insect such as a ladybug in

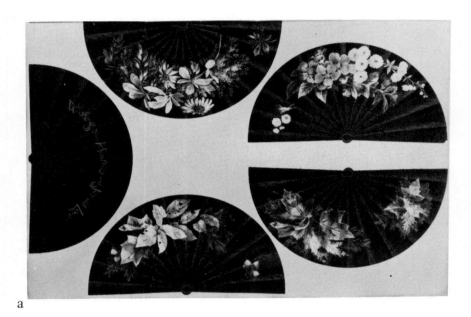

a

c

(a) Black background fans with lithographed flowers and leaves. (b) Valentine fans with silk fringe. *Hallmark Historical Collection.*

b

d

(c) Fans lithographed with landscapes and birds. (d) Folding fan and fan with silk fringe, 1891–1892. *Hallmark Historical Collection.*

color. They carried Christmas, birthday, and other greetings. There were also small fans with silk fringe and amorous greetings.

Shaped novelties and booklets continued to be popular items with L. Prang & Company and the number of these booklets was increased in the 1880s. A catalogue of 1885 included: *The Christmas Sheaf,* a collection of Christmas poems between illuminated covers stamped out in the shape of a sheaf of wheat; *Christmas Mince Pie, with Shakespearian Spice* by Lizzie K. Harlow included selections from Shakespeare with illustrations in monochrome. This booklet was cut and fastened to a cover in the shape of a piece of pie. There was also *A Christmas Plum Pudding.* This included comments by Jack Horner selected and illustrated with twelve monochromes by F. Schuyler Mathews. It was in the shape of a plum pudding. *The Story of a Dory,* with verses by Edward Everett Hale and color and line drawings by F. Schuyler Mathews, was in the shape of a dory with mast and anchor. *Flotsam and Jetsam,* with illustrations by L. K. Harlow, was in color and monotint in the shape of a yacht's mainsail of satin. The mast, gaff, and boom were nickel-plated. A pot of baked beans was a "souvenir of the Hub" (restaurant). These shaped booklets continued popular into the 1890s and in a catalogue of 1892–1893 several new shapes were added to the list of booklets available. These included:

Vesper Bells. Selections from the poets. Bell shape, enveloped.
Silver Chimes. Verses with illustrations in pen drawing. Bell shape.
Golden Bells. Poetic quotations. Bell shape. Three bells tied together with silk ribbon.

Prang's New Year Cards.

Order for Sets.	Number of Series.	Variety of Designs.	DESCRIPTION.	Size.	Telegraphic Cipher.	Retail price per set of 12.	Number of Series.
	1724	4	Pansies, Violets, Clematis, etc.	5 x5¼	Reader	$0 60	1724
	1803	6	Humorous Figures.	7⅞x4⅞	Reading	12	1803
	2019½	4	Summer Landscapes.	3¾x5¾	Realm	36	2019½
	2020¼	2	Children with Umbrellas in Snow-storm.	4¼x5¾	Reap	36	2020¼
	2032½	4	The Seasons. — Landscapes.	7¼x3¾	Reaping	60	2032½
	2219	4	Pink, Violets, Rose and Pansies.	7¼x3	Rebound	60	2219
	2407	4	Prize Piggies. Kittens, Chickens and Pup.	6x3¾	Rebuff	60	2407
	2419	2	Dressed-up Cats.	3⅞x6¾	Rebuke	84	2419
	2427	4	Wee Maidens. The Seasons.	4 x6¼	Recant	1 20	2427

Prang's Shape Booklets.

Price 50 cts.　　THREE BELLS. Price 25 cts.　　Price 50 cts.

Price 30 cts.　　MINCE PIE. Price 25 cts.　　PLUM PUDDING. Price 30 cts.

See page 17 for description

7

Christmas Mince Pie by Lizzie K. Harlow from L. Prang & Co. catalogue, 1892–1893. *Hallmark Historical Collection.*

Title page of *The Story of a Dory*. Original pen and ink sketch. *Hallmark Historical Collection.*

Christmas Salad, with illustrations by Lizzie K. Harlow. Shaped like a lettuce leaf.

A Day's Fishing. Verse by Lucie A. Harlow, with views by F. Schuyler Mathews, in a cover shaped as a sportsman's basket.

A Bunch of Daffodils. Verses by Robert Herrick and William Wordsworth. Illustrated with pen drawings by F. Schuyler Mathews. Shaped like a bunch of daffodils.

The Mayflowers. Verse by J. G. Whittier. Illustrated by F. Schuyler Mathews. Cover in the shape of a Mayflower bouquet.

The Old Farm Gate. Poem by Lurabel Harlow, seven pages of illustrations by Louis K. Harlow. Cover in the shape of an old farm gate. 7 × 9 inches.

Bouquets and Hats, From Youth to Age. Poem and design by Mrs. Mary H. Huntington. Illustrations in color and monotone by Helen A. Goodwin. Bonnet shape with openings showing faces.

The Cradle of Liberty. By Benson J. Lossing. Illustrated by F. Schuyler Mathews in monochrome and line drawings. Cover in shape of Independence Hall, Philadelphia.

Ye Ballade of Old Nantucket, 1746. Monochrome and pen drawings by F. Schuyler Mathews. Color cover in shape of Old Windmill at Nantucket.

There was also a small Easter booklet in the shape of an egg.

Prang also conformed to the taste of the times and reproduced some of his art prints in satin with plush mountings. Such a picture as the roses of the French artist Jean-Baptiste Robie, printed on satin and mounted on plush, sold for twenty-five dollars. The process of printing color lithographs on satin had been patented by L. Prang & Company early in the 1880s. At first the scenes were printed on regular cards with or without silk fringe but in the catalogue of 1885–1886 the

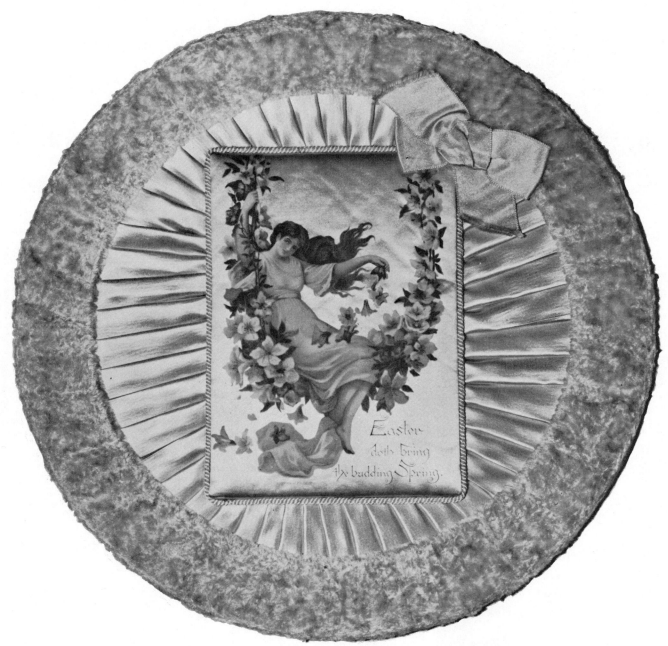

Easter greeting lithographed on satin. Pleated satin and plush mat, 1885. *Hallmark Historical Collection.*

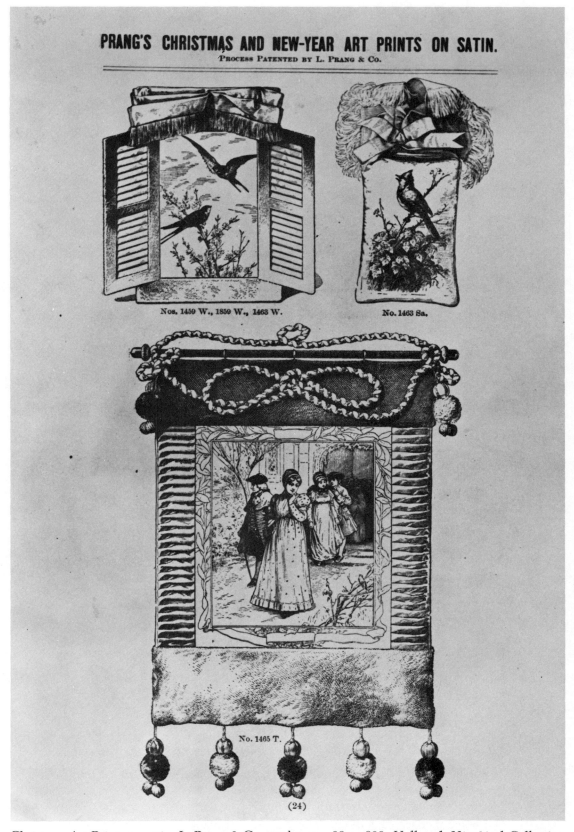

Christmas Art Prints on satin. L. Prang & Co. catalogue, 1887–1888. *Hallmark Historical Collection.*

satin cards were mounted on elaborate mounts of plush in various shapes with fringe and ribbon bows. The following list of different styles of mountings for Christmas and New Year's cards on satin is taken from the catalogue of 1885–1886:

B. Style.—An exquisite padded Satin Mount, in various appropriate colors. Easel back.

C. Style.—A rich Satin mount, in various appropriate colors, in shape of Clover Leaf, with fine silk fringe. Easel back.

G. Style.—A fine gilt beveled-edge mount, with easel back.

H. L. Style.—A Leatherette mount, trimmed with silk cord, silk ribbon, plush or satin corners according to subject. Easel back.

L. Style.—An exquisite padded Crepon Silk or Satin mount, trimmed with silk cord, ribbon and bow. Easel back.

P. Style.—An elegant mount of rich Silk Plush, in various colors. Easel back.

Pa. Style.—Fine mount, in shape of Square Palette, imitation of Bird's-eye Maple, Black Walnut, or Satin-Wood. Easel back.

R. Style.—Fan-shaped mount of rich Silk Plush and Satin, trimmed with Swan's-down, Silk Cord and Tassels. Easel back.

Sa. Style.—Rich Satin Sachet, trimmed with Silk fringe, ribbon and bow, Greeting on Satin ribbon.

Sc. Style.—A novel mount in shape of open Scroll, made of imitation Bird's-eye Maple, Black Walnut, or Satin-wood veneer. Easel back.

T. Style.—A rich Silk Plush and Satin BANNERET. Different colors. Fine brass cross-bar. Cord and tassels for hanging.

X. Style.—An exquisite mount of Pebbled Gold and rich Silk Plush. Easel back.

W. Style.—Heart-shaped mount of Rich Silk Plush or Satin, in different colors, trimmed with Silk Fringe and bow. Silk cord for hanging.

Y. Style.—A rich Silk Plush mount in various colors, with puffed Satin corners in harmonizing or contrasting colors. Easel back.

Z. Style.—A rich Silk Plush mount, two corners embellished with plaited Satin, in harmonizing or contrasting colors. Easel back.

The subjects on these fancy cards included flowers by Mrs. Whitney and Mrs. Fisher and idealized female heads and children with sleds, and landscapes by J. Francis Murphy. There was a unique satin banneret with a design of peacock feathers printed on silk and a poem by Joaquin Miller. This sold for $45. Other prices ranged from $15 to $60. There were also small screens made to fold and set on a table; shuttered windows that opened to reveal a silk landscape on a card; and an Easter card in the form of a plush lyre that held a card on its strings. There were also satin Easter crosses with fringed borders. These held lithographed cards. Others were framed in plush. Cards were also fastened to mountings in the shapes of leaves, flowers, shells, logs of wood, vases, and realistic pansies and chrysanthemums. A card depicting a crying baby was set within a hand-painted apple. Children's heads were also set on cards in the shape of cups, hats, or a snowball.

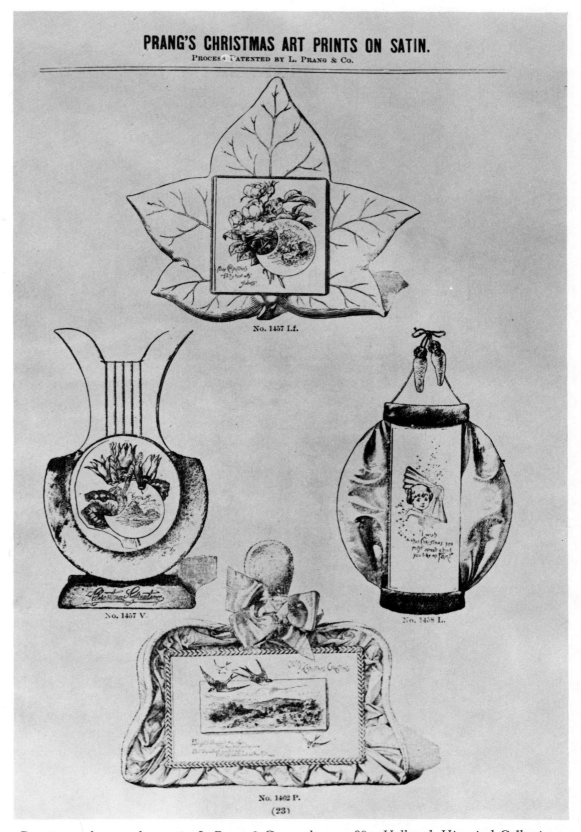

Greeting cards printed on satin. L. Prang & Co. catalogue, 1885. *Hallmark Historical Collection.*

In an 1890–1891 catalogue of L. Prang & Company the art novelties were made into useful gifts. There were chromos of flowers or children's heads placed on little satin bags holding sachets, on matchboxes, photograph cases, blotters, and letter holders, tiny cushions, baskets of flowers with cords to hang them, needle cases, glove and handkerchief cases, bookmarks, and slates. Bookmarks were cut out in the shape of roses, leaves, Japanese lanterns, Yule logs, and mandolins. These were made of satin and had hand-painted decorations. All these articles had cards attached. The cards were usually lithographed on satin and the mounts were of satin, plush, or imitation ivory with hand-painted decorations and trimmed with gold cord or bead ornaments.

These pleated, shirred, and beribboned novelties exhibiting the ultimate in Victorian sentimentalism and bad taste continued in popularity to the end of the century and were an important output of L. Prang & Company in their last years of business. No history of the company is complete without mention of the satin novelties that held satin cards and presented a new means of merchandising them. Undoubtedly these mounts and trimmings were not made by Prang but they were probably assembled at their plant. A search through old Boston newspapers and directories might reveal the name of the maker. Although these novelties are so lacking in taste, they are intimate and eloquent souvenirs of a past era and are thus worth collecting. Many cards have been removed from their fancy mounts and even if the novelties are found intact the silk would be torn and frayed. However, since they were expensive and were originally treasured there must be many still preserved in old trunks or forgotten bureau drawers in attics.

Another popular category for Prang collectors is the Art Book. These books were printed in the 1880s and 1890s under many different names: Art Books, Holiday Booklets, and Prang's Ribbon Booklets. All these books were of similar make-up and included a poem or collection of poems with appropriate monochrome or color illustrations. The more elaborate ones had satin, linen, or vellum covers with a design printed in color or hand painted. They ranged in size and price from the small 4¾″ × 5¾″ to 6¾″ × 5½″ booklets, and sold for 5 cents to 50 cents. These small ribbon booklets of which there were four different series were also sold by the dozen. There were also small Holiday Booklets and hand-colored linen-covered booklets, selling from $4 to $6 a dozen. Larger and more elaborate books sold for $2 to $5 each.

The subject matter of these books covers major holidays—Christmas, New Year's, and Easter. There were also booklets such as *The Haunts of Longfellow* and *The Home of Shakespeare*. Other booklets relating to flowers and nature included *Flower Fancies*. It had twenty-three pages, each page with a flower and a poem. The booklet was compiled by Alice Ward Bailey and illustrated by Lucy J. Bailey, Eleanor E. Morse, Olive E. Whitney, Ellen T. Fisher, Fidelia Bridges, C. Ryan, and F. Schuyler Mathews. Booklets included *The Voice of the Grass*, and there were booklets with scenes of Mount Desert, The Saco Valley, and the

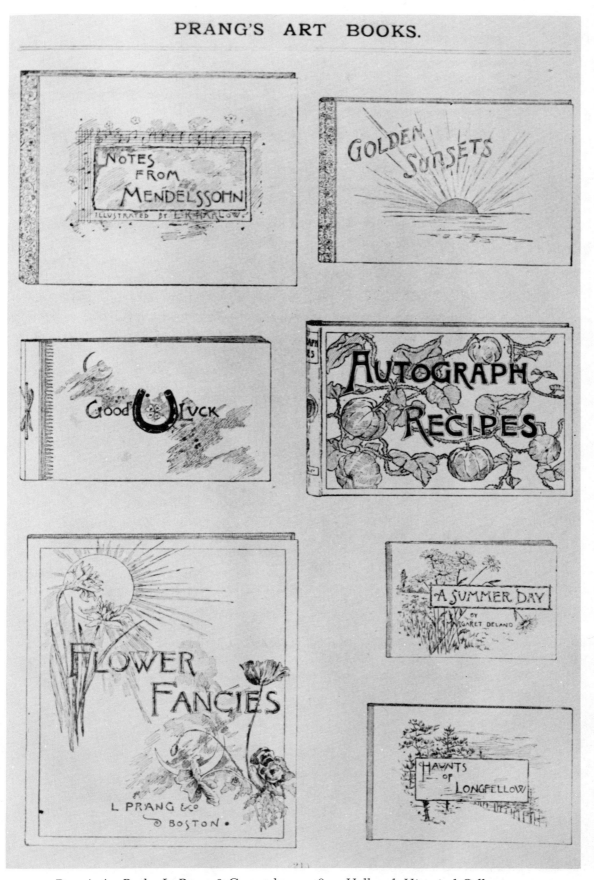

Prang's Art Books. L. Prang & Co. catalogue, 1892. *Hallmark Historical Collection.*

Pemigewasset Valley that were included in a series of "White Mountain Vistas" with illustrations by F. Schuyler Mathews and appropriate verses from the poets. There were also religious booklets including *The Lord Is Risen* and *Jesus, Lover of My Soul*. *A Garland of Songs* had words and designs by Lizbeth B. Comins and music adapted from well-known composers. *Baby's Lullaby Book* was a "sumptuous volume" with mother songs for each month set to original music. It was decorated with watercolors by W. L. Taylor and the surah sateen cover also had special color designs by the artist. This was a unique and artistic booklet and is extremely rare. Another particularly beautiful booklet is *The Golden Flower-Chrysanthemum*, 1890. This booklet included verses by Edith M. Thomas, Richard Henry Stoddard, Alice Ward Bailey, Celia Thaxter, Kate Upson Clark, Louis Carroll, Margaret Deland, Robert Browning, and Oliver Wendell Holmes. F. Schuyler Mathews designed the book, and watercolor illustrations were by James and Sydney Callowhill, Aloïs Lunzer, and F. Schuyler Mathews. This book is 12 × 10 inches and sold for $5 with a deluxe edition at $7.50. Also among the more elaborate books were *The Night Cometh* and *The Day Dawneth*, 1889. These were collections of poems with photogravures, pen vignettes, and a moiré ribbon cover with metal ornaments. *Come, Sunshine Come, Golden Sunsets,* and *Saul* by Robert Browning were other booklets published at this time.

The Wedding Booklet called "Wedding Bells" with verses and illustrations was divided into parts:

> The Wedding Day illustrated by Robert Blum.
> Going to the Church illustrated by Percy Moran.
> Before the Altar illustrated by Rosina Emmet.
> The Wedding Ring illustrated by Dora Wheeler.
> Cutting the Bridal Cake illustrated by Frederick Dielman.
> The Toast illustrated by Rosina Emmet.
> The Rice of Plenty illustrated by Leon Moran.

Sketch for booklet *A Tennis Set,* 1890. *Hallmark Historical Collection.*

Title page of *Flower Fancies,* 1890. *Hallmark Historical Collection.*

The Bridal Tour illustrated by Robert Blum.
The Voyage of Life illustrated by Dora Wheeler.
The Glory of Love illustrated by Walter Shirlaw.

They are recorded in Volume 8 of Prang's Proof Books in the New York Public Library.

The Old Garden by Rose Terry Cooke was published in 1888.

Among the booklets published in 1889 were: *Flower Fancies* by Alice Ward Bailey; *Mayflower Memories of Old Plymouth* with illustrations by Louis K. Harlow; *Notes from Mendelssohn* with illustrations by Louis K. Harlow; *Christ Is Risen* and *Easter Spires* by Annie D. Darling.

A Driftwood Fire by George A. Buffum with illustrations by F. Schuyler Mathews was published in 1890.

Autograph albums included *Mount Desert Autographs, Christmas Autographs, Evangeline Autographs,* and *Autograph Recipes.* The last is a 10 × 7-inch booklet with one hundred leaves including fancy titles, illustrations, humorous verses, and a sateen cover with a decorative design of a tomato vine printed in color. This book is a rare collector's item and if found with hand-written recipes would be even more valuable.

Prang's Holiday Booklets include the following titles:

Baby Dear	*June*
The Bird's Christmas	*Merrie Xmas*
Christmas	*A Merry Christmas*
Christmas Day	*Merry Times*
Christmas Greeting	*"Mew, Mew, Mew—How do you do!"*
Christmas Morning	*The Mistletoe*
Christmas Night in the Quarters	*Music in the Air*
Clouds and Sunshine	*Rose Time*
A Day in Summer	*The Seasons*
A Dream of Winter Changed to Spring	*The Seasons' Greeting*
Floral Booklet	*Star of the East*
From Land and Sea	*The Tempest*
Guiding Stars for Life's Voyagers	*A Visit from St. Nicholas*
Hang up the Baby's Stocking	*What the Bird Said to Bertha*
The Holly	*Winter*
Joy to the World	

PRANG'S RIBBON BOOKLETS, SERIES A. (CATALOGUE 1892-93)

Thy Duty	Hymn to the Nativity	In Excelsis Gloria
A Picture	And there were	Wealth is not
The Violet	Shepherds	Happiness
Katie's Wants	Old Carol	The Star in the East
Star of the East	Something Cheap	Hark, What mean those
The Will of God	The Rest of Faith	Holy Voices?
Evening Hymn	The Old House at	
Prayer and Promise	Home	

RIBBON BOOKLETS, SERIES B

The Present
Hand in Hand
My Creed
Only a Baby
Christmas Morning
Birth of Christ
Nearer, My God, to
 Thee

My Darling's Shoes
O Thou Holy Child
A Child's Thought of
 God
Rest Remaineth
To a Friend
A Farewell and a
 Sonnet

Strive, Wait, and Pray
Christmas Melodies
Thou Son of God
Welcome, Merry
 Christmas
A Visit from
 St. Nicholas

RIBBON BOOKLETS, SERIES C

Home
The Baby
Holly Song
A Fairy Song
Christmas Morning
The Saviour's Birth
To-day

Just as I Am
Song of the Rose
Once in Royal David's
 City
The Mistletoe
Little Dandelion
Oh! To be Ready

The Shepherd Boy
The Christmas Tree
Buttercups and Daisies
That Glorious Song of
 Old
God rest you Merry,
 Gentlemen

RIBBON BOOKLETS, SERIES D

Peace
Rock of Ages
The Mistletoe
Old Christmas
The Blessed Babe
What Child is This?
The Old Arm Chair

The Better Land
Ring out, Wild Bells
The Merry Christmas
 Time
Field Flowers
Christmas Carol
Abide With Me

If We'd Thought
The Voice of Spring
First Christmas Morn
A Little Girl's Letter
Peace on Earth, Good-
 will to Men

Prang issued the following booklets in hand-decorated linen covers and they were listed in the catalogue of 1892–1893.

The Christmas "Menu"et.
Baby's Secret.
The Pussies' Christmas.
Christmas Guests.
Christmas Joys.
A Christmas Duet.
Shakespeare's Beauties.
Santa's Favorites.
Christmas Time.
Song of the Seasons.
Flowers of Fancy.

These were small booklets 4¼ × 5 to 7 × 4½ and were packaged in envelopes.

Small Prang Art Books which sold from five cents to seventy-five cents included the following titles:

A Truly Story of My Dolls. by Elizabeth S. Tucker
A Sea Idyl. Poem by F. Schuyler Mathews.

WHITE MOUNTAIN VISTAS.
A Series in Monochrome by F. Schuyler Mathews.
 The Saco Valley.
 The Crystal Hills.
 The Pemigewasset Valley.

A Christmas Song. by Lizbeth B. Comins.
Percy's Surprize. by Lizbeth B. Comins.
Baby's First Christmas. by Lizbeth B. Comins.
My Christmas Fete. by Lizbeth B. Comins.
A Spring Song. Poem illustrated by F. Schuyler Mathews.
The Robin's Song. Poem illustrated by F. Schuyler Mathews.
The Hermit Thrush. Poem illustrated by F. Schuyler Mathews.
A Summer Day. Poem by Margaret Deland. Illustrated by Louis K. Harlow.
Sunlight and Shadow. Poem by Mrs. Lyman H. Weeks. Illustrated by Louis K. Harlow.
Twilight Fancies. Poem by Mrs. Lyman H. Weeks. Illustrated by Louis K. Harlow.
Midnight Chimes. Poem by Julia C. A. Dorr. Illustrated by Louis K. Harlow.
Voices of Nature. Written and illustrated by Ellen Beauchamp.
Three Little Pussy Cats. Illustrated by Ellen Beauchamp.
Kind Wishes for Each Day. Illustrated by Ellen Beauchamp.
My Light-house and other Poems. by Celia Thaxter.
Sweet Peas. Written by Keats. Illustrated in color with cover design in colors ornamentally treated.
Water Lilies. A fairy song by Mrs. Hemans.
Hymn to the Flowers. Written by Horace Smith. Floral cover design in color and gold.
The Yule Log. Written by Celia Thaxter. Illustrated by Miss L. B. Humphrey. Cover design in color.
Christmas Morn. Poem by M. J. Jaques. Illustrated by Miss L. B. Humphrey.
Christmas-tide. Poem by E. Amie S. Page. Illustrated by Miss L. B. Humphrey.
Winged Winds. Poem by Charles MacKay. Illustrated by Louis K. Harlow.
Jesus, Lover of My Soul. Poem by Rev. Charles Wesley. Illustrated by Louis K. Harlow.
Why? Lizbeth B. Comins.
Mary's Vision. Written and illustrated by Lizbeth B. Comins.
A Christmas Song for the Sorrowing. Lizbeth B. Comins.

A Tennis Set, in picture and verse. Lucie A. Harlow. Illustrated by F. Schuyler Mathews.

Golden Treasures. Gems of Thought. Illustrated by F. Schuyler Mathews.

Wheel of Fortune. Quotations. Illustrated by F. Schuyler Mathews.

The Cup of Happiness. Gleanings. Illustrated by F. Schuyler Mathews.

The Zodiac. Lizbeth B. Humphrey.

Home, Sweet Home. John Howard Payne. Illustrated by Louis K. Harlow with sketches of Payne's home.

A Garland of Songs. Words and design by Lizbeth B. Comins. Music adapted from works of well-known composers. Fifteen full-page monotint illustrations.

Ye Booke of Goode Luck. Ye luck in picture, by Louis K. Harlow. Ye vignettes in obbligato by F. Schuyler Mathews.

HAUNTS OF THE POETS.

A delightful series of booklets illustrated in monochrome and pen drawings by Louis K. Harlow, giving glimpses of places made famous and interesting by intimate association with the lives of the poets and authors represented—their birthplaces, later residences, quiet nooks, and resting places.

Haunts of Longfellow.
Haunts of Emerson.
Haunts of Holmes.
Haunts of Bryant.
Haunts of Whittier.
Haunts of Hawthorne.

The Spirit of the Pine. Esther B. Tiffany. Illustrated by William S. Tiffany.

The Halo, and other selections. Illustrated by Elizabeth B. Gilman.

The Story of Mistress Polly who did not Like to Shell Peas. Told and illustrated by Lizbeth B. Comins.

In 1890 *Child Life, A Souvenir of Lizbeth B. Humphrey* was issued by Prang in memory of this artist who worked for L. Prang & Company for many years. The book included all of Mrs. Humphrey's most popular cards and other paintings such as *The Boston Card* and other Christmas and Easter cards; *Childhood and Old Age* (4 heads); *Children with Garlands; Heads of Children; Children and Flowers; Woman Reading* and *Woman Picking Apples.* This last is a rare and interesting booklet.

These booklets carry on the tradition of the earlier nineteenth century gift books and would be valuable additions to a collection of such books. They are a neglected field of collecting and offer a fascinating and inexpensive category for the beginning collector.

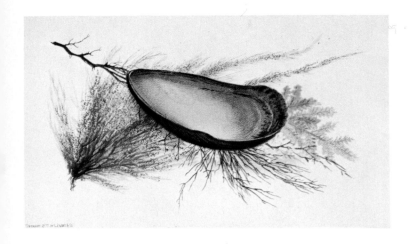

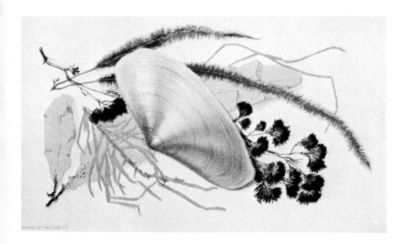

Early album cards: shells and seaweed. *Hall-mark Historical Collection.*

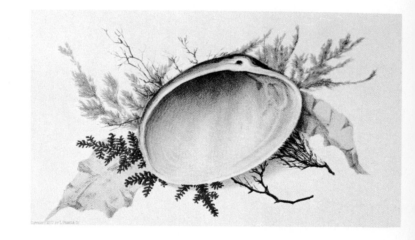

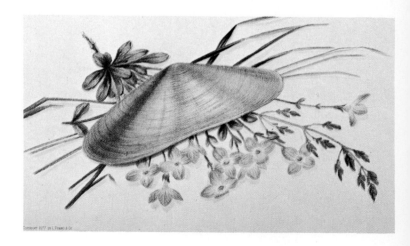

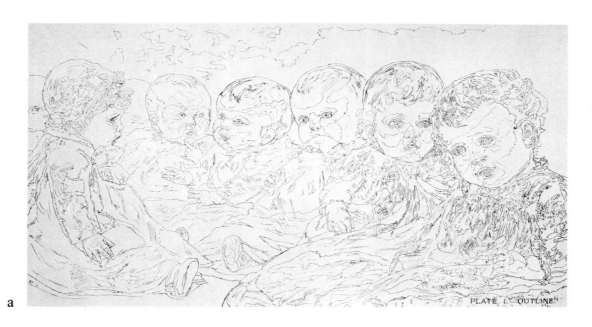

a

Ida Waugh, 18??: (a) plate 1, outline; (b) plate 6, three colors combined; (c) plate 10, five colors combined; (d) plate 22, eleven colors combined; (e) plate 38, nineteen colors combined—finished chromo.

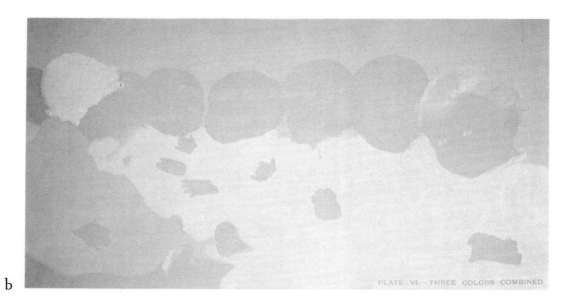

b

c

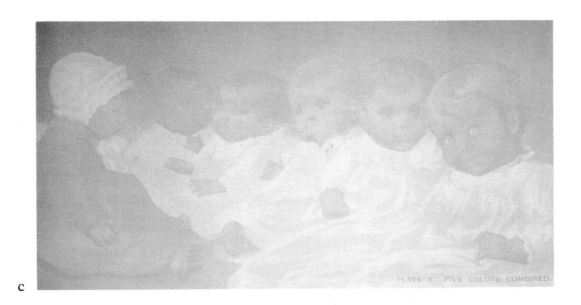

PLATE X. FIVE COLORS COMBINED.

d

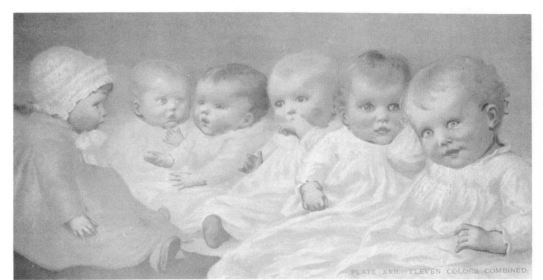

PLATE XXII. ELEVEN COLORS COMBINED.

e

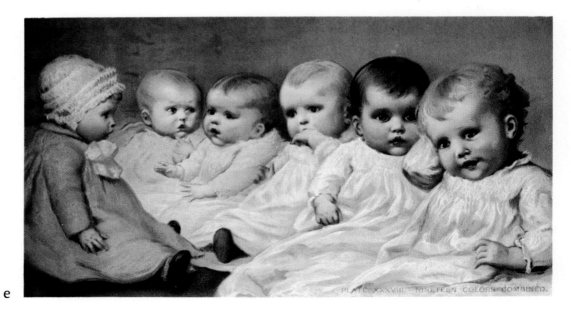

PLATE XXXVIII. NINETEEN COLORS COMBINED.

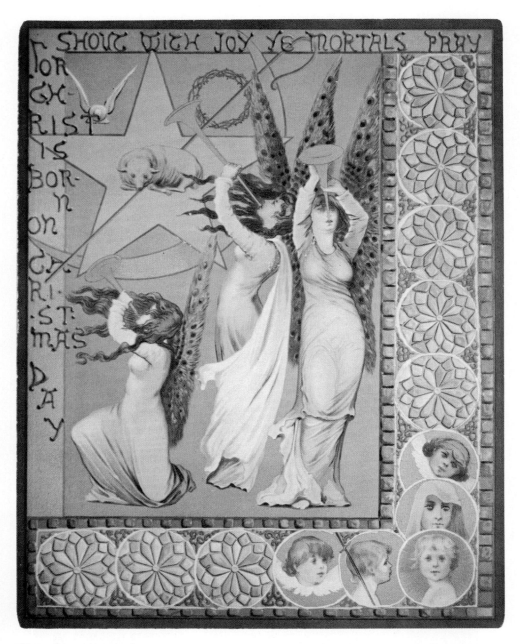

Second prize, second contest, 1881, by Dora Wheeler. *Hallmark Historical Collection.*

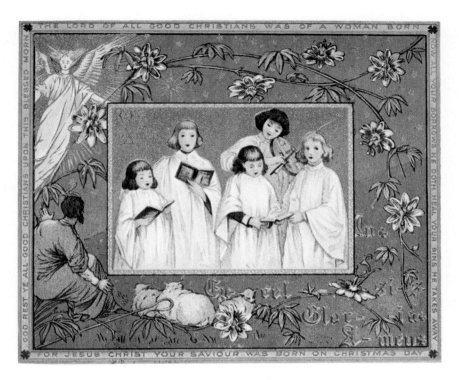

First prize, first contest, 1880. Christmas card by Rosina Emmet. *Hallmark Historical Collection.*

Two thousand dollar prize, third contest, 1882. Designed by Dora Wheeler. *Hallmark Historical Collection.*

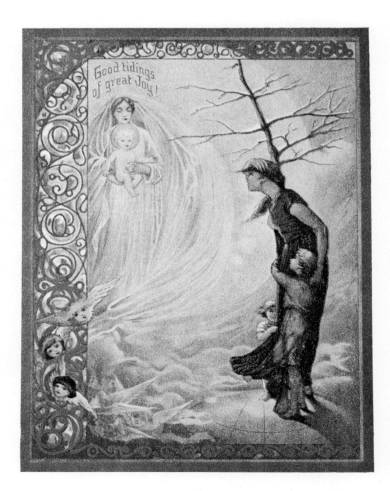

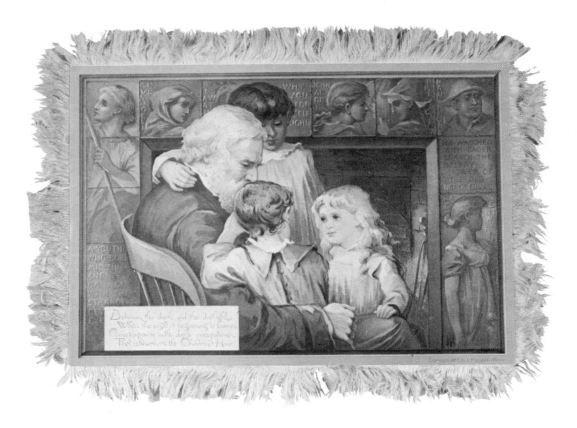

Longfellow's "Children's Hour." L. Prang & Co., 1883. Reverse of card has poem "Christmas Bells." *Hallmark Historical Collection.*

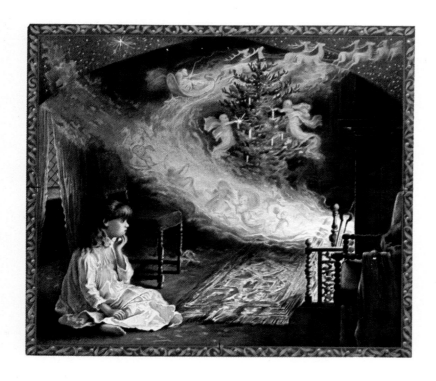

First prize, fourth Christmas card contest, 1885. Designed by C. D. Weldon. *Hallmark Historical Collection.*

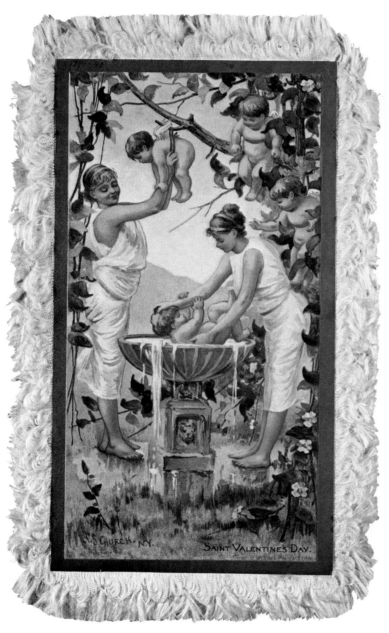

Valentine card, published by L. Prang & Co., from design by F. S. Church, 1885. *Hallmark Historical Collection.*

July 4th cards. L. Prang & Co.

Books and Educational Publications

MR. PRANG, ALTHOUGH INTERESTED IN IMPROVING THE ART TASTE OF THE ADULT public, was especially concerned with developing art appreciation in the young. From the beginning L. Prang & Company put out publications to promote art education in the schools. Indeed, cards for day schools and Sunday schools were among the earliest publications of the company. These consisted of motto cards, rewards of merit, certificates, illuminated scripture texts, and bookmarks and were the usual stock-in-trade of other printers and lithographers at that time. However, Prang also published sets of outline drawings and painting books. The drawings included household and farm utensils, fruit, flowers, trees, houses, animals, and human figures. There were series of drawings of single figures of children and of groups of children and flowers. These outline drawings were put up in small folios, each containing nine pictures. These drawings were similar to Prang's

early rare slate pictures. In 1871 Prang published *The American Painting Book,* which contained several illustrations of color values and intensities by Theodore Kaufmann. Kaufmann was a German American living in Boston and Prang was to publish lithographic portraits of several well-known men after paintings by Kaufmann as well.

Mr. Prang had visited art schools in Europe, especially in Germany, and he saw the value of their systematic study courses. Returning to America he sought to introduce art instruction in the public schools of Massachusetts. To accomplish this, trained teachers were needed. Mr. Prang not only initiated courses of art training but he was also in a position to supply the materials and to publish the books needed. As early as 1873, L. Prang & Company put out the *Art Educational Supply Catalogue.* Prang's materials for drawing in the schools included pencils for drawing, nonpoisonous paints, patent compasses for mechanical drawing, and Prang's School Measure to check drawings. These articles were advertised in his 1873 catalogue.

In 1874 Mr. Prang established an Educational Department within the company and began publication of the Art Education Series by Walter Smith, an Englishman who was the State Director of Art Education in Massachusetts. This series (1874–1876) comprised textbooks and manuals for drawing in public schools, copies for advanced study in outline, crayon, stump and sepia drawing, and examples for the study of historic ornament, plant forms for design and examples for building construction machinery, and so forth. Still other educational works were published to furnish material for the growing needs of art education in the schools. *Plant Forms Ornamentally Treated,* 1874, a booklet by Miss Grace Carter of the South Kensington Art School, London, England, consisted of two parts, each with five color plates. One of the important aids for teaching was the Trades Series published in 1874, consisting of twelve lithographs of trades and occupations called "Aids to Object Teaching." The scenes included:

Trades and Occupations. Carpenter. L. Prang & Co., 1874. *The Library of Congress.*

Trades and Occupations. Shoemaker. L. Prang & Co., 1874. *The Library of Congress.*

Trades and Occupations. Tailor. L. Prang & Co., 1874. *The Library of Congress.*

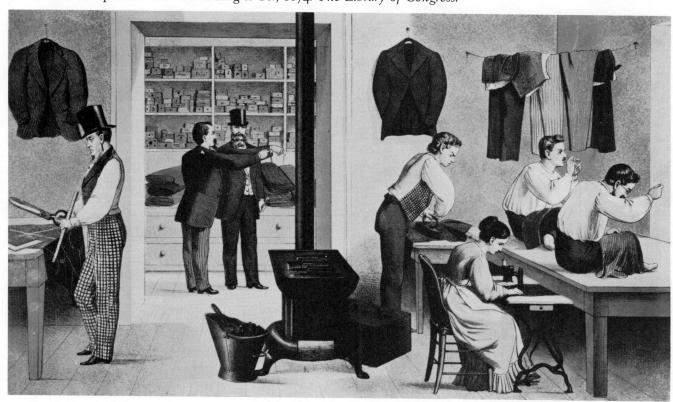

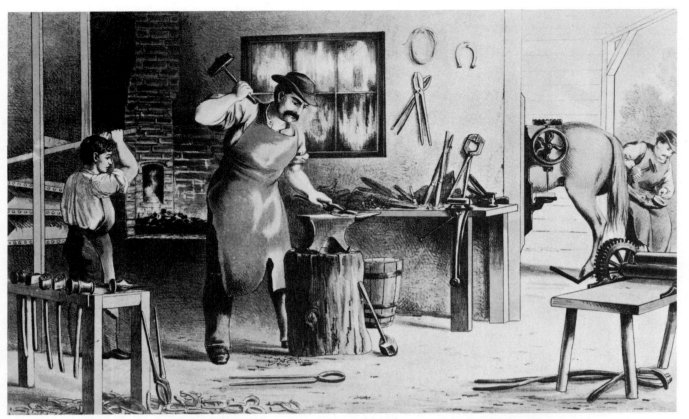

Trades and Occupations. Blacksmith. L. Prang & Co., 1874. *The Library of Congress.*

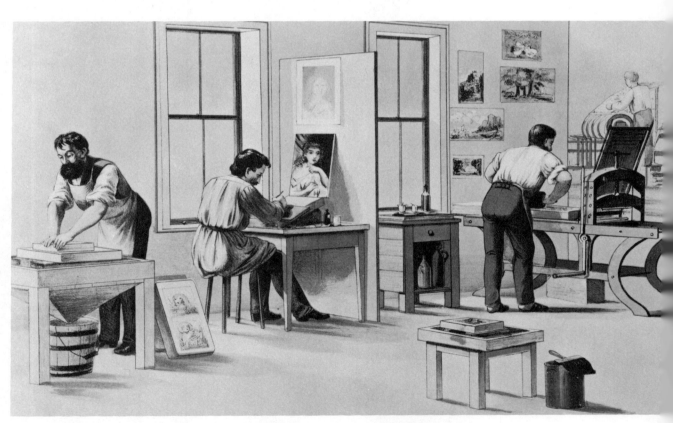

Trades and Occupations. Lithographer. L. Prang & Co., 1874. *The Library of Congress.*

Trades and Occupations. The Kitchen. L. Prang & Co., 1874. *The Library of Congress.*

Trades and Occupations. Gardening. L. Prang & Co., 1874. *The Library of Congress.*

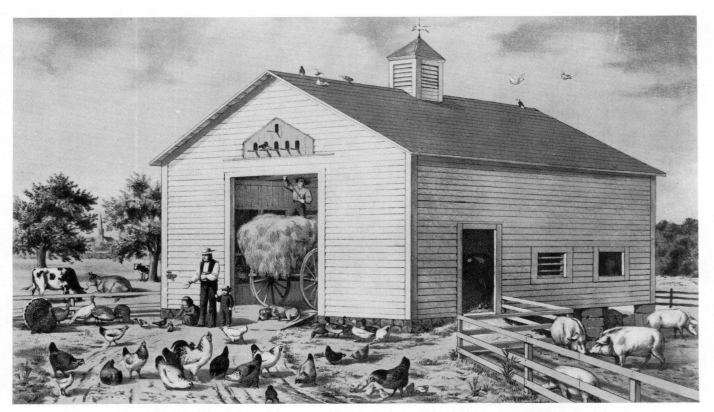

Trades and Occupations. The Farm Yard. L. Prang & Co., 1874. *The Library of Congress.*

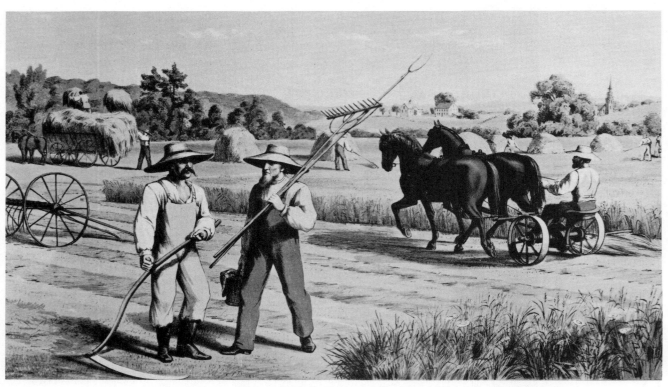

Trades and Occupations. Haymaking. L. Prang & Co., 1874. *The Library of Congress.*

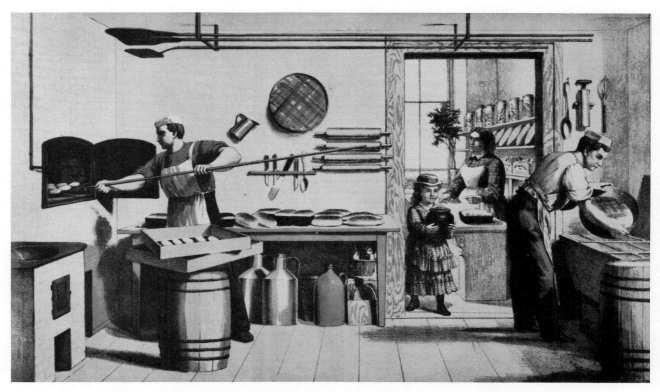

Trades and Occupations. Baker. L. Prang & Co., 1874. *The Henry Ford Museum.*

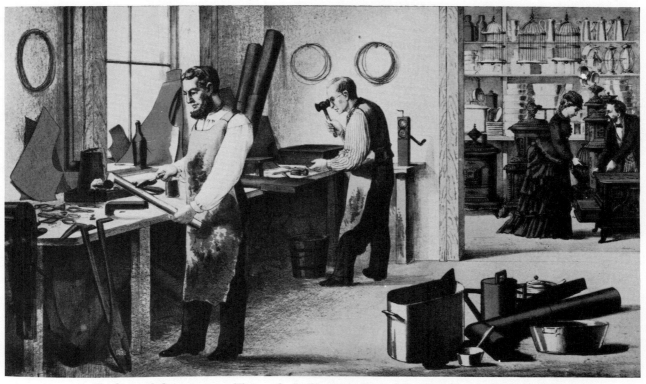

Trades and Occupations. Tinsmith. L. Prang & Co., 1874. *The Henry Ford Museum.*

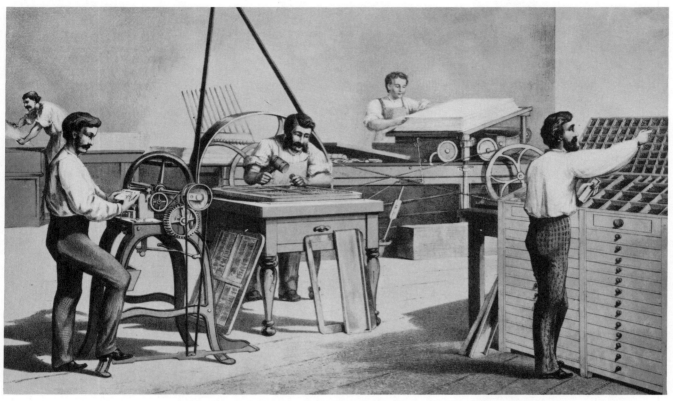

Trades and Occupations. Printer. L. Prang & Co., 1874. *The Library of Congress.*

These lithographs are rare collector's items and few complete series exist. The New-York Historical Society owns a partial set as do The American Antiquarian Society at Worcester, Massachusetts, the Free Library of Philadelphia, and the Library of Congress.

In 1876 *The Theory of Color in Its Relation to Art and Art Industry* by Koehler & Pickering was published and in 1878 *Prang's Standard Alphabet* was published.

In 1882 Prang formed the Prang Educational Company under which he published supplemental texts for Normal Art Classes. Mary Dana Hicks was the director and editor of all publications and for the next fourteen years she and Louis Prang did much to extend the teaching of drawing and allied subjects in the schools. This involvement in art education was to have more lasting value than any of Mr. Prang's other activities. In 1882 the Prang Educational Company published the *Illustrated Catalogue and Price List of Artists' Materials,* which included:

A. Materials for oil painting, brushes, paints, canvas, stools, etc. B. Materials for water colors, Prang moist water color sets, etc. C. Material for China Painting. fixtures, kilns, etc. D. Drawing papers. E. Artists' statuary and models, colored

Illuminated alphabet. Plate from "Prang's Standard Alphabet" listed in *Prang's Chromo,* 1868.

chalks, stationery, pencils, erasers, etc. F. Materials for lustre painting, chrome photography, retouching photographic, colors for tapestry and hand block printing; Etchers and engravers Materials; Lithographic crayons; Materials for wax paper flowers; Artists' tools, wood blocks, etc.; Articles for decorating; China Painting and plaques; Art books and art instruction aids; Materials and Decorators and Designers; Drawing instruments, T-Squares and triangles.

Mrs. Hicks wrote many books on teaching the industrial arts and her manuals, published by L. Prang & Company, were widely used. These manuals included books of drawing, instruction for teachers, home study, and correspondence courses. The instruction included form study, color, clay, paper folding, and drawing. These studies were arranged in cooperation with Pratt Institute of Brooklyn, New York. There were also books of art instruction for primary, intermediate or secondary, and grammar schools. *A Teacher's Manual for the Prang Course in Drawing* (book 1–6) was written by J. S. Clark, Mary Dana Hicks, and Walter S. Perry in 1890. The *Teacher's Manual for Prang's Complete Course in Form Study* by Clark, Hicks, and Perry was published in 1890–1891. Other art books published by L. Prang & Company included *Color Schemes for the Kindergarten* by Ross Turner; *Paper Folding and Cutting* (1892) by Kath-

erine M. Ball; *How to Enjoy Pictures* by M. S. Emery. A course in design with colored papers illustrating historic design was put together by George Sensery. *Art Instruction in the Primary School* by Mrs. M. D. Hicks was first published in 1890. In 1894 Prang published *Lessons in Pencil Drawing from Nature* followed by *First Lessons in Landscape Drawings,* both by W. N. Bartholomew. Other art instruction books published by L. Prang & Company included *Prang's Progressive Studies in Water-color Painting* (1890) by Will S. Robinson, *Studies in Composition and Color* by Louis K. Harlow, and *Augsburg's Drawing Book II* (1902) by D. R. Augsburg. The *Textbook of Art Education* by Froehlich & Snow was published in 1904.

L. Prang & Company carried a line of watercolors especially manufactured in Germany. Nonpoisonous colors for children were put up in decorated tin boxes under the names of Prang's Palette Colors and Prang's Eagle Colors. Prang crayons and other educational materials are still being manufactured by the American Crayon Company of Sandusky, Ohio.

Numerous painting books for children were published by L. Prang & Company. *Little Dot's Painting Book* was advertised in *Youth's Companion,* October 1894. The book was filled with pictures printed in color and duplicated in outline. A hinged metal box of Prang's nonpoisonous watercolors and a brush were included in the package, all for twenty-five cents. In the same year *Prang's Studies for Water and Oil Colors* was given as a premium to new subscribers to *Youth's Companion.* The book included illustrations of flowers—including asters, snowberries, violets, clematis, chrysanthemums, calla lilies, pansies, snowballs, pinks, daisies, peach blossoms, and Duchesse de Vallambrosa Roses.

Between 1893 and 1897 an important artistic journal called *Modern Art* was edited by J. M. Bowles and published by L. Prang & Company. This magazine was printed on fine art paper and had initial letters and other decorations by Annie C. Nowell, one of Prang's artists. Among the articles on art was "Mr. Prang's New Theory" by Katherine M. Ball which explained Mr. Prang's color theory. The magazine sponsored prizes for bookplates and posters and a copy of Arthur W. Dow's prize poster, now a collector's item, was given to new subscribers in 1895. The poster was a sunset scene on the Ipswich River in New England. The colors were delicate yellows and pinks and there was a border of green with a lotus decoration in a darker shade of green. Later the poster was put out in black and white. It was also illustrated in Scribner's book *Modern Posters,* 1895.

The magazine also included articles by Prang who regularly contributed such pieces to periodicals in the field. [Copies of this magazine are in the Rare Book Division of The New York Public Library.] In 1899 *Art Instruction in Primary Schools* included notes on paper folding by Arthur W. Dow who was later to become the head of the Art Department of Teacher's College, Columbia University.

These early art, educational, and painting books have collector's interest.

Frontispiece, by Louis Rhead *Modern Art,* Autumn 1895. L. Prang & Co. *Rare Book Division, The New York Public Library.*

L. PRANG & COMPANY

286 Roxbury Street - - - - Boston, Mass.

ART IN THE HOUSE
By Dr. J. von Falke. Edited with Notes by Charles C. Perkins

1 volume, large quarto, 384 pages, superbly illustrated with 60 full-page plates and nearly 170 illustrations in the text. Cloth, $7.50.
"A volume of royal beauty."—Boston Journal.
"Many things combine to give the book an extraordinary interest and importance.*** The publishers have spared neither pains nor money to increase the beauty and usefulness of the book."—Philadelphia Inquirer.

MUSHROOMS OF AMERICA, EDIBLE AND POISONOUS
By Julius A. Palmer, Jr.

In the above work the illustrations of the most common edible mushrooms, with their descriptions and the best manner of preparing them for the table, are printed, as well as the illustrations of those dangerous and suspicious varieties which are most likely to be confounded with the mushrooms given as edible.
The work is published in the following forms:
In two large charts containing 12 colored illustrations 8 edible and 4 poisonous of 28 species of the most common mushrooms, with full descriptions how to distinguish, and how to prepare them for the table; ready to hang on the wall. Price, $2.00.
The same, in 12 plates illustrations and 4 plates text, in strong and convenient portfolio. Price, $2.00.
The same, bound in boards. Price, $2.00.

ORCHIDS
By Alois Lunzer.

The selection of specimens has been very carefully made. The paintings are botanically correct, and the lithographic reproduction is faithful to the originals.
Two parts, each containing four plates, size 10x12 inches. Price, per part of four plates, $1.50.

Ad of L. Prang & Co. *Modern Art*, 1895. *Rare Book Division, The New York Public Library.*

The most valuable is the rare Trade Series. Also of particular interest are the early slate pictures and outline pictures for copying, the series, American Text Books of Art Education, by Walter Smith, 1875, and the series, Historical Ornament, by William R. Ware and Karl F. Heinzen, 1879. These books included ten plates of historical ornament. The price was $15 for the set or single plates could be purchased for $2 each. These plates give details of the historical styles and are still valuable references.

There were also books published for use by artists, craftsmen, and architects. These included books with patterns of ancient medieval and modern alphabets for use by painters, engravers, marble workers, and other tradesmen. Prang also published tables of alphabets in different styles of elegant lettering. There were two plates 11 × 14 inches printed in black with one tint. In the catalogue of 1883–1884 Prang's series, Standard Alphabets, was enlarged to forty-two plates, fourteen in color. Prang also published a series, Designs for Monuments and Headstones, of plates by R. E. Launitz and a book of monument design in six parts "invaluable to the marble worker, sculptor and architect." These monument books were early publications and were listed in the earliest catalogues.

Mr. Prang kept in touch with the practical art books that were being published in Europe and obtained the rights to reissue many of them in the United States. In 1879 L. Prang & Company published an American edition of *Architecture, Sculpture and Industrial Arts* by S. R. Koehler. *Notes on Egyptian and Greek Art* by John Spenser Clark was published in 1899. A textbook of history of art by S. R. Koehler was translated from the German and published by Prang. It contained over two thousand black and-white woodcuts. *How to Enjoy Pictures* by M. S. Emery was published in 1898.

L. Prang & Company published many books on flowers and natural history. In 1878–1880, there was *Native Flowers and Ferns of the United States* by the well-known botanist Thomas Meehan. This consisted of four volumes illustrated

Title Page, *The Native Flowers and Ferns of the United States,* by Thomas Meehan. L. Prang & Co., 1878. *Photograph Courtesy Roy Blakey. Collection of author.*

THE

NATIVE FLOWERS AND FERNS

OF THE UNITED STATES

IN THEIR BOTANICAL, HORTICULTURAL, AND POPULAR ASPECTS.

BY

THOMAS MEEHAN,

PROFESSOR OF VEGETABLE PHYSIOLOGY TO THE PENNSYLVANIA STATE BOARD OF AGRICULTURE, EDITOR OF THE GARDENERS' MONTHLY, ETC., ETC.

VOLUME I.

ILLUSTRATED BY CHROMOLITHOGRAPHS.

BOSTON: L. PRANG AND COMPANY.

Plate, Iris Versicolor, from *The Native Flowers and Ferns of the United States.*
Collection of author.

with colored lithographs by L. Prang & Company after paintings by Aloïs Lunzer. The book was published in two series of two volumes each and each volume contained forty-eight chromolithographs. The first series of two volumes was published by L. Prang & Company in 1878 and the second series of two volumes was published by Chas. Robson & Company in 1880. The lithographs in these volumes are of excellent color and composition and suitable for framing. However, the books themselves are also a collector's item for anyone interested in American botanical books, a field largely neglected by collectors.

Prang's Natural History Series for Children by Norman Calkins and Mrs. A. M. Dias was published in the early 1870s. The books were octavo size in colored wrappers. There were six volumes in the series—four on birds including swimming birds, scratching birds, wading birds, birds of prey, and gallinaceous birds and pigeons; two on quadrupeds included the cat family, weasel, squirrel, hollow-horned ruminants, and solid and hornless ruminants. Also included were the classification of plants. These books are illustrated with excellent quality color plates. A manual to accompany *Prang's Natural History Series* was published in 1873. In 1885 Selmar Hess published *Our Living World* which included a series of natural history prints and sixteen colored lithographs by L. Prang & Company showing birds in their native habitats. Each chromo is 5 × 8 inches, matted and ready for framing. The subjects of the prints include: *Paradise Flycatchers; Titmice; Resplendent Trogon; Dipper, Wagtails, and Wrens; Partridge; Woodcock; Mallard Duck; Lammergeyer; Black and White Kingfisher; Weaver birds;* and *Group of Finches*. These are all of fine design and the colors are precisely registered.

There are twelve chromolithographs by Prang in *Mushrooms of America* by Julius Palmer, Jr., which was published in 1885. These lithographs are in low-key colors—yellows, oranges, browns, and dull yellow greens, and the mushrooms are arranged in attractive patterns that make the plates suitable for framing. Prang also published a small book with color lithographs of orchids after paintings by Aloïs Lunzer. The book was in two parts with four 10 × 12-inch plates in each part.

The Tourmaline by A. C. Hamlin, M.D., which illustrated his collection of gems, contained four color lithographs by L. Prang & Company. The book was published by James R. Osgood in 1873. In 1890 *Gems and Precious Stones* by George F. Kunz, the well-known Tiffany & Company authority on gems, was published by the Scientific Publishing Company. It contained eight color lithographs by L. Prang & Company based on original designs by artists from Tiffany & Company.

Art in the House by Jacob von Falke was published by Prang in 1879. This is an important book on house decoration as it was practiced in America in the late nineteenth century. In the 1890s Prang published the *Classification of Clouds* for the United States Navy's Department of Navigation. Also, in the 1890s, *Pearls and Gem Cleavage Lines* was published by the Scientific Publish-

Scratching birds. Sheets of illustrations from Prang's Natural History Series. *The Harry T. Peters "America on Stone" Lithography Collection, Smithsonian Institution.*

ing Company. Undoubtedly further research would turn up many more books with lithographic illustrations by L. Prang & Company.

In 1898, at the age of seventy-four and after years of study on color classifications, Prang published the *Prang Standard of Color* and coauthored with Mary Dana Hicks and J. S. Clark *Suggestions for Color Instruction.* These books gave a practical guide to color harmonies and had a lasting influence on the teaching of theory in schools.

The greatest test of Prang's skill as a lithographer was the monumental book *Oriental Ceramic Art,* which illustrated W. T. Walter's great collection of Oriental porcelains. The book was published in ten large volumes and included 116 color lithographs and 437 black-and-white illustrations. Three artists, including James Callowhill, worked for seven years producing paintings of the porcelains from which the color lithographs were made. Each plate required from twenty to forty-four separate stones. An excerpt from the introduction to this work is of interest: "The plates in color with which this work is illustrated were made by Louis Prang, of Boston. The work of every European house of importance was examined before Mr. Prang was asked to make lithographs of three pieces of porcelain of different colors—his immediate success determined the question, and when two years later some twenty of the plates were shown to French lithographers in Paris, their criticism was that the impressions had been fortified by color from the brush; they could not believe that work of such excellence could be produced by simple lithography. This very satisfactory opinion has been since confirmed by many lithographers, and it is conceded that these plates represent the highest type of work that has been produced in that branch of art." The text was by Dr. S. W. Bushnell, a world authority on Oriental art. The books were published by D. Appleton & Company of New York in 1897 in a limited Atlas Folio edition of five hundred copies priced at $500 for each set of ten volumes. Today the books are worth thousands of dollars. Complete sets are in the Walters Art Gallery, Baltimore, Maryland; the Free Library of Philadelphia; and the New York Public Library. A few individual lithographs are available and are collector's items.

Frontispiece of *Oriental Ceramic Art. Hallmark Historical Collection.*

Chinese Dragon Vase from *Oriental Ceramic Art*. L. Prang & Co., 1897. *Hallmark Historical Collection.*

Civil War Maps and Pictures, Landscape and Sport Series

PRINTING CIVIL WAR MAPS, BEGINNING WITH ONE OF FORT SUMTER IN 1860, gave Mr. Prang the attention that he needed to get his business started. This Fort Sumter map was followed by other maps and plans of all the battles of the war. The maps were printed in black and white with the location of the particular battle overprinted in red. Prang provided red and blue crayons so that the purchaser could draw in other details of the battle. The maps in the collection of the Library of The Boston Athenaeum include the following:

Beaufort Harbor and coast line between Charleston, South Carolina, and Savannah, Georgia, with a five mile distance line in circles around Beaufort and railroad connections, roads, etc., etc. 22.5 x 29.7 cm. Boston 1861.

Map of the battle ground near Richmond showing plainly every point of

ANDREW JACKSON.
"The union must & shall be preserved"

MAPS OF THE EASTERN, MIDDLE AND SOUTHERN STATES;
FORTS SUMTER, PICKENS, MONROE AND MCHENRY.
PLANS OF WASHINGTON, ITS VICINITY, AND BALTIMORE.
PORTRAITS OF JACKSON, LINCOLN AND ANDERSON.
ROUTES, DISTANCES, &C.

ABRAHAM LINCOLN.

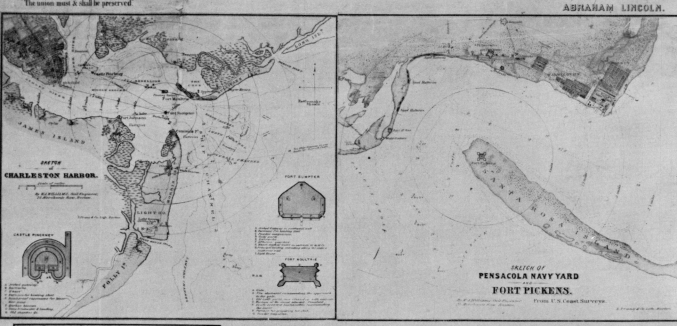

SKETCH of
CHARLESTON HARBOR.

CASTLE PINCKNEY

FORT SUMTER

FORT MOULTRIE

SKETCH OF
PENSACOLA NAVY YARD
and
FORT PICKENS.
From U.S. Coast Surveys.

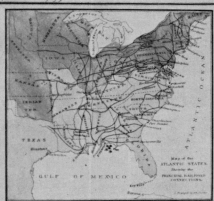

Map of the
ATLANTIC STATES
showing the
PRINCIPAL RAILROAD
CONNECTIONS.

MAJOR ANDERSON.
THE HERO OF SUMTER.

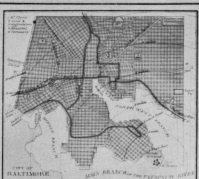

CITY OF
BALTIMORE
MAIN BRANCH of the PATAPSCO RIVER

ROUTES AND DISTANCES.

Distance from Boston to Washington, by Rail-
Road, through Baltimore,..........459 Miles
By Railroad from Boston, to Havre de Grace, Md., 385 "
From thence by Steamboat down Chesapeake Bay
to Annapolis, 60 Miles; from there to Wash-
ington, by Railroad, 38 Miles, making the en-
tire distance from Boston to Washington,........483 Miles
Distance from Boston to Fort Munroe, Va., by
Water,..........575 "
Distance from New York to Charleston, by Water,. 650 "
" " " " Savannah " 750 "
" " " " Fort Pickens " 1700 "
" " " " Mobile " 1775 "
" " " " New Orleans " 2000 "
Distance from Boston to Cincinnati, Ohio, by
Railroad, via N. Y. and Penn. & Ohio R. R.,...994 "
" " " " St. Louis,...1636 "
" " " " New Orleans...1526 "
Dist. from Washington, by Railroad, to Richmond, Va., 130 Mls
" " " " Petersburg, Va.. 152 "
" " " " Weldon. N. C., .216 "
" " " " Wilmington,..479 "
" " " " Augusta, Ga., .667 "
" " " " Monte'ry, Ala. .1013 "
" " " " Wheeling, Va.. .390 "
" " " " Harper's Ferry, .93 "

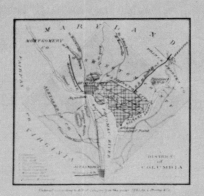

DISTRICT
of
COLUMBIA

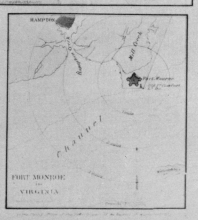

FORT MONROE
in
VIRGINIA

Published & Lith'd by L. PRANG & CO. 34 Merchants Row, Boston.
Sole Agent, J. HAVEN, 31 Exchange St.

Map of Forts Sumter, Pickens, Monroe and McHenry. Published by L. Prang & Co.,
1862. *Hallmark Historical Collection.*

interest of the late and present position of the Union Army. 48. x 63.7 cm. Boston 1862.

Model War map giving the southern and middle states with all their water and railroad connections compiled from the best authorities and the latest surveys. 63 x 100.5 cm. Boston 1862. (Variant of above map 66 x 95.5 cm.)

Army map of Georgia. 84 x 55 cm. Boston 1864.

War Telegram Map (of Virginia territory). 85 x 57.3 cm. Boston 1862.

Naval Expedition Map, containing eight different maps; illustrated by the flags of all maritime nations.

1.	The Four quarters of the globe	12.3 x 18.3 cm.
2.	Mississippi River from St. Louis to Memphis	29 x 8.3 cm.
3.	The lower Mississippi	16.2 x 15.6 cm.
4.	Cairo and vicinity	12.2 x 9.2 cm.
5.	Fort Pickens and Pensacola	16.3 x 9.1 cm.
6.	N. Carolina coast line	16.4 x 18.3 cm.
7.	Port Royal, Charleston and Savannah	17.1 x 15.5 cm.
8.	Mobile Harbor	13.6 x 6.9 cm.

Army map of Georgia. 84 x 55 cm. Boston 1864.

There was also a map of Washington, D.C., and Bull Run, 1861; a map of Fortress Monroe showing forts, towns, railroads, and rivers (23 × 15, three maps on sheet) and a map of Boston 1861. Many other maps were published. The maps were drawn under the direction of W. A. Williams, Civil Engineer.

Prang followed the maps by portraits of Civil War generals. There were seventy-two portraits of prominent men and generals "who served under the Union Flag during the Great Rebellion." The portraits were arranged alphabetically and divided into three parts and were "executed in superior line engraving and made up in extension book form with hard stamped covers." The price was thirty cents for each part of twenty-four portraits. An album of twenty-four small humorous sketches of the War called *Life in Camp* by Winslow Homer was put up in similar style. The scenes were small album size pictures 4¼ × 2⅜ inches. The subjects included:

"Fording."	"Late for Roll Call."
"The Field Barber."	"Hard Tack."
"Building Castles."	"Riding on a Rail."
"Water Call."	"Tossing in a Blanket."
"An Unwelcome Visit."	"Home on a Furlough."
"In the Trenches."	"The Girl He Left Behind Him."
"Good Bye."	"Drummer."
"The Rifle Pit."	"Surgeon's Call."
"A Deserter."	"Our Special" (which spoofs the artist
"Teamster."	himself showing him wearing a
"The Guard House."	goatee as well as a mustache).
"The Shell is Coming."	

FORDING.

THE GUARD HOUSE.

LATE FOR ROLL CALL.

A SHELL IS COMING.

WATER CALL.

STUCK IN THE MUD.

UPSET HIS COFFEE.

AN UNWELCOME VISIT.

"Life in Camp." Civil War sketches in color by Winslow Homer (4¼ × 2⅜ inches),
published by L. Prang & Co., 1864. *Hallmark Historical Collection.*

Homer himself drew at least one of the stones, for a letter from Homer to Mr. Prang written December 1863 states: "The stone was received all right. I shall commence it very soon, probably send it to you week from Wednesday." These humorous scenes were in color and were made up in a military album aimed to please the war veteran.

A larger and more important set of Winslow Homer Civil War scenes called *Campaign Sketches* was also put out in 1863. In *Prang's Chromo*, January 1868, these were listed and described as follows:

> Campaign Sketches.—Designed and drawn on stone by Winslow Homer. A series of spirited Camp scenes sketched on the spot by Mr. Homer and executed in high artistic style in crayon. These sketches are sold in sets of 6 copies put up in a neat cover. They represent,—
> 1. The Letter for Home.
> 2. Foraging.
> 3. Our Jolly Cook.
> 4. The Coffee Call.
> 5. A Pastime.
> 6. The Baggage Train.

Size of scenes 11 x 14 inches. Price per set, $1.50.

"Campagne [sic] Sketches." Civil War sketches by Winslow Homer, published by L. Prang & Company, 1863. *Prints Division, The New York Public Library.*

(a) Title page.

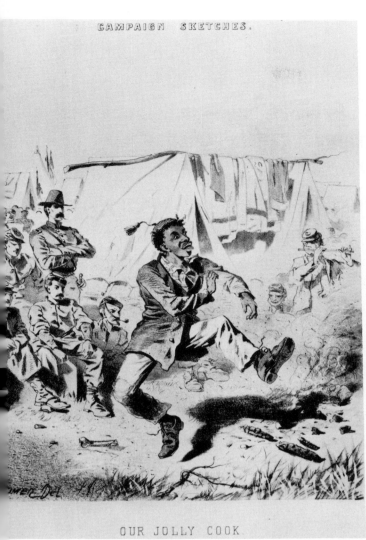

OUR JOLLY COOK.

(b) Our Jolly Cook.

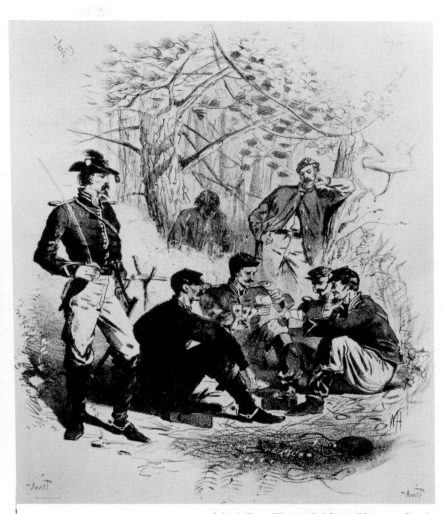

(c) A Pass Time, Soldiers Playing Cards.

(d) The Letter Home.

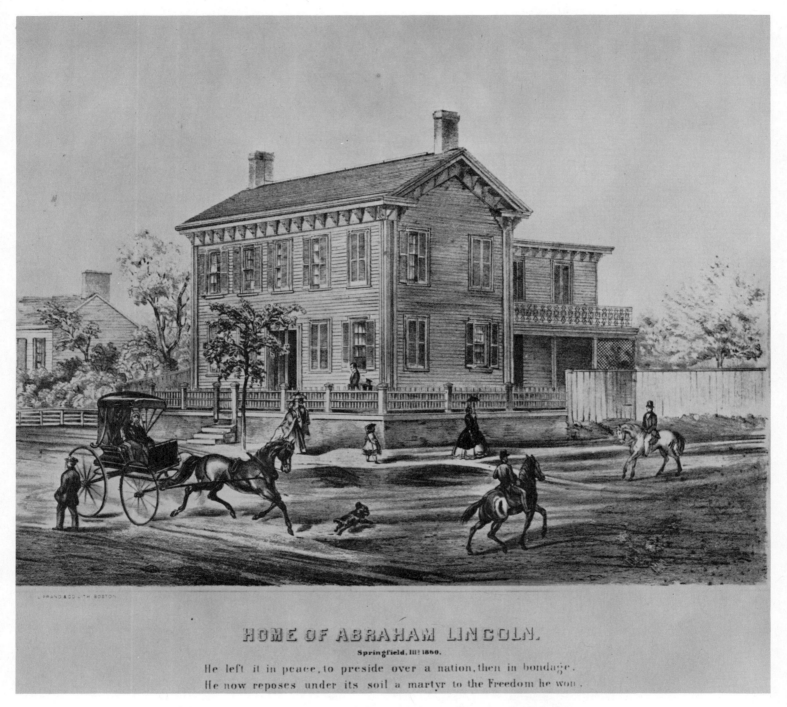

Home of Abraham Lincoln. Tinted lithographs published by L. Prang & Co., 1865.
Collections of Greenfield Village and the Henry Ford Museum.

This series is rare. When a set came up for auction a few years ago it sold for $485 and would be even more valuable today.

An early lithograph shows the home of Abraham Lincoln in Springfield, Illinois, as it looked in 1860.

There were several pieces of sheet music relating to the Civil War. The battle of Fort Donelson was celebrated in sheet music published by L. Prang & Company in 1862. There was also a music cover of Major General Halleck's Grand March published by L. Prang & Company. This depicted Halleck and an aide on horseback. Another early Civil War publication was a painting by Theodore Kaufmann of *Admiral Farragut in the Shrouds of his Vessel at the Battle of Mobile.* This was listed in the catalogue of 1871. The original painting was sold in the Prang Peremptory Sale at the Art Rooms, 817 Broadway, New York, December 7 and 8, 1875.

In the 1880s Prang published an important series of eighteen pictures depicting episodes of the Civil War. The Naval Battles were after paintings by Julian O. Davidson, the well-known marine painter. His paintings included *The Capture of New Orleans; The Encounter between the Monitor and the Merrimac; The Battle of Mobile Bay; The Fight between the Kearsarge and the Alabama; The Capture of Fort Fisher;* and *The Battle of Port Hudson.* The land battles of the war were painted by Thure de Thulstrup, a Swedish painter who came to America in 1873 and received his art training at the Art Student's League

The Encounter between the Monitor and the Merrimack. Chromo from painting by Julian O. Davidson. Published by L. Prang & Co. *Hallmark Historical Collection.*

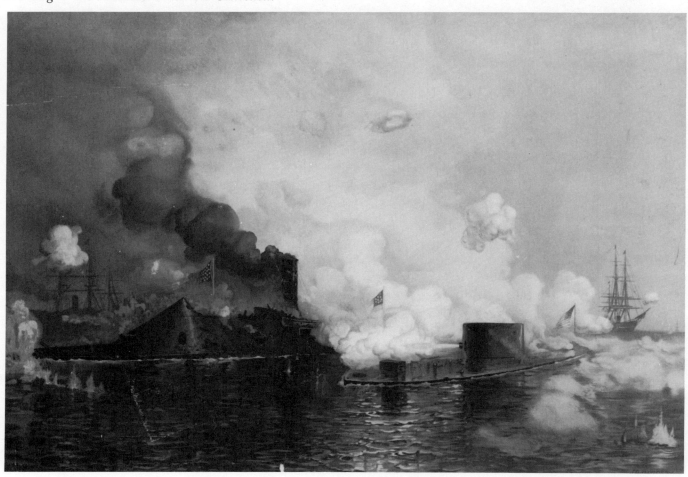

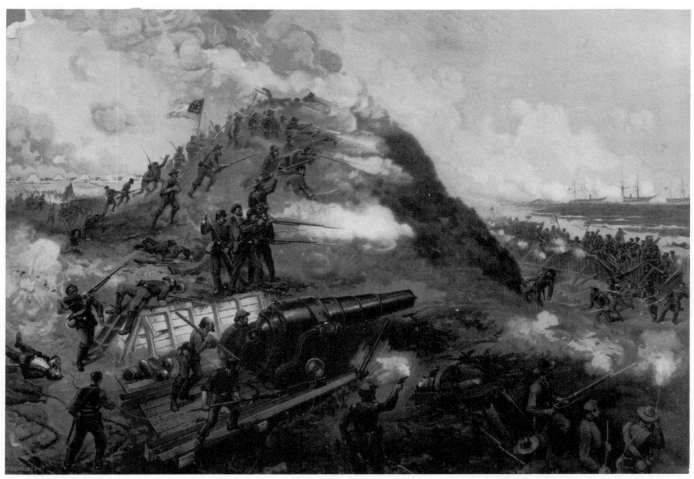

Capture of Fort Fisher. Chromo after painting by Julian O. Davidson. Published by L. Prang & Co. *Hallmark Historical Collection*.

in New York. He worked on the New York *Daily Graphic,* on Frank Leslie's publications, and for Harper & Brothers. His Civil War pictures that were made into chromos by Prang included *Sheridan's Final Charge at Winchester; Battle of Chattanooga; Sheridan's Ride; Battle of Fredericksburg; Battle of Gettysburg; Battle of Kenesaw Mountain; Battle of Alatoona Pass; Battle of Antietam; Battle of Spottsylvania; Battle of Shiloh; Siege of Atlanta,* and *Siege of Vicksburg*. A small booklet with the story of each battle was printed to accompany each picture. The pictures are not listed in the regular Prang catalogue but a special bound book was issued to announce their publication. The pictures were packaged in an easel portfolio with a maroon plush frame and had lining papers with a tan and black print of soldiers, guns, cannons, and other paraphernalia of war.

In the list of prices that Prang paid for the paintings is the notation, "Civil War. de Thulstrup—$250, $457.75, $400. Shiloh. Jo Davidson—$300–$375, Battle of N. Orleans; Mobile; Port Hudson."

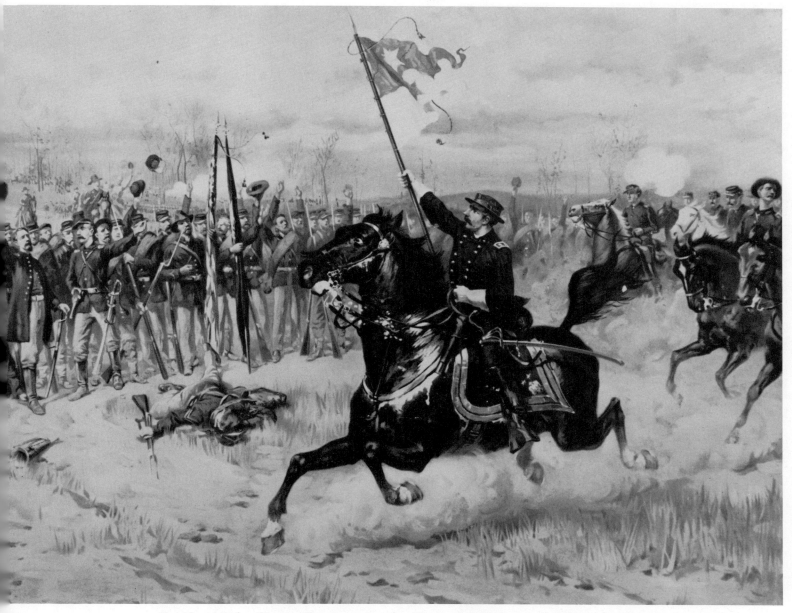

Sheridan's Ride. Chromo from painting by Thure de Thulstrup. Published by L. Prang & Co., 1885. *Hallmark Historical Collection.*

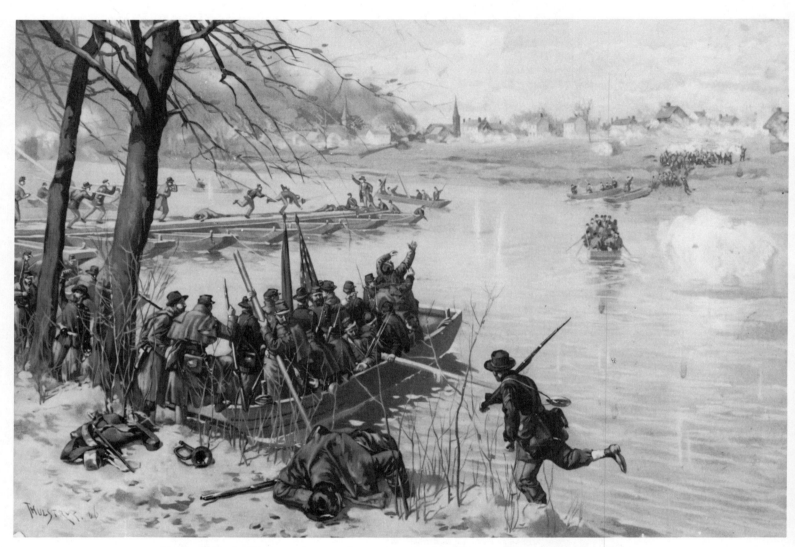

Battle of Fredericksburg. Laying the pontoon bridge. Chromo from painting by Thure de Thulstrup. Published by L. Prang & Co., 1886. *Hallmark Historical Collection.*

The Civil War lithographs were in Prang's exhibit at the World's Columbian Exposition in Chicago in 1893. Prang received many letters praising them and among the letters was one from Secretary of the Navy, David Porter. Five of the Civil War lithographs were later included in B. J. Lossing's book *History of the Civil War* published in 1912.

These Prang Civil War lithographs are some of the most interesting pictures of the Civil War. They have been neglected for so many years that there are not a great number in circulation and these are not usually found in good condition. It is not known how many of the chromos were printed but there must have been many thousands. Today they are ranked high with collectors of Civil War memorabilia.

In the 1860s de Thulstrup painted a portrait of General Grant for Prang. This was listed in *Prang's Chromo*, January 1868, and the original painting was in the Prang sale of 1892. The General wears his field hat and is "sporting his inevitable cigar." The print was put out in two sizes: 14 × 19 inches, in color, for fifty cents; and 14 × 19 inches, in plain crayon, for twenty-five cents. In 1886 Prang published a large folio of the life of Grant from West Point to Appomattox.

Also related to the Civil War was the large lithograph put out by Prang in 1888 for the Old Army Friends Publishing Company. This was lithographed from a painting by Darius Cobb and is a trompe l'oeil with a battered soldier's cap, canteen, and knapsack hanging against a door. At the lower left a piece of paper with an outline drawing of a tin cup has the inscription "Dipper Missing." This is a valuable collector's print and few are available. *Sold*, a Civil War episode by Julian Scott, was listed in Prang's catalogue of 1888–1889. In the Taber-Prang catalogue of 1923 two lithographs of the Spanish-American War are listed: *Manila Bay, 1898* and *Dash for Liberty, Santiago Harbor, 1898*. The artist's name is not given but the lithographs were probably published at the time the events occurred, in 1898.

In the late nineteenth century America was beginning to discover the beauties of her own land and since travel was difficult and not widespread, prints depicting the scenery of the various sections of America were in popular demand. Prang seized the opportunity to supply the market.

The first series of special scenery pictures aside from nearby New England scenes were the prints, 10 × 13 inches, of Cuban scenery by Granville Perkins. These lithographs are listed in *Prang's Chromo*, January 1868, and include the following scenes: *Santiago de Cuba, an inland scene, Santiago de Cuba, a view of the town from the bay, The Castle at the Entrance to the Cienfuegos*, and

Civil War still life. Chromo after painting by Darius Cobb for Old Army Friends Publishing Company, 1888.

Civil War scene. Chromo after painting, *Sold*, by Julian Scott, 1873. *The Library of Congress.*

Baracoa Isla de Cuba, a charming picture of the coast. However, the original watercolor sketches that Prang owned and sold in the Peremptory Sale in New York in December 1875 are listed as follows: *Trinidad de Cuba; In the mountains near Trinidad de Cuba; Cape Maize, Cuba; Cape Cruiz, Cuba; Sunset in Cuba,* and *Old Battery at the Entrance of Santiago de Cuba.* These Cuban prints were Prang's first publications after the Civil War maps and they were not successful. However, they were still listed for sale in the catalogue of 1878 under "Prang's Gems of American Scenery" as "Six Views in Cuba." Other pictures in the series of "Gems" included *Six Views of Yosemite, No. 1 & No. 2; Lake Winnipiscogee and Neighborhood, No. 1 & No. 2; Pemigewasset and Baker River Valley; Vermont Scenery; Six Views in Au Sable Chasm, Adirondacks; Six Views in the Adirondacks,* and *Six Beach Views.* Each picture was 5 × 7 inches and was mounted on white board 10 × 12 inches. A part of the Album of American Artists in 1870 included six pastorals by J. Foxcroft Cole. These lithographs were in black and white and were 10 × 20 inches.

A series of nine American views after *Ruggle's Oil-color Gems* was published by L. Prang & Company in 1867. The names of the pictures were: *White Mountain Scenery; White Mountain Scenery; White Mountain Scenery; Catskill Mountains; Catskill Mountains from Hudson River; Mount Washington, White Mountains; Table Rock, Niagara; Coast of Maine; Fishing Boat.* "These little pictures are perfect gems of color effect. They are sparkling, attractive and satisfactory to the eye; and they will find their adaption in finishing off the decorations of a drawing room. Size 4 × 5¼ inches. Price per nine copies $9." (*Prang's Chromo,* January 1868.) However, in *Prang's Chromo,* April 1868, the following paragraph appeared. "It is gratifying to know that the popular demand for pictures is almost in the exact ratio of their artistic excellence. Every touch of nature, whether on canvas or in chromo, is instantly recognized and applauded. The best things sell best; no reputation avails against the fact as it is. Ruggle's "gems" have not paid expenses, whereas Tait's groups go off with amazing rapidity." This note suggests that there were probably no reprints of Ruggle's "gems"; therefore they would be rare items and difficult to find today. The original paintings of *Ruggle's Gems* were sold in the Prang sale in Boston in 1899.

The Hudson River provided views for several of the most popular series of landscape scenes. There were several different series of them. Two, published in 1864, were album cards and are listed in Chapter Two. Six views on the Hudson after paintings by Max Eglau were published in 1871 and are listed in Prang's catalogue of that year. The pictures were:

> *The Hudson, from Cozzen's Hotel, West Point.*
> *On the Hudson, View of Break-Neck Hill.*
> *View on Hudson near West Point (1)*
> *View on Hudson near West Point (2)*
> *View on Hudson near West Point (3)*
> *View on Hudson near Catskill*

Four Views from "Ruggles Gems." Top left, *Mt. Washington*. Top right, *White Mountain Scenery*. Bottom left, *Table Rock, Niagara*. Right, *Fishing Boat. The Boston Public Library*.

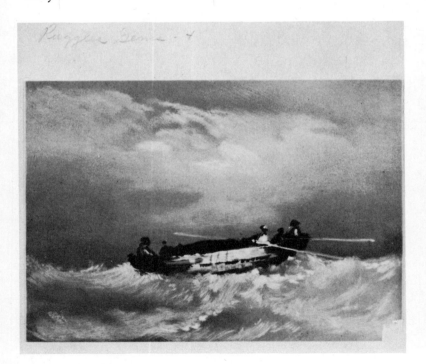

These prints were half chromos, 9 × 4½ inches. In the catalogue of 1878 similar views were listed as 14 × 9¾ inches. Because the artist's name is known these are more important than the other Hudson River series. However, in the catalogue of the Prang sale in Boston, Copley Hall, December 1899, twenty-five Hudson Views by Max Eglau were listed. Since Prang owned that number it seems possible that pictures by Eglau were used for all three Hudson River series. Indeed, one view by him including the house with outside stairway is found in two of the series.

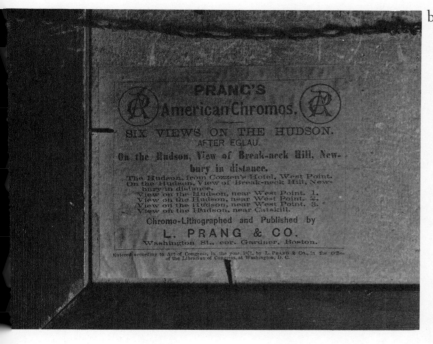

b

(a) *On the Hudson, View of Breakneck Hill.* Hudson Series after Max Eglau, 1871. (b) Tab pasted on back of picture. *Child's Gallery.*

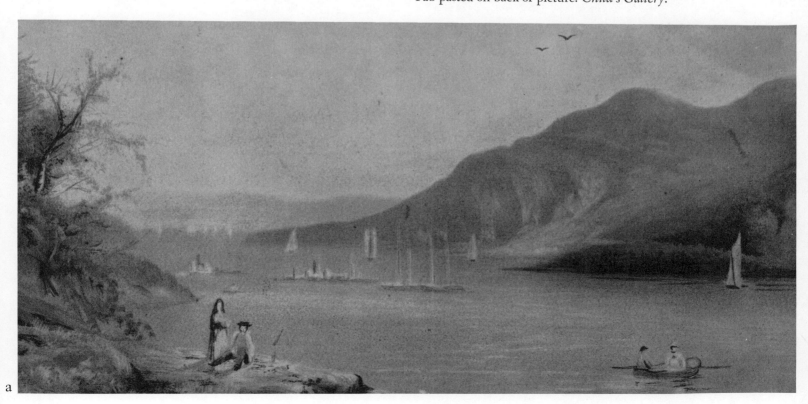

a

Twelve American coastal scenes, so far unattributed, of the same style and size as the Hudson River views of 1868 were published that same year. They included:

A Wreck on the Coast of Maine.
Wreck on Long Island Coast.
Pulpit Rock, Nahant, Mass.
Lighthouse on the Jersey Coast.
Light Ship.
Surf-bathing, Long Branch, N.J.
Second Beach, Newport, R.I.
The Life Boat.
White Head, Portland, Maine.
Cape Elizabeth, Maine.
Frenchman's Bay, Maine.

Six Views in Central Park printed at this time were from pictures by H. A. Ferguson. According to the catalogue of 1871 the scenes were: (Size 9⅛ × 4½.)

1. *New York City seen from the Green.*
2. *The Waterfall.*
3. *Rustic Summer House and City. (Evening)*
4. *Ivy Bridge, near the Cave.*
5. *The Lake and Bow Bridge.*
6. *The Terrace and Lake.*

There were also twelve American and foreign views of the same size as the Hudson views. These represented "views of mountains, of flood, of lakes and sea-shore, of spring and autumn."

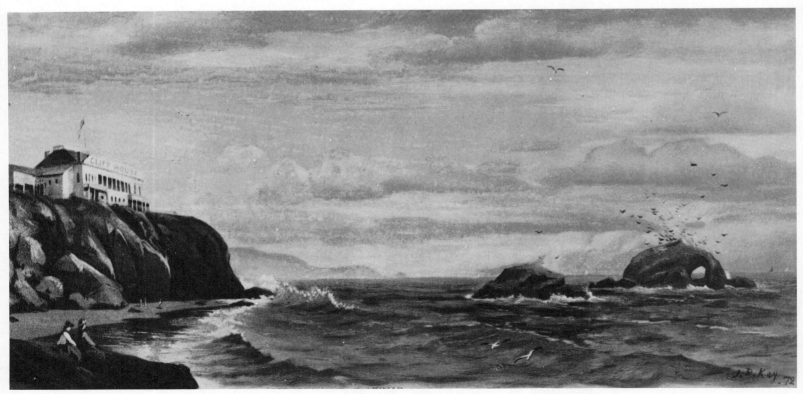

Cliff House, San Francisco. Chromo, L. Prang & Co., after painting by John R. Key, 1872. *Bancroft Library, University of California.*

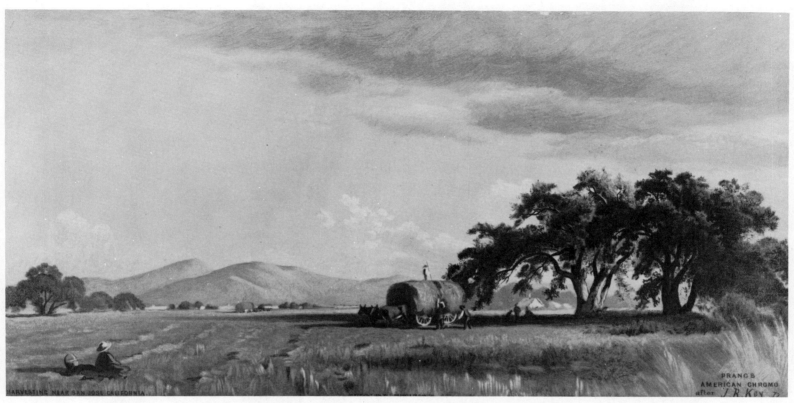

Harvesting near San Jose, California. Chromo, L. Prang & Co., after painting by John R. Key, 1872. *Bancroft Library, University of California.*

A series of California views after paintings by John R. Key were also early publications. The pictures were painted on location by Key in 1871–1872 and are mentioned in the art notes of *Scribner's Magazine* of that year. The subjects are listed in the Prang catalogue of 1878. They included: *The Golden Gate* (after a painting which won a medal at the Centennial Exposition in 1876); *Cliff House, San Francisco; Mt. Diablo; Lake Tahoe; Sacramento Valley; Harvesting near San Jose; Redwood Trees, Santa Cruz Mountains; Big Trees, Calaveras Grove; Yosemite Valley, looking East from Mariposa Trail; Yosemite Valley, Looking West; The Domes of Yosemite; Bridal Veil Falls, Yosemite; Nevada Fall, Yosemite.* The lithographs are 14 × 7 inches and sold for $3.00 each. Four scenes were upright; the others long. Two companion prints, *Santa Clara Valley, California,* and *The Glade, Allegheny Mountains, Maryland* were also by John R. Key. The chromos were 26 × 11¾ inches and sold for $10 each.

L. Prang & Company published New England scenes after paintings by J. M. Hart, and Benjamin Champney, which are listed in the following chapter.

The most important series of L. Prang & Company's landscape views were the chromolithographs of views in Yellowstone Park from watercolor paintings by Thomas Moran. The original oil paintings were made by Moran as official artist to the United States Government Expedition to Yellowstone Valley in 1871. The watercolors which were reproduced in the Prang Yellowstone Series were

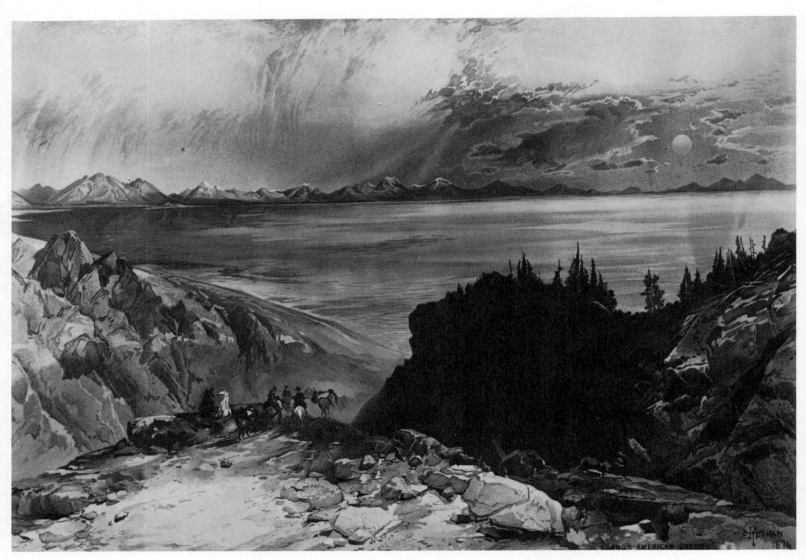

Great Salt Lake of Utah. Chromo after painting by Thomas Moran, 1875. *The Library of Congress.*

"executed expressly for Mr. Prang by Mr. Moran." Prang gathered together the fifteen sketches in one volume with accompanying text by Prof. F. V. Hayden, the geologist in charge of the expedition. The folio was published in 1876 and today remains as a monument of American bookmaking. The prints have never been surpassed as examples of the best American chromolithography. In these views Thomas Moran shows himself to be an interpreter of the iridescence of mist and sun, cloud, mountain, and river. Today this portfolio of chromolithographs is considered unexcelled among illustrations of the Far West. This is a rare and expensive item for the advanced collector. The prints are 9½ × 14 inches. A set of this rare series is owned by The New-York Historical Society. The fifteen lithographs are: *Mountain of the Holy Cross, Colorado; Summit of the Sierras, Nevada; Great Salt Lake, Utah; Valley of Babbling Waters, Utah; Great Falls of Snake River, Idaho; Hot Springs of Gardiner's River, Yellowstone National Park; The Castle Geyser, Yellowstone National Park; Lower Yellowstone Range seen from Yellowstone National Park; Yellowstone Lake, Yellowstone National Park; Mosquito Trail, Rocky Mountains, Colorado; Lower Falls and Sulphur Mountain, Yellowstone National Park; Head of Yellowstone River.* The large oil painting of the Grand Canyon of Yellowstone National Park, by Thomas Moran, was purchased by the Congress of the United States for ten thousand dollars and now hangs in the Capitol in Washington, D.C. The watercolors of this series, owned by Prang, were sold at the Prang sale at the American Art Galleries in New York in 1892. The watercolor painting *Mosquito Trail*, No. 345 in the sale catalogue, is now in the possession of the Hirschel & Adler Gallery, New York City. In 1964 the oil painting, *Mountain of the Holy Cross*, also by Thomas Moran, was owned by and exhibited at the Huntington Hartford Gallery of Modern Art in New York City. Thomas Moran painted two additional watercolor scenes of Western territory for Prang, which were also reproduced as chromos. They were *On the Lookout, a Ute Camp, Utah* and *Cliffs of the Upper Colorado River, Wyoming Territory.*

L. Prang & Company also made a series of chromos after paintings by A. T. Bricher, which are discussed in the following chapter.

Prang's catalogue of 1878 listed Prang's Gems of American Scenery. Each set contained six views, 5 × 7 inches, and sold for $1.00 per set. The sets were:

1. *Six Views in Yosemite Valley.*
2. *Lake Winnipiseogee and Neighborhood, No. 1.*
3. *Lake Winnipiseogee and Neighborhood, No. 2.*
4. *Pemigewasset and Baker River Valley.*
5. *Vermont Scenery.*
6. *Six Views in the Yosemite Valley.*
7. *Six Views in Cuba.*
8. *Six Views in Au Sable Chasm, Adirondacks.*
9. *Six Views in the Adirondacks.*
10. *Six Beach Views.*

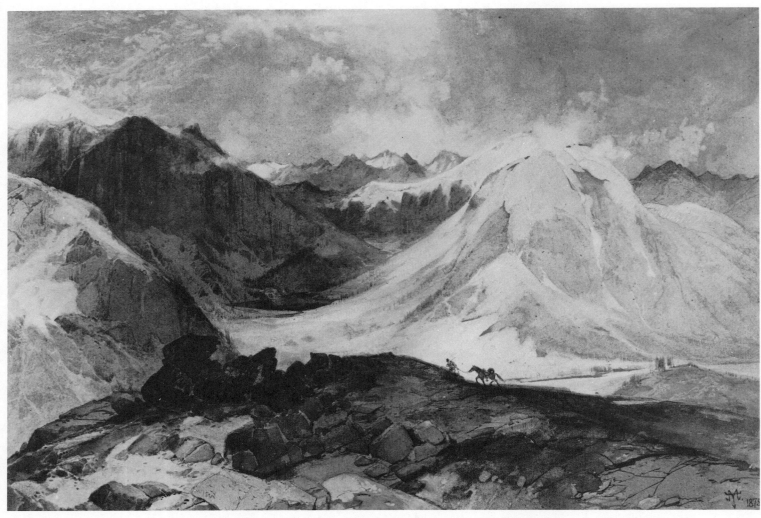

Mosquito Trail, Rocky Mountains of Colorado. Watercolor by Thomas Moran, painted to order for L. Prang & Co., 1875. Chromo was made after this picture. *Hirschel & Adler Galleries.*

These scenes were mostly from original sketches made on the spot by an artist sent there for that purpose.

L. Prang & Company continued to issue new landscape chromos of New England throughout the years. A new series was listed in the catalogue of 1888–1889 by the artist Louis K. Harlow who did many paintings and designs for Prang. This series included *Scenes of Castine, Maine*; *Near Boothbay Harbor, Early Morning*; *Evening Twilight*; *A Bit of Monhegan, Maine*; and *A Glimpse of the Sound, Connecticut*.

There were also Prang chromos illustrating various sports. A group of hunting, boating, and fishing scenes after paintings by E. B. Bensell were published in the early 1870s. These were humorous pictures. They were put out in pairs, two in each category, size 14 × 17 inches including the mat. A correspondent has reported the titles of the hunting scenes as *Before the Shot* and *After the Shot*. They show a man in hunting attire with his two dogs. Two children are watching from over the wall.

In the 1880s L. Prang & Company published an important series called Pictures of American Sport. These chromos illustrated important yacht races and were after paintings by well-known artists. They included *The Finish* (International Yacht Race between the *Puritan* and the *Genesta*, September 16, 1885) after a painting by William F. Halsall; *The Start* (International Yacht Race between *Mayflower* and *Galatea*, September 7, 1886) after a watercolor by Julian O. Davidson; *Victorious Volunteer* (International Yacht Race between the *Volunteer* and *Thistle*, September 30, 1887) after a painting by J. G. Tyler, and *Dash Around the Lightship* after a painting by Julian O. Davidson. These lithographs were ca. 30 × 22 inches including a margin. There was also a lithograph of the yacht *Galatea* from a painting by Marshall Johnson, one of the *Kremlin* at Mystic from a painting by F. M. Lamb, one of the *Victorious Vigilante*, and of the famous yacht *Mayflower* by William F. Halsall.

A series of winter and summer sports was also published in the 1880s. These were after watercolors by Henry Sandham and included *Tobogganing*, *Snowshoeing*, *Skating*, *Bicycling*, *Base Ball*, and *Lawn Tennis*. The lithographs were 15½ × 21½ inches except for *Snowshoeing*, which was 20 × 28 inches. The original watercolors from which these lithographs were taken were owned by Prang and were included in the American Art Gallery Sale in New York in 1892. In the early 1900s, Taber-Prang published a series of woman golfers, which proved to be very popular.

In the 1890s L. Prang & Company published a series of etchings. One series, Homes and Haunts of the Poets, was from original etchings by W. B. Closson. There was also a group of six etchings, called Picturesque Cambridge, after etchings by W. Goodrich Beal and another four of his etchings called The Times of Day. He also produced six etchings of views of Cape Ann, Massachusetts, which were reproduced by Prang. These were printed on Japan paper and

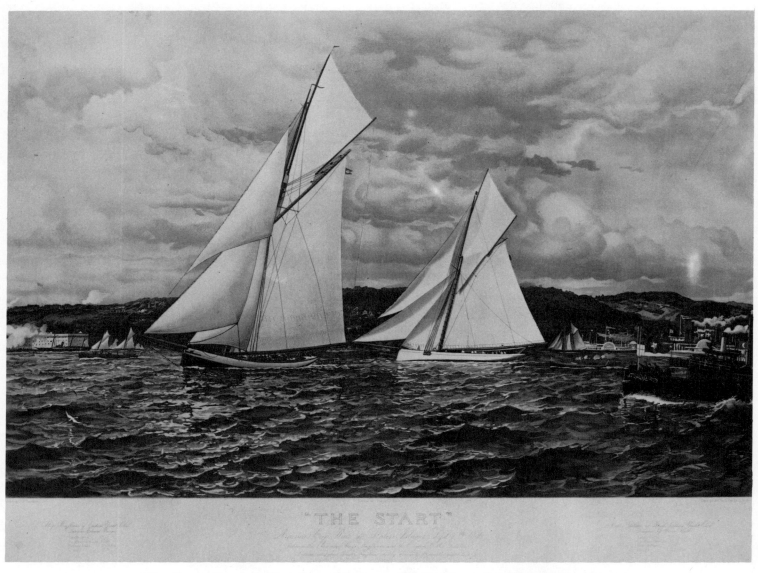

The Start. America's Cup Race Off Staten Island, Sept. 7th, 1886. Chromo by L. Prang & Co., 1887, from painting by J. O. Davidson. *Print Department, The Library of Congress.*

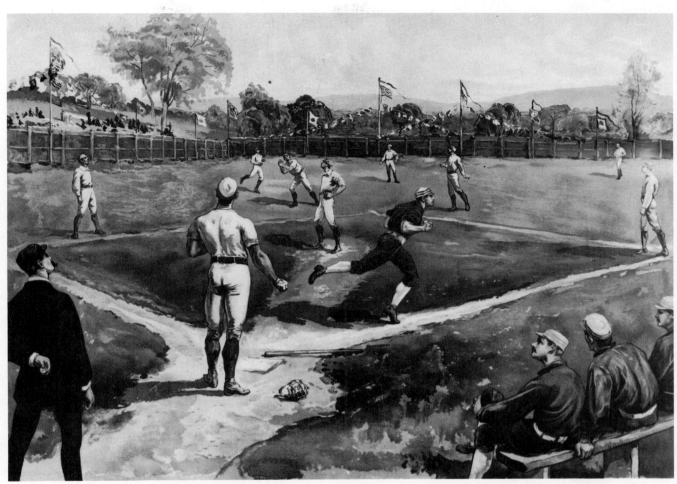

Base-Ball. Chromo (15½ × 21½ inches) from original painting by Henry Sandham, 1887. *The Library of Congress.*

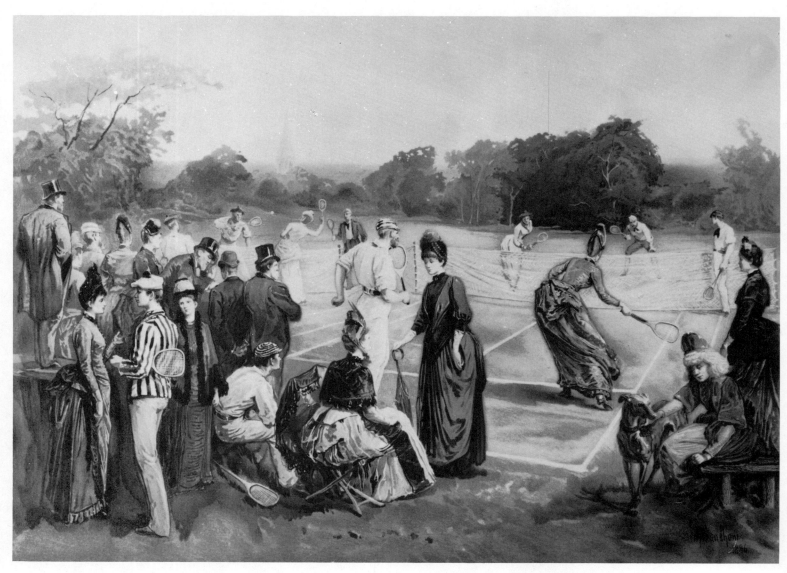

Lawn-Tennis. Chromo (15½ × 21½ inches). Published by L. Prang & Co., from original painting by Henry Sandham, 1887. *Hallmark Historical Collection.*

Series of women golfers. Published by Taber-Prang in early 1900s. *Hallmark Historical Collection.*

signed by the artist. A series of six etchings of Newport by Miss G. D. Clements and Miss E. D. Hale and another series entitled *The North Shore* by the same artists were also reproduced by Prang on Japan paper, 12½ × 9¾, and signed by the artists. These were 8⅞ × 6⅞ in portfolio.

A series of English scenes from watercolors by Louis K. Harlow were listed in the Holiday Catalogue of 1888–1889. The pictures were lithographed on satin and were 20 × 15¾ inches mounted on mats "for framing or for the easel." The subjects included *West Gate, Warwick; Stratford-on-Avon; Kenilworth Castle; The Old Bridge, Stratford; Warwick Castle, From the Ferry; Holy Trinity Church, Stratford; Anne Hathaway's Cottage;* and *The Shakespeare House.* The description of the lithographs given in the catalogue is as follows: "These Art Prints have been made on satin by a patented process invented by our Mr. Prang by means of which all the strength and spirit of the original has been preserved as well as that depth of color, peculiar softness, and richness of appearance so charming in water-color paintings. Therefore it is that these special Satin Art Prints can be distinguished from the originals only with the greatest difficulty." Prang also published many cards lithographed on satin.

Artists Whose Pictures Were Reproduced By L. Prang & Company

IN THE PERIOD THAT FOLLOWED THE END OF THE CIVIL WAR MANY WEALTHY Americans became patrons of art. Collections such as those of S. P. Avery, A. T. Stewart, James Lenox, and John Taylor Johnston of New York; W. T. Walters of Baltimore, Maryland; and Longworth of Cincinnati, Ohio, were formed at this time. These men traveled abroad and purchased pictures of old masters and those of recognized living artists from the schools of Britain (British artists), of France, and of Germany. They also supported the living American artists. The paintings included genre and costume pictures which illustrated sentimental literature and aspects of the past. Although pictures adorned the homes of the wealthy the mass of Americans knew little of art and popular taste in art was low; their only pictures were cheap garish prints. Louis Prang sought to fill this gap and to improve the aesthetic appreciation of the average American. Although

Prang initially produced small colored trade cards and other commercial items his real interest lay in fine art and color and in the reproduction of the work of recognized artists.

Many of Prang's early large chromos were reproductions of European museum-owned masterpieces and from copies made for his use in the Boston workshop he reproduced such paintings as Correggio's *Reading Magdalena* from the Dresden Art Gallery; Raphael's *Madonna of the Chair* from a copy for which he paid an artist $560; *Sistine Madonna;* and Murillo's *Madonna of the Immaculate Conception.* Before 1870 Prang also reproduced J. Cooman's *Family Scene in Pompeii* and *The Roman Beauty,* and *Primavera* by Moradei. There were also early chromos of Bouguereau's *The Baby* and *The Sisters. The Baby* was owned by the New York collector Johnston and sold in the Johnston sale in 1876 for $6,000. Paintings by Landseer and Rosa Bonheur were reproduced in half chromos. The paintings of other well-known living artists of Munich, Düsseldorf, Berlin, Brussels, Rotterdam, Paris, and London were also included among the early chromos.

Plaque, *The Reading Magdalena.* Chromo, 1898, after painting by Correggio. *Hallmark Historical Collection.*

Plaque, *La Primavera*. Chromo, 1878, after painting by Moradei. *Hallmark Historical Collection.*

However, from the beginning there were a great number of American artists represented in the chromos of L. Prang & Company. These artists included A. T. Bricher, A. F. Tait, Thomas Hill, Edward Moran, Thomas Moran, A. B. Durand, James M. Hart, Eastman Johnson, A. Bierstadt, F. S. Church, Benjamin and Wells Champney, Winslow Homer, R. D. Wilkie, William Trost Richards, J. G. Brown, John J. Enneking, Martin J. Heade, J. Francis Murphy, Max Eglau, Ralph Albert Blakelock, and Ross Turner as well as numerous lesser-known American artists. The artists were drawn from the membership of The National Academy of Design, The Society of American Artists, The American Water-Color Society, The Boston Art Club, The San Francisco Art Association, and other recognized artists' groups.

Retaliation. Chromo by L. Prang & Co., after painting by F. S. Church, 1884. *Hallmark Historical Collection.*

A JOYFUL CHRISTMAS TO YOU!

Landscape scene after J. Francis Murphy. *Hallmark Historical Collection.*

The first American artists whose pictures L. Prang & Company made in full chromos were Arthur F. Tait and A. T. Bricher. Chromos after paintings by Tait included *Group of Chickens, Group of Ducklings, Group of Quails, Pointer and Quail, Cocker Spaniel and Woodcock, Maternal Love* (deer), *Kluck Kluck, Take Care, The Intruder,* and *Dash for Liberty.* Tait also painted many small sketches of chickens for Prang which were made into greeting cards. The first of Bricher's paintings that Prang published as chromos were *Early Autumn on Esopus Creek, N.Y.* and *Late Autumn in the White Mountains.* These chromos were 9 × 18 inches. A group of landscape seasons—*Spring, Summer, Autumn, and Winter,* by Bricher were also made into chromos, 12½ × 16⅛ inches in size. There was also a group of Six American Landscapes after paintings by Bricher. These included:

1. *Souvenir of Lake George.*
2. *Twilight on Esopus Creek, N.Y.*
3. *Sawyer's Pond, White Mountains.*
4. *Mt. Chocorua and Lake, N.H.*
5. *On the Hudson, near West Point.*
6. *On the Saco River, North Conway, N.H.*

These prints were 4½ × 9 inches. The paintings from which they were made were sold in a Prang sale at Leeds Gallery in March 1870.

Maternal Love. Chromo plaque by L. Prang & Co., 1871, after painting by A. F. Tait. *Hallmark Historical Collection.*

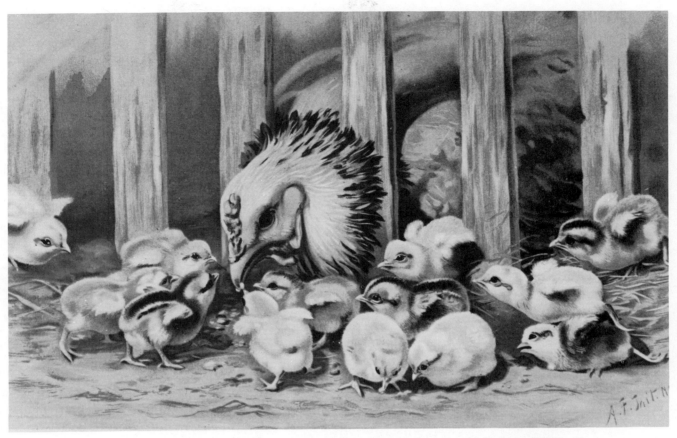

"Kluck! Kluck!" Chromo by L. Prang & Co., after painting by A. F. Tait. *Hallmark Historical Collection.*

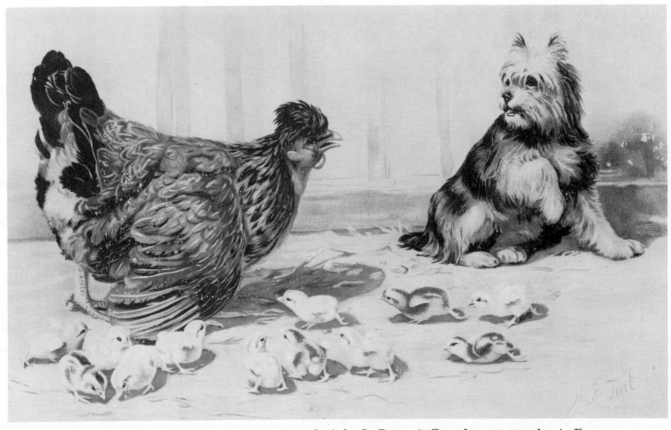

Take Care. Chromo (1½ × 13½ inches) by L. Prang & Co., after painting by A. F. Tait. *Hallmark Historical Collection.*

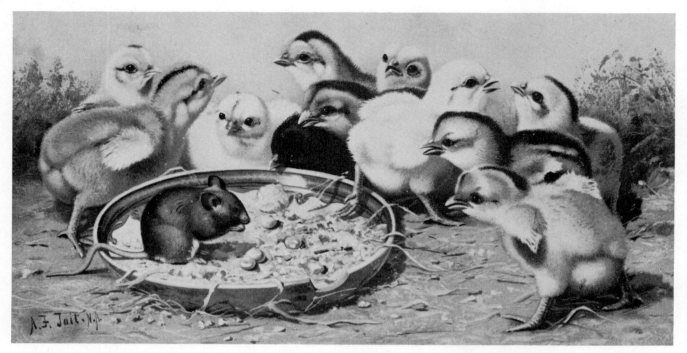

The Intruder by A. F. Tait. Chromo (6 × 11¼ inches) by L. Prang & Co. *Hallmark Historical Collection.*

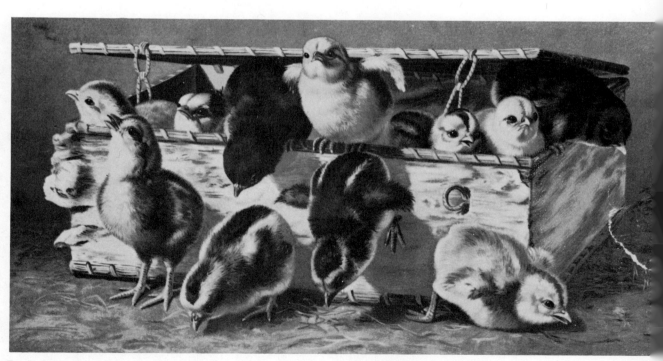

Dash for Liberty by A. F. Tait. Chromo (6 × 11¼ inches) by L. Prang & Co. *Hallmark Historical Collection.*

Bricher paintings in the Peremptory Sale of Prang's paintings in 1875 included: *Silver Cascade, View on Mississippi River,* and *Maiden's Rock on Lake Pepin, Mississippi River, Mountain Scene near Mt. Gregor opposite Prairie du Chien, Mississippi River, Bluffs at Homer on Mississippi River,* and *Barn Bluff, Red Wing, Minnesota.*

In the American Art Galleries sale of 1892 in New York the following Bricher paintings were listed in the catalogue:

Late Autumn, Saco River.
Narragansett Pier.
Sunset, Schinnecock Bay.
Winter in Maine.
Calm Morning, Scituate.
Clouds and Sunshine.
Springtime.
Summer, No. 2.

In the sale of 1899, Bricher's *Blue Point Oyster Boats, Far Rockaway,* and *Waterfall* were listed. Although Prang made a great many chromos after paintings by Bricher, it is not positive that all of these listed were reproduced.

J. G. Brown was another American artist after whose paintings Prang made early chromos. The paintings which included scenes with children, for which Brown was well known, included:

Maiden's Prayer.
Three Tom Boys.
Queen of the Woods.
Little Bo-Peep.
Playing Mother.

Prang also reproduced a large group of paintings by George C. Lambdin. The majority of these were of flowers although one, *Wild Fruit,* was a companion to Eastman Johnson's *Barefoot Boy.* There was also a group of large chromos (16 × 9 inches) by James M. Hart. These were:

Scene near Cayuga Lake, N.Y.—Spring.
Scene near Stockbridge, Mass.—Summer.
Scene near Farmington, Conn.—Autumn.
Scene near New Russia, N.Y.—Winter.

A group of chromos after paintings by Benjamin Champney included:

Mount Kearsarge.
Mount Chocorua.
Artist's Brook.
North Conway Meadows.
Haymaking in the Green Mountains.
Pumpkin Time.

A group of paintings by William Trost Richards was owned by Prang but it is not known whether they were reproduced as chromos since they are not listed in any catalogues. *The Storm is Coming* after James M. Hart and *The Close of Day* after Arthur Parton were issued as companion chromos (24⅓ × 13⅞ inches) and another set of early companion chromos was *Launching the Life-Boat* after Edward Moran and *Sunset on the Coast* after M. F. H. De Haas.

Mr. Prang also employed staff artists including Mrs. O. E. Whitney; Lizbeth B. Humphrey; Ellen T. Fisher, who painted flowers; Mrs. Sophia Anderson, whose chromos *Prattling Primrose* and *Dotty Dimple* were first popular in the 1870s; and F. Schuyler Mathews, who painted many landscape series and made designs for the backs of cards and designed booklets. Miss S. A. Winn also worked for Prang in the 1890s, and the chromo of her picture *The Prize Piggies* was the most popular one of the year 1891. Louis K. Harlow also worked on special series, booklets, and calendars. Harlow painted the Evangeline scenes, scenes of Shakespeare country, and a series of pictures of California missions. Harlow also painted many New England scenes and was one of the artists most represented in Prang's publications.

Another Boston artist who painted many pictures for Prang was R. D. Wilkie. In addition to the early still life dining room pictures and *Sacred Music,* a composition of cross, lyre, and flowers, 1874, Wilkie painted the series of small

Pages from Prang's catalogue, 1876, illustrating popular chromos. *Henry E. Huntington Library and Art Gallery.*

THE STORM IS COMING.

SUNSET IN CALIFORNIA.

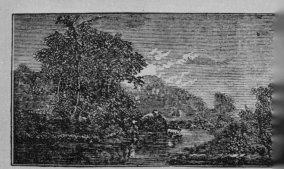

THE CLOSE OF DAY.

LAUNCHING THE LIFEBOAT.

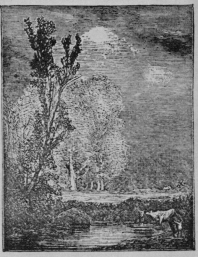

JOY OF AUTUMN.

SUNSET ON THE COAST.

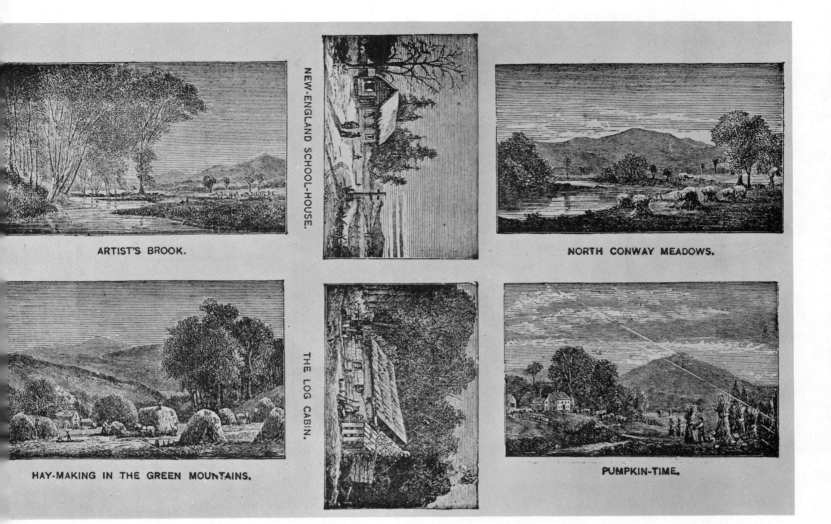

ARTIST'S BROOK.

NEW-ENGLAND SCHOOL-HOUSE.

NORTH CONWAY MEADOWS.

HAY-MAKING IN THE GREEN MOUNTAINS.

THE LOG CABIN.

PUMPKIN-TIME.

views of Pemigewasset and Baker River and the Adirondack Scenes as well as a group of twelve delightful scenes of Saratoga and Lake George. These scenes were put out as half chromos. The Saratoga and Lake George scenes were: *High Rock Spring; Lake George; Caldwell Lake; Pavillion Spring; Recluse Island; Bolton Church, Lake George; White Sulphur Springs; Lake George Narrows; Lake George from Bolton; Empire Spring; Old Red Spring;* and *Spring*. These are signed "W". They are 6½ × 4⅞ inches in size. Among the numerous small landscapes by Wilkie that are listed in the Copley Hall sale of Prang's paintings are six Philadelphia views, nine New England views, twelve White Mountain views, seven California views, six Connecticut views, and six Adirondack views.

Prang's chief lithographer, that is, the artist who drew the picture on stones, was the Englishman W. Harring but there was also a group of lithographers including Stocklein, G. Armstrong, Witt, J. K. Korpen, Strauss, and Morales. Often the chromos are signed with the name of the lithographer. Such artists as Winslow Homer drew many of their own pictures on stone.

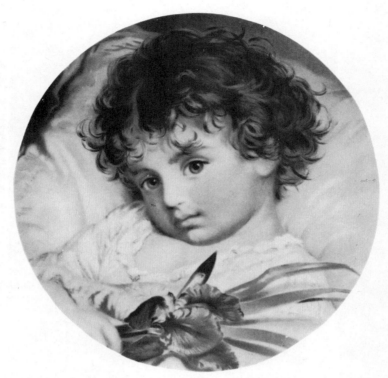

Prattling Primrose. Chromo by L. Prang & Co., 1878, after painting by Mrs. S. Anderson. *Hallmark Historical Collection.*

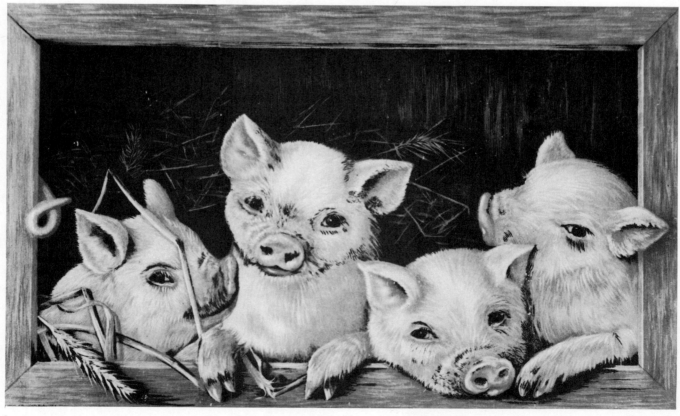

Prize Piggies. Chromo, 1891, by L. Prang & Co., after painting by Miss S. A. Winn. *Hallmark Historical Collection.*

A New England Wharf. Chromo, after Louis K. Harlow. *Hallmark Historical Collection.*

In his choice of pictures for reproduction Prang followed the popular taste of the times and his chromos produced a truly democratic art. The technical limitations of the lithographic process also determined the choice of pictures and not all of the chromos were interesting in their own right as paintings. Clear outlines and bright, bold colors reproduced best.

In his catalogue of 1878 Prang listed a group of still lifes under the heading of Dining-Room Pictures. These pictures, which were considered suitable to hang in the Victorian dining room, included pictures of fruit, berries, fish, and game. The earliest of these pictures were listed in the first issue of *Prang's Chromo,* January 1868: "Our fruit and flower pieces are admirably adapted for the decoration of dining-rooms and parlors. We intend to issue still other pictures of this character; and we venture to predict that the set when complete will be unrivalled either in Europe or America." The first chromos in the list were *Cherries in a Basket* and *Strawberries in a Basket* after oil paintings by Miss Virginia Granberry of New York. Chromos were also later made of *Currants* and *Raspberries* from paintings by Miss Granberry and a chromo of *Blackberries in a Vase* after an oil painting by Lily M. Spencer was also listed in the catalogue of 1878. Another dining-room picture was *The Kitchen Bouquet* by W. Harring, who was Prang's head lithographer. An illustration and description of this chromo is given in *Prang's Chromo,* Christmas 1868.

> *The Kitchen Bouquet* after W. Harring shows tomatoes in their glory of full ripeness,—luscious, bright in color, ready for the cook, to be served in one of the thousand different styles which he, as other cooks, invented. An American cook could miss a good many other things before he would do without tomatoes—easy to serve and always acceptable. It is well-handled as a picture, and shows that even the most familiar and seemingly vulgar subjects can be made poetical if treated by a man of ability. For dining-rooms, for restaurants, for vegetable and provision dealers, for seed-stores and others it will make an attractive picture.

Also under the heading of Dining-Room Pictures were *Trout* and *Pickerel* by George N. Cass. Each picture was 24 × 14 inches. The trout picture showed a fishing rod and a group of trout lying in the grass, while the pickerel were painted with a landscape background. There were also several chromos of dead game by Cass and one by G. Bossett. A fruit piece by C. Biele consisted of a group of grapes, peaches, and pears. There were also seven dessert pieces. *Dessert No. I* by R. D. Wilkie is a grouping of grapes, walnuts, a cut lemon, and other fruit on a table together with a wineglass and pitcher. *Dessert No. II,* also by R. D. Wilkie, shows a group of fruit and strawberries in a footed compote and a vase with flowers set on a table. There were four dessert pictures after paintings by C. P. Ream. Ream's *Dessert No. III* was a composition of cherries in a decorative Victorian footed compote set on a table and *Dessert No. IV* showed a similar footed compote with raspberries and on the table is a dish of ice cream and a

Dining Room Pictures from catalogue of L. Prang & Co., 1876.

Prang's Chromo.

A Journal of Popular Art.

Vol. I.	BOSTON, CHRISTMAS, 1868.	No. 4.

PRANG'S AMERICAN CHROMOS.

A FULL list of our American chromos and half-chromos, with size and retail price, will be found on the last page of this paper.

BRICHER'S LANDSCAPES.

Mr. Bricher is a well-known Boston artist, whose representations of American scenery, and especially of autumnal scenery, have always been received with much favor. Our chromos are reproductions of some of his most popular sketches. The companion-pictures — "Early Autumn on Esopus Creek," and "Late Autumn in the White Mountains" — are among the most favorite chromos of landscapes that have ever been introduced into this country. The "Six American landscapes" are little gems, charming in composition as well as in color. Their titles are, "Souvenir of Lake George," "Twilight on Esopus Creek, New York," "Sawyer's Pond, New Hampshire," "White Mountains," "Mount Chocorua, and Lake, New Hampshire," "On the Saco River, North Conway, New Hampshire," and "On the Hudson, near West Point."

"We have hanging in our modest room," says "The Syracuse Journal," "two chromos; after Bricher's "Early and Late Autumn on Esopus Creek, New York," and the White Mountains. They fill the room with a sense of beauty; and their glowing hues, so faithfully reproducing the parti-colored garb of autumn, are a constant pleasure to the eye as well as to the mind. There is about them the very haze of the lingering Indian summer; and one can look and dream as if in actual presence of that sweet yet mournful season. Prang's chromos are actually giving Democracy its art-gallery.

FRUIT AND FLOWER PIECES.

Our fruit and flower pieces are admirably adapted for the decoration of dining-rooms and parlors. We intend to issue still other pictures of this character; and we venture to predict that the set, when complete, will be unrivalled either in Europe or America. Each picture is from the palette of an artist who has achieved distinction in this branch of the profession.

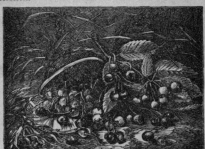

CHERRIES AND BASKET,

After Miss V. Granberry, of New York, is a most effective composition, with brilliant, harmonious coloring. "Miss Granberry," says a critic, " paints in the style of the pre-Raphaelites, and her work has been greatly admired in the New-York Academy. This chromo is a perfect copy of the original painting, and shows fidelity to nature in gradations of color, form, and grouping." "Cherries," says "The Hartford Post," " certainly never looked more luscious and tempting than they do in this gem of a picture." "Your chromo, 'The Cherries,'" writes Miss Lucy Larcom, " is very beautiful. The fruit is so deliciously real, it brings back the sunshine and breezes of early June; and one almost looks to see a robin's head bobbing suddenly in at the corner of the picture to peck at the 'black-hearts.'"

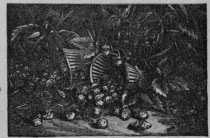

STRAWBERRIES AND BASKET,

Also by Miss Granberry, is a companion-picture to the preceding piece, equally beautiful, and by many critics preferred to "The Cherries." They are acknowledged to be the most beautiful pair of fruit-pieces ever produced in a popular form, and at the same time in an artistic style.

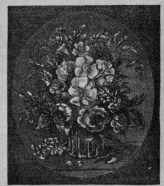

FLOWER BOUQUET.

This is a bouquet of flowers, mostly roses, of various tints and colors, — a very beautiful composition, regarded by many artists as one of the most perfect imitations of an oil-painting that we have produced. Says a Western art-critic, "'The Flower Bouquet' is an exquisite picture, containing exact representations of a large variety of flowers and leaves of all shades of color. The coloring is bright, and at the same time delicate and rich. The picture is so true to nature, that one is almost tempted to believe he can smell the perfume of the flowers." "'The Flower Bouquet,'" says another writer, "makes a splendid floral display." "It is a gorgeous imitation of our oil-paintings," writes Rev. Mr. Wheddon in "The Northern Christian Advocate," — "so perfect that one might be readily excused for thinking it the original. It is in a glass, standing upon a table, with blossoms of various brilliant hues, and buds in various stages of opening; while upon the table have fallen a few leaves and a sprig of the flowers. One is before me as I write; and it improves upon acquaintance, though I thought it a beauty at the first."

The companion-piece to this picture is "Blackberries in Vase," by Mrs. Lilly M. Spencer. The rich, dark color of the ripe fruit contrasts finely with the brilliant hues of the flowers in the companion-piece; while the picture is perfect in itself as a beautiful study from nature.

THE FRINGED GENTIAN.

This is one of the careful and faithful representations of vegetable life in which the pre-Raphaelite school of artists in New York excel. "It looks," says a critic, "as if it had been drawn with the aid of a microscope, the most Liliputian details are so exactly reproduced." It is after Mr. Newman's painting, which won distinction on its exhibition at the Academy. Mrs. Dall says of this chromo, " this simple, nameless group of gentians has kindled many an eye."

"The Chicago Republican" says, that "'The Fringed Gentian,' by A. R. Newman, is one of the most exquisite flower-pieces it has been our lot to see. We can readily believe that it cost more labor than many larger and more pretentious pictures. A slight description will indicate the difficulties of the task. In front of a mass of half-decayed limbs, which form a background, — the most pretty wood-color shades graduating into one another, — springs up the fresh gentian stalk, bearing its pale-green leaves, and radiant with the bright blue of its crowning blossoms. The whole is a sermon, — nay, better, a poem, — teaching of the presence of abounding life amid the ever-visible tokens of mortality. Artistically, nothing could be more perfect than the contrast of colors, — the living blue and green set off against the sober shades of the dead, decaying wood and leaves."

THE KITCHEN BOUQUET,

After W. Harring. Tomatoes in their glory of full ripeness, luscious, bright in color, ready for the cook, to be served in one of the thousand different styles which he, as other cooks, invented. An American cook could miss a good many other things before he would do without tomatoes, — easy to serve, and always acceptable. It is well-handled as a picture, and shows that even the most familiar and seemingly vulgar subjects can be made poetical if treated by a man of ability. For dining-rooms, for restaurants, for vegetable and provision dealers, for seed-stores and others, it will make an attractive picture.

EASTER MORNING.

This is a work the rare and exquisite beauty of which has given satisfaction to the most captious and capricious critics. We have never yet read nor heard one disparaging

Prang's Chromo, Vol. I, Christmas 1868, illustrating fruit and flowers. Henry E. Huntington Library and Art Gallery.

July (wheatfield against blue sky). Chromo, L. Prang & Co., after painting in "Twelve Months Series" by Fidelia Bridges. *Henry E. Huntington Library and Art Gallery.*

October (goldenrod and birds). One of "Twelve Months Series" by Fidelia Bridges. *Henry E. Huntington Library and Art Gallery.*

April (fruit blossoms and birds). After painting in "Twelve Months Series" by Fidelia Bridges. *Henry E. Huntington Library and Art Gallery.*

Easter cards with red backgrounds. *Hallmark Historical Collection*.

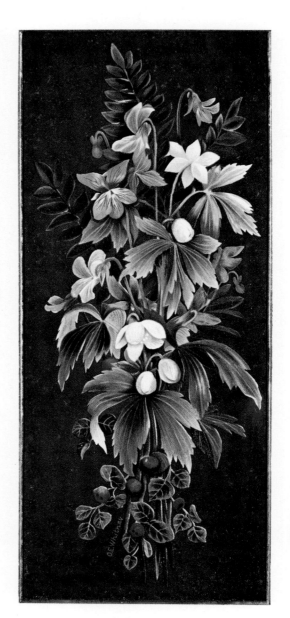

Black panel, *Pansies*. Chromo, L. Prang & Co., after painting by Mrs. O. E. Whitney. *Hallmark Historical Collection*.

Black panel, *Violets*. Chromo, L. Prang & Co., after painting by Mrs. O. E. Whitney. *Hallmark Historical Collection*.

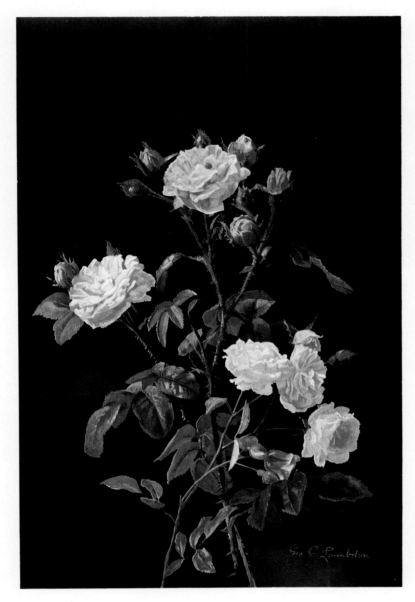

Roses. Chromo on dark ground. L. Prang & Co., after painting by George C. Lambdin. *Henry E. Huntington Library and Art Gallery.*

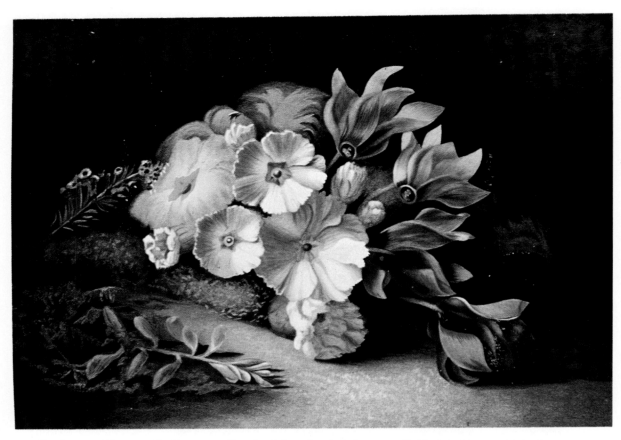

Cyclamen. Chromo, L. Prang & Co., by Mrs. O. E. Whitney. *Hallmark Historical Collection.*

Red Poppies, No. 4. Chromo, L. Prang & Co., after painting by T. Welch. *Hallmark Historical Collection.*

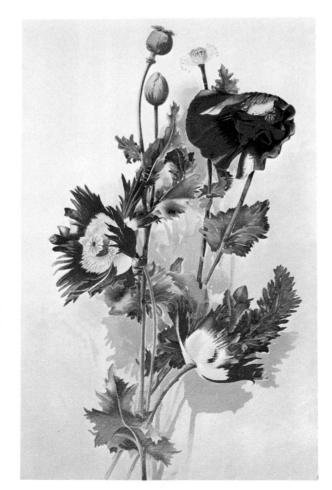

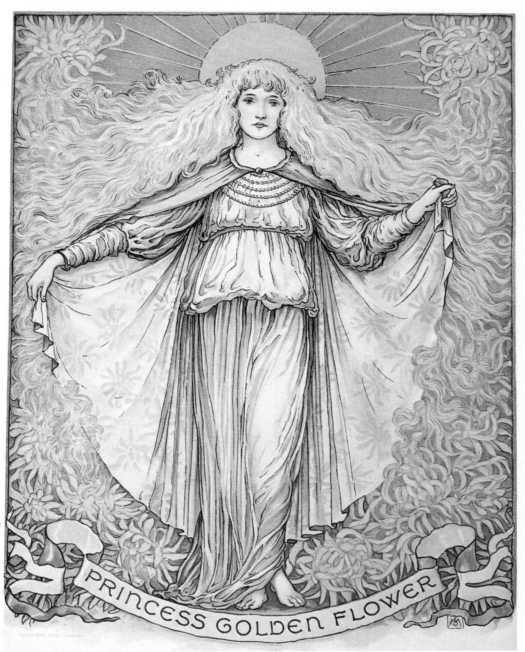

Princess Golden Flower. Cover of chrysanthemum booklet. Chromo, L. Prang & Co. *Hallmark Historical Collection.*

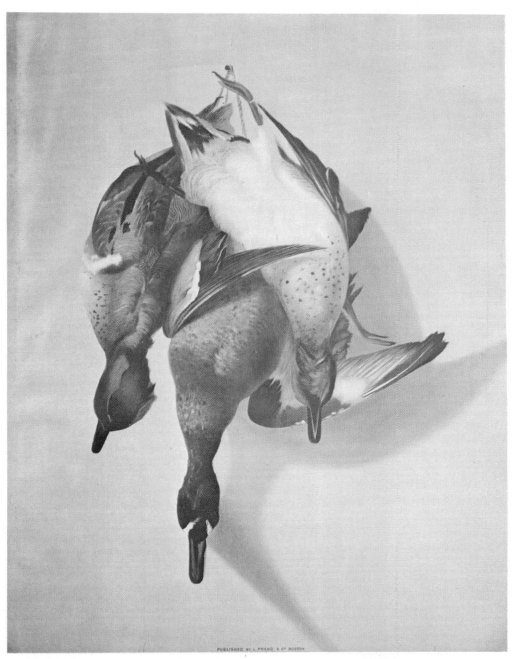

Game Piece No. 1 by George N. Cass. Chromo by L. Prang & Co. *Hallmark Historical Collection.*

piece of pound cake. There were also two other dessert pictures by Ream. *Dessert No. VII* after a painting by I. Wilms shows a group of grapes, nuts, and other fruit and a slender glass of white wine. Several pictures with groups of food—lobster, eggs, celery, and so on, and trout, grouse, tomatoes—were by R. D. Wilkie. These were later sold in a booklet, *Christmas Salad*. These Dining-Room pictures are interesting examples of late nineteenth century American still life painting and give a picture of the taste of the times. This democratic art was not only "for the people" but it was "of the people" as well.

Prang also kept abreast of the news. His first success had been the Civil War maps. As discussed earlier, when the first Negro Senator, H. R. Revels, was elected in 1870 Prang was also quick to take advantage of the public interest and commissioned Theodore Kaufmann to paint a portrait of Revels from which a chromo was made. Prang also made lithographs of Negro children after paintings by James H. Moser, the illustrator of *Uncle Remus*.

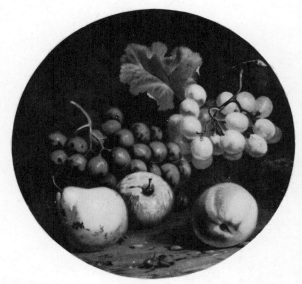

Fruit Piece No. 1. Chromo plaque published by L. Prang & Co., 1878, after painting by C. Biele. *Hallmark Historical Collection.*

Dessert, No. 3, 1871. Plums on Mother-of-pearl stand. Chromo plaque by L. Prang & Co., after painting by C. P. Ream. *Hallmark Historical Collection.*

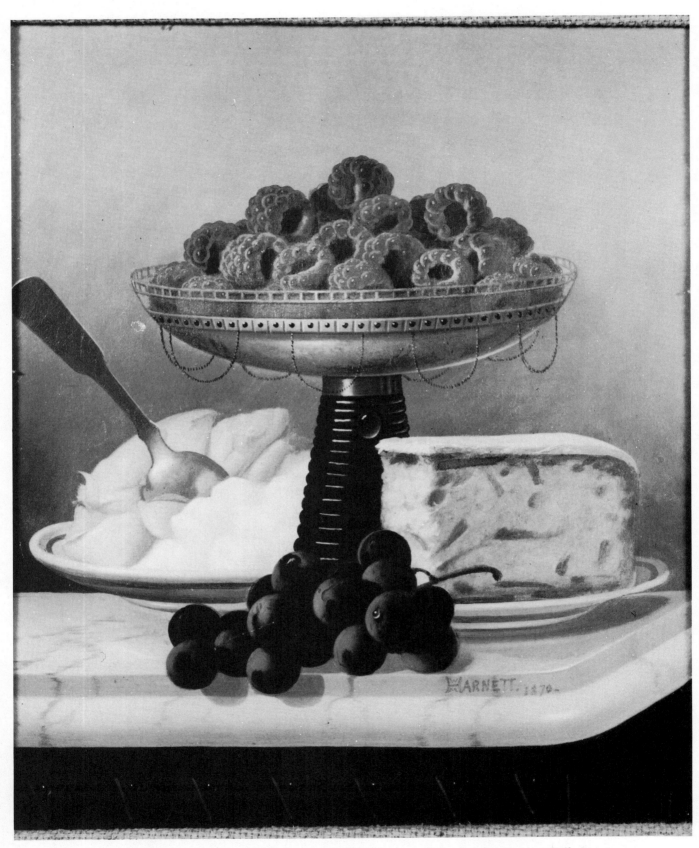

Dessert, No. 4. C. P. Ream. Now called Raspberries, Cake and Ice Cream. *Collection of O. B. Jennings.*

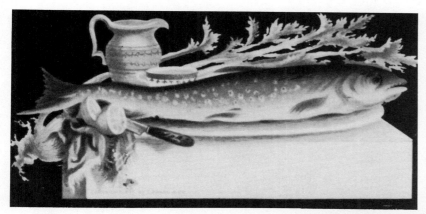

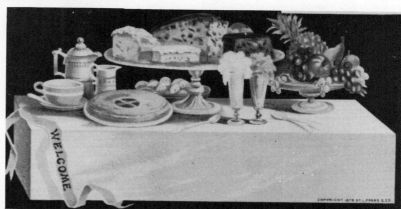

Christmas Salad, 1876. Lobster, Eggs, Celery, after painting by R. D. Wilkie. *Hallmark Historical Collection.*

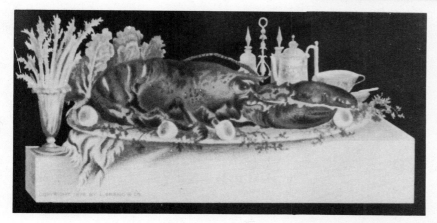

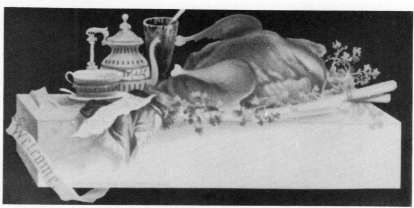

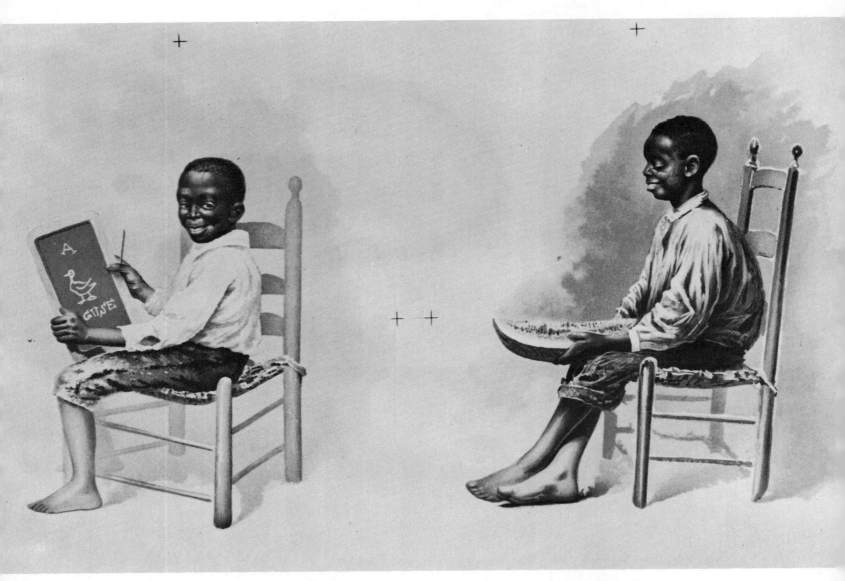

(a) *The Artist* (boy with drawing). (b) *The Gourmand* (boy with watermelon). Chromos by L. Prang & Co., after paintings by J. H. Moser, ca. 1890. *Hallmark Historical Collection.*

The International Yacht Races of September 1885, 1886, and 1887 were also recorded in Prang's chromos. For these pictures Prang engaged artists who were specialists in their fields: J. O. Davidson, J. G. Tyler, and Henry Sandham, who was known for his paintings of sports, a series of which he painted for Prang. Early in the 1870s Prang had printed four scenes from the Life of Columbus from watercolor copies by Henry Farrar after paintings by F. M. W. Turner. These included *Columbus at La Rabida; Departure of Columbus; Dawn on America;* and *The Landing.* The original paintings from which the lithographs were made were sold in the 1875 sale of Prang's paintings. For the World's Columbian Exposition in Chicago, May to October 1893, Prang lithographed a series of pictures of the life of Columbus after paintings by Victor A. Searles. These included *Departure of Columbus; Arrival of Columbus; Landing of Columbus; Return of Columbus,* and *Death of Columbus.* Prang also published a World's Fair Calendar for 1894 and a painting, *Columbus' Caravels in Sight of Land,* by J. G. Tyler. However, the most important souvenir that Prang printed of the Chicago Exposition was *Columbia's Courtship,* a booklet that was a picture history of the United States with verses and twelve designs in color by the English artist Walter Crane. This is a rare and attractive item. [Prang also printed a map of the Centennial grounds which had a wide distribution. Prang had an exhibit of chromos and original paintings in his Centennial booth. These included watercolors by Samuel Colman, Louis Tiffany, Winslow Homer, William Trost Richards, Miss Fidelia Bridges, Thomas Hill, Thomas Moran, and James M. Hart. There were oil paintings by Bierstadt, Lily Spencer, and Elihu Vedder. The important Yellowstone chromos were also on view.]

Prang purchased the majority of the pictures that he reproduced in his chromos and half chromos. The paintings were hung in a gallery at the plant and also in Mr. Prang's home. Other paintings were borrowed from private owners. The important *Sunset: California Scenery* after A. Bierstadt was "lithographed from the Original in possession of Miss Eliza Bierstadt" according to the label on the back of the chromo, while the series of watercolors of Yellowstone country were painted to order for Prang by Thomas Moran. Prang sent the artist John R. Key to California to paint the landscape series of California scenes and Louis K. Harlow was also sent to California to paint the California missions. The portraits of George and Martha Washington were crayon drawings from copies of the Stuart portraits in the Boston Athenaeum made for Prang by Fabronius, and Edward Moran's *Launching the Life Boat* was lithographed from a small copy made to Mr. Prang's order by Moran. A small copy of Thomas Hill's "Yosemite Valley," which was used in making the chromo, was painted for Prang by Mr. Hill. Mr. Prang owned *The Birthplace of Whittier* by Thomas Hill and also the well-known *Barefoot Boy* and *Boyhood of Lincoln* by Eastman Johnson. Since the paintings *The Boyhood of Lincoln* and *The Birthplace of Whittier* appear in the catalogue of the sale of 1870 and also in the catalogue of the 1875

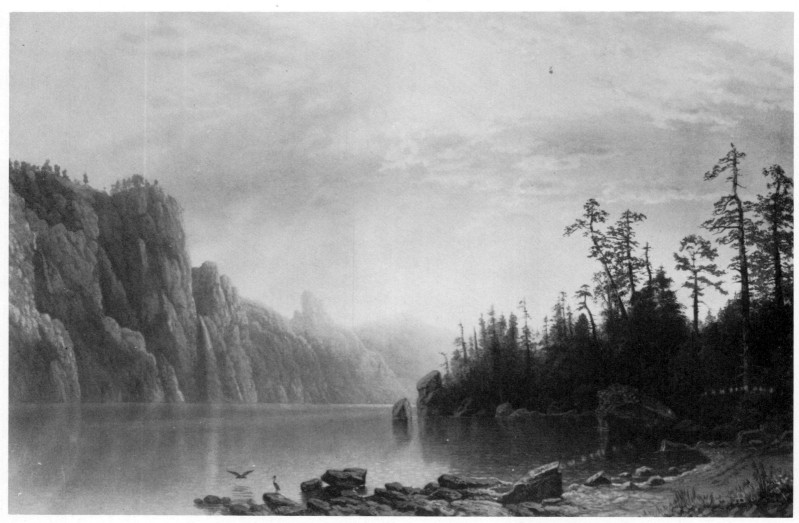

Sunset: California Scenery. Chromo (18 × 12 inches). L. Prang & Co., after painting by A. Bierstadt, 1868. *Hallmark Historical Collection*.

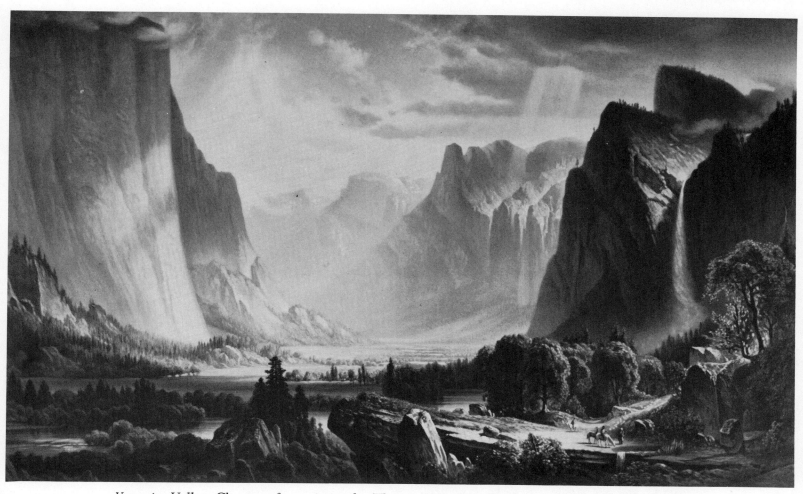

Yosemite Valley. Chromo, after painting by Thomas Hill. *Print Collection, Boston Public Library*.

PEREMPTORY SALE,

Tuesday and Wednesday, December 7 and 8, 1875.

OIL AND WATER-COLOR PAINTINGS,

FROM THE COLLECTION OF

LOUIS PRANG, ESQ., BOSTON.

NOW ON FREE EXHIBITION DAY AND EVENING

AT THE

ART ROOMS, 817 BROADWAY, N. Y.

TO BE SOLD BY AUCTION

ON THE EVENINGS OF

TUESDAY AND WEDNESDAY, DEC. 7 AND 8,

AT THE PLACE OF EXHIBITION,

SALE TO COMMENCE AT EIGHT O'CLOCK.

The Messrs. LEAVITT, Auctioneers,

Catalogue.

FIRST EVENING'S SALE.

N. B.—The paintings marked ⁙ have been chromo-lithographed in the celebrated establishment of Messrs. L. Prang & Co., Boston.

GEO. C. LAMBDIN, N. A., *Philadelphia*

1 Wisteria. Black panel.

GEO. C. LAMBDIN, N. A., *Philadelphia*

2 Blush Rose and Ivy. Black panel.

GEO. E. NILES, *Boston*

3* Sledding.

W. BOEHM, *Dresden*

4 Rembrandt and Saskia van Ulenburgh

(*Copy after Pembrandt. Original in the Royal Gallery at Dresden*)

Pages from Prang's Peremptory Sale catalogue, 1875.

sale it would seem that perhaps different-sized paintings were sometimes used for different-sized chromos of the same subject.

From time to time Prang sold his paintings, at one time under financial stress in a Peremptory sale. There are existing catalogues of four sales. Although all of the pictures in the sales had not been made into chromos, a comparison with the sale catalogues and the lists of chromos in the various Prang catalogues gives interesting data about the original pictures, the chromos, and the artists. The selling prices of some of the pictures are marked in several catalogues but there is no indication of who bought the pictures. Since many of these late nineteenth cen-

M. J. HEADE, *New York*

36* Flowers of Hope.

GUSTAV SÜS, *Dusseldorf*

37* Stealing is a Sin.

ARTHUR PARTON, *New York*

38* Haymakers Fording a Creek. Sunset.

J. WILMS, *Dusseldorf*

39* Still Life.

LUDWIG VOLTZ, *Munich*

40 Cattle-piece.

A. T. BRICHER, *New York*

41* On the Saco River, North Conway, N. H.

A. T. BRICHER, *New York*

42* Twilight on Esopus Creek, New York.

JOSEPH COOMANS, *Brussels*

43* The Farewell.

PHIL. HOYOLL, *London*

44 A Difficult Calculation.

PHIL. HOYOLL, *London*

45 Done at Last!

MISS ELLEN ROBBINS, *Boston*

46* Wild Flowers — Columbines, etc. (Water-color).

MISS ELLEN ROBBINS, *Boston*

47* Wild Flowers—Anemones, etc. (Water-color).

JOHN G. BROWN, N. A., *New York*

48* Three Tomboys.

MRS. L. L. WILLIAMS, *Boston*

49 Cat's-Cradle. (Water-color).

ARTHUR TURNER, (formerly of Boston.)

50 On the Upper Mississippi.

ARTHUR TURNER, (formerly of Boston.)

51 Upper Mississippi. Eagle Point, Dubuque, Iowa.

J. BENEDICTER, *Munich*

52 In the Old Castle at Heidelberg.

J. C. WIGGINS, *New York*

53 On the Hudson.

tury American paintings that were made into chromos by Prang are being collected today, the catalogues of Prang sales can give important and useful information. The catalogues may also be helpful in assigning not only original titles of pictures but in some cases a correction of the artist who painted them. For example, in my book *Collecting American Victorian Antiques* I used the painting *Raspberries and Ice Cream,* which had been sold to a New York collector with a forged signature of Harnett. This picture is listed and illustrated as *Dessert No. V* by C. P. Ream under Dining-Room Pictures in the 1878 catalogue of L. Prang & Company.

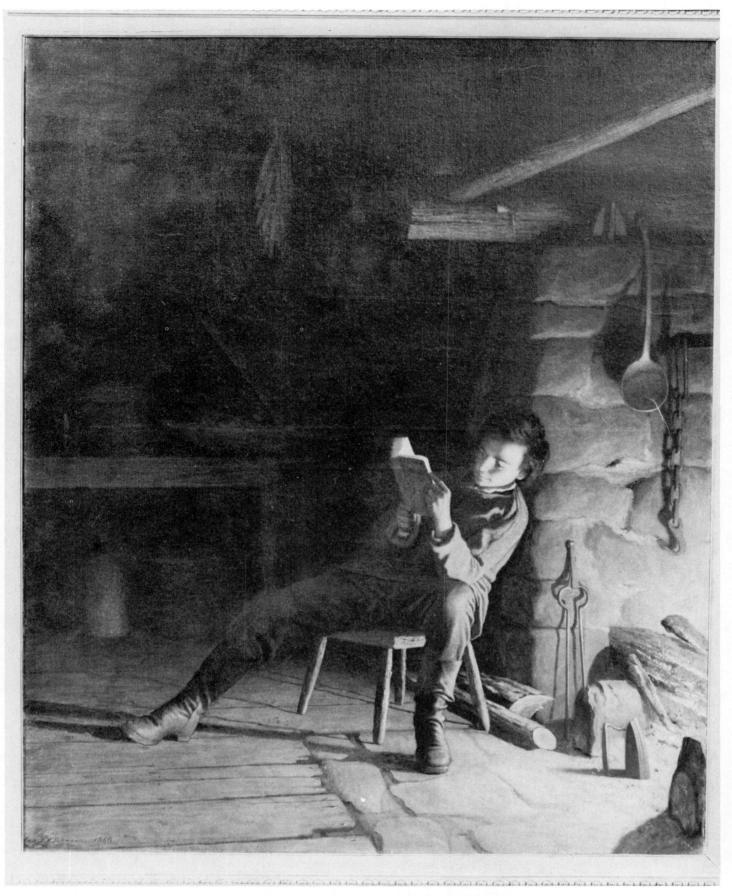

Boyhood of Lincoln, oil painting by Eastman Johnson, 1868. Chromo was made of this painting by L. Prang & Co. *The University of Michigan Museum of Art, Ann Arbor, Michigan.*

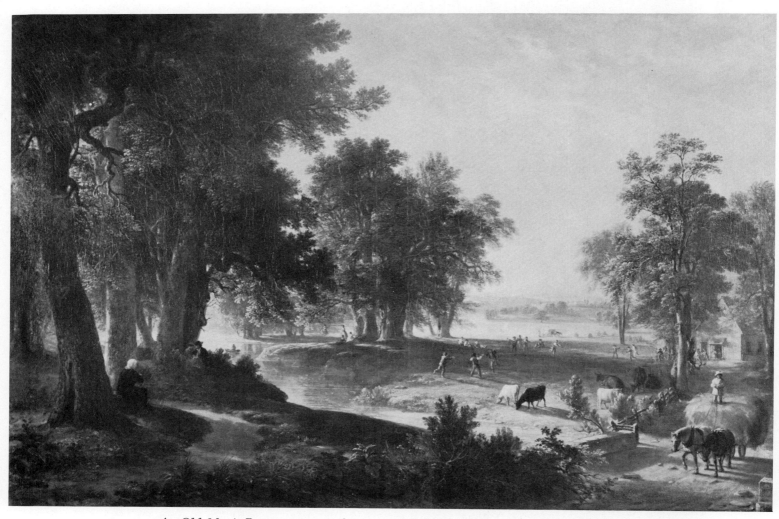

An Old Man's Reminiscences, oil on canvas by Asher B. Durand, 1845. Chromo was made after this painting by L. Prang & Co. *Albany Institute of History and Art.*

In March 1870 Prang sold between one hundred and fifty to two hundred paintings at the Leeds Art Galleries, 812 Broadway, New York. Included in this sale was Thomas Hill's *Birthplace of Whittier* for which Prang (according to a "List of Prices Paid Artists" in the Hallmark Collection) paid the artist $675. At the sale the painting sold for $225. It is now in Whittier's home, Haverhill, Massachusetts. In this same sale the small copy of Hill's *Yosemite Valley* sold for $550. John G. Brown's popular children's pictures *Queen of the Woods, Little Bo-Peep,* and *Playing Mother* sold for $375, $305, and $105 respectively. Their present whereabouts are not known. *The Family Scene in Pompeii* by Coomans, from which one of the earliest and most highly valued chromos was made, sold for $395. Eastman Johnson's *Boyhood of Lincoln,* for which Prang paid Johnson $800, sold for $700 and the small painting of the *Barefoot Boy,* perhaps the most popular of all Prang chromos, sold for $420. Other paintings of particular interest in this sale were the first two paintings that A. F. Tait made for Prang, the *Group of Chickens* and *Group of Ducklings,* which sold for $140 and $65 respectively.

On December 7 and 8, 1875, there was a Peremptory Sale of Oil and Water-color Paintings from the collection of Louis Prang, Esq. at the Art Rooms, 817 Broadway, New York. The sale was conducted by Messrs. Leavitt, Auctioneers. Included in the sale were 205 pictures by both American and European artists. Pictures of special interest to collectors today that were included in this sale were A. T. Bricher's *Scenes of the Hudson, Lake George; The Maiden's Rock on Lake Pepin, Mississippi River; Barn Bluff, Red Wing, Minnesota;* and *Mountain View near Mt. Gregor opposite Prairie du Chien,* and *Bluffs at Homer on Mississippi.* George C. Lambdin's *Water Lilies* on black panel, *White Lilies, Moss Roses, Calla Lilies, Tea-Roses,* and *Blush-Roses* on black panel were included in the sale as were A. F. Tait's *Cocker Spaniel and Woodcock, Pointer and Quail,* and *Maternal Affection,* A. B. Durand's *Reminiscences of an Old Man,* and paintings by Benjamin Champney. Thomas Moran's Yellowstone series and the series of California scenes by John R. Key were also in the sale. Two other pictures of particular interest because of their great popularity as chromos were *Little Prudy* and *Little Prudy's Brother* by Mrs. Elizabeth Murray. The complete list of artists included in the sale was as follows:

ARTISTS REPRESENTED IN THE PEREMPTORY SALE OF DECEMBER 7, 8, 1875.

AMERICAN

Beard, J. H., N.A., New York	Brown, John G., N.A., New York
Brevoort, J. R., N.A., New York	Cass, Geo. N., Boston
Brewerton, Col., Newport	Champney, Benj., Boston
Bricher, A. T., New York	De Haas, M. F. H., N.A., New York
Bridges, Miss F., Brooklyn	Durand, A. B., N.A., New York

Everett, Mrs. S. E., Boston
Farrar, Henry, New York
Ferguson, H. A., New York
Fuechsel, Hermann, New York
Gerry, Samuel L., Boston
Granberry, Miss Virg., New York
Gregory, Miss A. M., Boston
Hamilton, Jas., Philadelphia
Hart, Jas. M., N.A., New York
Heade, M. J., New York
Hill, Thomas, San Francisco
Irving, J. Beaufain, New York
Johnson, Eastman, N.A., New York
Kaufmann, Theod., Washington
Key, John R., Boston
Kuntz, Chas., New York
Lambdin, Geo. C., N.A., Philadelphia
Loveridge, Clinton, New York
Ludlow, Miss A. Ines, New York
McCord, Herbert, New York
Moran, Thomas, Newark
Morviller, J., Boston (deceased)

Munger, Gilbert, New York
Murray, Mrs. Eliz., New York
Nehlig, Victor, N.A., formerly
 New York
Niles, Geo. E., Boston
Parton, Arthur, New York
Perkins, Granville, New York
Ream, C. P., New York
Reinhart, B. F., New York
Remington, Miss E. H., New York
Robbins, Miss Ellen, Boston
Rossiter, T. P., New York (deceased)
Schiertz, Leo, Boston
Scott, Julian, New York
Tait, A. F., N.A., New York
Turner, A. M., formerly of Boston
Wiggins, J. C., New York
Wilkie, Robt. D., Boston
Williams, Mrs. L. L., Boston
Williams, Virgil, San Francisco
Woodward, J. D., New York

FOREIGN

Anderson, Mrs. Sophia, London
Bache, Otto, Denmark
Benedicter, J., Munich
Boehm, W., Dresden
Buchser, Franz, Solothurn
Cauwer, Leopold de, Belgium
Coomans, Joseph, Brussels
Dieffenbach, H. A., Paris
Eschke, Hermann, Berlin
Fohrbeck, Berlin
Gebler, O., Munich
Giron, C., Geneva
Gude, Hans, Düsseldorf
Holzhalb, R., Zurich
Hoyoll, Phil., London
Lemmens, E., Rotterdam (deceased)
Meyer, von Bremen, Berlin

Peel, Miss Florence, London
Roffe, W. J., London
Searle, Helen, Düsseldorf
Schick, Rudolph, Berlin
Schutze, W., Munich
Spitzweg, Carl, Munich
Süs, Gustav, Düsseldorf
Van Deegham, Th., Belgium
Van Severdonck, F., Brussels
Van Wyngaerdt, A. J., Rotterdam
Voltz, Friederich, Munich
Voltz, Ludwig, Munich
Waagen, Adalbert, Munich
Werner, Carl, Hamburg
Wieschebrink, Franz, Düsseldorf
Wilms, J., Düsseldorf

In February 1892, Prang sold another group of oil and watercolor paintings at the American Art Galleries, 6 East 23rd Street, New York. The sale lasted three days and paintings included the important Thure de Thulstrup and Julian O. Davidson Civil War battle scenes, and Thomas Moran's Yellowstone water-

colors including *Mosquito Trail, Rocky Mountains of Colorado* which was No. 345. This picture is now owned by Hirschel & Adler, New York. Also included in the sale were Tait's *The Dash for Liberty; The Intruder; Kluck Kluck;* and *Take Care;* Henry Sandham's Sports Series, and pictures by J. Wells Champney. William Trost Richards' *Sand Hills of New Jersey; Almy's Pond, Newport, R.I., Brandywine Creek, Pennsylvania,* and *Shores of Narragansett Bay;* Winslow Homer's *Sketch in Gray, Sketch in Color,* and *Spring* and a large group of Christmas cards were also included. In all there were about 450 pictures in the sale. The sale catalogue gave a description of each picture and a short biographical sketch of the artist and many of the pictures were illustrated. The sale disposed of the majority of the important paintings. The following is the list of artists whose paintings were included in the sale:

LIST OF ARTISTS REPRESENTED IN THE L. PRANG & CO. SALE AT AMERICAN ART GALLERIES IN FEBRUARY 1892.

Aubert, Jean
Barclay, J. E.
Beckwith, James Carroll
Beers, Jan van
Birkinger
Blashfield, Edward Howland
Bloodgood, Robert F.
Borris, Albert
Bouvier, A.
Bragger, C.
Bricher, Alfred Thompson
Bridges, Fidelia
Brissot, Felix Saturnin, de Warville
Brown, Matilda
Brownscombe, Jennie
Bunker, D. M.
Caliga, I. H.
Cass, George N.
Champney, Benjamin
Champney, J. Wells
Church, F. S.
Coleman, Charles Caryll
Coomans, Joseph
Dangon, Victor
Davidson, Julian O.
De Haven, F.
Dewing, T. W.
Dielman, Fred.
Dillon, Julia
Dolph, J. H.
Douzette, Louis

Doyen, G.
Duffield, Miss
Edwards, George Wharton
Emmet-Sherwood, Rosina
Enneking, John J.
Eschke, Oscar
Fenn, Harry
Field, Mrs. L. B.
Fisher, Ellen T.
Flory, Madame
Fortuny, Mariano
Fredericks, Alfred
Freer, Fred. W.
Garcia, R.
Gaugengigl, Ignaz Marcel
Giacomelli, Hector
Gibson, W. Hamilton
Gifford, R. Swain
Grant, C. R.
Graves, Abbott
Greatorex, K. H.
Halsall, William F.
Hardy, Miss A. E.
Harlow, Louis K.
Harper, William St. John
Hill, R.
Hill, Thomas
Hirschberg, Mrs. Alice
Hirt, H.
Homer, Winslow
Hoyall, Philip

Humphrey, Lizbeth B.
Insley, Albert
Irving, J. Beaufin
Janus, Virginia
Jenks, Phoebe
Johnson, Miss
Johnson, Eastman
Kiesel, C.
Laird, Alicia H.
Lambdin, George C.
Lossow, Heinrich
Low, Will H.
Mazzanovich, J.
McCord, George H.
McEntee, Jervis
Meyer, Johann Georg, von Bremen
Miessner, Alfred
Miller, W. von
Mitchill, Bleecker N.
Moradei
Moran, Leon
Moran, Percy
Moran, Thomas
Morviller, J.
Moser, James Henry
Murphy, J. Francis
Nefflin, Paul
Nehlig, Victor
Nile, George E.
Nowell, Annie C.
Parker, Elizabeth
Peirce, H. Winthrop
Peters, Anna
Pope, Alexander
Redmond, Frieda Voelter
Reinhart, Benjamin Franklin
Richards, W. T.

Rivoire
Robie, Jean-Baptiste
Robinson, Will S.
Rogers, F. W.
Sandham, Henry
Satterlee, Walter
Schachinger, G.
Schmidt, Auguste
Sears, Sarah C.
Seibert
Semenowski, E. Eisman
Silsbee, Martha
Taber, Florence
Tait, Arthur F.
Thulstrup, Thure de
Tiffany, Louis C.
Turner, A. M.
Turner, C. Y.
Turner, Ross
Tyler, James G.
Unknown
Vedder, Elihu
Volk, Douglas
Vollmer, R.
Wagner, Ferdinand
Waugh, Frederick J.
Waugh, Ida
Weir, J. Alden
Welch, Thad.
Weldon, C. D.
Werner, Carl
Wheeler-Keith, Dora
Winn, Susie A.
Wright, George
Wylie
Zogbaum, Rufus F.

There were still many small oil and watercolor paintings left. After L. Prang & Company merged with Taber Art Company in 1897 and the business moved to Springfield, a final clearance sale of pictures, including small sketches and odds and ends, was held at Copley Hall, Boston, December 1 through 8, 1899. There were 1,515 individual pictures both oil and watercolor. These consisted of calendars, valentines, a few Christmas cards including the 1881 and 1884 Prize Cards of Maud Humphrey, the Dora Wheeler Prize Cards of 1881, and the Will H. Low Prize Card of 1884. There were also designs for china painting, flowers, and small landscapes. Except for watercolors by Winslow Homer, including *Eastern Shore, North Woods,* and *Blue Point Oysters* and paintings of

chickens and deer by A. F. Tait, the paintings in this sale hold less interest for today's collectors of American nineteenth century painting. However, the beautiful series *Birds and Flowers* and *Months and Flowers* by Fidelia Bridges were in the sale. Also, the Columbus Series by Victor A. Searles and the Louis K. Harlow pictures of California missions which were in the sale should be of historical interest today.

The list of artists whose paintings were in the sale at Copley Hall is given in Appendix II.

Although there is no record of who bought the pictures at any of the sales, the whereabouts of some of them is known today. Several large paintings of the Yellowstone by Thomas Moran are in the Capitol at Washington, D.C. Thomas Moran's watercolor of *Mosquito Trail, Rocky Mountains of Colorado* was recently in the possession of the New York dealer Hirschel & Adler. The original watercolor of Winslow Homer's *The North Woods* is in the Currier Gallery of Art in Manchester, New Hampshire. A group of the watercolors of the Civil War land battles by Thure de Thulstrup including *Battle of Antietam, Battle of Kenesaw Mountain, Holding the Pass at Allatoona, Siege of Atlanta, Battle of Shiloh, Battle of Spottsylvania,* and *Sheridan's Final Charge at Winchester* are in the collection of the 7th Regiment in New York City.

Eastman Johnson's *Boyhood of Lincoln* is in the collection of the University of Michigan, Ann Arbor. Thomas Hill's *Birthplace of Whittier* is in Haverhill, Massachusetts, and A. B. Durand's *Reminiscences of an Old Man* is in the collection of The Albany Institute of History and Art. Tait's *Group of Ducklings* was sold by the Old Print Shop, New York, a few years ago but its present location is not known. Some of Prang's pictures are also undoubtedly in museum collections but until recently they have reposed in their cellars and are only now being brought out and put on view in their exhibition galleries. Many more of the pictures owned by Prang and from which he made his chromos will come to light now that collectors have become interested in late nineteenth century American painting.

In the original Prang collection owned by Edward Morrill of Boston, there were about one thousand letters written to Mr. Prang from famous persons both in America and Europe. Of special interest were fourteen letters from Whittier. One letter of three pages, written in 1873, was regarding someone pirating the *Barefoot Boy.* A letter from Howard Pyle in 1884 offered to do some Christmas cards. There were also letters from Longfellow, Henry Ward Beecher, Alexander Graham Bell, Barnum, Daniel Webster, Mark Twain, Walter Crane, and many others.

Mr. Prang was known in the art circles of his time and he was on intimate terms with many artists as is evidenced by his correspondence with such artists as A. F. Tait, Edward and Thomas Moran, and Winslow Homer. The letters of these artists to Mr. Prang give interesting information about the artists and their pictures. They are from the Hallmark Historical Collection.

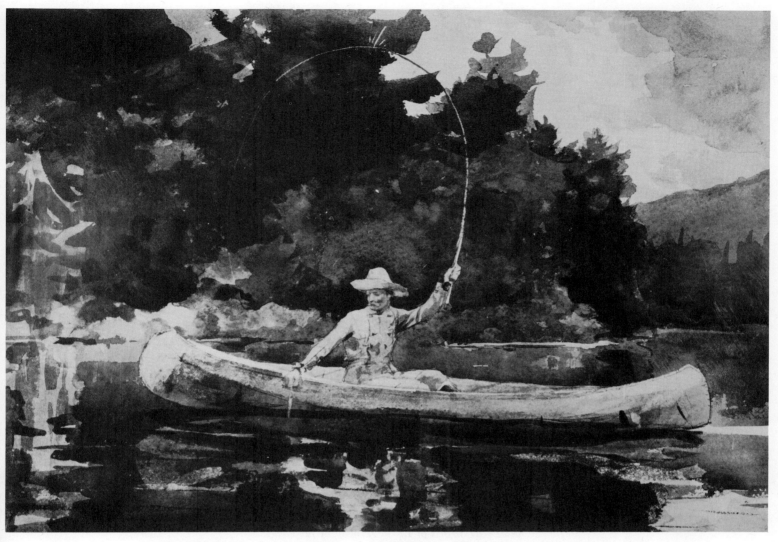

The North Woods, 1894. Watercolor by Winslow Homer from which chromo was made by L. Prang & Co. *Currier Gallery of Art.*

Edward Moran wrote Mr. Prang from Philadelphia, October 27, 1869:

> . . . the Chromo of the Life Boat comes next in order—as regards that—I have changed it so much from the original that it would have been of no use to you whatever and as the others were out I did not think it worthwhile to return it. Now then to the subject matter of the letter before me which is a request that I will send you a "Few lines to enhance the sale and increase the popularity of your Chromo in which I have no pecuniary interest." If you will send me one dozen of the Life-Boat for my own distribution to personal friends and the press I will in reply send you a letter for the public eye that will be all that you could desire.

Two letters to Mr. Prang from Thomas Moran deal with the watercolors of Yellowstone. On December 22, 1873, Thomas Moran writes:

> Your note asking if I was open to take a commission to paint 12 or more water-color pictures of the Yellowstone country was received. . . . In reply I would intimate that my previous transaction with you in a similar business was anything but satisfactory to me inasmuch as I made to your order three illustrations from American poets for which you were to pay me $75. When I sent them to you, you returned them merely saying that you had concluded that the publication of the work would prove too expensive.

On November 8, 1874, Moran writes to Prang:

> Since you were here I have made but one drawing of the series. . . . I have the designs ready to work on of Donner Lake, Twin Lake, Pikes Peak, Summit of the Sierras, Great Salt Lake & the Azure Cliffs of Colorado. Will send on two the latter part of this or the beginning of next week.

A letter from Tait to Mr. Prang reads as follows:

> Y.M.C.A. 23rd St. N.Y.
> Jan. 14, 1883.
>
> L. Prang, Esq. Boston—
> Dear Sir: I am in a fix in money matters and you would relieve my mind and hand if you will send me some either I will repay it or you can apply it to the work if this suits you. try to let me have two hundred dollars if possible. Your friend who was here with you when you last called called yesterday and took 3 or 4 small pictures of chickens and flowers. I shall be glad if they suit if not will try again. You know I am always at your service. Hoping you are well and with kind regards to Mrs. Prang.

Elihu Vedder wrote from the Century Association, 7 West Forty-Third Street, New York.

My dear Mr. Prang:

 My price for the picture the "Keeper of the Threshold" is $2500 but if I could find an immediate purchaser so as not to be obliged to take the picture back to Europe I would let it go for $2000 reserving all rights of reproduction. I understand that in case you find me a purchaser you do not want commission from me—but wish to be considered in the matter of reproduction—do you mean White and Black? Of course I would take you into consideration in case you mean reproduction in black and white if a satisfactory arrangement can be come to with Mr. Clark—but I want to reserve to myself the right to make my retouched reproductions which I find to be very profitable. Should Avery sell the picture in the meantime I could do nothing about it."

<div align="right">

Very truly yours
Elihu Vedder.

</div>

Although there is no record that *Keeper of the Threshold* was ever made into a chromo by Prang, the letter gives an insight into the dealings and also gives one of the reasons why some artists were against chromos—they made more money retouching black-and-white reproductions of their paintings themselves. The picture *Keeper of the Threshold* is now in the Carnegie Institute in Pittsburgh, to which it was given by Mrs. Vedder in 1901. It was painted in 1898 and was probably never sold.

An interesting record of prices that Prang paid for the paintings which he reproduced has escaped destruction and a few cards of the record are now in the Hallmark Collection. It is an incomplete record jotted down in pencil on long cardboard cards and is not dated. However, it gives an insight into the prices that were commanded by certain popular artists such as Ida Waugh and also reveals the meager fees often accepted by such now well-known painters as A. T. Bricher, George C. Lambdin, and Winslow Homer. A partial list of prices is given in Appendix IV.

The identification of Prang's prints and chromos is often a difficult matter. The small trade cards were sometimes put out without the Prang imprint and instead the cards may have the stamp of the company whose goods they advertise. The identification of the large chromos is established by the copyright which appears on the margin at the bottom of the print. Important chromos usually had a printed label on their back such as the one on the first chromo from the painting by Bricher which reads as follows:

<div align="center">

Prang's
American Chromos
Late Autumn in the White Mountains
After A. T. Bricher
Original in the possession of the Publishers
Chromo-Lithographed and Published by
L. Prang & Co.
Boston, Mass.

</div>

Entered according to Act of Congress in the year 1868 by L. Prang & Co. in the Office of the Librarian of Congress at Washington, D.C.

Other smaller pictures and cards were marked with copyright date in the lower corner of the print.

Many prints are signed with the name of the artist and lithographer and this is also a means of identification. If a print margin is trimmed the value is lost since for authenticity the print should show the Prang name with or without the copyright date.

The prize Christmas cards are marked with a label on their back telling the name of the artist and the prize and amount of prize money.

Color and condition of the chromo is also an important consideration. Many of the chromos are found with torn or trimmed margins and this reduces the value.

The chromos of L. Prang & Company hit the taste of the times. His publications along with Currier & Ives and other late nineteenth century lithographers were at one with the people. They pictured the customs, culture, interests, and social activities of the average person. The small cards and certificates provided messages of greeting for births and weddings, and even condolences in time of mourning. Landscape series pictured New York's Central Park, its lake, waterfall, bridges, and rustic summerhouse. There were also scenes of favorite beach and mountain resorts—the Hudson River, the Catskills, the White Mountains, Maine, and the Jersey shore. Other series pictured views on the Erie and Pennsylvania railways, Lake George, and the popular nineteenth century spa at Saratoga with its quaint Victorian springhouses and pavilions. The chromos of paintings sought to teach and to raise the art taste of the many; they were really an expression of the times and echoed the democratic taste of the people. With Prang's chromos, today's collector can not only have the fun of collecting but can also gratify his yearning and nostalgia for things past.

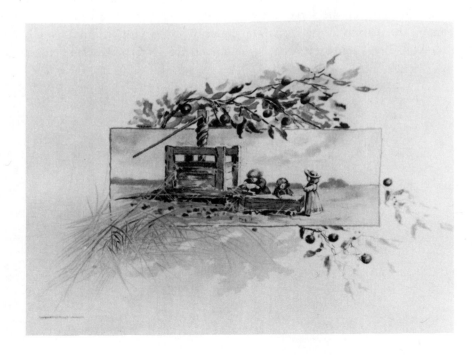

5003.

Leeds Art Galleries,
817 & 819 Broadway.

Henry H. Leeds & Miner,
AUCTIONEERS,
Salesrooms, 93 Chambers and
77 Reade Streets.

CATALOGUE
OF

Mr. LOUIS PRANG'S

COLLECTION OF

PAINTINGS

AND

OTHER WORKS OF ART,

By American and European Artists,

TO BE SOLD AT AUCTION

By Henry H. Leeds & Miner,

AT THE

LEEDS ART GALLERIES, 817 AND 819 BROADWAY,

On ~~Tuesday~~ *Thursday* and ~~Wednesday~~ *Friday* Evenings,

MARCH 17 & 18 1870.

At half-past 7 o'clock.

Now on Exhibition, Day and Evening, until time of sale.

TERMS CASH—CURRENT FUNDS.

A sufficient deposit will be required from all purchasers, at the option of the Auctioneer which deposit shall apply to all goods purchased at this sale.
All purchases must be paid for within twenty-four hours from the day of sale or the deposit will be forfeited and the sale annulled or the goods resold for account of purchaser at the option of the Auctioneer.

John Polhemus, Printer, 102 Nassau Street, N. Y.

22

STUART. (GILBERT)

120 Geo. Washington.
121 Martha do } Companions.

Copied from the originals in the Boston Athenæum, by Fabronius, of Boston. The parts left unfinished in the originals are here supplied. It is well known that the Washington portraits, by Stuart, are the best in existence, and these copies are very faithful.

122 2 Colored Prints.

123 Photograph, Raphael Madonna.

——————

SECOND EVENING'S SALE.

COLMAN. (SAML.) N. Y.

75,00

124 Duck Pond.

A sweet little picture by a great Artist. The only work of Mr. Colman which has as yet been re-produced in Chromo Lithography. This painting was chromoed under the title "Near Bethel" on the Androscoggin, which title turned out to be wrong after it was too late to change it.

DE HASS. (M. F. H.)

Of Rotterdam, now of New York, Pupil of Louis Mayer.

23

255,00 125 Sunset on the Coast

A superb picture and a fine specimen of this Artist's well known Marine Sunsets.

MORAN. (EDW.) PHILA.

200,00 126 Launching the Life Boat.

A smaller copy by the Artist's own hand, and painted to Mr. Prang's order, from the large picture which was exhibited some years ago, creating quite a sensation.

TAIT. (A. F.) N. Y.

127 Group of Chickens.

140,00

If any picture in the U. S. can be said to have a national reputation, it is this one, being the first of Mr. Prang's productions and which proved a great success. The introduction of chromo-lithography into America must date from its publication.

128 Group of Ducklings.

65,00

Companion to the above, by the same artist.

CORREGGIO. (ANTONIO)

129 The Reading Magdalen.

45,00

After the original in the Royal Gallery at Dresden.

LEMMENS. (EMILE) Deceased.

Of Lenlis, Pupil of Lasalle.

24

1125-0 130 The Poultry Yard.

The Pictures of Lemmens, who ranked foremost among the Poultry painters of our day, and is noted for the poetical sentiment, which he infused into his works, are rapidly disappearing from the market, and are consequently becoming more valuable from day to day.

BACON, (Henry.)

Boston, Pupil of Ed. Frere.

75,00 131 The Doctor.

A good specimen of this fast rising young artist, and the only one of his works so far reproduced.

BRICHER, (A. T.)

Of Boston, now of New York.

70,00 132 Early Autumn on Esopus Creek, N. Y.

70,00 133 Late Autumn in the White Mountains.

Two very fine examples of Mr. Bricher's style, and certainly the best known of his works.

BRICHTER, (A. T.)

35,00 134 Spring.

35,00 135 Summer.

35,00 136 Autumn.

35,00 137 Winter.

}Companion pieces.

25

BRICHER, (A. T.)

138 Six American Landscapes.

5,5-0 each

Souvenir of Lake George.
Twilight on Esopus Creek, N. Y.
Sawyer's Pond, White Mountains, N. H.
Mount Chocoma and Lake, N. H.
On the Saco River, North Conway, N. H.
On the Hudson, near West Point.

JOHNSON, (Eastman) N. Y.

Pupil of Ed. Frere.

139 The Boyhood of Lincoln.

780,00

This picture formed the main attraction of the 43d Academy Exhibition, (1868).

JOHNSON, (Eastman,) N. Y.

140 The Barefoot Boy.

420,00

" Blessings on thee, little man.
Barefoot Boy, with cheeks of tan."

The gem of the collection, and truly a representative American picture. Mr. Whittier calls it "a charming illustration " of his little poem, and the cordial reception given to the chromo, proves that poet and painter have touched a cord in the heart of the people. Next to Mr. Tait's " Group of Chicken's," there is not another picture in the U. S., as well and as favorably known as Mr. E. Johnson's " Whittier's Barefoot Boy."

·26

HILL, (Thomas)

Of California, now of Boston. Pupil of Meyerheim.

225,00

141 The Birthplace of Whittier, the Poet.

Mr. Hill, generally known as the California Artist, has painted this picture after a sketch made on the spot, and it has been approved by the poet as an exact transcript of his early home.

HILL, (Thomas)

142 The Yosemite Valley.

550,00

A small copy, painted by Mr. Hill himself to Mr. Prang's order, of his celebrated 6x10 foot picture, which was sold to a wealthy Californian, while on exhibition in San Francisco.

UNKNOWN. (French School.)

21,00

143 Flower Bouquet.

VAN WYNGAERDT, (A. J.) Belgium.

50,00

144 Spring Time.

A charming picture by this excellent Artist.

MORVILLER, (J.) Dec'd.

35,00

145 Sunlight in Winter.

A very fine specimen of this Artist, whose works may be said to be out of the market.

·27

SPENCER, (Lilly M.) N. Y.

50,00

146 Blackberries in a Vase.

One of the best fruit pictures ever painted by this talented lady.

BROWN, (Jno. G.) N. Y.

375,00

147 Queen of the Woods. }

305,00

148 Little Bo-Peep. } Companions.

105,00

149 Playing Mother.

Three fine specimens of this favorite Artist, whose happy delineations of American child life have earned him the name of "Children Brown."

COOMANS, (Pierre Olivier Joseph.)

Of Brussels, Pupil of Van Hasselaere De Keyser and Baron Wappers; several Medals.

395,00

150 Family Scene in Pompeii.

Mr. Coomans' pictures are highly valued, and seldom to be met with at auction sales. The present specimen is one of the best, if not the best, which have found their way to America, and the chromo being the most remarkable production of the art of lithography ever brought out anywhere, has given it a special additional value.

GRANBERY, (Virginia) of New York.

105,00

151 Cherries and Basket.

List of Chromos from 1871 Catalogue

TABLE OF CONTENTS

Chromos	4
Half Chromos	20
Crayon Drawings, etc.	22
Album Pictures	24
Prang's Imperials	27
American Views	28
Card Picture Holders and Albums	29
Miscellaneous Card Publications	30
Prang's Artistic Picture Cards	32
Publications for Schools	33
Motto Cards	40
The Beatitudes of our Lord	46
Illuminated Crosses	47
Illuminated Book-Marks	48
Marriage Certificates	49
Alphabets and Designs	50
Pastimes and Games	52
Juveniles and Toy Books	54
Miscellaneous Publications	56
Steel Engravings	58

CHROMOS
FAC SIMILE COPIES OF OIL AND WATER-COLOR PAINTINGS

All our Chromos are fac similes of Oil and Water-Color Paintings by the best masters. They are artistic copies, and in most cases equal to the originals.

Autumn Leaves—Maple.
Aututmn Leaves—Oak and Elm.
Companion pictures, truthful representations of natural specimens.
Size of plate, 10½ × 14. Price each plate, $1.00.

Wood Mosses and Ferns.
Bird's Nest and Lichens.
Companion pictures, after watercolor paintings by Miss Ellen Robbins. They are favorite pieces for Ladies' rooms.
Size of plate, 10½ × 14. Price each plate, $1.50.

Group of Chickens.
After an oil painting by A. F. Tait.
Size, 10 × 12⅛. Price per copy, $5.00.

Group of Ducklings.
After an oil painting by A. F. Tait. This picture is a companion to our Group of Chickens, and is every way equal to that so much admired picture.
Size, 10 x 12⅛. Price per copy, $5.00.

Group of Quails.
After an oil painting by A. F. Tait. The composition of the Group of Quails is one of the most attractive ever painted by Mr. Tait, and we have endeavored to do justice to its merits.
Size, 10⅛ × 14. Price per copy, $5.00.

Six American Landscapes.
After A. T. Bricher.
Size of each, 4⅜ × 9. Price per set of 6 copies, $9.00.

Names of Pictures

SOUVENIR OF LAKE GEORGE
TWILIGHT ON ESOPUS CREEK, N.Y.
SAWYER'S POND, NEW HAMPSHIRE, WHITE MOUNTAINS
MOUNT CHOCORUA AND LAKE, NEW HAMPSHIRE
ON THE SACO RIVER, NORTH CONWAY, NEW HAMPSHIRE
ON THE HUDSON, NEAR WEST POINT

Early Autumn on Esopus Creek, N.Y.

Late Autumn in the White Mountains

(Valley of North Conway.) Companion pictures, after oil paintings by A. T. Bricher. These two pictures represent well-known landscape scenes, and have been carefully selected for the popularity of the subjects, as well as for their brilliancy of execution, peculiarly adapted to the reproduction in chromo. Mr. Bricher, the well-known landscape painter of Boston, has done his best in preparing the originals, and has watched with great interest the reproduction of his pets by the process of printing. The proofs have satisfied him that artists need no longer look towards England or Germany for a good chromo, and we feel proud of his testimonials to that effect.

Size of each, 18⅝ × 9⅛. Price per pair. $12.00.

The Bulfinch.

The Linnet.

Companion pictures, after paintings in body color by William Cruickshank, of London. These pictures are very excellent copies of masterly originals. The subjects are of a poetical nature, and embody the birds' nests with the birds, who, seeing the spoliation of their most cherished treasures, fall dead, broken hearted.

Size, 7⅞ × 10. Price per pair, $6.00.

The Baby, or Going to the Bath. After Bouguereau.

The Sisters.

Companion pictures. These chromos are the equals of any ever produced. The subjects are exceedingly attractive.

Size, 7 × 9⅜. Price per pair, $6.00.

The Poultry Yard.

After an oil painting by E. Lemmens, the celebrated French fowl painter. This is one of Lemmens's best creations, spirited in drawing, beautiful, harmonious and tender in color. It represents a flock of poultry, attracted by the fall of a flower-pot containing some corn. The splendid rooster, proud in bearing, and with curiosity excited, surrounded by his flighty family of hens, hurrying towards the spot of attraction to gain the first pick, forms a picturesque and life-like scene.

Size, 14 × 10⅛. Price per copy, $5.00.

Poultry Life, A.

Poultry Life, B.

Companion pictures, after E. Lemmens.

Flower Bouquet.

After an oil painting by ———. A bouquet of flowers, magnificent in composition and brilliant in color. Very few pieces of equal merit have ever been produced.

Size, 13¼ × 16¼. Price per copy, $6.00.

Blackberries in Vase.

After an oil painting by Lily M. Spencer. The rich, dark color of the ripe fruit contrast finely with the brilliant hues of the flowers in the companion piece, while the picture is perfect in itself as a beautiful study from nature.

Size, 13¼ × 16¼. Price per copy, $6.00.

Correggio's Magdalen.

After the well-known original in the Dresden Gallery, painted in oil by Antonio Allegri of Correggio, in the sixteenth century. Correggio's name and fame has spread with civilization over all the continents, and it stands highest wherever his works are best known. His Reading Magdalen is famous as a specimen of his peculiar rich and brilliant style of coloring, as well as for its representing woman's beauty to perfection; and copies painted or engraved have found their way into all collections of the connoisseurs of art.

To reproduce the exact style and character of the original painting, and to make such a work available for the million, has been reserved for the art of Chromo-Lithography. We are proud of this achievement of our art, and with confidence do we bring this work before the public, believing that our picture will well compare with the best painted copies ever produced from the exquisite original.

Size, 12½ × 16⅜. Price per copy, $10.00.

Under the Apple Tree.
Rest on the Roadside.

Companion pictures, after oil paintings by Niles, whose happy rendering of scenes in child-life are well known. We give here two of his latest creations, the one a boy occupying himself at a barrel standing under an apple tree, evidently enjoying the result of his labors; the other a little girl, resting at the roadside, amongst grasses, shrubbery and rocks, presenting that bewitching expression of countenance peculiar to girlish meekness and innocence.

Size, 7 × 9. Price per pair, $5.00.

Cherries and Basket.

After an oil painting by V. Granberry. A most effective composition, with brilliant, harmonious coloring. It is one of those pictures which everybody admires, and which cannot fail to sell wherever it is seen.

Size, 13 × 18. Price per copy, $7.50.

Strawberries and Basket.

After an oil painting by V. Granberry. A companion picture to Cherries and Basket, and fully equal to it in merit.

Size, 13 × 18. Price per copy, $7.50.

Kid's Play-Ground.

After an oil painting by A. Bruith. The subject of this picture is a kid playing with a calf, watched by their elders, and attracting even, by their grotesque gambols, the attention of some ducks in a pond near by. We cannot speak too highly of the artistic merits of the painting. The composition, drawing and coloring are exquisite, and we have endeavored to give as close a copy of the beautiful original as our art will allow.

Size, 11 × 17½. Price per copy, $6.00.

A Friend in Need.

After an oil painting by F. Schlesinger. A country scene, composed of a village in the distance, with trees in the middle, and the village pump in the immediate foreground. A happy looking village boy lending his friendly aid to a pretty rustic damsel, who is quenching her thirst at the pump, the handle of which he is plying vigorously. The position of these figures, in connection with the dog, who also enjoys the cooling draught, forms a most interesting group, which is excellently rendered in strong, effective colors.

Size, 13 × 16½. Price per copy, $6.00.

Fringed Gentian.

After a water-color painting by H. R. Newman. The Fringed Gentian is one of the most exquisite flowers of nature; and this is a fac simile of it, drawn in the careful and conscientious style of the pre-Raphaelite school.

Size, 7 × 10⁷⁄₁₆. Price per copy, $6.00.

Easter Morning.

After an oil painting by Mrs. James M. Hart. This is one of the most universally admired chromos that has ever been issued. It is a massive white marble cross, adorned with the most beautiful flowers. We have received letters warmly praising it from the most eminent female authors of America.

The original has the inscription "Easter Morning" on the base of the cross. At the suggestion of many of our friends, we have published an edition of this picture in which the inscription is left out, to enable its use as a memorial plate.

Size, 14 × 21. Price per copy, $10.00.

The Barefoot Boy.
After an oil painting by Eastman Johnson. This is an illustration of the familiar lines of Whittier:

> "Blessings on thee, little man,
> Barefoot boy, with cheek of tan."

It is the portrait of a "young America", in homespun clothing, barefooted, and with that self-reliant aspect which characterizes the rural and backwoods children of America. It is very charming.
Size, 9¾ × 13. Price per copy, **$5.00.**

Sunlight in Winter.
A New England winter landscape, after J. Morviller, an artist who made a specialty of winter scenes, and was admitted to be the best painter of snow in America.
Size, 24⅛ × 16⅜. Price per copy, **$12.00.**

Sunset.
California scenery, after A. Bierstadt. This is one of the best efforts of the artist, and the chromo is also pronounced to be one of the best reproductions ever brought out. It represents a rocky California valley, where nature has remained undisturbed in her grandeur and solitude. The rays of the setting sun have bathed the river, and the rocks on its banks, in a flood of golden light, while impenetrable darkness already hovers over the forest in the foreground.
Size, 18⅛ × 12. Price per copy, **$10.00.**

Horses in a Storm.
After R. Adams. Two horses, one a splendid gray, the other a chestnut horse, fleeing in terror before the storm, which is discharging its thunderbolts in the distance.
Size, 22¼ × 15¼. Price per copy, **$7.50.**

Our Kitchen Bouquet.
After Wm. Harring. A fine group of vegetables, prominent among which is that queen of the kitchen garden, the tomato.
Size, 18¼ × 13⅜. Price per copy, **$5.00.**

The Two Friends.
After Giraud. A little girl playing with a large Newfoundland dog.
Size, 13 × 16¼. Price per copy, **$6.00.**

The Unconscious Sleeper.

After L. Perrault. A little boy asleep in his chair, while a cat is licking the butter from his bread. Companion to the above.

Size, 13 × 16¼. Price per copy, **$6.00.**

Fruit Piece, No. 1.

After C. Biele. Representing grapes, a quince, etc.

Size, 16 × 12. Price per copy, **$6.00.**

The Boyhood of Lincoln.

After Eastman Johnson. This great national picture, painted by the same artist who produced the "Barefoot Boy", is full of artistic excellencies, apart from its associations. It represents the future President, studying a book by the light of the chimney fire in his paternal log cabin. What better picture to have constantly before the eyes of the rising generation? It teaches that in America there is no social eminence impossible to the lowest youth, who, by perseverance, study, and honesty of life and purpose, shall seek to reach the ranks of the rulers of the people.

Size, 16¾ × 21. Price per copy, **$12.00.**

Harvest. (North Conway).

After B. B. G. Stone. Autumnal scenery in the White Mountains.

Size, 8½ × 14¼. Price per copy, **$5.00.**

The Doctor.

After Henry Bacon. A boy trying his medical skill upon his ailing pet—a cat—which evidently does not enjoy the process, judging by the resistance made to the nursing hand. Excellent in drawing, and most comical in effect.

Size, 8⅜ × 11. Price per copy, **$8.00.**

The Crown of New England.

After Geo. L. Brown. This picture presents a daybreak view of Mount Washington and its sisters, taken on the slope of a mountain midway between the valleys of the Connecticut and Androscoggin, late in the month of October. The snows have fallen on the bald summits of the mountains; the early frosts have transfigured the foliage in the valleys; the first rays of light are bathing the hill-sides to the East in a luminous glow; away to the West, in the ravines, the dense darkness of night still gloomily lingers; while in the intervening space, the sun is struggling with the dark shadows of the giant sisters, and the thick mists and vapors of the breaking morn. The original of this chromo was bought by the Prince of Wales, for £1000

sterling, as a companion to the "Bay of New York", which was presented to him by a party of gentlemen when he was visiting this country. These two pictures by Mr. Brown are said to be the only representatives of American art in the gallery at Windsor Castle.

Size, 23⅞ × 14⅞. Price per copy, $15.00.

Six Views in Central Park, New York.

After H. A. Ferguson.

1. NEW YORK CITY, SEEN FROM THE GREEN.
2. THE WATERFALL.
3. RUSTIC SUMMER HOUSE AND CITY (EVENING).
4. IVY BRIDGE, NEAR THE CAVE.
5. THE LAKE AND BOW BRIDGE.
6. THE TERRACE AND LAKE.

These views have been chosen for their varied and picturesque effect from among the many in which the great and beautiful Park abounds, and the artist's conscientious rendering of the same will be appreciated by the resident citizens as well as by the travelling public.

Size of each, 9⅛ × 4½. Price per set, $4.50.

Currants.
Raspberries.

Companion pieces, after Miss Virginia Granberry. It will be unnecessary to say anything in praise of these two pictures. Miss V. Granberry has long been favorably known to the public, not only by the productions of her hand, but also by our chromos after her masterly paintings entitled "Strawberries" and "Cherries", to which the two now offered correspond in size as well as in subject.

Size, 18 × 13. Price per copy, $7.50.

A Companion to "The Barefoot Boy," Wild Fruit.

After George C. Lambdin. This represents a little barefoot girl, leaning listlessly against the trunk of a tree and enjoying some of the wild grapes which she has been gathering from the vines overhanging her head. The demand for a mate to the little "Barefoot" has always been great, and we are glad to say that we have at last succeeded in procuring a picture which is worthy of hanging by its side, not only by the spirit pervading it, but also by its execution.

Size, 9¾ × 13. Price per copy, $5.00.

Sunset on the Coast.

After M. F. H. De Haas. Mr. De Haas is well known as one of the best of American marine painters and has, especially of late, shown his peculiar

powers in fixing upon the canvas the effulgent glories of the sunset, re-
flected from the wastes of the ocean. Our picture is one of the most masterly
productions of the artist in this line, combining the gorgeous coloring of
Turner with a strength and vigor altogether his own. The scene is laid on
some rock-bound shore, upon which a brig has stranded and is left alone,
abandoned to the mercy of the waves and winds. We subjoin the artist's
testimony regarding the faithfulness of our reproduction. Mr. De Haas
writes under date of May 27, 1869:

"Since I received the chromo you sent me, taken from my painting
(Sunset on the Coast), I have been carefully looking over a great many of
those lately published, foreign and American, both imitations of water and
oil paintings, but have so far met with none superior to yours. In imitation
of oil colors, and without having been re-touched by the artist, I think I have
seen none so good as yours. The modulation of the different tints in the sky
and water is very much like the original. I do not doubt but that this publi-
cation will add greatly to your already so well established reputation."
Size, 24 × 13¾. Price per copy, $15.00.

Launching the Life-Boat.

(Companion to the above.) After E. Moran. Mr. Moran ranks second to
none of our American marine painters, and we feel proud, that, in having
reproduced this as well as the previous picture, we have given to the public
two masterpieces of American art, such as have never before been ap-
proached by the hand of the chromo artist. Mr. Moran's picture is in perfect
contrast to Mr. De Haas's. While the latter is glowing with color, the former
is gray and sombre. Here the storm is yet raging in its fury, and the heavens
are covered with black clouds. There it has already spent its force, and
through the riven cloud-veil a flood of light is bursting upon the destruction
which the storm has wrought. There the work of destruction is completed;
the vessel which once bore hopeful hearts towards an unknown goal has
stranded; the hopeful hearts, mayhap, are no more; the struggle is over; the
brig is abandoned, and no sign of life is to be seen, far or near, with the
exception of a few sea-gulls and some sails showing faintly on the distant
horizon. Here the struggle is yet going on. The vessel in distress in the
offing, the life-boat just about to be launched, the crowds of men thronging
the shore, and eager to extend a helping hand to their suffering fellowmen—
all these tell a story which, although totally different, is yet a complete
counterpart of that told by the "Sunset on the Coast." While one may be
called the opening scene of the tragedy, the other illustrates its close.
Size, 24 × 13¾. Price per copy, $15.00.

Baby in Trouble.

After Chas. Verlat. A companion to "The Unconscious Sleeper." A baby,
crying at the top of his voice, and defending himself vigorously against a

large dog, which has intruded upon his breakfast, while a cat is beleaguering him on the other side. We gratefully acknowledge the liberality of Mr. Alvin Adams (of the Adams Express Co.), the possessor of the original, who has generously opened his fine gallery to us, and has allowed us to unfold some of the treasures contained in it to the public. The picture now under consideration is a very fine one, rich in tone and natural in expression, and we have spared no pains to reproduce it worthily.

Size, 13⅛ × 16¼. Price per copy, $6.00.

Pointer and Quail.
Spaniel and Woodcock.

Companions, after A. F. Tait. All we need do to recommend these pictures is to remind our friends of the fact that Mr. Tait is the artist who painted our "Chickens", certainly the most popular and most extensively sold chromo ever published anywhere.

Size of each, 12 × 10. Price per copy, $5.00.

Spring-Time.

Companion to "Harvest," after A. J. van Wyngaerdt. This exquisite little landscape, or we might perhaps appropriately call it this idyl on canvas, is not only a most fitting companion to our popular chromo, "Harvest", on account of its subject, but also on account of its composition. It represents a cool, green meadow, upon which cows and sheep are grazing, bordered on the left by the outskirts of a grove, while towards the right the eye sweeps into the far distance, until it is arrested by the blue hills which close the horizon.

Size, 14¼ × 8½. Price per copy, $5.00.

After the Rains.
Before the Frosts.

Companion pieces after water colors by Miss Florence Peel, of London. These beautiful creations of Miss Peel's brush will be welcomed by all lovers of the floral world. They are brilliant yet tender in color and excellent in execution and composition. The first represents primrose, cyclamen, etc. The second chrysanthemum, late violets, mountain ash berries, etc.

Size of each, 9⅜ × 6⅝. Price per copy, $3.00.

A Family Scene In Pompeii.

After Joseph Coomans. Mr. Coomans is a Belgian artist who almost makes a specialty of family scenes in the days of old Rome, and the one selected by us ranks among his best. This picture recommends itself to the public for various reasons. It is painted by one of the best of living artists; it represents not only a family scene (a mother at work with her needle, while her little

boy is at her side), but also a piece of antique life, thus illustrating the manners of the most powerful nation of antiquity, in a manner which no book or books can ever reach; and lastly, it is the most elaborately finished chromo ever published by us, having required more plates in chromoing it than any other picture so far reproduced by us.

Size, 14¾ × 19. Price per copy, $20.00.

Spring, after A. T. Bricher.
Summer, after A. T. Bricher.
Autumn, after A. T. Bricher.
Winter, after J. Morviller.

Companions. Mr. Bricher has long been a favorite of the public, and is well-known to our friends by his pictures of "Early Autumn" and "Late Autumn". The landscapes painted by him which we now introduce, have already found favor in the eyes of the public, although it is not long since they were published. "Winter," after the lamented J. Morviller is not altogether new to our patrons, being part of the same scene which is embodied in Mr. Morviller's larger picture, "Sunlight in Winter;" yet it is a distinct picture by itself, as can readily be seen by only comparing the sizes and shapes of the two.

Size of each, 12⅞ × 16⅛. Price per copy, $6.00.

Near Bethel, on the Androscoggin.

After S. Colman. A beautiful bit of New England scenery, full of poetical sentiment.

Size, 12⅞ × 6⅞. Price per copy, $4.00.

The Birthplace of Whittier, the Poet.

After Thos. Hill. Mr. Whittier himself writes of this chromo: "The chromo of Hill's picture seems to me one of the best specimens of the art. I cannot see how it could be better. It is the old homestead as it was when I left it thirty years ago."

Size, 26 × 16⅞. Price per copy, $15.00.

Playing Mother.

After J. G. Brown. This is a very pretty companion to our popular chromo "The Barefoot Boy." It represents a little girl who has put on her mother's cloak, cape and hat and is quite sure that everybody will take her for "ma" now.

Size, 9¾ × 12⅞. Price per copy, $5.00

Easter Morning.

After Mrs. Jas. M. Hart. This is a copy reduced in size, of our larger chromo

of the same title. We have only yielded to the wishes of our friends in bringing out this cheap edition.

Size, 6¾ × 10¼. Price per copy, **$3.00.**

The Queen of the Woods.
Little Bo-Peep.

Companions after J. G. Brown. The first of these gems, by a popular delineator of American child-life, represents a beautiful girl of about ten years, crowned with a coronet of wild flowers, and leaning against the trunk of one of the mighty giants of the forest. The second is the picture of a chubby little rogue who has no doubt just run away from his mother and is endeavoring to hide behind the red leaves of a sumach bush.

Size of each, 14⅛ × 18⅛. Price per copy, **$6.00.**

First Lesson in Music.

After T. Lobrichon. The *Boston Journal* says of this chromo: "It represents the 'Dot' of the household receiving from her little sister her first lesson in the art of making a toy trumpet give forth its tone. It is exceedingly well drawn, and the children are pretty types of household blessings."

Size, 15 × 18. Price per copy, **$6.00.**

City Life. After De Vos.
Country Life. After F. Lautenberger.

Companions. Both dog pictures: the first showing two pet dogs lying upon a richly-hung table, amid books and other evidences of learning. The second representing a shepherd's dog sharing his frugal meal with a magpie.

Size of each, 8 × 6¼. Price per copy, **$1.50.**

Scene near Cayuga Lake, N.Y.—Spring.
Scene near Stockbridge, Mass.—Summer.
Scene near Farmington, Ct.—Autumn.
Scene near New Russia, N.Y.—Winter.

Companions after Jas. M. Hart. Mr. Hart, who stands unsurpassed in the poetical rendering of his subjects, has here selected four most beautiful American scenes, and has dressed them in the garb of the different seasons.

Size of each, 16 × 9. Price per copy, **$5.00.**

Travelling Comedians.

Nos. 1 and 2. Companion pieces after De Vos. These two little humorous pictures represent trained dogs and monkeys, ready to enter the circus. They will be especially pleasing to children.

Size of each, 6⅞ × 6½. Price per copy, **$1.50.**

Flowers of Hope. After M. J. Heade.

Flowers of Memory. After Miss E. Remington.

Companions. Mr. Heade's picture represents a branch of trailing arbutus set into a delicate sea-shell, and standing upon the table of a lady's boudoir. Miss Remington's consists of pansies and rosemary, thrown over a couple of volumes of Shakespeare, in illustration of the words of Ophelia: "There's Rosemary, that's for remembrance;—and there is Pansies, that is for thoughts." Size, 14⅜ × 8½. Price per copy, **$5.00.**

Wild Flowers.

Nos. 1 and 2. Companions, after Miss Ellen Robbins. Miss Robbins is a favorite flower painter, and is already well known to our patrons by her exquisite drawings of "Wood Mosses and Ferns" and "Bird's Nest and Lichens."

Size of each, 10 × 7. Price per copy, **$2.00.**

The Joy of Autumn.

After Wm. Hart. This is the most gorgeous chromo ever published. Mr. Hart revels in the bright tints of our autumnal woods, and the picture chosen by us is a very effective specimen of his style. A clump of trees dressed in the red and yellow of their Indian summer costume, relieved against a dark sky, portentous of the coming storm, and illumined by a sudden flash of sunlight, pouring through a broken cloud—these are the elements of a picture so brilliant as almost to dazzle the eye.

Size, 16⅛ × 20. Price per copy, **$12.00.**

Prairie Flowers.

After Jerome Thompson. Mr. Thompson, whose pictures have long since become favorites with the public, has here pictured to us the rich floral garb of our wide, wild natural garden, the pride of the West—the boundless prairie. The main objects in the picture are, however, two children, "Prairie Flowers," as well as the plants surrounding them. This will form an excellent companion to the "Joy of Autumn."

Size, 16⅛ × 20. Price per copy, **$12.00.**

Wild Roses.

After Mrs. Nina Moore. The rich color and natural arrangement of the composition of this chromo will be appreciated by all those who can detect poetry in the wild flowers that grows by the wayside.

Size, 12⅛ × 9. Price per copy, **$3.00.**

View on the Hudson, near West Point.

Lake George.

Companions after Hermann Fuechsel. These chromos represent some of the most lovely scenery on our continent. There is hardly an American traveller who has not visited these two spots, and to all of them they will be welcome mementos of hours delightfully spent, and of places grown dear to them.

Size of each, 26 × 15¼. Price per copy, **$12.00.**

Senator Revels.

After a portrait from life by Theod. Kaufmann. Mr. Revels, as is well known, is the first colored man in the Senate of the United States, where he occupies the chair which was filled by Jefferson Davis, immediately before he was elected to it. Mr. Fred. Douglass, in a letter published in No. 8 of our "Chromo Journal," speaks strongly in favor of this portrait, and Mr. Revels himself bears testimony to its fidelity.

Size, 11 × 13¼. Price per copy, **$3.00.**

Little Prudy.
Little Prudy's Brother.

Companions, after Mrs. Eliz. Murray. We here give the public two of the lovely water-color drawings of this distinguished lady artist, representing, the one a pretty little country girl, the other her younger brother. The girl has gathered some wild flowers, which she is holding in her apron, while the boy is holding out a bunch of grapes, as if offering it to a passer by. These chromos are sold neatly mounted in a mat.

Size of picture, 7½ × 9½ each. Size of mat, 14 × 17 each.
Price per copy, **$4.00.**

The Three Tom Boys.

After John G. Brown. This picture represents three romping girls, who are in the midst of their out-door sports during school vacation. All three have taken possession of one swing, and are each of them trying to make it turn a different way, amid joyous bursts of girlish laughter.

Size, 17 × 21. Price per copy, **$15.00.**

The Maiden's Prayer.

After John G. Brown. A young girl, just arisen from her sleep, and yet in negligee, has clasped her hands in devotion, while her Bible is lying before her on the table. The chamber in which the scene is laid is illuminated by the gray, cool light of the early morning. It is altogether one of the most pleasing productions of this favorite artist.

Size, 14 × 18. Price per copy, **$12.00.**

The Dandelion Girl.
Sledding.

Companions after G. E. Niles. The two pictures by Mr. Niles, "Rest on the Roadside," and "Under the Apple-Tree," which were published by us some time ago, have given a wide popularity to this artist, which will be sustained by those now offered to our patrons.

Size of each, 10½ × 7. Price per pair, $5.00.

Ruggles' Gems.

After Dr. Ruggles. Four charming little pictures by the late Dr. Ruggles, whose small paintings of American scenery were popularly known and appreciated under the title of "Ruggles' Gems."

Size of each, 3½ × 5. Price per set, $3.00.

Little Christel, No. 1.

Three illustrations, by E. Knobel, of the pleasing poem, entitled "Little Christel", having for its theme the command, "Be ye doers of the Word, and not hearers only." The three pictures are set in one mat, with the poem printed underneath in gold letters.

Size of mat, 21 × 13. Price per copy, $3.00.

Little Christel, No. 2.

One of the three illustrations mentioned above, with an extract from the poem.

Size of mat, 11 × 14. Price per copy, $1.00.

Bouquets, Nos. 1, 2, 3 and 4.

Four exquisite water-color paintings, on tinted ground, representing the most beautiful of our garden flowers in various combinations. Mounted on white board.

Size of pictures, 7 × 9⅜. Price per copy, $1.00.

Portrait of Beethoven.

After Fred. Schimon. This portrait of the great maestro is acknowledged to be the best in existence. The original is preserved in the Royal Library at Berlin, and permission to copy it, especially for the purpose of being reproduced by us in chromo-lithography, was obtained through the intercession of Mr. H. Kreismann, U.S. Consul at Berlin. The copy was executed by Mr. Rudolph Schick, and the fact that it is a fac simile of the original, is certified to by the celebrated historical painter, Prof. Carl Becker, of Berlin, and by Dr. Bruns, the Royal librarian, in letters which are in our possession.

Life size, 18 × 23¼. Price per copy, $20.00.

Cabinet size, 11 × 14. Price per copy, $5.00.

Mount Chocorua.

North Conway Meadows.

Companions after Benjamin Champney. Mount Chocorua is one of the finest peaks in the White Mountains of New Hampshire, interesting not only in its natural beauty, but also from the weird Indian tradition attaching to it, which makes it the scene of the death of Chocorua the Indian prophet. The companion picture represents a quiet New England harvest scene, full of lyrical sentiment.

Size of each, 24 × 15. Price per copy, $9.00.

The Storm is Coming. After Jas. M. Hart.

The Close of Day. After Arthur Parton.

Companions. Mr. Hart's picture represents the rising of a thunder storm, whose dark clouds overhang the distance, while the sun is still shining upon the trees in the foreground. A herd of cattle is seen, in an attitude which recalls the lines in Thomson's "Seasons:"

> "In rueful gaze
> The cattle stand, and on the scowling heav'ns
> Cast a deploring eye, by man forsook."

And, in fact, it is by these lines, that Mr. Hart was inspired for the picture. Mr. Parton gives us a sunset on Claverack Creek, Columbia Co., New York. In the middle ground some haymakers, tired with the toil and heat of the day, are fording the creek, homeward bound, with a wagon heavily laden with hay. The trees in the left foreground and those in the distance convey the idea of a meadow enclosed by the forest. But what gives most charm to the picture is the flood of mellow golden light in which the whole is bathed by the setting sun.

Size of each, 24⅛ × 13⅞. Price per copy, $12.00.

Portrait of Rev. Henry Ward Beecher.

After an oil painting from life. The great popularity of Mr. Beecher, who is probably better known throughout the length and breadth of the whole land, than any other living American, will secure a wide circulation to this excellent chromo. We have spared no pains to make it equal to the original and the faithfulness of the likeness is attested by the eminent preacher himself, who writes as follows: "I am no judge of my own likeness but the chromo of Prang's is regarded by my friends as excellent, both in color and in resemblance to the original. I wish you success."

Size, 14 × 17. Price per copy, $5.00.

Maternal Love.

After A. F. Tait. The power of love, be it the love of the youth for the

maiden, of friend for friend, of child for parent, or, purest of all—of the mother for her offspring, has often been the painter's theme. Seldom, however, if indeed ever, has this subject been treated with so much tenderness and refinement as in the picture under consideration, altho' it represents only a deer caressing a fawn in the cool shadow of the forest.

Size, 14 × 10¼. Price per copy, $5.00.

Day's Work is Done.

A companion to "Near Bethel." After Herbert McCord. An evening scene. The orb of day has descended below the horizon, illuminating the western sky with the splendors of the red and gold and purple tints of a summer sunset while the shadows of night have already spread their pall over the landscape. The trees of the distance, the village church with its slender spire, and one or two houses stand out in dark relief against the rich colors of the background, which are visible through the branches of the trees, and the windows of the buildings. All bustle and excitement has ceased, man as well as nature has gone to rest, and silence reigns supreme: "Silence, silence everywhere, on the earth and in the air." It is truly a picture upon which one may gaze, when soul and body are tired.

Size, 12⅞ × 6⅞. Price per copy, $4.00.

Six Views on the Hudson.

After Max Eglau.

Size of each, 9 × 4½. Price per set of 6 copies, $4.50.

Names of pictures.

THE HUDSON, FROM COZZEN'S HOTEL, WEST POINT.

ON THE HUDSON, VIEW OF BREAK-NECK HILL, NEWBURGH IN THE DISTANCE.

VIEW ON THE HUDSON, NEAR WEST POINT. 1.

VIEW ON THE HUDSON, NEAR WEST POINT. 2.

VIEW ON THE HUDSON, NEAR WEST POINT. 3.

VIEW ON THE HUDSON, NEAR CATSKILL.

These views are the same size as "Six American Landscapes," and "Six Views in Central Park, N. Y." They are exceedingly pleasing, and will serve very well as mementos of the charming scenery on the Hudson, of which they are literal transcripts.

Lashed to the Shrouds.

(Farragut passing the forts at Mobile.) After Theod. Kaufmann. This is a most spirited historical picture, representing the gallant old Admiral, as he appeared when he had himself tied to the rigging of his flagship and when upon the report that torpedoes were in the way, he shouted back "Damn the torpedoes! Go ahead!"

Size, 20½ × 25¼. Price per copy, $10.00.

Madonna.

After Murillo. The head and bust, life size, from one of Murillo's celebrated "Conceptions". One of the most angelic representations of the virgin mother ever painted. The chromo is a most excellent imitation of the original and will commend itself not only to those who take a religious interest in the subject, but also to the lovers of classic art.

Size, 20½ × 25⅝. Price per copy, $20.00.

Madonna.

After Murillo. The same as the preceding, but showing three quarters of the body, although on the whole smaller in size.

Size, 14 × 18. Price per copy, $10.00.

The New England School-House.

After Miss A. M. Gregory.

The Log Cabin.

After J. H. Gregg. Companion pieces. The first represents the New England school-house, symbol of our eastern civilization as Whittier describes it when

> "A winter sun
> Shone over it at setting,
> Lit up its western window-panes,
> And low eaves icy fretting."

While the second shows the log cabin, surrounded by the trees of the forest in their summer robes, the pioneer sitting before it with gun by his side, thus typifying the somewhat rude life of our hardy settlers.

Size of each, 18 × 13. Price of each, $5.00.

The Wayside Inn.

After Thomas Hill. The old country house here represented, with the surrounding trees, glad in all the glory of an American autumn, is an exact portrait of the Inn "in Sudbury town" where Longfellow has laid the scene of his "Tales of a Wayside Inn". It is therefore not only interesting as a very fine work of art, but will also prove acceptable to the many admirers of our great poet.

Size, 26 × 18. Price per copy, $15.00.

Trout.

Pickerel.

Companions by Geo. N. Cass. These two pictures will be valued by all sportsmen, while at the same time they will form excellent decoration for the dining-room. "Trout" represents summer, "Pickerel", winter.

Size of each, 21 × 14. Price of each, $7.50.

Dessert, No. 1.
Dessert, No. 2.

Companions, after R. D. Wilkie.

Very beautiful dining-room pictures. No. 1 representing grapes, apples, peaches, nuts together with lemons, a handsome pitcher and a glass of lemonade; No. 2, a fine vase with some flowers surrounded by plums, bananas, oranges, a pineapple, a broken cocoanut and a dish of strawberries, etc. Rich in color and novel in design.

Size of each, 10¼ × 15. Price of each, **$5.00.**

Dessert, No. 3.
Dessert, No. 4.

Companions, after C. P. Ream.

What we have said about Dessert, No. 1 and 2, is equally applicable to these two pictures, although they are totally different in design, in color, and even in shape. No. 3 represents plums in an elegant mother-of-pearl stand, around which are grouped a white grape, a peach, and a knife; No. 4 gives us raspberries in a similar stand, accompanied by a plate of ice-cream, a plate with cake, and a blue grape.

Size of each, 10 × 12. Price of each, **$5.00.**

Nasturtiums.
Petunias.

Companions after Miss Christine Chaplin.

Two exquisite water-colors, representing large bouquets of these favorite flowers.

Size of each, 12 × 19. Price of each, **$2.00.**

Pastoral Scene.

After James M. Hart. Trees, meadows and brook, laughing in the sunlight of a lovely spring-day, a girl reading and a number of sheep at rest, these together combine to make a picture, as sweet and as poetical as any yet painted by this celebrated artist.

Size, 24¼ × 13¾. Price per copy, **$15.00.**

Bouquet of Moss Roses.

After a water-color painting by Mrs. O. E. Whitney.

Size, 10 × 12. Price per copy, **$1.00.**

CATALOG OF PRANG PICTURE SALE

CATALOGUE
of
LOUIS PRANG'S COLLECTION
SOLD BY PUBLIC AUCTION
OIL AND WATER-COLOR PAINTINGS
FRIDAY, DECEMBER 1,
Beginning promptly at 2.30 P. M.

F. G. ATWOOD.
1. Months (pen and ink).

ALICE W. ADAMS.
2. Four Child Studies.

GRACE BARTON ALLEN.
3. Lilies.
4. Roses.

W. N. BARTHOLOMEW.
5. Beach at Ebb Tide.
6. Road to the Shore.

F. G. ATWOOD.
7. Cities (pen and Ink).
8. World's Fair (pen and ink).

E. B. BENSELL.
9. Hunting Scene.
10. Boating Scene.
11. Fishing Scene.

A. F. BELLOWS.
12. Landscape.
13. Moonlight.

GEORGE BARSE, JR.
14. An Old Time Favorite.
15. Female Head.

L. K. HARLOW.
72. Gathering Seaweed.

L. B. COMINS.
73. Figure.
74. Louisa Alcott.

CHARLES COPELAND.
75. Wheeling.

L. K. HARLOW.
76. Landscape.
77. Old Stone Bridge.
78. Landscape.
79. Pines in the Twilight.

FIDELIA BRIDGES.
80. Duck's Paradise.
81. Duck's Paradise.

CHARLES COPELAND.
82. Landscape.

FIDELIA BRIDGES.
83. Duck's Paradise.
84. Duck's Paradise.

LUCY COMINS.
85. Flower Design for China Painting.
86. Flower Design for China Painting.

LOUIS K. HARLOW.
87. Twilight Glow.
88. Golden Twilight.
89. Fast falls the Eventide.

LUCY COMINS.
90. Flower Design for China Painting.
91. " " "
92. " " "
93.
94. Fruit Design for China Painting.
95. " " "
96. " " "
97.

8

WINSLOW HOMER.
16. North Woods.

LOUIS K. HARLOW.
17. Old Toll House.
18. Golden Harvest.
19. Midwinter.
20. Snowbound.
21. Bit of Ailesbury.
22. A Bit of Chelsea.

FIDELIA BRIDGES.
23. Birds.
24. Birds and Landscape.
25. " "
26. " "

HARRY BEARD.
27. Three Fairies.
28. Thanksgiving Card.

MRS. FRANCES BRUNDAGE.
29. Child with Kittens.
30. The Bride.
31. Wild Rose.

ALFRED T. BRICHER.
32. Blue Point Oyster Boats.

W. GOODRICH BEAL.
33. Among the Clouds.
34. Two Landscapes.
35. Three Landscapes.
36. Four Landscapes.

A. VON BEUST.
37. Spring.
38. Summer.
39. Autumn.
40. Winter.
41. Flowers and Butterflies.

A. F. BROOKS.
42. Head.
43. Head.

MAUD HUMPHREY.
44. Valentine.
45. "
46. "
47. Easter.
48. "
49. "

M. W. BONSALL.
50. Age, Four Weeks.
51. Bluebeard's Wives.

M. L. BOURDIN.
52. Roses Die.
53. Violets.

A. F. BUNNER.
54. Venice.

KATHARINE L. CONNOR.
55. Two Roses.
56. A Picture.
57. Spring.

LOUIS K. HARLOW.
58. Birch Point.
59. Old Hemlocks.
60. Pleasant Homes.

KATHARINE L. CONNOR.
61. Summer.
62. Autumn.
63. Winter.

L. K. HARLOW.
64. London View.
65. " "
66. " "
67. " "
68. " "
69. " "

L. B. COMINS.
70. Calendar of Roses.
71. Children Decoration.

11

ELLEN T. FISHER.
98. Wisteria.
99. Flowers.

A. VON BEUST.
100. Flowers and Butterflies.

C. F. GORDON CUMMINGS.
101. Temple Gate at Nikko, Japan.
102. Gateway of Shinto Temple, Japan.

E. CALDWELL.
103. Three Blind Mice.

A. VON BEUST.
104. Flowers and Butterflies.

ELLEN T. FISHER.
105. Tulips.
106. Flowers.
107. Nasturtiums.

A. VON BEUST.
108. Flowers and Butterflies.

PALMER COX.
109. Brownies.

MRS. ARTHUR CARROL.
110. Tulips.

CHRISTINE CHAPLIN.
111. Flowers.

LUCY COMINS.
112. Fruit Design for China Painting.
113. Fruit Design for China Painting.

C. F. DURAND.
114. Easter Design.

FRANCIS DAY.
115. Girl in Costume.

FRIDAY, DECEMBER 1
Beginning promptly at 7.30 P. M.

E. MEYNER.
131. Still Life.
132. Still Life.

ADELE McGINNIS.
133. Sleep.

JAMES H. MOSER.
134. Soup.
135. Good Night.

LEON MORAN.
136. Modesty.

THURE DE THULSTRUP.
137. Grant.

S. A. MULHOLLAND.
138. Landscape.

JAMES H. MOSER.
139. Two Washington Views.

LOUISA MASON.
140. Roses.

FRANK MILES.
141. Love and Youth.

MONTEGAZZA.
142. Strolling Musicians.

MARIANNE MATHIEU.
143. Flowers (California Escholzia).

C. E. McLEAN.
144. Flowers.

MAUD HUMPHREY.
145. Three Valentines. 167. Flowers.
146. Valentine.

L. B. HUMPHREY.

116. Figure.
117. Child.
118. Four Birthday Cards.
119. Bryant's Home.
120. Calendar.
121. Study Head.

F. F. ENGLISH.

122. Monday Rest.

L. C. EARLE.

123. News of the Strike.

KATHARINE L. CONNOR.

124. Lilacs.
125. Fleur-de-lis.

FRANK T. MERRILL.

126. Evangeline Head.
127. " "
128. " "

PERCY MORAN.

129. Shepherdess.

W. McGRATH.

130. Landscape.

HENRY SANDHAM.

216. Wheeling through the Year.

FIDELIA BRIDGES.

217. Flowers.
218. Flowers.
219. Landscape with Birds.
220. Landscape with Birds.

HENRY SANDHAM.

221. Flowers.

VICTOR A. SEARLES.

222. Departure of Columbus.
223. Arrival of Columbus.
224. Landing of Columbus.
225. Return of Columbus.
226. Death of Columbus.

F. B. SCHELL.

227. Fairmount, from Lewis Hill, Philadelphia.

PAULINE SUNTER.

228. Child .
229. Four Fairies.

W. L. TAYLOR.

230. Figure Study.
231. Figure Study.

J. G. TYLER.

232. Shipwreck of St. Paul.

ROSS TURNER.

233. Water-Color Sketch.
234. " "
235. " "

PATTY THUM.

236. Joys of Easter.

F. E. TOWNSEND.

237. Three of a Kind.
238. Handle with Care.

C. Y. TURNER.

239. In the Orchard.

IDA WAUGH.

240.
244. Child Study
245.
246. 241.
247. 242.
248.
249. 243.
250.

ELLEN T. FISHER.

251. Flowers.
252. Flowers.
253. Fleur-de-lis.

W. L. PALMER.

168. Winter.

ELIZABETH F. PARKER.

169. Water Lilies.

WALTER PARIS.

170. Flowers.

WILL S. ROBINSON.

171. Surf.
172. Old Fish-houses, Cape Ann.
173. Solitude.

FIDELIA BRIDGES.

174. Landscape with Birds.
175. Landscape with Birds.

C. RYAN.

176. Flowers.
177. Flowers.

FRANK T. MERRILL.

178. Evangeline Head.
179. " "
180. " "

ANNIE C. NOWELL.

181. Flowers.
182. Flowers.

C. RYAN.

183. Flowers.
184. Flowers.

EMIL H. RICHTER.

185. Mediæval Still Life.

BURNHAM RIGBY.

186. Pastel Head.

WILL S. ROBINSON.

187. Evening.

ELLEN A. RICHARDSON.

188. China Design.
189. " "
190. " "
191. " "

SECOND AFTERNOON'S SALE.

SATURDAY, DECEMBER 2,

Beginning promptly at 2.30 P. M.

FRANK FOWLER.

254. Fancy Head.

MRS. L. B. FIELD.

255. Flowers.

J. G. FERRIS.

256. Washington Dancing the Minuet with Dolly Fairfax.

F. W. FREER.

257. Winter.

E. GRIVAZ.

258. Cats.

VIRGINIA GERSON.

259. Child.

CHARLES P. GRUPPE.

260. Windmill.

MRS. GOODYEAR.

261. Blossoms.

R. B. GRUELLE.

262. Early Morning (East Gloucester).

BESSIE GRAY.

263. Roses.
264. Poppies.

C. RYAN.

192. Flowers.

WILL S. ROBINSON.

193. At Anchor.

L. K. HARLOW.

194. New England Bridge.
195. " " "
196. " " "
197. Evangeline Landscape.

ELLEN A. ROBBINS.

198. Narcissus.

W. T. RICHARDS.

199. Home of Tennyson.

J. J. REDMOND.

200. Landscape.

H. W. RICE.

201. Harbor View.

AUGUSTE SCHMIDT.

202. Flowers.
203. Flowers.

ROSE MULLER SPRAGUE.

204. Mother Goose Figure.
205. Mother Goose Figure.

L. K. HARLOW.

206. Five Sketches.
207. Mt. Desert.

ROSE MULLER SPRAGUE.

208. Mother Goose Figure.
209. " " "
210. " " "
211. " " "
212. " " "
213. " " "

MAUD STUMM.

214. Roses.

MAUD HUMPHREY.

265. Four Children.
266. Violets and Mayflowers.
267. Easter Card.

L. K. HARLOW.

268. Home of Shakespeare.
269. Home of Shakespeare.

W. HAMILTON GIBSON.

270. Bridal Veil.

MARIE GUISE.

271. Chestnut Sorrel.
272. Grey Thoroughbred.

HENDRICKS A. HALLET.

273. Sheep.

IDA WAUGH.

274. Child Study.
275. Child Study.

ALICE HIRSCHBERG.

276. On the Beach.

IDA WAUGH.

277. Child Study.

ALICE HIRSCHBERG.

278. French Chambermaid.

L. B. HUMPHREY.

279. Easter Design.
280. Birthday Card.

ALICE HIRSCHBERG.

281. The First Muff.

LAMBERT N. HOLLIS.

282. Flowers.
283. Two Birds.

L. K. HARLOW.

284. Home of Shakespeare.
285. " " "
286. " " "

L. B. HAZLETON.

287. Four Figures.

L. B. HUMPHREY.

288. Birthday Card.

LAURA C. HILLS.

289. Roses.
290. "
291. "
292. "

W. K. HORTON.

293. Old Garden.
294. Hollyhocks.

IDA WAUGH.

295. Child Study.
296. Child Study.

W. K. HORTON.

297. Roses.

M. J. HUYGHUE.

298. Pond-lilies and Cross.

IDA WAUGH.

299. Child Study.
300. Child Study.

MARY HART.

301. Garland of Violets.

M. A. HARRISON.

302. Poppies.

IDA WAUGH.

303. Child Study.

H. HELMICK.

304. Priscilla.

IDA WAUGH.

305. Child Study.

MRS. TERESA HEGG.

306. Eucalyptus.
307. Crocus.

E. KRATZER.

334. Study.
335. "
336. "

VIRGINIA JANUS.

337. Pansies.

E. KRATZER.

338. Study.
339. Flowers.

F. M. KNOWLES.

340. View of Gloucester.
341. Wharf at Gloucester.

P. KRAMER.

342. Ideal Head.

ALOIS LUNZER.

343. First Opening.
344. Flowers.
345. Five Flower Studies.

PAUL DE LONGPRE.

346. Rose.

M. L. LEWIN.

347. Marine.
348. "
349. "
350. "
351. "

F. N. LAMB.

352. The Attack.
353. The Retreat.

R. MAINELLA.

354. Venice.
355. Egypt.
356. Egypt.

S. A. MULHOLLAND.

357. Landscape.
358. Landscape.

D. HOPKINS.

308. Humorous Sketches.

W. H. HOLMES.

309. "'Deed I Didn't."

H. W. HERRICK.

310. Birds.
311. "
312. "
313. "

LAURA C. HILLS.

314. Roses.
315. "
316. "

MRS. HARCOURT.

317. Venice.
318. "
319. "

L. K. HARLOW.

320. New England Bridge.
321. " " "
322. " " "

ELLEN D. HALE.

323. Angel.

VIRGINIA JANUS.

324. Pansies.

L. B. HUMPHREY.

325. Two Children.
326. Longfellow.
327. Study Head.

VIRGINIA JANUS.

328. Violets.
329. Last Rose of Summer.
330. Pansies.

MAUD HUMPHREY.

331. Valentine.
332. "
333. "

W. A. McCULLOUGH.

359. Watteau Calendar.
360. Watteau Calendar.

ALFRED MIESSNER.

361. Spring.
362. Summer.
363. Six Heads.

EMILY P. MANN.

364. Chrysanthemums.
365. La France Roses.

LOUIS MEYNELLI.

366. Child with Bouquet.

L. K. HARLOW.

367. First Snow Fall.

W. A. McCULLOUGH.

368. Watteau Calendar.
369. Watteau Calendar.

ALFRED MEISSNER.

370. Three Animals.
371. Autumn.

LOUIS MEYNELLI.

372. Figure.

ALFRED MEISSNER.

373. Winter.

LOUIS K. HARLOW.

374. Winter.

J. FRANCIS MURPHY.

375. October.
376. Landscape.

SECOND EVENING'S SALE.

SATURDAY, DECEMBER 2,
Beginning promptly at 7.30 P. M.

J. FRANCIS MURPHY.

377. Winter Scenes.
378. Landscape.

F. SCHUYLER MATTHEWS.

379. Two Valentines.
380. New Year's.
381. Pumpkin Pies.

J. FRANCIS MURPHY.

382. Landscape.

E. MATLOCK.

383. Four Landscapes.

KATHARINE L. CONNOR.

384. Birthday Week.
385. " "
386. " "
387. " "

A. F. BROOKS.

388. Head.

M. W. BONSALL.

389. Happy Family.
390. Madcap Violets.

A. F. BELLOWS.

391. Landscape.
392. Landscape.

L. B. HUMPHREY.

432. Calendar.
433. Four Children.
434. Child and Lamb.

W. GOODRICH BEAL.

435. Night Cometh and Day Dawns.
436. Two Landscapes (monochrome).

L. B. HUMPHREY.

437. Child and Lamb.
438. Holidays.

MRS. ALICE HIRSCHBERG.

439. Girl with Fan.

LAMBERT N. HOLLIS.

440. Flowers.

LAURA C. HILLS.

441. Valentine.

VIRGINIA JANUS.

442. White Cats.

E. KRATZER.

443. Roses.
444. Roses.

LOUIS K. HARLOW.

445. Home from the Mill.

ALOIS LUNZER.

446. Rhododendrons.
447. Tulips.
448. Fruit Piece.

PAUL DE LONGPRE.

449. Flowers.
450. Flowers.

W. K. HORTON.

451. Roses.

M. L. LEWIN.

452. Landscape.
453. Four Small Landscapes.
454. Landscape.

W. N. BARTHOLOMEW.
393. Beach and Boat.

E. B. BENSELL.
394. Boating Scene.
395. Hunting Scene.
396. Fishing Scene.

GEORGE BARSE, JR.
397. Spring.

J. FRANCIS MURPHY.
398. Four Small Landscapes.

GEORGE BARSE, JR.
399. Female Head.

J. FRANCIS MURPHY.
400. Landscape.

FRANCES BRUNDAGE.
401. Rose.

A. VON BEUST.
402. Children and Animals.

FRANCES BRUNDAGE.
403. Lily of the Valley.

L. K. HARLOW.
404. Mt. Desert.
405. Mt. Desert.
406. Two Summer Scenes.

A. VON BEUST.
407. Children and Animals.

HARRY BEARD.
408. Thanksgiving Card.

L. K. HARLOW.
409. Two Winter Scenes.

ALFRED T. BRICHER.
410. Salisbury Beach.

GOODRICH W. BEAL.
411. Four Landscapes (monochrome).
412. Night Cometh and Day Dawns.
413. Night Cometh and Day Dawns.

CHARLES COPELAND.
414. Dreams.

KATHARINE L. CONNOR.
415. Child and Daisies.
416. Yes or No.

CHARLES COPELAND.
417. Two is Company.

KATHARINE L. CONNOR.
418. Birthday Week.
419. " "
420. " "

L. C. EARLE.
421. Philosopher.

LUCY COMINS.
422. Four Flower Studies.

BESSIE GRAY.
423. Roses.
424. Roses.

MAUD HUMPHREY.
425. Two Girls.
426. Easter.

W. GOODRICH BEAL.
427. Night Cometh and Day Dawns.
428. Night Cometh and Day Dawns.

MAUD HUMPHREY.
429. Easter.
430. Easter.

HENDRICKS A. HALLET.
431. Haystacks.

S. A. MULHOLLAND.
455. Sunset on the Lagoon.

F. M. LAMB.
456. Two to One; Watch the Gray.
457. Kremlin at Mystic.

W. A. McCULLOUGH.
458. Happy Days.
459. May Day Party.

W. K. HORTON.
460. Roses.

W. H. HOLMES.
461. "I Done Nothing."

ALFRED MIESSNER.
462. Three Cherubs.
463. Please Write Something for Me.
464. Shadow of the Cross.
465. Girl with Umbrella (Sketch).

EMILY P. MANN.
466. Yellow Roses.

LOUIS MEYNELLI.
467. Artist and Model.
468. Young Farmer.
469. Easter in Heaven.

J. FRANCIS MURPHY.
470. Winter Scene.
471. Winter Scene.

L. K. HARLOW.
472. New England View.
473. Fox Island, Me. (Twilight).
474. Evangeline Landscape.
475. Evangeline Landscape.

F. SCHUYLER MATTHEWS.
476. Fancy Head.
477. Fancy Head.

TUESDAY, DECEMBER 5,
W. L. TAYLOR.
738. Figure Study.
739. Figure Study.

ROSS TURNER.
740. Old Custom House, Salem.
741. House of Dr. Grimshawe, Salem.
742. Old Street, Salem.
743. Hawthorne's Birthplace, Salem.
744. House of Seven Gables, Salem.
L. K. HARLOW.
745. New England View.
746. The Hush of Twilight.

FIDELIA BRIDGES. 747. Months
751. Months and Flowers. 748. "
752. Months and Flowers. 749. "
750. "
KATHARINE L. CONNOR
753. Blossom Time.

G. M. WHITE.
754. Marine.

ELLEN T. FISHER.
755. Mullein.
756. Flowers.

IDA WAUGH.
757. Child Study.
758. Child Study.

MRS. O. E. WHITNEY.
759. Autumn Leaves.
760. Wisteria and Cross.
761. Flower Piece.
762. Flowers.

THADDEUS WELCH.
763. Three Fancy Heads.
764. Three Fancy Heads.

FIDELIA BRIDGES.
765. Birds and Nests.
766. " " "
767. " " "

LOUIS MEYNELLI.
478. Child Studies.

FRANK T. MERRILL.
479. Mayflower Head.
480. Mayflower Head.

ALFRED MIESSNER.
481. Girl with Muff.

LEON MORAN.
482. Girl with Roses.

ALFRED MIESSNER.
483. Bacchus.

ANNIE C. NOWELL.
484. Poppy Slumber Song.
485. Flowers.

WILL S. ROBINSON.
486. The Open Sea.

C. RYAN.
487. Flowers.
488. Flowers.

EMIL H. RICHTER.
489. An Offering.

BURNHAM RIGBY.
490. Pastel Head.

ELLEN A. RICHARDSON.
491. China Design.
492. " "
493. " "
494. " "
495.

ELLEN A. ROBBINS.
496. Flower Piece.

L. K. HARLOW.
497. New England View.

500.
J. J. REDMOND.
498. Landscape.
501.
502
AUGUSTE SCHMIDT.
499. Flowers.

THIRD AFTERNOON'S SALE.

MONDAY, DECEMBER 4,
Beginning promptly at 2.30 P. M.

MAUD STUMM.
503. Mayflowers in Bowl.
504. Violet Bouquets.

W. L. TAYLOR.
505. Figure Study.
506. Figure Study.

L. K. HARLOW.
507. Mt. Desert Views.
508. Six Sketches.

ROSS TURNER.
509. Spring.

W. L. TAYLOR.
510. Figure Study.
511. Figure Study.

IDA WAUGH.
512. Child Study.

THADDEUS WELCH.
513. Blue Hills and Neponset River.
514. Water Lilies.

L. K. HARLOW.
515. Evening Bells.

THADDEUS WELCH.
516. Apple Blossoms.

G. M. WHITE.

517. Marine.
518. Marine.

L. K. HARLOW.

519. Evangeline Landscape.

M. W. BONSALL.

520. Johnny Jump Ups.

IDA WAUGH.

521. Child Study.
522. Child Study.

M. W. BONSALL.

523. Age, Four Weeks.

A. F. BROOKS.

524. Head.

ELLEN T. FISHER.

525. Flowers.
526. Flowers.

IDA WAUGH.

527. Child Study.

ELLEN T. FISHER.

528. Flowers.
529. Flowers.

A. F. BELLOWS.

530. Landscape.
531. Landscape.

W. N. BARTHOLOMEW.

532. Beach Scene.
533. Willows.

A. VON BEUST.

534. Children and Animals.
535. Children and Animals.

L. K. HARLOW.

536. Roadside Birches.
537. Sunset in Rockland Harbor.
538. Old Farm by the Creek.

FIDELIA BRIDGES.

560. Birds and Flowers.
561. " " "
562. " " "
563. " " "

ALICE HIRSCHBERG.

564. Girl with Doll.

LAMBERT N. HOLLIS.

565. Birds.
566. Birds.

LIZBETH B. HUMPHREY.

567. Girl with Basket.
568. Girl on the Bank.
569. Barefoot Boy with Berries.
570. Girl carrying Berries.

W. K. HORTON.

571. Roses.
572. Roses.

VIRGINIA JANUS.

573. Black Cats.

E. KRATZER.

574. Roses.

ALOIS LUNZER.

575. Fruit Piece.

PAUL DE LONGPRE.

576. Flowers.
577. Flowers.

M. L. LEWIN.

578. Landscape.
579. Landscape.

ELLEN T. FISHER.

580. Flowers.
581. Morning Glories.

W. A. McCULLOUGH.

582. Maypole.
583. Four Children.

GEORGE BARSE, JR.

539. Female Head.

MRS. FRANCES BRUNDAGE.

540. Pansy.
541. Violet.

ALFRED T. BRICHER.

542. Far Rockaway.

W. N. BARTHOLOMEW.

543. An Intervale.

ELLEN T. FISHER.

544. Flowers.
545. Clover and Buttercup.

W. GOODRICH BEAL.

546. Three Pen and Ink Sketches.
547. Night Cometh and Day Dawns.
548. Night Cometh and Day Dawns.

CHARLES COPELAND.

549. Sail in Sight.

KATHERINE L. CONNOR.

550. Blossom Time.
551. Blossom Time.

L. B. COMINS.

552. Figure.

FRANCES BRUNDAGE.

553. At the Pump.

BESSIE GRAY.

554. Roses.
555. Roses.

FRANCES BRUNDAGE.

556. Gathering Holly.

MAUD HUMPHREY.

557. Four Little Girls.
558. Calendar.

L. B. HUMPHREY.

559. Meditation.

ALFRED MIESSNER.

584. Little Girl.
585. Baby.

FIDELIA BRIDGES.

586. Four Sea Birds.
587. Birds and Nests.

EMILY P. MANN.

588. Yellow Roses.

L. K. HARLOW.

589. Marine.
590. The Road to the Wharf.

LOUIS MEYNELLI.

591. Child.
592. Easter in Heaven.

J. FRANCIS MURPHY.

593. Two Winter Scenes.

F. SCHUYLER MATTHEWS

594. Fancy Head.

FIDELIA BRIDGES.

595. Birds and Flowers.
596. " " "
597. " " "
598. " " "

FRANK T. MERRILL.

599. Mayflower Head.
600. Mayflower Head.

PERCY MORAN.

601. When the Wedding Gifts Arrive.

LOUIS K. HARLOW.

602. Summer.

ANNIE C. NOWELL.

603. Flowers.

WILL S. ROBINSON.

604. Water-Color Sketch.

ELLEN T. FISHER.

605. Wild Roses.
606. Golden Rod.

L. K. HARLOW.

607. Poetry of the Charles.
608. Two Marines.
609. Landscape.

EMIL H. RICHTER.

610. Dreams.

FIDELIA BRIDGES.

611. Bird Study.
612. " "
613. " "

BURNHAM RIGBY.

614. Pastel Head.

ELLEN A. RICHARDSON.

615. China Design.
616. " "
617. " "

ELLEN A. ROBBINS.

618. Flower Piece.

AUGUSTE SCHMIDT.

619. Flowers.

ROSE MULLER SPRAGUE.

620. Design.
621. Design.

MAUD STUMM.

622. Panel of Pansies.

L. K. HARLOW.

623. Landscape.
624. Landscape.

W. GOODRICH BEAL.

666. Night Cometh and Day Dawns.
667. " " " "
668. " " " "
669. " " " "
670. " " " "

FRANCES BRUNDAGE.

671. First Visit.

FIDELIA BRIDGES.

672. Birds and Flowers.
673. " "
674. " "
675. " "
676. " "
677. " "

FRANCES BRUNDAGE.

678. Waiting.

FIDELIA BRIDGES.

679. Months and Flowers.
680. Months and Flowers.

KATHARINE L. CONNOR.

681. Blossom Time.

MAUD HUMPHREY.

682. Valentine.
683. Valentine.

L. B. HUMPHREY.

684. Study Head.
685. Study Head.

ELLEN T. FISHER.

686. Flowers.
687. Flowers.

L. K. HARLOW.

688. The Bend in the River.
689. Plymouth.
690. Plymouth.

W. K. HORTON.

691. Roses.

THIRD EVENING'S SALE.

MONDAY, DECEMBER 4,
Beginning promptly at 7.30 P. M.

L. K. HARLOW.
625. Two Landscapes.
626. Four Little Landscapes.

FIDELIA BRIDGES.
627. Two Birds and Flowers.
628. Birds and Garden.
629. Birds and Orchard.

C. RYAN.
630. Flowers.

G. M. WHITE.
631. Marine.
632. "
633. "

THADDEUS WELCH.
634. On the Concord River.
635. Old Manse, Concord.

W. L. TAYLOR.
636. Figure Study.
637. Figure Study.

IDA WAUGH.
638. Child and Dolls.
639. Child and Hen.

ROSS TURNER.
640. Sketch.
641. "
642. "

L. K. HARLOW.
643. Home of Shakespeare.
644. Vineyard Haven.
645. Home of Shakespeare.
646. Vineyard Haven.
647. Vineyard Haven.

THADDEUS WELCH.
648. Three Fancy Heads.
649. Three Fancy Heads.

MRS. O. E. WHITNEY.
650. Flower Piece.

CHARLES COPELAND.
651. The Race.

W. GOODRICH BEAL.
652. Night Cometh and Day Dawns.
653. Night Cometh and Day Dawns.

WILL & FRANCES BRUNDAGE.
654. Children at Seashore.
655. Children at Seashore.

IDA WAUGH.
656. Child and Kittens.

ALOIS LUNZER.
657. Still Life.

PAUL DE LONGPRE.
658. La France Roses.
659. Double Cherry Blossoms.

M. L. LEWIN.
660. Marine.
661. Marine.

IDA WAUGH.
662. Child and Doll.

FRANCES BRUNDAGE.
663. Child's Head.

L. K. HARLOW.
664. Evangeline Landscape.
665. On the Sands of Cape Cod.

E. KRATZER.
692. Flowers.

ALOIS LUNZER.
693. Fruit Piece.

L. K. HARLOW.
694. California Mission.
695. "
696. " "
697. New England View.
698. California Mission.

PAUL DE LONGPRE.
699. Study of Purple Lilacs.

L. K. HARLOW.
700. New England View.
701. Six Landscapes.

M. L. LEWIN.
702. Landscape.
703. Landscape.

PAUL DE LONGPRE.
704. La Belle Lyonnaise Roses.

S. A. MULHOLLAND.
705. Looking toward the Grand Canal.

W. A. McCULLOUGH.
706. Fairy Calendar.

ALFRED MIESSNER.
707. Miniature Heads.
708. A Study.

L. K. HARLOW.
709. New England View.
710. Vineyard Haven.
711. Early Snow in the Mountains.

ELLEN T. FISHER.
712. Flowers.
713. "
714. "

L. K. HARLOW.
768. Poets of the Merrimac.
769. " " "
770. " " "
771. " " "
772. " " "

KATHARINE L. CONNOR.
773. Blossom Time.

W. GOODRICH BEAL.
774. Night Cometh and Day Dawns.
775. Night Cometh and Day Dawns.

L. C. EARLE.
776. Busy Day.

ELLEN T. FISHER.
777. Wild Parsnips and Dandelions.
778. Daisies.
779. Flower Piece.

BESSIE GRAY.
780. Roses.

MAUD HUMPHREY.
781. Easter.

L. B. HUMPHREY.
782. Birthday Card.
783. " "
784. " "

LAURA C. HILLS.
785. Valentine.

W. K. HORTON.
786. Roses.

E. KRATZER.
787. Flowers.

ALOIS LUNZER.
788. Fruit Piece.

ALFRED MIESSNER.
715. Study Heads.
716. Three Cat Designs.

EMILY P. MANN.
717. Catherine Mermet Roses.

LOUIS MEYNELLI.
718. Child with Garland.

F. SCHUYLER MATTHEWS.
719. Fancy Head.

FRANK T. MERRILL.
720. Mayflower Head.

ANNIE C. NOWELL.
721. Flowers.

FIDELIA BRIDGES.
722. Birds and Flowers.
723. " " "
724. " " "
725. " " "
726. " " "
727. " " "

ELLEN A. RICHARDSON.
728. China Design.
729. China Design.

L. K. HARLOW.
730. A Quiet Inlet.
731. New England View.
732. The Mountain Stream.

ELLEN T. FISHER.
733. Mullein and Ox-eyed Daisies.
734. Azaleas.
735. Iris.

BURNHAM RIGBY.
736. Pastel Head.

ROSE MULLER SPRAGUE.
737. Head.

L. K. HARLOW.
789. New England View.
790. " " "
791. " " "

BESSIE GRAY.
792. Poppies.
793. Roses.

ANNIE C. NOWELL.
794. Flowers.
795. Flowers.

ALFRED MIESSNER.
796. Ideal Head.
797. Secrets.
798. Shakespeare Heads.

LIZBETH B. HUMPHREY.
799. Two Easter Cards.
800. Easter Design.

PAUL DE LONGPRE.
801. Morning Glory.
802. Morning Glories.

L. K. HARLOW.
803. Marine Sketch.
804. " "
805. " "
806. Home of Shakespeare.

ANNIE C. NOWELL.
807. Flowers.

W. A. McCULLOUGH.
808. Fairy Calendar.
809. " "
810. " "

ALFRED MIESSNER.
811. Caught in the Storm.
812. Children and Dolls Dancing. (After Ida Waugh.)
813. Four Children.
814. Two Children.

FRANK T. MERRILL.
815. Mayflower Head.

LOUIS MEYNELLI.

816. Figure.

MAUD HUMPHREY.

817. Valentine.
818. "
819. "

J. FRANCIS MURPHY.

820. Five Sketches.

FIDELIA BRIDGES.

821. Birds and Nests.
822. " " "
823. " " "

C. RYAN.

824. Flowers.

ELLEN T. FISHER.

825. Flower Piece.
826. Philadelphia Lilies and Daisies.

L. K. HARLOW.

827. Evangeline Landscape.
828. Landscape.
829. California Mission.
830. " "
831. " "
832. " "
833. " "
834. " "
835. " "
836. " "

ALFRED MIESSNER.

837. Head (red crayon).
838. Head " "

L. K. HARLOW.

839. Evangeline Landscape.
840. Millstream.

FIDELIA BRIDGES.

841. Months and Flowers. 901.
842. " " " 902.
843. " " " 903.
844. " " " 904.

IDA WAUGH.

886. Child Study. 905.
887. " " 906.
888. " " 907.

MRS. O. E. WHITNEY.

889. Flowers.

THADDEUS WELCH.

890. Three Fancy Heads. 891
TUESDAY, DECEMBER 5,

G. M. WHITE.

892. Marine.
893. "
894. "

M. L. LEWIN.

895. Marine. 908.

ELLEN T. FISHER

896. Flowers. 909.

THURE DE THULSTRUP.

928. Grant.

LOUIS K. HARLOW 910.
911.
929. Windmill on Long Island.
930. Connecticut Creek. 912.
931. Anchored. 913.
932. Evening Rest. 914.
915.

J. R. DeCAMP.

933. Lincoln (charcoal). 916. Char Sketch.

A. C. FENETY.

934. Crayon Head.

C. A. REIS.

935. Crayon Head.

L. K. HARLOW.

936. Eight Monochromes.
937. Black and White Landscape.

J. FRANCIS MURPHY.

938. Landscape (black and white oil). 922.
939. Landscape (monochrome). 923.
940. " " 924.
941. " " 925.
942. " " 926.
943. " " 927.

L. K. HARLOW.

845. Mt. Desert.
846. Seashore Twiligh..

MAUD HUMPHREY.

847. Valentine.

WINSLOW HOMER.

848. Eastern Shore.

ROSS TURNER.

849. Gallows Hill, Salem.
850. Old Bakery, Salem.
851. An Old Wharf.

MAUD HUMPHREY.

852. Three Girls.

L. B. HUMPHREY.

853. Figure.
854. Birthday Card.

ALICE HIRSCHBERG.

855. Girl in Field.

PAUL DE LONGPRE.

856. Rêve d'Or Roses.

L. K. HARLOW.

857. Mt. Desert.
858. New England View.
859. Mt. Desert.

ROSS TURNER.

860. Old Witch House, Salem.

ELLEN T. FISHER.

861. Flowers.
862. "
863. "

M. L. LEWIN.

864. Landscape.
865. Landscape.

ALFRED MIESSNER.

866. Study Heads.
867. Four Girls in Blue.
868. Four Heads.

ANNIE C. NOWELL.

869. Flowers.

F. SCHUYLER MATTHEWS.

870. Fancy Head.

MRS. J. FRANCIS MURPHY.

871. Landscape.

WILL S. ROBINSON.

872. On the Docks, Cape Ann.

E. H. RICHTER.

873. Japanese Still Life.

BURNHAM RIGBY.

874. Pastel Head.

ELLEN A. RICHARDSON.

875. China Design.
876. China Design.

AUGUSTE SCHMIDT.

877. Flowers.

MAUD STUMM.

878. Carnations.

ROSE MULLER SPRAGUE.

879. Head.

W. L. TAYLOR.

880. Figure Study.
881. Figure Study.

L. K. HARLOW.

882. New England View.
883. Marine Sketch.

ROSS TURNER.

884. Ancient Court, Salem.
885. Old Ward House, Salem.

MRS. O. E. WHITNEY.

944. Panel of Pansies.
945. Autumn Leaves.

SUSIE A. WINN.

946. Animals Playing Games.
947. " " "
948. " " "
949. " " "

L. K. HARLOW.

950. Black and White Landscape. 917.
951. " " " " 918.
952. " " " " 919.
953. " " " " 920.

ABBOTT THAYER.
SUSIE A. WINN.

921. Study
954. Tiddle-de-Winks.

THADDEUS WELCH.

955. Study.
956. Head.
957. Three Fancy Heads.
958. Three Fancy Heads.
959. Scene near Norwood, Mass.
960. Emerson's Home, Concord.
961. Wayside Inn, Concord.
962. Haying, Concord.
963. Golden Rod.
964. Flowers.
965. Flowers.

R. D. WILKIE.

966. Sketch of the Holy Land.

W. J. WHITTEMORE.

967. Winter Scene.

MRS. L. L. WILLIAMS.

968. Cat's Cradle.

JOHN L. WOOD.

969. On the Pier.

HAROLD B. WARREN.

970. Springtime on the Height.
971. After the Rain.

ROBERT BLUM.

988. The Bridal Tour.
There are ships on the sea and tides flowing.
There are shouts of the loud merry crew.

LEON MORAN.

989. The Rice of Plenty.
Who shall say memento mori?
Who this day shall doubt or fear?

DORA WHEELER.

990. The Voyage of Life. 991.
Smiling away with the full tide flowing,
1007. But ah, there never was yet a sea
1008. That knew not of rain or of mad storm blowing;
And turning of tides continually.

UNKNOWN. 1012.
1013.
1009. Six Boston Views. 1014.
1010. Six Boston Views. 1015.
1011. Twelve White Kittens. 1016.

JOAQUIN MILLER. 1017.
1018.
991½. Unpublished Poem. 1019.
1020.
F. B. TOWNSEND. 1021.
1022.
992. Easter Design. 1023.
1024.
FLORENCE MACK. 1025.
1026.
993. Pastelle.

BEARD.

994. "Won't Speak to You Again!"

PHIZ. 881.)

995. Three Comical Pictures.
996. Three Comical Pictures. 1003.

E. S. T.

997. Crayon Head.
998. Crayon Head. 1004.

UNKNOWN.

999. Vase with Flowers. 1005.
1000. Escape of Gen. Putnam.
1001. Game.
1002. California Pepper Tree. 1006.

LAURA WOODBURY.

972. Birds and Cardinal Flowers.
973. Birds and Apple Blossoms.

K. WITKOWSKI.

974. Two Children.

LOUIS K. HARLOW.

975. Golden Gate.
976. Sutro Heights and Seal Rocks.
977. Giant Redwoods.
978. Drive to Monterey.

J. CALLOWHILL.

979. Bride Roses.

ELLEN T. FISHER.

980. Roses.
981. Orange Blossoms.

ROSINA EMMET.

982. Before the Altar.
 Crowned with a crown that is all-beholding,
 The orange bloom and the myrtle bay.

DORA WHEELER.

983. The Wedding Ring.
 Pure as water the jewel gleaming;
 Endless as love is the wedding ring.

ROBERT BLUM.

984. The Wedding Day.
 Scatter white roses; a road of roses,
 Scattered by maidens where she may tread.

PERCY MORAN.

985. Going from the Church.
 From the threshold of God's altar—
 Bells may peal and men may pray.

ROSINA EMMET.

986. The Toast.
 Drink the bride's health: "Thou art sacred
 As this shining goblet's brim."

FREDERICK DIELMAN.

987. Cutting the Bridal Cake.
 The bridal cake! As a song that singers
 Stand mute before and thrill as they stand.

WEDNESDAY, DECEMBER 6,

GEORGE F. BARNES.

1043. Christmas Design.

WALTER SATTERLEE.

1044. Christmas Design.
1045. " "
1046. " "

E. H. BLASHFIELD.

ROBERT F. BLOODGOOD.

1048. Christmas Card.

WALTER SATTERLEE.

1049. Christmas Design.
1050. Christmas Eve.

ELLA F. PELL.

1051. Easter Figure.
1052. Easter Design.

WALTER SATTERLEE.

1053. Four Heads.

L. B. COMINS.

1054. Christmas Design.
1055. Christmas Design.

ROSINA EMMET.

1056. Christmas Card.

ELIHU VEDDER.

1057. Christmas Design.

F. S. CHURCH.

1058. Christmas Design.
1059. Christmas Design.

MAUD HUMPHREY.

1060. Christmas Design.
1061. Christmas Design.

I. H. CALIGA.

1062. Christmas Design.

C. C. COLEMAN.

1063. Christmas Design. (Third Prize, 1881.)

W. S. COLEMAN.

1064. Decoration.
1065. Decoration.

ROSINA EMMET.

1066. Christmas Design.

L. B. HUMPHREY.

1067. Christmas Design.
1068. " "
1069. " "

T. W. DEWING.

1070. The Light of the World.

L. D. DE WITT.

1071. Merry Christmas.

W. L. TAYLOR.

1072. Christmas Card.
1073. Christmas Design.

F. S. CHURCH.

1074. Christmas Card.

FREDERICK DIELMAN.

1075. Christmas Design. (Third Prize, 1881.)

ROSINA EMMET.

1076. Merry Christmas.
1077. Merry Christmas.

F. W. FREER.

1078. Christmas Design.

ALFRED FREDERICKS.

1079. Christmas Design.

JENNIE BROWNSCOMBE.

1080. Christmas Design.
1081. Christmas Design.

W. GOODRICH BEAL.

Night Cometh and Day Dawns.
 " " " " " "
 " " " " " "

FIFTH EVENING'S SALE.

WEDNESDAY, DECEMBER 6,

Beginning promptly at 7.30 P. M.

CHRISTMAS CARDS AND PRIZE DESIGNS.

PITOU.

1129. Santa Claus.

H. WINTHROP PIERCE.

1130. Christmas Design.

WALTER SATTERLEE.

1131. Christmas Design. (Third Popular Prize, 1881.)
1132. Christmas Design.
1133. Valentine.
1134. Birthday.

ROSE MULLER SPRAGUE.

1135. Christmas Design.
1136. Christmas Design.

HENRY SANDHAM.

1137. Christmas Design.
1138. New Year's Design.

T. L. SMITH.

1139. Christmas Card.
1140. " "
1141. " "

JENNIE BROWNSCOMBE.

1142. Christmas Design.
1143. Christmas Design.

L. B. COMINS.

1144. Christmas Design.

MAUD HUMPHREY.

1082. Christmas Design.
1083. A Kiss to My Sweetheart.
1084. Christmas.
1085. "
1086. "

WALTER SATTERLEE.

1087. Christmas Design.
1088. " "
1089. " "
1090. " "

L. B. HUMPHREY.

1091. Christmas Design. (Third Prize, 1881.)
1092. " "
1093. " " (Boston Card Prize, 1884.)

MAUD HUMPHREY.

1094. Christmas Design.
1095. Christmas Design.

J. CARROLL BECKWITH.

1096. Christmas Design.

ALFRED FREDERICKS.

1097. Christmas Design.

W. HAMILTON GIBSON.

1098. Christmas Design.

LAMBERT N. HOLLIS.

1099. Christmas Design.
1100. Christmas Design.

LAURA C. HILLS.

1101. Six Christmas Designs.

WILLIAM ST. JOHN HARPER.

1102. Christmas Design.

L. Y. IPSEN.

1103. Merry Christmas.

PHŒBE JENKS.

1104. Christmas Design.

ROSINA EMMET.

1145. Christmas Card.
1146. " "
1147. " "

THOMAS MORAN.

1148. Birth of Christ.

ALEXANDER SANDIER.

1149. Christmas Tree.
1150. " Night.
1151. " Night.
1152. " Design.

MISS SHEPHERD.

1153. Christmas Design.

W. L. TAYLOR.

1154. Christmas Card.
1155. Christmas Design.

MAUD HUMPHREY.

1156. This With My Love.
1157. One I Love.

A. M. TURNER.

1158. Christmas Design.

FLORENCE TABER.

1159. Christmas Design.

ELIHU VEDDER.

1160. Christmas Design.

IGNAZ M. GAUGENGIEGL.

1161. Christmas Design.

FREDERICK DIELMAN.

1162. Rebecca.

DOUGLAS VOLK.

1163. Christmas Design.

IDA WAUGH.

1164. Christmas Design.
1165. Christmas Design.

IDA WAUGH.
1166. Merry Christmas.
1167. Christmas Card.
1168. " "
1169. " "

ELIHU VEDDER.
1170. Aladdin.

DORA WHEELER.
1171. Christmas Design.

IDA WAUGH.
1172. Christmas Card.

DORA WHEELER.
1173. Christmas Design.

ROSINA EMMET.
1174. Christmas Card.
1175. Christmas Card.

WALTER SATTERLEE.
1176. Christmas Card.
1177. " Design.
1178. " Design.

THOMAS MORAN.
1179. Christmas Design.

DORA WHEELER.
1180. Christmas Design. (Second Prize, 1881.)

W. L. TAYLOR.
1181. Christmas Design.

DORA WHEELER.
1182. Christmas Design.
1183. Christmas Design.

W. L. TAYLOR.
1184. Christmas Design.

J. CARROLL BECKWITH.
1185. Christmas Design.

FREDERICK DIELMAN.
1186. Christmas Design.

F. LUDOVICI.
1105. Christmas.

MAUD HUMPHREY.
1106. Christmas Design.
1107. With All My Heart.

WALTER SATTERLEE.
1108. Christmas Design.
1109. " Design.
1110. " Card.
1111. " Card.

THOMAS MORAN.
1112. Christmas Design.

THEODORE LIEBLER.
1113. Christmas Card.

WILL H. LOW.
1114. Christmas Design. (Second Prize, 1884.)

ALFRED MIESSNER.
1115. Christmas Design.

F. SCHUYLER MATTHEWS.
1116. Christmas Design.
1117. Christmas Design.

IDA WAUGH.
1118. Christmas Card.
1119. Christmas Card.

F. SCHUYLER MATTHEWS.
1120. Merry Christmas.
1121. Christmas Card.

LEON MORAN.
1122. Christmas Designs.

PERCY MORAN.
1123. Christmas Design.

THOMAS MORAN.
1124. Christmas Design.

DORA WHEELER.
1187. Christmas Design.

D. E. WYAND.
1188. A Merry White Christmas.

THOMAS MORAN.
1189. Christmas Design.

MAUD HUMPHREY
1190. Christmas Design.
1191. " "
1192. " "

UNKNOWN.

ELLA F. PELL.
1193. Christmas.
1194. Christmas Design.

D. E. WYAND.
1195. Christmas Card.

F. S. CHURCH.
1196. Christmas Card.

C. HOWARD WALKER.
1197. Merry Christmas.

THOMAS MORAN.
1198. Christmas Design.

ROSINA EMMET.
1199. Christmas Card.
1200. Christmas Card.

L. B. HUMPHREY.
1201. Christmas Design.
1202. Christmas Design.

J. ALDEN WEIR.
1203. Christmas Card.

C. D. WELDON.
1204. Christmas Design. (First prize, 1884.)

T. L. SMITH.
1205. Christmas Time.
1206. Christmas.
1207. Christmas Time.

1211.
1212.
1213.
1214.
1215.
1216.
1217.
1218.
1219.
1220.
1221.
1222.
1223.
1224.
1225.

WILLIAM H. HUNT.

SIXTH AFTERNOON'S SALE.

THURSDAY, DECEMBER 7
Beginning promptly at 2.30 P. M.

OIL PAINTINGS.

ELLA F. PELL.
1226. Figure Design.
1227. " "
1228. " "

BAIRD.
1229. Hen and Chicks.
1230. Hen and Chicks.

A. BERTSIK.
1231. Contemplation.

E. BRUNELLI.
1232. Kittens.

W. H. BEARD.
1233. New Year Call.

ARTHUR F. TAIT.
1234. Chickens.

F. S. CHURCH.
1235. Idyll.

LILIAN CHERIOT.
1236. An Intruder.

J. CALIFANO.
1237. Coming Storm.

MRS. ODENHEIMER FOWLER.
1238. Study Head.
1239. Study Head.

W. H. HILLIARD.
1240. On the River Geisen, Holland.
1241. Friesland, Holland.

MARSHALL JOHNSON.
1270. Yacht *Mayflower*.

F. LEMMENS.
1271. Barnyard.

THOMAS HILL.
1272. Birthplace of Whittier.

DR. RUGGLES.
1273. Miniature Landscapes.

HENRY SANDHAM.
1274. The Old School House.

W. H. BEARD.
1275. Animal Study.
1276. " "
1277. " "

MRS. S. P. SCHAFER.
1278. A Yard of Pansies.

HELEN SEARL.
1279. Fruit Study.

CHARLES W. STETSON.
1280. By a Pool.

J. G. TYLER.
1281. Vigilant.

PATTY THUM.
1282. Flowers.
1283. Flowers.

ARTHUR F. TAIT.
1284. Chickens.
1285. Deer.

ALEXANDER POPE.
1286. Game Piece.

WADSWORTH THOMPSON.
1287. The Three Pets.

FRANK FOWLER.
1327. Head.

J. G. TYLER.
1328. Viking Ship Approaching Vineland.

A. F. TAIT.
1329. Deer. 1330. Landscape with Pets.

THURSDAY, DECEMBER 7.

SUSIE A. WINN.
1296. Kittens.

THADDEUS WELCH.
1297. Blue Hills.
1298. Landscape.
1299. "
1300. "
1301. "
1302. "
1303. "

H. HELMICK.
1304. Memorial Day.

THADDEUS WELCH.
1305. Landscape.

R. D. WILKIE.
1306. Sketch of the Holy Land.

C. A. WALKER.
1307. Flowers.

FERDINAND WAGNER
1308. Elsa.

THADDEUS WELCH.
1309. Eight Flowers.

FRED J. WAUGH.
1310. Children and Flowers.

C. A. WALKER.
1311. Roses.
1312. Lilies.

1350.
1351.
1352.
1353.
1354.
1355.
1356.
1357.
1358.
1359.
1360.
1361.
1362.
1363.

ELLA F. PELL.

1242. Figure Design.
1243. " Study.
1244. " Study.

FRANK FOWLER.

1245. Head.
1246. Figure.

BLAKELOCK.

1247. Returning Home.

ALFRED T. BRICHER.

1248. Waterfall.

J. W. DUNSMORE.

1249. Figure.

W. H. BEARD.

1250. Owl.
1251. Chickens.
1252. Animals.
1253. "
1254. "
1255. "
1256. "

JEAN ROBIE.

1257. Roses.

J. HIDDEMAN.

1258. Latest News.

J. H. HATFIELD.

1259. Washing Day.

M. A. HEAD.

1260. Mayflowers.

MARSHALL JOHNSON.

1261. Yacht *Galatea*.

THADDEUS WELCH.

1262. Old Manse, Concord.
1263. Emerson's Home, Concord.
1264. Willows near Concord.
1265. Concord River.
1266. Battle Ground at Concord.
1267. School of Philosophy at Concord.
1268. Concord View.
1269. Willows on the Sudbury, Concord.

W. H. BEARD.

1288. Animal Study.
1289. " "
1290. " "
1291. " "
1292. " "

IDA WAUGH.

1293. What Is It?
1294. Children with Chicken.
1295. Prize B

Beginning promptly at 7.30 P. M.

OIL PAINTINGS.

W. H. BEARD.

1313. Puppy. 1331.

F. S. CHURCH. 1332.

1314. Retaliation.

J. FRANCIS MURPHY. 1333.

1315. Landscape (monochrome).

J. G. TYLER. 1334.

1316. Columbus Caravels.

THOMAS MORAN. 1335.

1317. Landscape.

W. H. HILLIARD.

1318. Near Geisen, Holland. 1336.
 1337.

LEON MORAN.

1319. A Winter Girl. 1338.

WM. J. McCLOSKEY.

1320. Oranges. 1339.

J. W. DUNSMORE.

1321. Figure. 1340.

FRANK FOWLER.

1322. Figure.

F. S. CHURCH. 1341.

1323. Cupid's Bath.

72

BESSIE GRAY.

1428. Seven Daisies Dear.
1429. Six Legend of the Rose.
1430. Fifteen Bermuda in June.
1431. Eleven At the Gates of Sleep.
1432. Nine Violet Book and Poets' Garden.
1433. Nineteen Flower Beautiful and Morning Glory.
1434. Seven Nasturtiums.
1435. Twenty Handful of June Pansies.
1436. Fourteen Sweet Peas.
1437. Seven Carnations.

L. K. HARLOW.

1438. Three Sketches.
1439. Seven "
1440. Five "
1441. Eight "
1442. Twelve Autumn Joys.
1443. Four Mayflower Memories.
1444. Seven Poets' Homes.
1445. Ten Marine Views.

ALOIS LUNZER.

1446. Nine Flowers.
1447. Sixteen Orchids.

F. LUDOVICI.

1448. Horse Show.
1449. Dog Calendar.
1450. Dog Show.

A. H. LAIRD.

1451. Nine Flower Studies.

LOUIS MEYNELLI.

1452. Four Homestead.

F. SCHUYLER MATTHEWS.

1453. Eight Chrysanthemums.
1453½. Fish Design for China.
1454. Places that Our Lord Loved.
1455. Come Sunshine. (Eight illustrations.)
1456. Drift Wood. (Twelve illustrations.)
1457. No Sect in Heaven. (Seventeen illustrations.)
1458. Seven Birthday Cards.

FRANK T. MERRILL.

1459. Seven Outlines.

VITA MARVELL.

1460. Old Melodies.

C. RYAN.

1461. Three Flower Studies.

W. R. RIDGEWAY.

1462. Six Birds.

VICTOR NEHLIG.

1364. Don Quixote.

THADDEUS WELCH.

1365. On the Neponset.

WALTER PARRISH.

1366. English Scene.

THADDEUS WELCH.

1367. Jamaica Pond.

CARL KRUEGER.

1368. Spreewald.

F. PERCY WILD.

1369. Coasting.

W. H. HILLIARD.

1370. Geisen, Holland.

ELLA F. PELL.

1371. Figure Design.

C. A. WALKER.

1372. Roses.

IDA WAUGH.

1373. Babies Creeping After Bees.

F. S. CHURCH.

1374. Cupids.

C. A. WALKER.

1375. Peonies.

CONRAD KIESEL.

1376. Study Head.

ELLA F. PELL.

1377. Figure Design.
1378. " Study.
1379. " Study.

J. FRANCIS MURPHY.

1380. Landscape (monochrome).
1381. Landscape (monochrome). 1382.

SEVENTH AFTERNOON'S SALE.

FRIDAY, DECEMBER 8,

Beginning promptly at 2.30 P. M.

HELEN ARDING.

1404. Eight California Flowers.

MRS. J. A. CHAIN.

1405. Six Colorado Views.

HARRY BEARD.

1406. Four Children and Pets.
1407. Morning, Noon and Night.
1408. Cupid a Dunce.

BOCHELER.

1409. Calendar.

KATHARINE L. CONNOR.

1410. Twelve Flower Sketches.
1411. Three Valentines.
1412. Seven Flower Studies.
1413. Six Flower Studies.
1414. Ten Text Cards.
1415. Fifty-two Miscellaneous Designs.
1416. Six Violet Designs.
1417. Five Flower Studies.
1418. Seven Forget-me-nots.

L. B. COMINS.

1419. Sixteen Mistress Polly.
1420. Sixteen Garland of Song.

LUCY COMINS.

1421. Flower Studies.
1422. Four Easter Designs.

EMMA DOUGHTY.

1423. Six Flower Designs.

M. EGLAU.

1424. Twenty-five Hudson Views.

OSCAR ESCHK..

1425. Seven Marines.

ELLEN T. FISHER.

1426. Four Flowers.
1427. Twelve Miscellaneous Flower Studies.

R. B. GRUELLE.

1427½. Old Fort Gloucester.

Beginning promptly at 7.30 P. M.

DR. RUGGLES.

1463. Nine Landscapes.

ROSE MULLER SPRAGUE.

1464. The Shepherd's Dream.
1465. The Man Without a Heart.
1466. Plight of a Princess.

VICTOR A. SEARLES.

1467. California Calendar Design.

MRS. BELLE D. SESSIONS.

1468. Good Wishes for the Season.

W. L. TAYLOR.

1469. Twelve Illustrations.

MISS TALCOT.

1470. Six Flower Designs.

A. THOLEY.

1471. Seven Massachusetts Militia.
1472. Massachusetts Militia.

MRS. O. E. WHITNEY.

1473. Six Crosses.
1474. Six Autumn Leaf Designs.
1475. Thirteen Flower Pieces.

R. D. WILKIE.

1476. Twenty Landscapes.
1477. Six Philadelphia Views.
1478. Nine New England Views.
1479. Six White Mountain Views.
1480. Seven California Views.
1481. Six Connecticut Views.
1482. Six Adirondack Views.
1483. Six White Mountain Views.

ELLEN T. FISHER AND OTHERS.

1484. Twelve Miscellaneous Designs.

LONGPRE AND HUMPHREY.

1485. Studies. 1486. Twelve Designs.

Appendix 4

Prices Paid by Artists

de Longpré
 Lilacs. $60.
 Roses. $60.
 Clematis. $40.
 La France Roses. $40.
 Iris & Lilacs. $60.

P. Moran. Christmas card. $60.

L. K. Harlow. Landscapes, Large $200–$300.
 Small $50–$75.
 Civil War

de Thulstrup. $250, $457.75, $400, Shiloh.

Jo. Davidson. $300–$375. Battle of N. Orleans, Mobile, Port Hudson.

H. Sandham
 Lawn Tennis. $150.
 Skating. $150.
 Tobogganing. $150.
 Bicycling. $150.
 Base Ball. $150.
 Flower piece. $50.

Giacomelli
 Scenes with birds: Sparrows, purple finch, chickadee, cedar birds, etc. $90
 to $200.

W. Satterlee
 Christmas & Easter. Bicycle and Telephone Santa Claus. $20 to $50.

Winslow Homer. Water colors. $40–$50.

J. W. Champney. Landscapes with children. $75–$150.

Brissot. Sheep. $110.

J. F. Murphy
 Months. $50.
 2 Winter Landscapes. $150.

F. W. Freer
 Roses in Fish Glass. $100.
 Heads—Seasons. $100.

C. Y. Turner
 2 Girls in Orchard. $500.

Ross Turner

Morn at Venice, At Anchor, Sunset, Cape May, N.E. Sunset. Roses. $50 each.

G. Barse, Jr.

Head, Old time Favorite. $50.

V. Dangon

2 flowers, Wisteria & Peonies. $100.

A. Lunzer

16 orchids. $14.
2 flowers in Vase. $10.
Chicken in Egg shell. $5.

T. Welch

2 lambs heads. $5.
Apple Blossom. $10.
Poppies #2. $10.
Nasturtiums #2. $20.
Duchesse de Vallombrosa Roses. $20.
Jacqueminot Roses. $20.
Merchant Prince, dog. $20.
Calf head. $40.
Bull head. $40.

F. S. Church

White Fawn. $450.
Lion in Love. $450.
Retaliation. $350.
Idyl. $80.
2 Valentine cards. $175.
Christmas cards. $40.
Children and animals. $150.

J. W. Mazzanovich

4 Seasons. $200.
4 Seasons. $100.

A. F. Tait

7 animal pictures. $233.
2 animal pictures. $67.
Intruder. $200.
"Dash for Liberty." $200.

J. Robie

Wedding Bouquet. $581.

Roses. $400.
Flowers. $1200.
Roses and Jewelry Box. $400.

G. Lambdin
> Azaleas & Roses. Roses and Buds. each $60.

G. Lambdin. Calla Lily. $50.

A. Seifert.
> Child's Head. $125.
> Monk, Nun. $10 each.

J. J. Enneking
> Child with Book. $230.
> Child with Kitten. $250.

T. Hill. "Birthplace of Whittier." $675.

A. T. Bricher
> Water Fall. $10.
> 8 landscapes. $284.

C. Werner
> Temple of Solomon, Job's Well, Cradle of the Savior, Walls of Jerusalem, Milk Grotto, Grotto of Jeremiah, Damascus Gate, Tomb of Judas. $210 each.

Wylie. Water Lilies, Peacock feathers. $25.

Louis C. Tiffany. Landscape. $175.

Harry Beard
> Plaque Cat. $15.
> 3 children & cats. $105.
> Cupid at window. $75.
> 3 Birthday cards, storm, rainbow, sunshine. $225.
> Child, $35; Child head, $15; 4 girls heads, $60; Monkey, $25; Owl, $25.
> 3 birthday cards—Morning, Evening, Night. $225.
> 4 children & animals. $140.
> 2 cupid dances. $100.

J. H. Beard
> Pup. $100. 2 Pups. $200.
> 6 heads Nations. $300.

A. Pope
> Hector. $50. "Sorcerer." $50. Dove. $100.

Frederick Waugh. "Waiting for Santa Claus." $100.

F. W. Rogers
 Large Pup. $300. Small. $150.
 Pup and Hat. $200.
 Terrier, My Model. $150. Setter. $100.

E. Vedder
 1st prize 1881. $150.
 "Aladdin." $300.
 "Goddess." $150.

J. H. Moser. Negroes & heads. $15 each.

Eastman Johnson. "Boyhood of Lincoln." $800.

Geo. N. Cass. Trout, Pickerel. $150 each.

G. Doyen. Child with flowers. $200.

Baird. 2 chickens. $100.
 Copy of Madonna of Chair. $560.

Mrs. E. T. Fisher.
 Flowers: Milkweed, Petunias, Asters, Hollyhocks, Marygolds, Chrysanthemums, Goldenrod and Hemlock, Peonies and Daisies. $150.
 Sweet peas, Tulips, Nasturtiums, Caraway, Thistle and Goldenrod, Wild Parsnips and Dandelion, Garden Iris, Gladiolas, Balm and Spirea, Daisies, Fringed Gentian, Pansies, Magnolia, Cowslips, Wisteria, Snow balls, Wild Roses, Morning glories, Beach, Maple and Oak leaves, ferns, poppies, Blackberries, Moss roses, Dogwood, Zinnias, 4 flowers in baskets. Clover Christmas card. All $100 each.

Miss Humphrey
 Longfellow. $150.
 Whittier. $150.
 Bryant. $150.

Miss Ida Waugh
 Children's Party. $220.50.
 I'm a Daisy. $200.
 Birthday Cake. $125.
 Children and Flowers. $125.
 First Step. $250.
 Prize Babies. $100.
 Walking Match. $100.
 Right or Left. $100.
 Playing School. $125.
 Children's Party. $125.

Index

Illustrations are indicated in italics

Ackermann, Arthur, 42, 90
ad (L. Prang & Co.) in *Modern Art*, *130*
advertising, 62
 advertisements, *64, 65*
 calendars used for, 66–67
advertising items, 59
"Aids to Object Teaching." *See* Trades and
 Occupations
album cards, 4, 32, 34
 birds, *28*, 63
 butterflies, 28
 congratulation, 33
 flowers, 28
 friendship, 33
 Hudson River series, 29
 listed in *Prang's Chromo,* Christmas
 (1868), 32
 nursery rhymes, 33
 photographic likenesses, list of, 34–35
 railroad scenes, 33
 roses on, 91
 seaweed, 28
 shells and seaweed, *color insert 1*
 special occasion, 73
 subjects of, 4, 27
album insertion cards, 34
Album of American Artists, 153
Album Pictures, 32
 in Oil Colors, 30
Albums, Prang
 autograph, 115
 price of, 34
 size of, 33
Almanacs, Capitol, 67
alphabet, illuminated, *127*
Alphabet, Prang's Standard, 126, *127,* 131
alphabets, illuminated, 39
American Antiquarian Society, The, 126
 Prang greeting card collection at, 90
American Art Galleries, sale at, 159, 175,
 195
 artists represented in, 196–97
American Art Gallery
 Christmas card designs exhibited in, 77
 Sale (1892), 159, 161, 175
American Artists, Album of, 153
American Artists, Society of The, 169
American Artists Series, 4
American Chromos, Prang's, list of (1868),
 14
American Coast Scenes, 29, 156
American Crayon Company, 128
American Painting Book, The, 120
American Text Books of Art Education
 (Smith), 131
American Watercolor Society, The, 169
Animal Game Series, 55
animal pictures, 54
April (Bridges), *color insert 2*
Armstrong, G., 177

Art Books, 112, *113*
 list of, 117–18
Art Classes, Normal, supplemental texts
 for, 126
art education
 cards as, 77
 Prang's contribution to, 26
Art Education Series (Smith), 120
Art Educational Supply Catalogue, 120
art instruction books, 127–28
Art Nouveau productions, 22, 25
art novelties, as gifts, 112
art prints on satin, 81, 107, 109, 166
Art Rooms, N.Y., artists represented in
 sale at, 194–95
Arts Series, 62
Art Studies, Prang catalogue of (1888–
 1889), "The Twelve Months" listed
 in, 101
Artist, The (Moser), 186

ARTISTS

Adams, R., *15*
Anderson, Mrs. Sophia, 20, 176, 178
Audsley, 38

Bacon, Henry, *18*
Bailey, Lucy J., 112
Beal, W. Goodrich, 161
Beard, Harry, 54
Beard, J. H., 54
Beard, W. H., 84
Bensell, E. B., 84, 161
Biele, C., 180, 183
Bierstadt, A., 169, 187, *188*
Blakelock, Ralph Albert, 169
Blashfield, E. H., 81
Bloodgood, Robert F., 81
Bonheur, Rosa, 168
Bossett, G., 180
Bouguereau, Adolphe, 168
Bricher, A. T., 5, 6, 17, 159, 169, *172,* 175,
 194, 201
Bridges, Fidelia, 84, 95, 97, 98, 112, 187,
 198, *color insert 2*
Brown, John G., *19,* 20, 169, 175, 194
Brownscombe, Miss Jennie, 84, 98
Bruith, A., *15*
Bushnell, S. W., 136

Caliga, I. H., 81
Callowhill, James, 98, 114, 136
Callowhill, Sydney, 114
Cass, George N., 180, *color insert 2*
Champney, Benjamin, 157, 169, 175, 194
Champney, J. Wells, 169, 196
Church, F. S., 76, 169, *170, color insert 1*
Clements, Miss G. D., 166
Closson, W. B., 161

Cobb, Darius, 36, 151, *152*
Cole, J. Foxcroft, 3, 153
Colman, Samuel, 77, 80, 187
Comins, Lizbeth B., 114, 117
Comins, Lucy B., 41
Coomans, J., 17, 168, 194
Correggio, 168, *168*
Crane, Walter, 187

Davidson, Julian O., 147, *147, 148,* 161,
 162, 187, 195
De Camp, J. R., 36
De Haas, M. F. H., 20, 176
De Vos, 54
Dewing, Thomas, 81
Dieffenbach, 55
Dielman, Frederick, 81, 84
Dow, Arthur W., 67, 128
Durand, Asher B., 169, *193,* 194, 198

Eglau, Max, 153, *155,* 169
Emmet, Rosina, 77, 80, 81, *color insert 1*
Enneking, John J., 169

Fabronius, 36, 187
Farrar, Henry, 187
Ferguson, H. A., 156
Fisher, Mrs. Ellen T., 84, 95, 110, 112, 176
Fredericks, Alfred, 77, 81
Freer, Fred W., 81
Frye, Mary Hamilton, 55
Fuechsel, Herman, 21

Gaugengigl, I. M., 81
Georgi, 22
Giacomelli, Hector, 101
Gibson, W. Hamilton, 81, 101
Granberry, Miss Virginia, 17, 180
Gray, Bessie, 98

Hale, Miss E. D., 166
Half Chromos, Prang's, list of (1868), 14
Halsall, William F., 161
Harlow, Lizzie K., 105, *106,* 107
Harlow, Louis K., 22, 118, 128, 161, 166,
 176, *179,* 187, 198
Harper, W. St. John, 81
Harring, William, 11, 177, 180
Hart, James M., 21, 22, 157, 169, 175, 176,
 187
Hart, Mrs. James M., 92
Hart, William M., 21
Heade, Martin J., 21, 92, *92,* 169
Hegg, Theresa, 95
Herman, 22
Hill, Thomas, 11, 169, 187, *189,* 194, 198
Hills, Laura C., 85
Hirst, Claude Raquet, 65
Homer, Winslow, 4, 17, 30, *141, 142–43,*
 144–45, 169, 177, 187, 196, 198, *199,*
 201

Humphrey, Lizbeth B., 74, 81, 82, 84, 118, 176
Humphrey, Maud, 52, 66, 85, 197

Janus, Mrs. Virginia, 98
Johnson, Eastman, 10, 11, 13, 17, 20, 22, 35, 169, 175, 187, 192, 194, 198
Johnson, Marshall, 161

Kaufmann, Theodore, 36, 37, 38, 120, 183
Key, John R., 156, 157, 157, 187, 194
Kratzer, E., 98

Lamb, F. M., 161
Lambdin, George C., 20, 98, 175, 194, 201, color insert 1
Landseer, Sir Edwin, 168
Launitz, R. E., 131
Lee, Miss Jennie, 17, 38
Lemmens, E., 7, 11
Longpré, Paul de, 95
Low, Will H., 81, 84, 196
Lunzer, Alois, 98, 99, 114, 133

Mathews, F. Schuyler, 41, 67, 90, 105, 112, 114, 176
Moradei, 168, 169
Moran, Edward, 20, 169, 176, 187, 198, 200
Moran, Leon, 64, 65, 84
Moran, Percy, 84
Moran, Thomas, 84, 157, 158, 159, 160, 169, 187, 194, 195, 198, 200
Morse, Eleanor E., 112
Morviller, J., 15
Moser, James H., 183, 186
Mucha, Alphonse, 23, 25
Murillo, Bartolomé, 168
Murphy, J. Francis, 110, 169, 171
Murray, Mrs. E., 20, 52, 194

Nast, Thomas, 47
Newman, H. R., 92
Niles, 17
Nowell, Annie C., 98, 99, 128

Parmenter, Joseph G., 84
Parton, Arthur, 21, 176
Perkins, Granville, 151
Perkins, Lucy Fitch, 55
Pierce, H. Winthrop, 84
"Pilule del," 42, 43

Raphael, 168
Raquet, Claude, 65
Ream, C. P., 180, 183, 184
Rehm-Victor, 22
Reinhart, B. F., 20, 20
Remington, Miss E., 21, 92
Rhead, Louis, 22, 67, 69, 70, 129
Richards, William Trost, 169, 176, 187, 196
Richardson, Ellen A., 41
Robbins, Miss Ellen, 21
Robie, Jean-Baptiste, 95, 107
Ruggles, 17, 153, 154
Ryan, C., 112

Sandham, Henry, 161, 163, 164, 187, 196
Satterlee, Walter, 81, 82
Schimon, Ferdinand, 36
Scott, Julian, 151, 152
Searles, Victor A., 66, 187, 198
Smith, Nancy, 55
Spencer, Miss Lily M., 17, 180, 187
Sprague, Rose Mueller, 52
Steele, T. S., 22
Stuart, Gilbert, 4, 36, 187

Tait, A. F., 5, 7, 17, 76, 169, 172, 173, 174, 187, 194, 196, 198, 200
Taylor, W. L., 114
Thompson, Jerome, 21
Thulstrup, Thure de, 36, 147–50, 151, 195, 198
Tiffany, Louis, 187
Turner, A. M., 84
Turner, F. M. W., 187
Turner, Ross, 101, 169
Tyler, J. G., 161, 187

Vedder, Elihu, 80, 81, 187, 200, 201
Volk, Douglas, 84
Volkman, von, 22

Waugh, Ira, 52, 53, 201, color insert 1
Weir, J. Alden, 84
Welch, Thaddeus, 98, color insert 2
Weldon, C. D., 84, color insert 1
Wheeler, Dora, 77, 78, 80, 81, 84, 197, color insert 1
Whitney, Mrs. O. E., 34, 38, 61, 74, 84, 95, 96, 97, 98, 110–12, 176, color insert 2
Wilkie, R. D., 169, 176, 177, 180, 183, 185
Williams, W. A., 141
Wilms, I., 183
Wilson, Matthew, 36
Winn, Miss S. A., 176, 178
See also prize-winners

Artists, Album of American, 153
artists' groups, 169
Artists' Materials, Illustrated Catalogue and Price List of, 126–27
artotypes, 22
autograph albums, 115
Avery, S. P., 167

backgrounds, greeting card, 77
banneret, satin, 110
Barefoot Boy, The (Johnson), 10, 11
reproduction of, described, 13, 16–17
Base-Ball (Sandham), 163
Battle of Fredericksburg (de Thulstrup), 150
Beauchamp, Ellen, 52
Beecher, Henry Ward, portrait of, 36
beer advertisements, Prang, 63, 64, 65
Beethoven, Ludwig van, portrait of, 36
bird cards (Arm & Hammer), 63
Bird's View Map of Harvard, 3
birth announcement, 72

birthday cards, 74
humorous, 75
black and white prints
fowls, 4
Homer Civil War sketches, 4
booklets, 112
chrysanthemum, cover of, color insert 2
flower, 98
humorous, 44
list of, 105, 107, 114–16
religious, 114
shaped, 105
bookmarks
illuminated, 38, 39
rose, 91
shaped, 112
books
art, 52
art instruction, 127–28
children's, 50, 51, 52, 58
flower, 131
house decoration, 133
humorous, 56, 57
natural history, 131
panorama, 56, 57
Boston Art Club, The, 169
Boston, Athenaeum, The, 139, 187
Boston Public Library, Prang albums in, 63
Bowles, J. M. (ed., Modern Age, art journal), 128
Boyhood of Lincoln (Johnson), 20, 192
broadsides, 59
Bryant Christmas card, 84
Burdick, R., trade card collection of, 63
business cards, 74

calendars, 59, 61, 66–67
California, Sketches for, 67
children's, 66
decorative, 66, 67
extension, 61
poster, 67, 69
Seashore, Sketches for, 67
World's Fair, 187.
See also trade cards
California Calendar, Sketches for, 67
Calkins, Norman (co-author with Mrs. A. M. Dias of Prang's Natural History Series), 133
"Campagne [sic] Sketches" (Homer), 144
title page of, 144
Campaign Sketches (Homer), 144, 145, 147
Capitol Almanacs, 67
Capture of Fort Fisher (Davidson), 148
card portraits, listed in 1871 Prang catalogue, 34
cards
embossed, 77
illuminated, 17, 38, 73
imported, 90
on satin, 108, 110, 111
ribbon scroll, 74
shaped, 110
Sunday school, 4.
See also album cards; birthday cards; greeting cards, etc.

cartoon, Civil War, 4
Catalogue and Price List of Artists' Materials, Illustrated, 126–27
catalogues, 22, 25, 61, 77, 84, 92, 93, 101, 103, 112, 147, 159, 166
 merchandise, 59
 Peremptory Sale, 190–91
 Prang (Easter card, 1885), cover of, 71
 Prang (Spring, 1879), title page, 71
 Prang, title page of, 71
 See also Prang Catalogue
Centennial Exposition (Phila.), 21, 44
 See also Prang, medals won by
Chesterfield, Ruth, 50, 51
Chickens, Group of (Tait), 5
Child Life, A Souvenir of Lizbeth B. Humphrey (booklet), 118
childhood, pictures of, 20
children
 educational materials for, 128
 on trade cards, 63
 pictures of, 52, 53, 54, 175
 shadow pictures of, 55
children's books, 50, 51, 52
 collections of, 58
children's calendar, 66
Children's Hour (Longfellow), *color insert 1*
Children's Party (Waugh), 53
children's pictures, 20, 175
china painting
 flower designs for, 40
 fruit designs for, 41
Christmas Art Prints on satin, 109
Christmas cards, 4, 67, 75, 76, 78, 79, 80, 82, 83
 competitions for, 26, 77–84
 description of early, 76
 first by Prang, 22, 74
 humorous, 76, 84
 illuminated, 38, 73
 imported, 90
 left-over, 84–85
 poster advertising, 68
 prize-winning, 79, 80, 82, 202
Christmas Mince Pie (Harlow), 105, 106
Christmas Salad, 1876 (Wilkie), 185
Christmas Stocking Library, 45, 47
chromolithographs, 1, 133
 Prang's first, 5
 See also lithographs
Chromolithography, 2
 process of, 13, 16–17
Chromos, 11
 complimentary, 11, 71
 flower, 21, 91–102
 identification of, 201–2
 Prang's American, 2.
 See also roses
Civil War
 episodes of the, 147–52, 195
 generals, portraits of, 4, 141
 history of (Lossing), 151
 maps, 4, 139, 140, 141, 183
 music relating to, 147
 scene of, *Sold* (Scott), 152

sketches (Homer), 4, 30, 144–45, 147
 still life (Cobb), 152
Clarke, Rebecca S. (author of *Little Prudy,* and *Dotty Dimple Series*), 52
Cliff House, San Francisco (Key), 156
collections, art, 167
Colman, Samuel, 77, 80, 187
color, Prang's interest in, 3
Color, The Theory of . . . (Koehler & Pickering), 126
color lithography
 beginning of, 2
competitions, Christmas cards, 26, 77–84
Conflict, The (Cole), 3
Copley Hall (Boston), sale at, 41, 52, 197–98
copyrights, 201–2
"Court Cards," 84
crayon, lithographic, 2, 3
crayons, 128
crosses, illuminated, 38
Currier & Ives, 1, 202
cut-out items, 103
Cyclamen (Whitney), *color insert 2*

Dame Duck's Lecture (book), 49
dance programs, 41
Dancing Pansies (chromo), 102
Dash for Liberty (Tait), 174
Dawkins, Henry (engraver), 59
designs, (china) painting, 40–41
Designs for Monuments and Headstones (Launitz), 131
Dessert, No. 3, 1871 (Ream), 183
Dessert, No. 4 (Ream), 184
Dias, Mrs. A. M. (co-author with Norman Calkins of *Prang's Natural History Series*), 133
"Dickens Memorial, A" (album card), 40
Dining-Room Pictures, 180, 181, 183
Doctor, The (Bacon), 18
Doll Books, 45, 46, 103
Douglass, Frederick, letter from, re Sen. Revels, 37
Downey, Henry M., quoted, 22, 63
drawings, outline, 119
Dreaming Daisy (Anderson), 20
Ducklings, Group of (Tait), 5, 7
Duval & Son, P. S. (color lithographers), 2

Eagle Colors, Prang's, 128
Early Autumn on Esopus Creek, N.Y. (Bricher), 5
Easter card catalogue, Prang, 81
 cover of, 71
Easter cards, 74, 76
 satin, 81
 with red backgrounds, *color insert 2*
Easter Greeting, An, 75
Easter greeting lithographed on satin, 108
Easter lily cross, large (Whitney), 96
Easter Publications
 poster advertising, 67, 70
Eclat du Jour (Mucha), 23
Educational Company, Prang, 126
educational publications, Prang's, 119–28
embossed cards, 77

employees, number of, in Prang & Co., L., 21
Encounter between the Monitor and the Merrimack, The (Davidson), 147
engravers
 Dawkins, Henry, 59
 Hurd, Nathaniel, 59
 Revere, Paul, 59
 Smither, James, 59
Estes & Lauriat, books published by, 52
etchings, 161, 166
extension cards, 62

Family Scene in Pompeii (Coomans), 17
fans
 black background, 104
 folding, 105
 lithographed with landscape and birds, 105
 valentine, 104
 with silk fringe, 104, 105
Farm Yard Story, A (toy book), 49
 quote from, 50
female figures with garlands (proof sheet), 100
Ferry & Napies, 40
Fine Art Publications poster, 68
flag and arms pictures, 54–55
Flora and *Rosa* (Humphrey), 52
floral cards, 33, 60, 63
 on black ground, 33
 See also trade cards
Florida State University, children's book collection at, 58
flower cards, 74, 84, 110
flower chromos, 21, 91–102
Flower Fancies, title page of (Bailey), 114
Flowers of Hope (Heade), 92, 98
flower wreaths with mottoes, 97
Fort Fisher, Capture of (Davidson), 148
"Fortune Telling Cards No. 2," 55
"Fortune Telling Flowers, No. 1," 55
fowls, broadside portraits of, 4
Franklin Brewing Company, advertisement for, 64
Fredericksburg, Battle of (de Thulstrup), 150
Free Library of Philadelphia, 126, 136
Fruit Piece No. 1 (Biele), 183

"Gallery of American Painters," 17
Game Piece No. 1 (Cass), *color insert 2*
games, lithographed, 55, 58
Gems of American Scenery, Prang's, 153, 159, 161
generals, Civil War, portraits of, 4, 141
George Wiedemann Brewing Co., 63–64
 advertisement for, 65
Girl dancers, 25
Gleason's Pictorial, 3
Gourmand, The (Moser), 186
Grant, General
 lithograph portrait of (de Thulstrup), 36, 151
Great Salt Lake of Utah (Thomas Moran), 158

greeting cards
 Prang, as collector's items, 90
 printed on satin, 90, 111
 sizes of, 76
Group of Chickens (Tait), 5
Group of Ducklings (Tait), 5, 7

half chromos, 3
 Old Dock-Square Warehouse (print), 4
Hallmark Collection, 90, 194, 201
hand printing, 21
Harvesting near San Jose, California (Key), 157
hat tips (labels), 40
"Hearts are Trumps," valentine poster ad, 87
Hiawatha picture (Smith), 55
Hiawatha silhouettes (Frye), 55
Hicks, Mary Dana, 25, 126-27, 128, 136
Hirschel & Adler Gallery, 159
Historical Ornament series (Ware and Heinzen), 131
H.M.S. Pinafore cards, 62-63
Holiday Booklets, 112
 list of, 115
Home of Abraham Lincoln (tinted lithographs), 146
Horses in Storm (R. Adams), 15
Hudson River Views, list of, 29
humorous books, 56, 57
humorous cards, 42, 44
Huntington Hartford Gallery of Modern Art, 159
Huntington Library, 58
Hurd, Nathaniel (engraver), 59
Husband Wanted (panorama), 57

illuminated alphabet, 127
illuminated cards, 17, 38, 73
illuminated mottoes, 39
Illustrated Catalogue and Price List of Artists' Materials, 126-27
Imperials, Prang, 34
imported cards, 90
ink, lithographic, 3
International Centennial Exposition, 60
International Exposition (Paris), 21
In the Forest (toy book), 48
Intruder, The (Tait), 174
Invention of Lithography, The (Senefelder), 2
"Iris Versicolor" (plate from *The Native Flowers and Ferns of the United States*), 132

Johnston, John Taylor, 167, 168
Jonquils (Nowell), 99
judges, Christmas card competition, 77, 80, 84
July (Bridges), *color insert 2*
July 4th cards, *color insert 1*

Kid's Playground, The (Morviller), 15
Kimmel & Foster (lithographers), 60
Kinderlieden (book), 50
"*Kluck! Kluck!*" (Tait), 173
Korpen, J. K. (lithographer), 177

labels
 hat, 40
 Prang-printed, 63
Landscape scene (Murphy), 171
landscape views. *See* Scenery
landscapes, 5, 21-22. *See also* Scenery
Landscapes, Six American (Bricher), 172
"Language of Flowers, The" (illuminated cards), 39, 55
Late Autumn in the White Mountains (Bricher), 5, 6
Launching the Lifeboat (Edward Moran), 20
Lawn-Tennis (Sandham), 164
Leeds Art Galleries, sale at, 194
Leeds Gallery, 172
Leland, Charles G., *Mother Hubbard* book described by, 50
Lenox, James (art collector), 167
Leslie, Frank (ed., *Gleason's Pictorial*), 3
letters in Prang collection, 198, 200-201
Library of Congress, 126
Life in Camp (Homer), 4, 30, 141, 142-43
 sketches from, 142-43
Lincoln, Abraham
 and son Tad, 4
 home of, 4, 146, 147
 lithographs of, 36
 postcard of, 44
Lincoln, Boyhood of (Johnson), 20, 192
"Literature Cards," 84
lithographers
 Armstrong, G., 177
 Bufford, J. H., 2, 60
 Endicott, 60
 Harring, W., 177
 Kimmel & Foster, 60
 Korpen, J. K., 177
 Major & Knapp, 60
 Morales, 177
 Sarony, 60
 Sharp, William & Sons, 60
 Stocklein, 177
 Strauss, 177
 Witt, 177
lithographs, 2
 See also flower chromos
lithography, beginning of, 2-3
Little Bo-Peep (Brown), 19, 20
Little Miss Riding Hood (toy book), 46
Little Prudy (Murray), 20, 52
Little Prudy's Brother (Murray), 20, 52
Longfellow Christmas card, 84
Longfellow stationery, 39
Longworth (art collector), 167

McLoughlin Brothers, 55
Magic Cards, 56
Maiden's Prayer (Brown), 20
Major, Knapp & Co., N.Y., 2, 60
Maps, Civil War, by Prang, 4, 139, 141, 183
 of Forts Sumter, Pickens, Monroe and McHenry, 140
masterpieces, Prang reproductions of, 168
Maternal Love (Tait), 172
Mayer, Julius, 3

Meehan, Thomas, 131
Melanopolychromes ("Pilule del"), 42, 43
menu cards, 41-42, 43
Metropolitan Museum of Art, trade card collection in, 63
Modern Art (artistic journal), 128
 advertisement from, 69
 Frontispiece, 129
 Prang ad in, 130
 Prang's connection with, 22, 128
Modern Art, Huntington Hartford Gallery of, 159
Modern Posters (Scribner's), 128
Monitor and the Merrimack, Encounter between the (Davidson), 147
monument series, 131
Moore, Clement (author), 47
Moore, E. C., 77
Morrill, Edward, Prang letters owned by, 198
Mosquito Trail, Rocky Mountains . . . (Thomas Moran), 160
Mother Goose pictures (Perkins), 55
motto cards, 38
motto crosses, 96, 97
mottoes
 flower wreaths with, 97
 illuminated, 39
Murray, Mrs. E. (author, *Little Prudy* and *Little Prudy's Brother*), 52
Museum for Preservation of New England Antiquities, Prang greeting card collection at, 90

National Academy of Design, 169
Native Flowers and Ferns of the United States, The, Title page (Meehan), 131
 Iris Versicolor, Plate from, 132
Negro minstrels, four scenes of (chromos), 24, 25
New England Wharf, A (Louis K. Harlow), 179
New Version of Old Mother Hubbard, A (book), 50, 51
New Year's cards, 4, 75, 77, 84
 illuminated, 73
New-York Historical Society, 126
New York Public Library, 136
 Proof Books in, 63
 Rare Book Division, 128
Norcross, greeting card collections at, 90
Normal Art Classes, supplemental texts for, 126
North Woods, The (Homer), 199
novelties
 art, as gifts, 112
 shaped, 105

"Object Teaching, Aids to." *See* Trades and Occupations
October (Bridges), *color insert 2*
Old Army Friends Publishing Company, 151
Old Man's Reminiscences, An (Durand), 193

Old Mother Hubbard, A New Version of (Chesterfield), 51
On the Hudson, View of Breakneck Hill (Eglau), 155
Orchids (Lunzer), 99
Oriental Ceramic Art (Walters), 22, 26, 136
 Chinese Dragon Vase from, 138
 Frontispiece of, 137
Our Women Warriors (portrait series), 35
outline drawings, 119

painting books, children's, 128
paintings, Prang's
 Peremptory Sale of, 98, 147, 153, 175, 190, 190
 prices paid for, 101, 148, 201
Palette Colors, Prang's, 128
panels (chromo)
 black (Whitney), *color insert 2*
 Eclat du Jour (Mucha), 23
 Four Times of Day, The (Mucha), 25
 Reverie du Soir (Mucha), 23
panorama book, 56, 57
Pansies (Whitney), *color insert 2*
Parker Brothers, 55
patents, color-printing, 2
Philadelphia Centennial (1875), postcard celebrating, 44
Philadelphia Free Library, 58
photographic likenesses of men in public life, list of, 34–35, 38
Pinafore, H.M.S. (illuminated cards), 62–63
Plant Forms Ornamentally Treated (Carter), 120
plaques
 Kid's Playground, The (Bruith), 15
 Maternal Love (Tait), 172
 Poultry Yard, The (Lemmens), 7
 Primavera, La (Moradei), 169
 Reading Magdalena, The (Correggio), 168
 Sunlight in Winter (Morviller), 15
Playing Mother (Brown), 20
Poets, Haunts of the, 118
Poor Richard's Maxims (album), 30, 31
portraits:
 Beecher, Henry Ward, 36
 Beethoven, Ludwig van, 36
 Civil War generals and prominent men, 41
 Grant, General, 36
 Lincoln, Abraham, 4, 36
 Sumner, Charles, 36
 Washington, George, 4, 36, 187
 Washington, Martha, 4, 36, 187
postcards, 44
poster
 Christmas Cards, advertising, 68
 Easter Publications, 70
 Fine Art Publications, 68
 most valuable Prang, 67
 prize, 128
 valentine, advertising, 87, 90
poster calendar, 67, 69
 cover design for, 69

posters, 22, 59, 61
 valentine advertising, 87
Posters, Modern (Scribner's), 128
Poultry Yard, The (Lemmens), 7
Prang, Louis
 art interests of, 167–68, 183
 background of, 3
 color theory of, 128
 death of, 25
 early prints produced by, 4
 maps by, 4
 medals won by, 21
 original paintings owned by, 52
 portrait of, 9
Prang & Co., L.
 advertising clients of, 67
 art books by, 52
 books illustrated by, 52
 books published by, 50, 131
 branch offices of, 21–22
 number of employees in, 21
 views of plant, exterior and interior, 8
 visit to plant, described, 21
Prang & Mayer, prints by, 3–4
Prang catalogue
 Easter card, cover of, 71
 1871, 147
 1876, pages from, 176–77
 1878, Flower Pieces listed in, 92, 93–95
 (Spring, 1879), title page of, 71
 1885, 111
 1887–1888, 109
 1890–1891, art novelties listed in, 112
 See also catalogues
Prang chromos
 flower, 91–102
 popularity of, 26
Prang Color Prints, 22
Prang Educational Company, 126
Prang, medals won by, 21
Prang's American Chromos, 2, 14
Prang's Chromo, A Journal of Popular Art, 4, 71
 album cards listed in, 32, 91
 beginning of, 11–13
 page from Vol. I, no. 4, 14
 reproduction of page from first edition, 12
 volumes cited:
 Jan. 1868, 4, 29–30, 38, 40, 50, 85, 144, 151, 180
 Sept., 1868, 73
 April, 1869, 5, 13, 16–17, 18, 47
 Sept. 1870, 21
 quote from on Sen. Revels, 37
 Christmas (1868), 92, 180, 182
Prang's Chromo Advertiser
 1870, 55
 Sept., 1870, 47, 56
Prang's Half Chromos, 14
Prang's Imperials, 34
Prang's Standard Alphabet, 126, 131
Prattling Primrose (Anderson), 20, 178
Primavera, La (Moradei), 169
Princess Golden Flower, *color insert 2*
printing business, Prang's, 11
prints, identification of, 201–2

Prize Cards, 197, 202
Prize Piggies (Winn), 178
prize winners, Christmas-card competitions
 Coleman, C. C., 80
 Dielman, Frederick, 81, 84
 Emmet, Rosina, 77, 80, 81, *color insert 1*
 Fredericks, Alfred, 77, 81
 Humphrey, Miss L. B. (Lizbeth B.), 81, 82, 84
 Low, Will H., 84
 Moran, Thomas, 84
 Morse, Alice S., 77
 Sandier, Alexander, 77, 79
 Satterlee, Walter, 81, 82
 Taber, Miss Florence, 81
 Vedder, Elihu, 80, 81
 Weldon, C. D., 84, *color insert 1*
 Wheeler, Dora, 78, 80, 81, *color insert 1*
proof sheet, female figures with garlands, 100
Psaligraphy, 40

Queen of the Woods (Brown), 20

Raspberries, Cake and Ice Cream (Ream), 180, 184
Reading Magdalena, The (Correggio), 168
Rebus Cards, 56, 57,
 illuminated, 39, 56
Red Poppies, No. 4 (Welch), *color insert 2*
Reichards Gallery, N.Y., 84
"Resurgam," (Gibson), 81
Retaliation (Church), 170
Revels, Senator H. R. (Kaufmann), 36, 37–38, 183
Revere, Paul, 59
Reverie du Soir (Mucha), 23
Rewards of Merit cards, 38
Ribbon Booklets, 112
 lists of, 115–16
ribbon scrolls, cards with, 74
Roessle Brewing Co., 63, 65
 advertisement for, 65
Rosa, Flora and (Humphrey), 52
Rose of Boston, The (booklet), 39
roses, 27
 chromos of, 95, 98, *color insert 2*
 Prang's interest in, 91
"Ruggles' Gems," (scenery) four views from, 154

San Francisco Art Association, The, 169
Sarony (lithographer), 60
satin
 art novelties on, 112
 art prints, 81, 107, 109, 166
 cards on, 90, 110, 166
 Christmas Art Prints on, 109
 color lithographs on, 107
 Easter greeting lithographed on, 108
 flower lithographs on, 101
 greeting cards printed on, 111
 peacock feather on, 74
 scenic lithographs on, 166
 valentines lithographed on, 88, 89
Satin Art Prints, 166
satin banneret, 110

satin cards, mountings for, listed, 110
scenery, 17, 21, 151, 153–61
 American Coast Scenes, 29, 156
 California, 156, 157, 188
 Central Park, 156, 202
 Cuban, 5, 151, 153
 English, 166
 Far West, 159
 foreign, 156
 Hudson River, 27, 29, 30, 153, 155, 202
 New England, 151, 157, 161
 Prang's Gems of American Scenery, 153, 159
 Ruggles' Oil-Color Gems, 17, 153, 154
 White Mountains, 27, 30, 202
 Yellowstone Series, 157
School Measure, Prang's, 120
Scientific Publishing Company, 133
Scratching birds, (Natural History Series), 134–35
Seashore Calendar, Sketches for, 67
Senator H. R. Revels, (Kaufmann), 36, 36, 37–38
Senefelder, Alois (author of The Invention of Lithography), 2
series
 alphabet, 126, 131
 American artists, 4
 Animal Game, 55
 art education, text books, 131
 arts, 62
 doll, 45, 46, 103
 etchings, 161, 166
 Hudson River, 29, 30
 landscape, 202
 monument, 131
 natural history, 131–33, 134–35
 portrait, 35
 sport, 161, 196
 women golfers, 165
 See also Trades and Occupations
shadow pictures of children (Dieffenbach), 55
Sharp, William (lithographer), 2, 60
Shaw, John Mackay, children's book collection of, 58
Sheridan's Ride (de Thulstrup), 149
signatures, artists', 202
Sinclair, T. (lithographer), 2
slate pictures, books of, 50 51, 120, 131
Smith, Walter (author of Prang's Art Education Series), 120, 131
Smither, James (engraver), 59
Society of American Artists, The, 169
Society Prints, 42
Sold (Scott), Civil War scene, 152
Souvenir of Lizbeth B. Humphrey, A (booklet), 118

Spanish-American War, lithographs, 151
sperm whaling, lithograph of, 3
Sport, Pictures of American, (series) 161
sports, Prang chromos of, 161
Sports Series, 196
Standard Alphabet, 126, 131
Start, The. America's Cup Race Off Staten Island (Davidson), 162
stationery, Longfellow, 39
Stewart, A. T. (Art Collector), 167
still lifes, 21, 180, 183
 by Jerome Thompson, 21
 by Martin J. Heade, 21
 by Miss Ellen Robbins, 21
 by Mrs. E. Remington, 21
 Civil War (Cobb), 152
"stockcards," 62
Stocklein (lithographer), 177
Stone Fleet, The View of the (chromo), 4, 5
stone, lithographic, 2
 substitute for, 21
Story of a Dory, The, title page of (Edward Everett Hale), 107
Story of Hans the Swapper, The (panorama), 46
Stowe, Mrs. Harriet Beecher, 38–39
Sub-Rosa (chromo), 102
Sumner, Charles, lithograph portrait of, 36
Sunday-school cards, 4, 32, 50, 119
Sunlight in Winter (Morviller), 15
Sunset: California Scenery (Bierstadt), 188
Sunset on the Coast (De Haas), 20

Taber Art Company, 22, 36, 63
Taber-Prang Art Company, 22, 24, 25, 25, 44, 63
Take Care (Tait), 173
tape measure, satin, 40
telephone card, extension, 62
Tennis Set, A (sketch for booklet), 114
Thaxter, Celia (verse writer), 77, 80, 81, 114
theatrical prints, 25
Theory of Color, The . . . (Koehler & Pickering), 126
The Twelve Months (list of), 101
Three Tom Boys (Brown), 20
Toy Books, 46–49, 58
trade cards, 59, 60, 61, 62, 63, 168, 201
 children, 63
 collections of, 63
 list of companies using Prang's, 62–63
 See also calendars
trademarks, Prang
 original drawing for, 70
 rose, 71, 91

Trades and Occupations, 120–26
 Baker, 125
 Blacksmith, 122
 Carpenter, 120
 Farm Yard, The, 124
 Gardening, 123
 Haymaking, 124
 Kitchen, The, 123
 Lithographer, 122
 Printer, 126
 Shoemaker, 121
 Tailor, 121
 Tinsmith, 125
Trades Series, 120, 131
Travelling Comedians (De Vos), 54
"Twelve Month Series," color insert 2
twirl cards, 55

valentine cards (trade cards), 60
valentines, 42, 74, 85, 86, color insert 1
 fans, 104
 humorous, 44
 poster advertising, 67, 87, 90
 rare, 88, 89
verses, authors of, for cards, 77
Vienna Exposition, 74
Vienna World's Fair, 21
View of the Stone Fleet, The (chromo), 4, 5
Violets (Whitney), color insert 2
Visit from St. Nicholas, A (toy book), 48

Walters Art Gallery, 136
Walters, W. T., 22, 26, 98, 136, 137, 167
Washington, Booker T., photograph of, 38
Washington, George and Martha, portraits of, 4, 36, 187
Watercolor Society, The American, 169
watercolors (artist's supplies), 128
watercolors (paintings), 74, 187
wedding announcement, 72
White, Stanford, 80
Whittier Christmas card, 84
Who Stole the Bird's Nest? (toy book), 47
Wiedemann Brewing Company, George (advertisement for), 65
Wild Fruit (Lambdin), 20
Wild roses and morning glories. . . . (Nowell), 99
window cards, 67
women golfers, series of, 165
World's Columbian Exposition, 151, 187
World's Fair Calendar, 187

Yosemite Valley (Hill), 189
Young Commodore (Reinhart), 20